Bangk

Bangkok Found

Reflections on the City

Alex Kerr

RIVER
BOOKS

First published and distributed in 2010 by River Books
396 Maharaj Road, Tatien, Bangkok 10200
Tel. 66 2 222-1290, 225-0139, 224-6686
Fax. 66 2 225-3861
E-mail: order@riverbooksbk.com
www.riverbooksbk.com

ISBN 978 974 9863 92 3

Editor: Narisa Chakrabongse
Production supervision: Paisarn Piemmattawat
Design: Reutairat Nanta
Cover design and illustrations: Vasit Kasemsap
Cover paintings: "Lost in the City" courtesy of Navin Rawanchaikul,
and "Zero" and "One" courtesy of Thongchai Srisukprasert.

Print and bound in Thailand by Kyodo Nation Printing Services Co., Ltd.

CONTENTS

FOREWORD

Bangkok Found is a sequel. Its genesis lies in *Lost Japan* (published in 1993), which consisted of essays describing things I had seen or done in Japan since growing up there as a child. None of the chapters were directly linked to the others, but together they summed up my feelings for Japanese culture. There were essays on owning an old thatched house in the mountains, on Kabuki, art collecting, real estate business, and the spirit of Kyoto and Osaka.

Even as I was writing *Lost Japan*, I was already spending half of my time in Bangkok. In fact, I wrote almost all of *Lost Japan* in Thailand, seated by the lotus pond in the garden of the old Hilton Hotel. As the years went by I realized that I was re-living in Bangkok a Thai version of the world I had seen in Japan: old houses, masked drama, art collecting, even real estate. This time, however, everything was drastically different.

In the case of Japan, my starting point was as an insider, someone who had grown up there and spoke Japanese fluently. In Thailand, I came to live permanently in Bangkok when I was over forty years old. Thai culture had lots of surprises in store, causing me to go back and question much that I'd taken for granted in Japan. In Japan I felt that I had graduated, but in Thailand it was like going back to school again.

In the end, my thoughts on Thailand congealed into *Bangkok Found*. This book, too, is a series of essays based on personal experiences. Some chapters mirror those of *Lost Japan*, such as the ones on old houses and traditional arts; yet reach very different conclusions. Other chapters take up new subjects, missing from the earlier book, such as shops, condos, slums, food, sex and nightlife. Nevertheless, while Thailand gave me new understandings, Japan is always in the back of my mind.

It's a peculiarity of this book that while writing about Thailand I often refer to Japan and China. I have a strong belief that such comparisons bring needed context to Thailand, a country that is often compared to the West, or discussed in a cultural vacuum. Everywhere in Asia we can find temples and palaces, traditional dance, hierarchical politeness, colorful street life, a mix of Western and local influences and so forth. My interest lies in figuring out what makes these things truly different in Bangkok.

While this book is an unfictionalized account of my experiences, I did change a number of names to protect the privacy of friends.

Transliteration of Thai words is a thorny issue, since the language features numerous sounds with no equivalents in English. I've tried to stick with the officially sanctioned RTGS (Royal Thai General System), because it's the most phonetic. But sometimes I chose variant spellings because they're closer to common usage – so I apologize for any inconsistent spellings

During the years of incubation for *Bangkok Found*, I wrote another book on Japan, called *Dogs and Demons*, which was more journalistic in tone, very hard-hitting in its critique of the damage done to Japan's environment and old cities. Thailand has equally serious problems, but *Bangkok Found* is not that kind of book. In Japan, foreign writers have tended to be generous, if not adulatory about things Japanese, so I felt there was a need for a countervailing view. In Thailand, however, other scholars are better equipped than I to write the big exposé. So I'm returning to the earlier approach of *Lost Japan*, which is about seeking and discovery.

This book took years to write and re-write because Bangkok is an elusive place. Just when I thought I knew something, the city would reveal itself in a different light, and it was back to the drawing board. Bangkok has so radically altered my views (for example, on art collecting, or on the relationship of tourism to traditional arts) that at times I've wanted to go back and revise *Lost Japan* too. I'm sure that the minute this book is consigned to the printers, I'll have a new epiphany and will want to add a chapter that hasn't occurred to me yet, or maybe write another book from a different angle. So keep your eyes out for the next sequel in the series.

Acknowledgements

Dozens of people helped over the years with the writing of *Bangkok Found*. Professor Vithi Phanichphant was a fount of wisdom and wit concerning traditional Thai culture. Writer Philip Cornwel-Smith gave invaluable advice during the book's long gestation. Anucha "Tom" Thirakanont, Peeramon "Big" Chomdhavat, and Surat "Kai" Jongda guided me to an understanding of Khon masked drama. Zulkifli Bin Mohamad introduced me to contemporary Asian dance based on traditional forms. Dr Navamintr "Taw" Vitayakul instructed me in Thai food and gave freely of his wide knowledge of Thai design and history.

I owe much to the readers of the books' many revisions:Vasit Kasemsap, Timo Ojanen, Paul Cato, Cameron McMillan, Ari Huhtala, Kristian Tuomikumpu, David Fedman, Moana Tregaskis, Toshiaki Yamada, Garrett Kam and Kathy Arlyn Sokol.

Many thanks to Vasit Kasemsap for designing the cover and supervising the illustrations, and also to artists Navin Rawanchaikul and Thongchai Srisukprasert for their cooperation in using their art works for the book's cover. The cover combines Navin's *Lost in the City* mural with Thongchai's pair of paintings *Zero* and *One*.

Also, I'm grateful to flower artist Sakul Intakul for granting permission to use one of Jirasak Thongyuak's photos from Sakul's book on Thai flower culture *Dok Mai Thai* as the basis for one of the illustrations; to Lanna artist Neti "Bee" Phikroh, who drew the image of the *hatsadiling* (elephant-bird); Khanchai "Jom" Homjan, Khon mask maker and Instructor of Rajabhat Chadrakasem University, who drew the samples showing the development of *prajam yam* and *kranok* patterns of Lai Thai design; contemporary dancer Pichet Klunchun for allowing me to use a photo of him performing with elephant mask; Lanna dancer Ronnarong "Ong"

Khampha, who provided a photo of himself performing modern dance with *fon leb* fingernail extensions; and the National Archives of Thailand for permission to use historical photos from the Archives' collection.

Thanks to Ginny Bird and Ping Amranand, who supplied essential information about the Alabaster/Bird, and Svasti families. Also to Emmy Bunker for her insights into the international art world and to MR Chakrarot Chitrabongs who made sure that I didn't forget to mention the *Traiphum* cosmology.

I offer heartfelt appreciation to my staff at Origin who stayed up late many nights working on the photographs, illustrations, layout, indexing, research, and fact-checking for the book: Tanachanan "Saa" Petchsombat, Vitsanu "Soe" Riewseng, and Rachen "Num" Suvichadasakhun.

Finally, thanks to my unofficial "godfather" Douglas Latchford and to so many others friends and guides over the years in Bangkok.

PREFACE

BY PHILIP CORNWEL-SMITH

Alex and I are Siamese twins. Joined at the eye. We've led parallel lives in Bangkok and both ended up publishing our views on Thai culture. Many of our observations occurred whilst together – on templespotting jaunts, in Bangkok taxis, at festivals upon full moon. Finding Thailand with Alex has been enhancing, revelatory, fun. And sometimes spooky.

Call it telepathy. Time and again, we'd find that we'd noticed the same detail, chosen the same thing, photographed the same moment, such was our synergy from the off. We first met in 1997, once Alex had permanently moved here. Introduced at the Foreign Correspondents Club of Thailand, we became friends after attending a Thai dance. It seems we've watched every Bangkok stage event since. If you want the heart of this book, skip to the chapter on dance. There you'll find his muse.

When we came to write books on Bangkok, each penned the preface for the other. That might seem way too back-scratching, but it reflects our joint presence throughout. With *Very Thai: Everyday Popular Culture*, Alex helped me develop the concept, content and tone. From the time Alex first conceived writing a book about Bangkok, I've subbed drafts, prodded memories, received calls from Japan to bounce ideas around. We mulled potential chapters while floating down the river on a ferry. Out of one such brainstorm, I came up with the title, *Bangkok Found*, as a pun. Of course, Bangkok can never really be found.

Something found implies a search – and something lost. For Alex, that search meant life beyond Japan, or rather, more life than Japan.

Alex earned his repute by celebrating things Japanese, in art collecting, conservation, calligraphy, commentary. Even among the

Japanese, he's a go-to-guy on what makes the country tick. Pundits, tycoons, prime ministers – all mine his thoughts on how to manage heritage. For three decades, he has run courses on Kyoto traditions, first at Oomoto Foundation and now as founder of the arts *dojo* Origin. At Chiiori he restored a thatched mountain house. Through Iori, he turns ancient machiya homes into guesthouses with authentic tatami ambiance. Initially appealing to foreigners – from Nipponophiles to the US First Lady – the courses now cater mostly to Japanese. Long a rare voice for preservation as a source of post-industrial wealth, Alex now finds the public shares his wavelength. His outsider voice caught the local ear.

Alex made his conservation case – and his name – with *Lost Japan*. The book chronicled what he had uniquely witnessed: the last masters of a disappearing traditional culture. Kept restocked on the Japan shelf of bookstores worldwide since 1996, it became Lonely Planet's best-selling non-guidebook. He wrote it first in Japanese prose that makes native-speakers swoon. As a result, it won the Shincho Literary Prize. He's the only foreigner to breach such a literary bastion.

Elegies to lost cultures can smack of romanticisation, but Alex smacked back with evidence. To show how Japan lost itself, he dissected the development-state in the book *Dogs and Demons: The Fall of Modern Japan*. Many Japanese appreciated this articulation of widespread unease, though Western Japanologists bristled at the withering of their role-model. They blustered, Alex prevailed. Most every article or analysis of contemporary Japan now draws ideas, examples, even phrases, from *Dogs and Demons*. Like Malcolm Gladwell's *Tipping Point* or Tom Friedman's *The World is Flat*, Alex Kerr shifted a paradigm, coined a lexicon, changed people's minds.

Alex then changed his own mind about what mattered to him personally. In Japan he had become a public figure, a contradictory fate for an author. Writers need a refuge, a place to unwind, to think, to write. Thailand offers that sanctuary with a hospitality that comes with ease. Amid its multi-ethnic milieu he met many others with the same motivation to relish Bangkok's freewheeling phase.

12

In this mid-life adventure, he tackled many challenges: launching a firm; building a Thai stilt house; investigating the art trade; accompanying Thai Buddhism's leading monks to New York. His work in Kyoto continues to grow, but once his soul had found Bangkok, Japan lost something of Alex.

Lost Japan – Bangkok Found; in this sequel Alex finds the Siamese yin to his Japanese yang.

That begs the question whether Bangkok will become a sequel to Kyoto. Years hence, readers may view this memoir-meditation as another 'last witness' account of a traditional culture we lost. After all, Thailand's development template is Japan.

Maybe Alex found Bangkok just in time. Traditional culture survives, and sometimes thrives, in what at first glance is a dauntingly concrete conurbation. Through his Bangkok and Chiang Mai branches of Origin courses, Alex seeks to explain aspects of this culture that get overlooked or misunderstood. Championing something old in a land enamoured of things new can be a sensitive matter. In Alex, we have a guide seasoned in how to couch delicate issues within the context of 'Asian values'.

Alex changed my mind, too. He affected the very way I looked at, and thought about, Asia. Exploring Bangkok with him after I'd been here several years has helped me find the city anew. These reflections on his adopted home might open fresh perspectives for visitor and resident alike.

Alex believes in mentors. In reaching for the right allusion, he can draw upon his mentors in Japan, citing "as David Kidd would say" insights, or ponder: "How would Tamasaburo put that?" In turn, Alex has mentored me in the most common and crucial pitfall for the Westerner in the East: how to say what needs to be said without anyone losing face.

As in *Lost Japan*, Alex finds a way to say more than he physically writes. Thais pride themselves on maintaining surface harmony. After all, the city where Alex found himself is named after angels. Some of them appear in these pages – along with a few dogs and demons. The angels' behaviour can leave outsiders befuddled, while initiates read the smiles for signs of what's really going on.

This book might be about Alex's life in Bangkok. It's also a primer on how to read and react to those smiles. The tourism authority promotes the city's less noticed sights as 'Unseen Bangkok'. Alex addresses another dimension: 'Unthought Bangkok'.

Philip Cornwel-Smith is author of *Very Thai: Everyday Popular Culture*, *Time Out Bangkok* guidebook, and the forthcoming *Very Bangkok: Neighbourhoods, Networks, Tribes*.

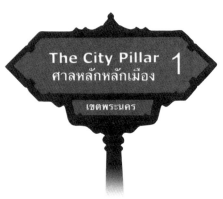

THE CITY PILLAR

Not being a morning person, I tend to remember mornings when something of note took place in my life. One of these was daybreak of April 21, 2002. I found myself walking in the early dawn light from Saranrom Park near the Grand Palace in a parade headed towards the City Pillar to celebrate the 220th anniversary of the founding of Bangkok.

Paothong Thongchua, who was in charge of the ceremonies, had engaged people from all over Thailand to create elaborate flower offerings, which they carried in procession, wearing colorful silks. I and a few other foreigners whom Paothong had alerted to the event, had also been told to wear Thai costume for the occasion. Once arrived at the Shrine, we settled in for hours of ritual performed by Brahmanic priests, enveloped in clouds of incense.

Located across the street from the Royal Palace at its northeast corner, the small Shrine of the City Pillar comes rather far down the list of "must-sees" in most guidebooks. The big tourist buses don't stop here; the few foreigners wandering inside are people who happened on the place while walking around the royal city. Yet this shrine is the official center of Bangkok, the first thing to be built after Bangkok became the capital.

Just fifteen days after his coronation in 1782, King Rama I set up the city pillar here to mark the founding of Bangkok, and only later did he start constructing the Grand Palace. The exact moment of the raising of pillar, as fixed by the astronomers, was 6:45am on April 21, 1782.

I'm not sure what modern-day astronomers would say about the number 220, but we all felt that today's anniversary marked a mystic turning point in the history of the city. For me it was a return to a place that I'd been visiting, without really knowing what it was, for thirty years. My eyelids drooping at 6:45am as the priests chanted and the incense wafted over us, I started thinking about what had brought me here.

December 28, 1989, I was seated reading a newspaper on the bullet train going from Kyoto to Tokyo, when a voice from on high boomed in my ears, and proclaimed one word: *Bangkok!*

In the next instant, I could hear only the hum of the speeding train. In all my life, it was my first and last visitation from heavenly spirits. Carefully putting down my newspaper, I thought what could this mean. The fact was that until that moment I had practically forgotten Thailand, which had accounted for a few interludes in my life in the 1970s. I had not seen Bangkok in over ten years.

My life until then was largely lived in Japan. My family came to Japan in 1964 when my father, an American naval officer, was posted to the base in Yokohama. I was then twelve years old and found a fascination with Japan that inspired me later to study Japanese at Yale and Chinese at Oxford, and after 1977, to take a job in Kyoto and live in Japan permanently. By 1989, when the Voice spoke, I was deeply involved in studying Japanese arts, writing about Japan, doing business in Japan. There seemed to be no reason why I would ever leave.

But, as I sat there on the train, memories of Bangkok flooded in. Looking back now I can see that my experiences with Bangkok came in waves, each one drawing me a little closer, until at last in 1997 I washed up on shore.

The first wave came when I visited Bangkok in 1973, on the way back to America after a university year in Japan. In those years

before the Khaosan Road area became an international backpacker mecca, backpackers stayed at the Malaysia Hotel. It served as a nerve center for young people, where you could pick up information about any place in Thailand, Nepal or beyond, from papers stuck up on the message board in the hallway.

In the city, I experienced very much what backpackers still do today: I wandered Chinatown, set a bird free at Wat Pho, marveled at the Grand Palace, and boated to the Floating Market. The streets brimmed with intriguing things for sale. I bought one of my first antiques on that trip: a 15th century incense burner picked up at the flea market in Sanam Luang, the square in front of the Palace.

While wandering around Sanam Luang, I also stumbled on the Shrine of the City Pillar, a small structure sheltering a golden column to which streams of worshippers brought flowers and incense. My companion, a Thai student guiding me around in order to practice his English, whispered, "We believe that when this pillar was raised, human beings were sacrificed and their remains buried beneath it so that they would forever stand guard and protect the city. It's thought to have awesome power – it can grant wishes, but it can also harm the weak of spirit. Be careful about this place."

The reason I made the trip was a pilgrimage to meet John Blofeld, an authority on Taoism, to whom I'd been introduced by my mentor David Kidd in Kyoto. John had lived in Beijing in the twilight years of the 1940s before the Communist takeover. He had inspired me with his books about exploring the secrets of the Tao with pale-skinned immortals who dwelled in cloudy hermitages in China's remote mountains. John was part of the diaspora of "old China hands" who, after the Communist victory in 1949, had relocated around Asia, some to Taiwan and Hong Kong, others to Japan. John had chosen Bangkok.

Navigating a maze of back streets, I sought out the guru. Off the traffic-choked main avenues, Bangkok was still leafy, even rural in those days. John Blofeld lived in a traditional Thai compound. Above the mayhem of dogs and screaming children in the muddy yard below, John presided serenely on the verandah of a wooden house raised up on stilts. He sat me down on the terrace in front of

a golden Burmese Buddha, and proceeded to expound Taoist arcana, and other secrets, such as why roofs in Thailand and China curve upwards at the eaves. It is, he explained, to purge a taboo.

When you raise up a building, you are breaking a taboo against the earth – and so the eaves, rather than pointing back down at the earth, should rise again at the tips to point up towards the sky. Since then I've heard other explanations, probably more accurate historically, but none that satisfy the heart in the same way. I never look at curving Thai or Chinese rooflines without remembering that conversation.

Aside from calm afternoons spent chatting with John on his verandah, Bangkok went by in a whirl. At that point, immersed in college study of China and Japan, I saw Bangkok as a stop along the way of learning more about Asia, not as a destination in itself. So, just as young travelers continue to do today, I used Bangkok as a jump-off point for traveling to Burma. Returning after a week in Burma, I felt at once relieved to find creature comforts like air-conditioning, and a slight sense of disappointment. Compared to Rangoon, where most people still wore *lungyi* (Burmese sarongs) and the largest structures to be seen in cities and in countryside were golden pagodas, Bangkok seemed like just another crowded dusty Asian city.

I visited Bangkok a few more times during the 70s, usually on the way to Burma or Nepal. Then, in 1977, my long university years ended, and on the advice of David Kidd, I took a job at the Oomoto School of Traditional Japanese Arts, outside of Kyoto. Another old China hand like John Blofeld, David Kidd was a legendary art dealer who had lived in Beijing in the late 1940s and early 1950s. During the long years of Mao's Communism, when China was basically closed to outsiders, he made a home in Japan, inspiring a generation of young students of Japanese art.

In 1977, David restarted my Thai connection when he invited a young Thai from Bangkok, Ping Amranand, to attend the Oomoto School. At Oomoto, while studying Noh drama and Tea Ceremony, Ping and I became fast friends. In fact, Ping was with me on the day that I first discovered Tenmangu, the abandoned Shinto shrine

near Oomoto which later became my home. In 1978, I went to Bangkok to visit Ping, and it was on this trip that I first started to think of Bangkok as a place to live.

Ping came from an exotic background. David Kidd, with his flair for exaggeration, had introduced Ping to us as a "Thai prince who lives in a palace." Ping modestly explained that he was not a prince, and only his mother, not himself, had a noble title; and the palace was merely a place his grandfather had purchased and which Ping sometimes visited but never much lived in. But he was in fact a descendant of King Rama IV.

Ping's family was heavily Anglicized, so much so that his aunt Nunie spoke better English than she did Thai. His mother Pimsai, who died the year before I saw Ping in Bangkok, wrote eloquently in English, penning a book on gardens, and evocative memoirs about her childhood in England and later return to Thailand. Most of the family were educated in England, including Ping's brother Pok, who had actually been at Oxford while I was there, although we had never met.

The British influence went way back. Ping's great-grandfather, Prince Svasti, was the first Siamese to study at Oxford. However, what fixed Britain firmly in the family's destiny was the coup of 1932 that abolished absolute monarchy. King Prajadhipok (Rama VII) went into self-imposed exile in London in 1934, abdicated in 1935, and remained in England for the rest of his days. Ping's mother and her sisters grew up in London where their father served the exiled King. Only in 1951 did they return to Bangkok.

During my week in Bangkok, Ping took me up for a weekend to the old capital of Ayutthaya where we explored 17th century ruins and paid respects at one of the temples with his grandmother. Naked children with topknots swam in the canals, a glimpse of something soon to disappear; nowadays one only sees a scene like this painted on tourist trinkets. As the grandmother entered the temple, everyone fell to their knees. It was a lesson in what being descended from royalty still meant in Thailand.

Back in Bangkok, an interminable drive through horrible traffic would bring me to a quiet leafy road off Sukhumvit and there I'd

find cheerful Nunie, Ping's aunt, surrounded by her helpers and disciples, mixing up vats of dye and melted wax for her small factory of tie-dye fashion. One of her disciples was later to visit Oomoto along with Nunie's daughter Oy, and in time became one of Thailand's leading fashion designers.

But at that point we were all still young, and Nunie's atelier had more the feel of a hippy establishment than *haute couture*. Nunie and the gang of cousins who surrounded her – Ping, Ing, and Oy –

Boy with topknot
Topknots were cut at about twelve to fourteen years old.

became an adopted family for me. Nunie had a scholarly bent and was a goldmine of information on almost every subject. She explained to me how a certain flower in the garden was valued by the Siamese not for its looks, but for its scent; over here in a corner stood a different tree, planted because it protects against ill fortune.

Looking back I realize that the milieu I had fallen into with Ping and his family was part of the huge extended family of Thai minor royalty. Earlier reigns had enormous harems (King Rama IV had 43 consorts, Rama V had 153), producing hundreds of princes and high court ladies, who built their own palaces, dozens of which still stand in Bangkok today. Their descendants were honored with titles, following the Chinese system of nobility, in which you go down one rank in each generation. So the son of a King was a Prince, his son a MC (*Mom Chao*), his son a MR (*Mom Ratchawong*), and his son a ML (*Mom Luang*). After the fifth generation, the children no longer bear titles, although they are allowed to add the suffix na Ayudhya ("Of Ayutthaya") to their name. Ping's mother and her sisters were all MR, but since the noble ranks only moved in the male line, Ping had no title.

After generations of prolific polygamy, suddenly, with Rama VI, monogamy became the rule. The next three reigns of Rama VI, VII, and VIII produced no male heir, and King Bhumibol Adulyadej (Rama IX), fathered a modestly sized family of four children. What that means is that hundreds of people in Bangkok today claim royal descent, but the higher ranks are disappearing. You would hardly ever meet a MC these days. It's mostly MRs and MLs, and in another fifty years, most of these will be gone too.

Meanwhile the nobility still have clout in Bangkok. They feature on the boards of companies, in high society, and in politics. In 2009, MR Sukhumbhand Paribatra, scion of an illustrious noble family, won election as Governor of Bangkok. However, the land ownership that gave the nobility much of its power is dissipating as siblings break up larger plots on the death of their parents, and families sell property bit by bit to keep up their life-style. It used to be said that there were three powerful groups in Bangkok: the nobility, the army, and the Chinese businessmen. Of these, the nobility is fading, and slowly but surely will disappear. That leaves the army and the Sino-Thai businessmen as heirs to the city. Of course, in those days I hardly knew about this background, because Ping, Nunie, and their family were far too discreet to talk about any of it.

I went back to the Shrine of the City Pillar, and this time learned a little more. When he established the pillar, King Rama I was following an animistic Thai tradition of erecting a wooden pole to mark the center of each town or village. Years later, when traveling in Burma north of the Thai border, I saw the origin of this when I came across a small wooden pillar standing at a village crossroads. But Nunie cautioned me, "Don't assume that City pillars are such ancient Thai things. They actually derive from the stone Shiva lingams that stood in the great temples in Angkor. So they're really Khmer in origin."

The pleasant time spent with Nunie and her family was during daylight hours. On this visit I was more prepared to see what the night had to offer. When darkness fell, Bobby Bird, son of Willis H. Bird, one of the pioneer Americans who had been in Bangkok since World War II, came to pick me up in a car filled with his friends, and we would go off careening madly through the streets.

Bobby and his sister Ginny opened the door for me to the exotic nightlife of the 1970s. Bangkok was a smaller town then and old families like the Birds loomed larger in the scheme of things than they do now. When Baron Arndt Krupp von Bohlen und Halbach flew into town and threw a big party on the boat Oriental Queen, handing out as party favors diamond rings and rubies to the prettiest boys and girls, Bobby and Ginny were of course there. So was the young fashion designer whom I met during the day at Nunie's studio. At one point I helped Bobby arrange for a Venetian bank owner to host his international guests at an old Bangkok mansion for a party – that lasted for a month. Bobby had 19th century costumes tailored for all the guests, as well as waiters, cooks, and servants, who were trained in palace etiquette. A truckload of orchids arrived every day.

Bangkok at that time reflected the hedonistic abandon of the post-1960s liberation and pre-AIDS era, a decade when London and New York, too, were at their most decadent. A party for a month, entirely in antique costume, with an endless supply of fresh orchids, was one form it took in Bangkok.

Bobby and Ginny hailed from a family who encapsulate the role played by British and American expats in forming modern Thailand. Their ancestor, Henry Alabaster, came to Bangkok from the Isle of Wight in the 19th century to work for the British Embassy. Alabaster met King Rama V, who took a liking to him, and ended up as advisor to the King's many projects to modernize the nation. He built the first paved road in the country, called "New Road" (also known as Charoenkrung) along which stand the Oriental Hotel and River City antiques center, and he also founded the National Museum and the Post Office.

Alabaster's British wife got fed up with the heat, the mosquitoes, and the King's constant calls on her husband's time, so she packed up their three sons and returned to Britain. At this point, Alabaster married a Thai woman with whom he had two more sons. The King bestowed upon the family a Thai name, translating Alabaster as "White Stone," or *Savetsila*, in Thai. The two sons continued their father's work as civil servants, in the process gaining

aristocratic titles of the sort that were granted to non-royal officials. One of them (Ginny and Bobby's grandfather) founded the Forestry Department. He also produced fifteen children from five wives. The oldest of the fifteen was Siddhi Savetsila, who was to play a momentous role in Thailand during World War II. When the War broke out in 1941, Field Marshal Phibunsongkhram allied himself with the Japanese, allowing them free use of Thailand as a base for invading the Malay Peninsula and Burma. At the time, Siddhi was in his freshman year at MIT University in Boston. A call went out from the Thai Embassy for volunteers who would return to Thailand to fight for freedom against the Japanese occupation. Siddhi and a handful of young Thai men signed up, becoming the "Free Thai Movement," who fought the Japanese underground until the end of the War, with the help of the CIA, then called the OSS. The activities of the Free Thai had a huge impact on Thailand's later relations with America, since they allowed Thailand to be treated at the war's end as a victim and not an ally of the Japanese. In later years, Siddhi rose to become Air Chief Marshall, Deputy Prime Minister, and eventually Privy Councillor to the King.

Willis H. Bird, an army colonel from Philadelphia, was assigned by the OSS to work with the Free Thais during the War. He befriended Siddhi, and when Willis moved to Bangkok in 1947, he married Chalermsri, youngest of Siddhi's fifteen siblings. He proceeded then to build a business career in Bangkok, in the process founding the Bangkok Stock Exchange.

The family history of the Svastis and the Savetsila/Birds contrasted strongly with what I was familiar with in Japan and China. It was inconceivable that a foreigner or descendant of one would have founded any important national institution in either of those countries, much less the Post Office, the National Museum, the Forestry Department, and the Stock Exchange. Meanwhile, Thais had been living and studying abroad for generations, as you could hear in the clipped British accents of Nunie and her children. All this made Bangkok feel truly "international" in a way I'd felt before in New York, but never in any other Asian city. The mixed-

race Savetsila/Birds and the foreign-educated Svastis were misfits in their way, and yet they had successfully built niches for themselves in Bangkok. It made me feel that I, too, could create a life here.

Bangkok began to exert its spell. So entrancing was the city that I made plans to move here and work as an English teacher. It was to be a big break with my past and background, since I knew next to nothing about Southeast Asia. Nevertheless, I made my decision to leave Japan. Nunie arranged for a job and even a little house in Bangkok. When I returned to Kyoto in December 1977, I was all set to announce my departure to Oomoto.

There was just one tiny cloud on the horizon. The night before I left Bangkok, Nunie did a divination using the old Chinese book of hexagrams called the *I Ching*. When I asked how my Bangkok life would go, we got the hexagram *The Abysmal*. "In the abyss one falls into a pit," the I Ching said, "Misfortune." And sure enough, on arrival at immigration in Osaka, I made the mistake of marking on my health card that I'd had a bit of diarrhea. Armed guards rushed me off to a hospital where they kept me in solitary quarantine for a month. David Kidd later said they were right to hospitalize me, but it should have been for mental reasons – for being naive enough to write the truth on the health card.

As the *I Ching* had foreseen, Japan was not ready to let me go, for immediately on emerging from the hospital, something happened that changed everything: I met the Kabuki actor Tamasaburo, and became infatuated with Kabuki actors and their world. Before I knew it, all thoughts of Thailand had flown my mind. I wrote Nunie to say I wouldn't be needing the job or the house. I spent the next few years submerged in the backstage of the Kabuki Theater. Japan reclaimed me. A decade went by without another visit to Bangkok.

During those ten years, there were some twinges. My father, after retirement, sailed around the world for years on a small yacht, and on Christmas 1983 I went to visit him in Tahiti. One evening I took the ferry from Tahiti to nearby Moorea where we were anchored. It was dusk, and the Tahitians were lounging in the

evening breeze, both men and women wearing flowers in their hair scented with coconut oil. As they murmured soft syllables of Tahitian in gentle ripples of sound, the evening light gleamed off their smiling white teeth. At the stern, seated squarely on a stool, legs akimbo, sat one of those ubiquitous Chinese shop ladies: dressed from head to toe in black satin, with her hair pulled back in a severe bun, and her face in an unmoving frown. It was obvious that the fierce Chinese madame and the gentle Tahitians, although co-existing for generations in these islands, belonged to completely different cultural universes. I thought to myself at that moment, "I've spent most of my life in north Asia, but it's the south and the islands – they're my people!" I felt for a instant the tug to Thailand, but the moment passed, and after that I forgot again.

And yet, when the Voice from heaven spoke on the bullet train in 1989, I knew instantly what it meant. A seed planted long ago had been quietly growing for the last decade. Maybe the Voice knew that I'd neglected Thailand far too long, and that I needed some prodding. In any case – it must be a classical pattern for mid-life crisis – something inside that had been buried so deep I hardly suspected its existence, burst forth, and there was no resisting it. It's just such moments that drive wives to leave their husbands and move to Acapulco, or businessmen suddenly to sell their companies and pour their energies into a fresh field. It must have been something like this that incited Henry Alabaster to leave the Isle of Wight and board a boat to Bangkok a century ago. At the time I had a busy life in Japan, and had no idea what to do in Thailand, or even what the country would now be like. Nevertheless, by the time that train reached Tokyo, I had made up my mind: I was moving to Bangkok.

And so, nervous but filled with anticipation, I found myself on April 11, 1990, driving through Bangkok's dark streets on the way to the hotel. The first thing that struck me was the darkness, such a contrast to brightly-lit Japan. Even now I think Bangkok must be one of the darker Asian metropolises, and that night it lent the city an atmosphere of invitation. Images of street carts, children selling flowers, and people lounging in front of shophouses, filtered

through my taxi windows as I drove through those shadowed avenues. I knew this was the right place for me.

During the following week, I made another pilgrimage to the Shrine of the City Pillar. It had been rebuilt in 1986 and looked quite different from what I remembered. This time there was not one pillar, but two. One was tall and thin; the other was short and fat. Which one was the true City Pillar? Guidebooks said nothing about it; nobody I asked seemed to know. In fact, most of my friends didn't seem even to have noticed that there were two pillars.

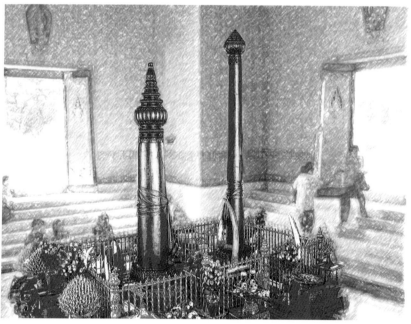

Shrine of the City Pillar
left: the pillar of King Rama IV.
right: the pillar of King Rama I.

I did a bit of research. It turns out that tall thin one is the original City Pillar put up by Rama I. When first erected, it had contained within (or below it) the horoscope for the city, which it is said, had a lot do with the Burmese who had invaded and sacked

Ayutthaya in 1767. However, by the time of Rama IV, it was apparent that the big threat to Thailand was not the Burmese, but Western colonial powers. So in 1852, not long after he acceded to the throne, King Rama IV had a new horoscope cast and a new City Pillar (the short fat one) put in place of the old one. Rama I's pillar was removed and stashed against the shrine wall, which is where it had been standing in the shadows for over a century, unseen by most visitors (including me), when I had first visited.

In the 1986 restoration of the Shrine, officials rediscovered Rama I's pillar and stood it up again so that it joined Rama IV's pillar in the duo we see today. But although they now stand side-by-side, Rama IV's shorter pillar is considered to be the true center of Bangkok.

I learned that other old cities, such as Petchabun and Ayutthaya had city pillars too, making Bangkok's pillar just one in a long evolution. But despite having visited Ayutthaya repeatedly in the 1970s, I just couldn't remember ever seeing the city pillar there. I went to Nunie, who laughed, and said, "Don't take any of this at face value." She proceeded to give me a history lecture: "First of all, there's no record of the word *Lak Mueang* ("city pillar") being used before Rama I founded Bangkok. City pillars might have existed but they were probably known by different names. Secondly, all the other *Lak Mueang* we see now trace back to Field Marshall Phibunsongkhram (Thailand's dictator for much of the 1930s and 1940s). At one point, Phibunsongkhram decided to move the capital to Petchabun, and as a first step he set up a *Lak Mueang* there. They never did move the capital, but officials saw city pillars as advancing Thai identity, and so they set them up in other towns. They're erecting them in more and more places these days, and people soon think they've been there forever. The reason you didn't see a city pillar in Ayutthaya when you went before is that they only put it up in the 1980s."

So, a simple thing like the City Pillar that represents the heart of Bangkok turns out to be two things, not one thing. As for the other city pillars, including even the one in the ruins of ancient Ayutthaya, they're merely the recent inventions of modern bureaucrats.

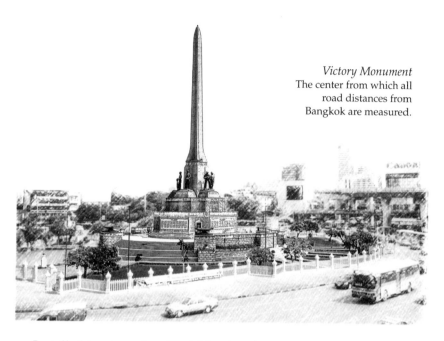

Installed to strengthen Thai identity, the tradition they celebrate
actually may have come from Cambodia. Meanwhile, the story of
human sacrifice, in which many Bangkok dwellers still believe,
also turns out to be nothing but myth, Bangkok's original "urban
legend." No evidence exists that such a thing took place.

This was my introduction to the slippery, dualistic world that is
Bangkok. History is largely an illusion; and where there is one
pillar, there is always another, a Plan B. Or even a Plan C. When
driving on the freeway and seeing a sign that said, "125 kilometers
to Bangkok," I had assumed that the distance was calculated from
the City Pillar. However, I later discovered that for highways, the
government has chosen yet another center for Bangkok: the
Victory Monument. A 50-meter-tall obelisk raised by Field
Marshall Phibunsongkhram in 1941, it commemorates a now
nearly-forgotten battle with the French colonial authorities in Laos
and Cambodia. The Victory Monument is a gigantic version of a
city pillar done in Western (or Egyptian) style. So Bangkok actually
has two centers: the old royal Shrine of the City Pillar, and the new
Victory Monument.

The questions surrounding the City Pillar made me realize that

learning about Thailand was not going to be the straightforward course of study I was accustomed to in Japan. I found myself reading George Kates' *The Years That Were Fat*, an account of his move to Beijing in the 1930s, after having made a career as a screenwriter in America. He wrote on his arrival in Beijing, "How was it that I, an American in my early middle years, should find myself here for no practical reason whatever; launched by my own will to pursue what turned out to be, beyond question, the single most rewarding adventure of my life?" Like Kates, I was coming to Thailand in middle age with another life behind me.

So began a long gradual process, where I would travel back and forth, spending increasing amounts of time in Thailand. In 1990 I met my future partner Khajorn; in 1991 I rented my first apartment. Soon I was addicted to Bangkok and spending three or four months of each year there. With no business to do, I found that it was a good place to write. I would spend long afternoons in the Hilton Hotel gardens drinking coffee and writing *Lost Japan*. Being away from Japan made it easier to write about it.

Although I was coming often, during this phase I was basically a tourist. It's a fairly common lifestyle for foreigners who live part time in Bangkok. Thousands shuttle back and forth between their home countries and Thailand, just as I did. Tourist life in Bangkok was exciting and *sanuk* (fun), with excursions to Pattaya and the island of Samet, markets, discos, restaurants, Saturday afternoon at Chatuchak Market, and Sunday brunch at the Sukhothai Hotel.

Life got more exciting in February 1991, when a military coup toppled the elected government, and by spring of 1992, a civil uprising against the military junta filled Bangkok's streets. It ended in tragedy with soldiers shooting scores of demonstrators around the Democracy Monument. My partner Khajorn was in the crowd that day, and narrowly escaped with his life. Knowing that he had little political interest, I asked him, "Why did you go down there?" "Because it was *sanuk*," he replied. Even revolutions have a *sanuk* side in Bangkok, as we were later to see in the coup of 2006, when people offered flowers to the soldiers, and dressed their babies in khaki to be photographed next to submachine guns and tanks.

The events of 1991 and 1992 were my first coup in Thailand, but not my last. It took years before I had some feeling for what was going on, but over time I came to see that the many coups Thailand has seen over the decades are the surface fractures of a huge rift within society. Deep systemic weaknesses allow some groups and institutions a disproportionate hold on power, while resentment builds up within society, periodically exploding in violent episodes such as the anti-coup uprising in 1992, and the clash between the Yellow Shirts and the Red Shirts in 2007-2009.

The rift has taken different forms over the years. In the 1970s students fought rightist generals. In 1991-92, the newly arisen middle class opposed the generals. In the late 2000s, the focus had moved to the supporters and enemies of Prime Minister Thaksin, who later organized themselves into the Red Shirts and Yellow Shirts.

Foreign observers have tended to see the yellows as the urban elite and the reds as the rural poor, but it's hardly that simple. A vocal Yellow Shirt friend of mine says, "It's not about the cities and countryside. Yellows and Reds exist in both those places. It's between the politically aware and the ignorant who are manipulated by corrupt politicians." The Red Shirts, whose party won repeatedly in the popular vote, but was removed from power by the army and the courts, dismiss such remarks as condescending. They say it's simply a matter of allowing the people their voice under true democracy. The rift – so contentious that one can't even define it easily – never seems to go away, and might be growing worse. At times it goes underground, and Thailand experiences periods of calm, and then it rises back to the surface, and the country witnesses fresh upheavals.

In 1992, I had yet no idea of all this. In fact, the 1991-92 coup and its downfall at the hands of the street uprising, was succeeded by a long stretch of what seemed to be stable democracy and peace. Many thought then that coups were a thing of the past. In any case, my emphasis was still on *sanuk*, and my visits to Bangkok became more frequent. In 1993 I moved to a small apartment in Pratunam, and the time spent in Bangkok increased, until I was living half of each year here.

By this time much had changed among my old circle of friends. In 1988 Bobby Bird had died, still young. His sister Ginny had moved to Hong Kong where she ran a trading firm. Nunie had thrown herself into trying to save the rain forests of northern Thailand and was rarely around, but I did manage to get to Chiangmai to see her now and then. Ping, traveling between Washington DC and Bangkok, was well advanced in a career making him one of Thailand's leading photographers. Nunie's young disciple had parted ways with his mentor and gone on to make a splash as a fashion designer for Bangkok's glitterati. We were all growing up, and so was the city.

Finally, in August 1997, the big moment came. I took a larger apartment that would fit my books and belongings, packed them up, and shipped everything to Bangkok in a container. I sent out a letter to all my friends announcing my departure from Japan and the intent to establish a program of traditional Thai arts modeled on what we had done at Oomoto for Japanese arts. This time when I consulted the *I Ching*, it said, "*The Creative*, sublime success."

On Sep 5, 1997, Khajorn and I and some friends gathered in the big empty apartment to which the furniture and books had not yet been delivered. We popped open a bottle of champagne and toasted to Bangkok. I had finally arrived, twenty-four years after my first visit, and eight years after the Voice spoke on the bullet train.

Well, not quite. The karmic bonds with Japan hold strong. Despite having moved to Thailand, I still spend about half of each year in Japan, maintain a home and a company in Kyoto, and continue writing and speaking there. Japan keeps its hold on me, and I can see now that it always will. In a sense, I've ended up like the Shrine of the City Pillar – an old life and a new life standing side by side.

Nevertheless, after 1997 Bangkok became my base. Once I was no longer a tourist and had become a resident, I faced new challenges. Establishing a school of Thai arts was a good idea, but how was I to do anything in Thailand when I knew so little about it? Having prided myself on being an expert on East Asian culture, it came as a shock to realize that my classes in university had given me

only the most cursory introduction to Indonesia and Cambodia, with nary a word about Thailand, Burma, or Laos. I knew almost nothing, and to my professors also, I now realized, Southeast Asia was a blank. One old friend, on hearing of my departure in 1997, asked with genuine concern, "How could you leave Japan, with its depth and richness, for Thailand, where the culture is so shallow?"

My instincts told me then, and my experiences confirm now, that this is far from the truth. There was, after all, a reason why John Blofeld, seeker after Taoist mysteries, had chosen Bangkok. What he sought wasn't to be found in Hong Kong or Kyoto. Bangkok's fascination rests in the fact that, while being a world-class modern city, the threads to the past have not been cut.

One sees a way of life that harkens back through centuries of Thai kingship, to Angkor, Java, Sri Lanka, southern China, and even further back to ancient India. Modern Thais are heir to an incomparable cultural richness no longer alive in industrialized Japan or post-Cultural Revolution China. You could see this in shape of the flower offerings that we carried to the City Pillar on April 21, 2002. Seemingly new, especially the ones designed by Paothong and his young followers, the designs and concepts behind them went back hundreds, maybe thousands, of years.

There was more going on that day, of course, than just flowers. Most peculiar was the choice of the 220th anniversary (rather than, say, the 222nd, or the 225th) in which to hold such a lavish ceremony. No one ever could tell us why this day was so important.

So, as happens often in Thailand, we make up theories to try to understand it. One Thai friend says, "It goes back to the original concept behind the City Pillar – to protect the city. People in charge must have sensed that big changes, economic and political, were taking place in Thailand that would pose a threat. It's like when you are living in a house and you begin to see omens and realize that something is wrong, so you hold a merit-making ceremony to exorcise the trouble."

During the 2007-2009 Yellow Shirts/Red Shirts demonstrations, it was even suggested by some that it might be time to set up a third City Pillar. Says my friend, "We've exhausted Plan A and Plan B,

so now we need to create Plan C, this time not to ward off the Burmese or the Western Powers, but to protect against the discord within."

Of course erecting a third pillar is not really practical. So the merit-making event took the form of a parade of flowers.

Well, that's just one explanation for something that maybe has no explanation. Thailand will always remain a challenge for me because of vagaries like the City Pillar, and because there is such a gap between my feelings for this place and my background. My academic training was in Chinese art and philosophy – one might say that my mind was in China. My life has been in Japan. My heart lay in Thailand. Eventually, after many zigzags along the way, the mind and life followed the heart to Bangkok.

LIGHTNESS

I was stunned when I first saw the roofs and towers of the Grand Palace across the expanse of the Sanam Luang grounds. Decades later, no matter how many times I view it, from far away across the river, or driving by in the evening when the illuminated spires glow with orange light, I get the same thrill. The reason that I found the City Pillar in the first place was that I was hanging around the neighborhood of the Grand Palace, fascinated by its glittering splendor. But what could be more hackneyed than this?

Some things – Mona Lisa, the Taj Mahal – become so familiar from a thousand picture postcards that we stop looking at them and forget what makes them truly masterpieces. The same is true for Bangkok's Grand Palace, to which every tourist is dragged whether they like it or not. Its conglomeration of shapes and objects leaves most visitors utterly baffled as to their intent or meaning; the glitter and the busy-ness of decoration flies in the face of many Westerners' ideas of simplicity and proportion; and for Japanese, it's anything but refined and restrained. These preconceptions get in the way of seeing the Palace for what it really is, but, as often happens with cultural icons, the very thing that seems clichéd and overdone is where the wonder lies.

I think it starts from the dualism I found in the City Pillar, which also expresses itself in the layout of the old royal city. Everyone knows about the Grand Palace; few realize that there was a second grand palace, almost as big as the first, just to the north. Called the *Wang Na* ("Front Palace") it served as the residence of the heir to

35

the throne or the King's favorite brother, covering the land north and west of the Grand Palace all the way up to what is now Phra Arthit Road. In 1851, King Rama IV elevated the Prince of the Front Palace, Pinklao, to the title of King, and so for a few decades in the mid 19th century Thailand even officially had two Kings – foreigners at the time used to call Pinklao the Second King.

After 1880 the Front Palace grounds were broken up, but you can still track the remains in the northern part of *Sanam Luang* (the royal ground north of the palace), Thammasat University, the National Theatre, and the National Museum. A few original buildings from the Front Palace still stand, among them the Phutthaisawan Chapel at the entrance to the National Museum, the purest surviving example of Ayutthaya-style grandeur. A broad expanse of wooden flooring surrounds a throne supporting the Phra Buddha Sihing, once the palladium (city protector) of Chiangmai, while around the walls, *devas* (gods) in profile raise their hands in attitudes of prayer. When a guest comes to visit me in Bangkok, after visiting the Grand Palace and other more famous sites, this is where we come for a moment of sublime perfection.

The Front Palace, as it turns out, didn't just vanish; its parts transformed into the heart of historical culture in Bangkok. The way the dualism works in Bangkok is that nothing ever completely goes away. The first pillar wasn't replaced, it was added to, and likewise, the Second King didn't supercede, but merely acted as deputy to the first and actual King. This happens in modern Thai political history as well, in which disgraced financiers and deposed dictators never quite disappear; they just travel abroad for a while and then return in a new guise.

To some degree, history everywhere in the world is a created artifact. But in Bangkok, you feel this more acutely than elsewhere. Japan and China have worked hard to pull a veil over the horrors of World War II and Mao Zedong's Cultural Revolution, but far less successfully. Maybe it's because they're more influential countries, more in the eye of the world, and hence suffer tighter scrutiny. Thailand is just not important enough for world scholars and historians to have paid attention.

But I think there's more to it. The Thais hide better, embellish better. The whole thrust of royal Siamese culture since Ayutthaya was the building of fantasy worlds, ethereal realms that are not of this earth. A lot of thought and choreography go into creating illusion. When the King used to meet foreign ambassadors in the early-1800s, he would wait until they all gathered; then a curtain would be pulled back, revealing him on a high golden throne, a vision of the divine. It was a political statement, but it was also gorgeous pageantry.

Political statement as gorgeous pageantry: Bangkok goes on doing this incessantly, especially at times of royal anniversaries, such as we experienced in 2006 (the 60th anniversary of the King's coronation), and 2007 (the King's 80th birthday). One form it takes is the *sum chalerm phrakiert*, or decorative arch. It's not clear when *sum* arches first started, but old photographs show a dramatic *sum* in the form of elephants with raised trunks spanning Ratchadamnoen Avenue, built in 1907 in honor of King Rama V's return from a trip to Europe. It's believed that the King was inspired by the triumphal arches he saw in Europe. At the same time, the concept could well have come from China's *pai lou* arches (multi-tiered gates built over roadways). Beijing used to be full of these, until Mao tore most of them down.

The *sum* arches of Thailand, in contrast, are booming. It's possible that *sum* paralleled the growth of roads when they overtook canals as the town's chief transport artery. Some towns such as Chiangmai boast *sum khao mueang* ("entering-town *sum*") spanning the bridges at the city's edge. In Bangkok the most dramatic *sum* still arch over Ratchadamnoen, the royal avenue leading in three sections from the Sanam Luang parade grounds to the Golden Mount and down to the old parliament house at Ananta Samakhom Throne Hall.

Those in charge of commissioning new *sum* expend much expense and effort into their design. You see *sum* surmounted with layer upon layer of carved and molded angels, *nagas*, *garudas*, lions, lotus buds, elephants, flames, and clouds, all embellished in gold, pink, purple, orange, and blue with swirling *Lai Thai* design

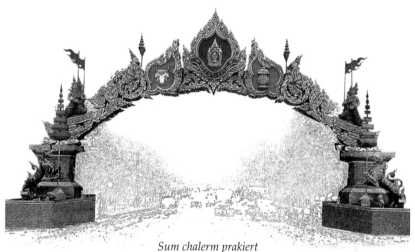

Sum chalerm prakiert
Ceremonial arch over Ratchadamnoen Nok Avenue
in honor of King Bhumibol's 80th birthday.

motifs. However spectacular, *sum* are not permanent structures; they keep replacing them with new ones, each more elaborate than the last.

Grand *sum* flourish in the old part of town, with its concentration of palaces and government offices. In fact most romantic architecture is found here. The rest of the city tends definitely to the drab, which has got Bangkok its bad reputation as chaotic and ugly. But even in the modern city, you encounter variants of *sum* everywhere. One of the first things that visitors see after arrival at Suvarnabhumi International Airport is a big *sum* surmounting the expressway. Scattered throughout town are golden *khrueang ratchasakkara*, decorated altars and signs honoring the king or other royal family members. Some of these tower five meters or more; smaller versions stand at the entrances to banks, hotels, office buildings, at street corners, or draped over bridges.

These all celebrate the royal cult. On the "civilian" level, decorative gates are so endemic as to merit a chapter of their own in Philip Cornwel-Smith's book *Very Thai*. Gates may matter more than what lies within. I discovered this when I was asked to contribute to the improvement of my partner Khajorn's old school in his village up north. Some time later, when I went back to see

the school, I found that they had raised an impressive stone gate, and next to it a big plaque with my and the other donors' names, carved in marble. The school, however, remained untouched. In Bangkok, wherever you go you will see wrought-iron gates forged lovingly with lots of swirling vines and tendrils, and details picked out in gold.

Few would say that Bangkok is beautiful. As fond as I am of this city, I wouldn't try to make excuses for the overall drabness and clutter, because it's my belief that an attractive environment is important and that people really need it. It's East Asia's great tragedy that all the way from Japan down to Indonesia, historic towns have suffered brutally from modernization, and the new cities built in their place offer little to please the eye. Bangkok is making some efforts to improve, with proposals to tear down unsightly structures in the old town, and lots of talk about planting more trees. Simple things like lighting up old temples and churches along the river go a long way to bring back some scenic appeal.

Nevertheless, given Bangkok's other pressing problems, designing or legislating a beautiful city comes rather far down the agenda. So the clutter will go on much as it has before. Meanwhile, glamour expresses itself in *sum* arches, *khrueang ratchasakkara* altars, and gates. We see these things so often that it's easy to dismiss them as trite public displays of "Thainess." But from the point of view of the skill and creativity that goes into them, they are truly epiphanies of decorative art. I can't think of another big city with anything like this. It's part of the exuberance that makes Bangkok so colorful.

On the subject of epiphanies, however grimy and chaotic the modern city may be, the Grand Palace is by itself enough to keep Bangkok on the list of major cultural capitals. The situation is similar to Beijing. In a few decades, Beijing has changed beyond all recognition, into a soulless array of huge modern building-blocks with all the charm of a massive public housing project. But the world will forever have to visit Beijing because the Forbidden City and the Temple of Heaven remain in all their glory, and these are places that everyone wants to see.

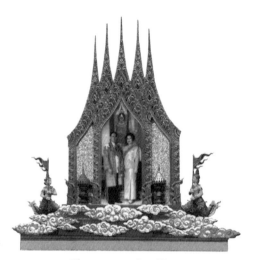

Khrueang ratchasakkara
Decorative altar honoring
King Bhumibol and Queen Sirikit.

The same goes for Bangkok. People grumble about the ugliness of Bangkok. I'm often asked how I could stand it. It's assumed that anyone with the slightest love of beauty would find it impossible to live here. And indeed, most of the city does consist of mildewed cement, rusty corrugated tin, glass, signs, and wires. But they're not giving sufficient weight to the Grand Palace. So long as it stands, truly exhilarating beauty will always be with us in Bangkok.

The palace, outrageous in its golden extravagance, strikes many modern visitors as simply kitsch. For my aesthetic friends from New York or Tokyo, it comes as a shock, even as an offense to their firmly held faith in minimalism. Spires upon spires, twisting *chofa* finials, inlaid ceramics in repetitive patterns gleaming on every surface, statues in brilliant technicolor of celestial maidens with bird tails, ogres with tusks, and monkeys with beaks – it's all too much. If you're coming from the well-ordered nobility of Angkor, the imperial grandeur of Ming China, or the chic simplicity of Zen in Kyoto, it comes across as an Oriental Disneyland. It's the Asian equivalent of Ludwig's fairy-tale castle in Bavaria.

Which is to say, charming, but trivial. Open a book dedicated to the marvels of the East, and you will likely see illustrations of Angkor Wat, Borobudur, the Forbidden City, but rarely Bangkok's Grand Palace. It falls under the category of "tourist curiosity," not under "art," or "architecture." It hardly counts even as an example of great "city squares," even though the view from the Sanam Luang grounds rivals the Champs Élysées, the Vatican, Red Square, and

Tiananmen for dramatic effect, and in my view, outdoes all of them in magic.

It's worthwhile to think a bit about where the magic lies. As heritage sites go, the Grand Palace is rather young, built mostly in the 19th century. It does not conform to a particular plan. It lacks the cosmic structure of the Forbidden City, with its central axis and grand symmetrical courtyards. Instead, it's a higgledy-piggledy collection of structures of every size and shape, built and unbuilt at the whim of successive Kings. It's part of the vague, anti-historical essence of Bangkok: the Grand Palace today grew organically from a century of process, making it nearly unrecognizable from the original complex of 1782.

Nevertheless, the Grand Palace does express one basic idea, and that is the re-creation of the glory that had been Ayutthaya. The early Kings self-consciously styled the city as a copy of their vanished earlier empire. It's one giant sigh of nostalgia for a mythical past. The Ayutthaya Empire, in its turn, harkened back to the Khmer Empire at Angkor, with input from Laos, Burma, China, and Java along the way.

When the first kings of Bangkok started building the Grand Palace, they drew on a vast vocabulary of cultural forms. Here's where the tradition of never discarding plans A or B, but merely piling them up in layers, while adding plans C, D, and more, comes fully into play. The builders of the Palace reached into the history of their neighbors, their own ancient tribal background, and the West, and they took from these: ceramics, vines and flower motifs, roofs, towers, pagodas, statues, paintings, pediments, arches, windows, gods, and mythological flora and fauna. And incorporated them *all*. The *prang* towers (Mount Meru, center of the world, topped by Indra's trident) evolved from the towers of Angkor; the *chofa* (roof finials) came down with animist Thai tribes when they descended the river valleys from China. *Chofa* are deeply old, coming to us from a time when people believed in *naga* serpents and gods of the land and sky.

Thailand's curving eaves are one of these primal things. It's my theory that the rising eaves of Southeast Asia went north and

41

became the typical curved roofs of China. China, while it calls itself the "Central Kingdom," actually accepted a surprising degree of influence from its barbarian neighbors. For example, the folding fan, which practically symbolizes China today, came from Japan. The older Chinese fans are heart or peach-shaped. Japan, home of origami, thought up the idea of folding.

The ancient roofs of China, as we can see from burial ceramics from the Han dynasty and earlier, are absolutely straight. Han architecture consisted of a series of raised triangles, rather like Burmese buildings today. Yet at some point, Chinese rooflines

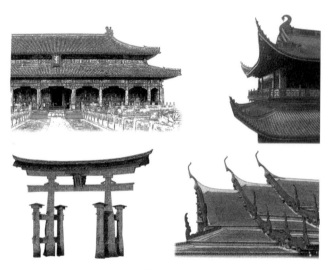

Rising eaves of East Asian architecture
clockwise from top left: Forbidden City in Beijing (North China);
Temple in Hangzhou (South China); Thai temple; Japanese Torii gate.

began to curve, and it appears to have come from the animist south. The farther north you are, the straighter the roofs, as you can see in the Forbidden City, with its rather stern and formal structure. When you travel south below the Yangtze, roofs become more and more fanciful, and in the far south they're positively outlandish, twisting upwards like candy curlicues, and encrusted with so much stuff that you can hardly see where the roof starts and ends.

The power of these roofs has intrigued me ever since I was a student visiting Bangkok for the first time in 1973 and made the pilgrimage to meet Taoist scholar John Blofeld, in the hope that he would know the answer. I think that having started in Southeast Asia, rising eaves were later able to sweep all before them in China, Korea, and Japan because at a deep level they satisfy a craving in the human mind. We seem to like anything that points to the sky. Hence the universal love of pyramids, minarets, church steeples, castle turrets, obelisks, onion domes, and skyscrapers. The genius of upward-turned eaves is that it transforms even flat rooftops into skypointing fingers. Of course, despite this theory of southern origin, the question of where these curving roofs first came from has never been thoroughly researched. Not that it matters. In Bangkok we live with plenty of unanswered questions.

The Burmese sack of Ayutthaya in 1767 left a shock that the Siamese never recovered from. My Thai friends can hardly bear to look at the Shwedagon Pagoda in Yangon because they know that its surface shines with the gold looted from Ayutthaya. Well, not really. Actually it's the gold of San Francisco, purchased by Burma's King Mindon in 1871.

As for the sack of Ayutthaya, this Burmese atrocity, burned into the Thai national consciousness, may not have been as thorough-going as people believe. According to Chiangmai University's Professor Vithi, there was plenty still standing after the Burmese withdrew. It was the merchants of Bangkok who finished off Ayutthaya. Vithi says, "The Chinese were the contractors whose job it was to bring bricks to Bangkok to build the new temples, palaces, and the walls of the city. That's why they burned Ayutthaya. It's easier to burn the old brick walls, the mortar falls off, the bricks get hardened. Just pick good bricks, put them on a bamboo raft and float them down to Bangkok and sell them. Instead of making the brick, trying to fire it and so forth, it's all there. It was easier to burn it down. That's why Ayutthaya disappeared, and it all went into building the new capital at Bangkok."

The sack of Ayutthaya is part of the myth and counter-myth that makes Thai history such a maze. But one thing is certain: the Thai

felt an acute sense of loss at the fall of the old glorious capital. So the new royal city copied the old as closely as possible: they raised a City Pillar, and dug a canal to the east of the river to duplicate Ayutthaya's oval-shaped island; they built the Grand Palace, and within it a royal temple, and a Front Palace and a Back Palace. They renamed old temples that predated the capital's move to Bangkok to fit in with Ayutthaya's traditions, such as Wat Mahathat, the Temple of the Holy Relic. Surrounding the royal temple stand *bai sema*, leaf-shaped monoliths which demarked sacred boundaries in ancient times. This shape also is echoed in the crenellations of the palace's surrounding wall.

What got built in Bangkok, while relatively new, contains a wealth of cultural reference that would be hard to find in almost any other structure in the world: wall paintings of the *Ramakien* (the Thai version of India's *Ramayana* epic); peaked windows showing Islamic influence; rooflines from the Thai tribes' old homelands in Lanna, Laos, and further north; towers and Hindu gods from Angkor, "demon mask" motifs from Java; stone guardians and bonsai from China; stupas from Sri Lanka: trapezoidal doors from Ayutthaya. Plus thrones modeled like boats, lintel supports in the shape of birds and serpents, and demons and angels from all over the place. The Grand Palace is a gigantic treasure box, filled with the accumulated lore of East Asia.

It happened just in time. By the end of the 19th century, when King Rama V was putting the finishing touches on the Grand Palace, the pressure of Western-led modernization had made it already an anachronism. Nothing like it could ever be built again. The palace complex in Bangkok is the last great architectural undertaking to rise when Asia's old ideals were still intact.

Most people would of course hardly be aware of all this. What pleases visitors seeing the palace for the first time is simply the effect of dazzling fantasy. The basic structures came mostly from Sri Lanka or Angkor, but almost every form has been stretched out. While built of heavy stone, the twinkling complex feels insubstantial.

That lightness is a calculated effect, crafted in royal Ayutthaya.

It's part of a long process, whereby over the centuries buildings stretched taller, windows narrowed, stupas got sleeker, columns tilted inwards, and every surface came to shine with gold and reflective inlay. The political purpose of the palace is to express strong and serious things: wealth, power, and empire. Yet, the Thai way to do this is to commute it into lightness. The effect emanates from hundreds of pillars slanting at less-than-90-degree angles, spires rising up to impossible thinness, and *Lai Thai* filigree flaring upwards like bird flight or flames.

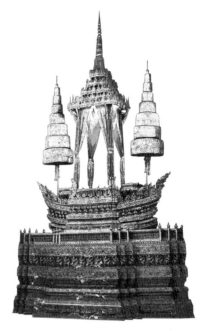

Busabok Maha Mala Chakraphat Phiman Throne in the shape of a boat in the Grand Palace.

The multiplicity of towers and spires, and the sparkling mosaics covering walls and columns were not, as most visitors would imagine, just a way of making things prettier. Behind them lies a philosophy, encapsulated in the 14th century *Traiphum* Cosmology, which describes a hierarchy of worlds, rising from hell, to our earth, heaven, and beyond to nirvana. According to the *Traiphum*, our world centers on a cluster of sacred mountains encircling the highest mountain of them all, supreme Mt Meru.

Inheriting the tradition from Angkor, Thai temples and palaces were built to symbolize the sacred mountains with Mt Meru as the axis of the universe. Hence the many spires. In the *Traiphum* it's written that Mt Meru, when seen from our continent, looks bright and crystalline, glowing with emerald light. Hence the twinkling surfaces. They tell us that we're no longer on earth; we're at the cosmic center, gem-like abode of the gods. The lightness of the

palace is not accidental; it's the world's most complex and extreme statement of lightness.

Lightness isn't everything, of course. There's nothing to compare with the restful harmony of an old Zen garden in Kyoto. Just as the Thais make serious things look light, the Japanese make modest, day-to-day things look momentous. A tea bowl, lumpy and brown, has all the imposing gravity of a mountainside. It's part of the Zen idea of bringing us back to basics, to focus on the moment however bland or uneventful it might appear to be. The moss gardens of Kyoto ground us in the Earth. In contrast, the palaces of Bangkok lift us up to heaven. When away from Japan, I miss the mossy meditative calm of old Kyoto. But when away from Bangkok I long for the tapering towers that carry me skyward.

For Thais, the Grand Palace resonates at another level, stirring something deep in their hearts, because it conjures up the world of old Kings, Queens, and their courts, with all the ritual that enveloped their lives in those scintillating throne halls and inside the taboo courtyards of the royal concubines. I can think of few countries where the royal palace has such a hold on people's imagination and affection. Far from being an unreal Disneyland, the Grand Palace for Thais is intensely real, summing up the nation and its glory.

Or not. I have young Thai friends who've never visited the palace. They tell me it's completely irrelevant to their lives and the accumulation of all that old stuff leaves them cold. Their elders shudder when they hear this, fearing that Thai culture is coming to a sad end. But symbols like the Grand Palace wield much greater power than anyone can imagine. In China, a century after the last Emperor ceded his throne, Tiananmen, the gate to the Forbidden City, still acts as an irresistible magnet for Chinese national consciousness. Brand new generations who had been taught to reject their history and despise the Emperors, stand before it in awe. In Thailand, where Kings still reign, even the most jaded youth of Siam Square carry the imprint of the Grand Palace's towers and gables somewhere deep in their souls.

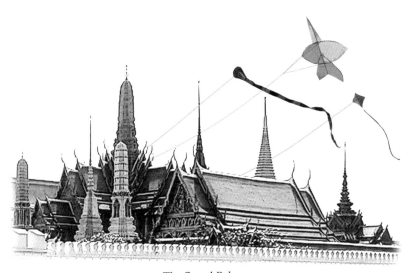

The Grand Palace
In summer, hundreds of kites fly over
Sanam Luang, the Royal Ground in front of the Palace.

I remember once driving through Kyoto with an old friend, John McGee, a Canadian who had lived in Japan for decades and had become a tea master. As our car passed under the huge red *torii* gate at the entrance to Heian Shrine, John remarked, "When I see this, I always say to myself, 'Look at me, little John from Canada, and see how far I've come and what an amazing place I'm in now!'" I thought at the time, "What a cliché! By now John surely should have outgrown his amazement at the exotic east."

Ever since Edward Said's *Orientalism*, which outlined how the Europeans in the 19th and early 20th centuries justified colonial superiority by seeing Asia as "exotic," we've learned as Westerners to guard against this tendency. Exotic is something that tourists seek; it's not an acceptable emotion for a serious student of the culture, much less a long-term resident.

But in Bangkok, whenever I behold the Grand Palace, I feel exactly as John did at the Heian Shrine *torii*. Those sparkling rooftops look like nothing else in this world. Especially when lit up at night with the moon rising behind. Or in March, when hundreds of people are flying kites in Sanam Luang, and you glimpse the spires of the palace across the grounds with long snaky tails of kites fluttering about. At those moments I can't resist thinking, "What an amazing place I'm in now!"

Tsitl

It was early 1991, and Khun Sukrit was trying to sell me an island. Sitting in his spacious Bangkok office, I could see large color-coded maps displayed on the wall, showing the pieces of the island that he had succeeded in buying, and the patches that still remained in the hands of local fisherman. Located just a short boat ride from Phuket, this island was ripe for development into a prime resort and holiday villa destination.

Khun Sukrit hailed from Phuket, where he had somehow made a fortune, much of which he had poured into acquiring his island. To the side of his desk stood a small Buddhist altar, flanked by oval *phanphum* about 20cm tall in the shape of lotus-buds. Originally flower offerings made of folded banana leaves, they now come in durable plastic as well as aluminum for home and office use. Sukrit's were made of solid gold and silver. He was a man of substance.

Only recently Adrian Zecha, legendary developer of the Aman Resorts, had opened his gorgeous Amanpuri on Phuket, which soon set the standard, not only for vacationing for the super-wealthy, but for the business of selling villas. Amanpuri, it was rumored, retailed the adjoining villas for a million dollars apiece. At the end of the day, this development earned Zecha a luxury hotel for free plus a war chest of extra cash. Khun Sukrit had found an even better property, on a prettier headland overlooking a more picturesque beach, and he owned most of the island, so the resort and villas could be absolutely exclusive.

Phanphum
Pair of altar decorations in the shape
of lotus buds, in gold and silver.

Of the people in the room, the one for whom it was most important that this deal go through, was me. At that time I was working in Tokyo, representing Trammell Crow, the American real estate developer. I worked for a branch of the company called Trammell Crow Ventures (TCV), which acted like an investment bank, raising money from foreign capital sources for Trammell Crow developments. TCV opened the Tokyo office during the height of the Japanese "Bubble" of the late 80s, our mission being to induce Japanese banks and insurance companies to invest in big construction projects. By winter of 1989, Trammell Crow had acquired well over a billion dollars of Japanese money, and it seemed that the sky was the limit.

In these days of abbreviations for all occasions, such as *SNIFOMC* ("sitting naked in front of my computer"), everyone in the business world at least should be familiar with *TSITL*. It stands for "the sky is the limit" and when you hear *TSITL*, it means a collapse is just about to happen. And so it did. The Nikkei stock index, which had risen to 39,000 at the end of 1989, began dropping in Jan 1990, and within a few years had fallen below 15,000.

Unlike Bangkok's later Collapse of 1997, however, the Japanese Bubble contracted in slow motion. Real estate values held their own, at first; banks, while in fact bankrupt, hid their losses; at the time there was little panic. Everyone thought this was just a little blip on Japan's unstoppable march forward. I, too, had no idea that the loss of wealth was so severe that two decades later the country still would not fully recover. What I did know was that it was getting harder to find projects in the States with good returns that we could offer to the Japanese. More importantly, since the Voice had spoken on the bullet train in winter of 1989, I was now determined to move

50

to Bangkok. I thought that somehow I could leverage the TCV work from Tokyo to Thailand.

A bit of research showed that Bangkok in 1990 was in the middle of a major boom, and so I convinced the Dallas headquarters to pay for a trip to Thailand. The idea was to find development projects that we could introduce to our investors in Japan. At first I relied on my old friend Ginny Bird's relatives and their contacts. They drove me around outlying areas of the city and showed me great patches of empty land that were mostly reedy swamps. I learned the Thai measurements of land: *tarang wah* (4 square meters), and *rai* (1600 square meters).

Of course, a foreigner or a foreign corporation cannot legally buy or own land in Thailand. In those days, before the law was relaxed, foreigners could not even own an apartment. However, you could invest in a Thai firm, or lend money to a real estate venture. Possibilities were everywhere: much of Sathorn was still lined with decaying mansions. Drive deep into the sois and you would come across mysteriously empty plots only a few meters from a major residential district. Ginny's friends were all purchasing land as fast as they could. One of them, the wealthy owner of a water bottling company, would get in his car on a Sunday morning, load the trunk with a suitcase of cash, and drive around the suburbs buying up fields as he went.

Compared to America's staid market, where accountants with specialized computers calculated down to two decimal points the exact IRR ("internal rate of return") on investment that could be expected, Bangkok real estate seemed like a true adventure. I felt this must have been what it was like back in the swashbuckling days of the 1950s when Trammell Crow staked out acres of pasture near Dallas and, with a handshake, made a deal to develop it into a gigantic Trade Mart that changed the face of the city. The possibilities were huge.

Real estate makes a good lens for understanding a place. New development is like water running downhill – it flows along channels bounded by landscape, neighborhoods, zoning, and local ways of doing business, and these gives cities their distinct look and feel.

In the case of Bangkok, there were reasons for all those empty fields at the end of the sois. It had to do with the way the city has grown. It began with water, not with land. Bangkok was originally nothing but a swamp criss-crossed with canals, so watery that the first Western traders lived in riverboats moored along the banks of the Chao Phraya. Sukhumvit, Surawongse, Sathorn – many of Bangkok's important arteries began life as canals, not roads. Then, as Bangkok began to expand, the city slowly drained the swamps and paved the canals.

The loss of the old water-cities is a notable chapter in the story of modern Asia. Once towns like this thrived everywhere, as we can see from the fact that Osaka, Calcutta, Bangkok, Suzhou, and Edo (old Tokyo) all once claimed to be "Venice of the East." Life in the Japanese cities of Osaka and Edo thrived along canals lined with homes and warehouses, thronged with rice barges and ferries during the day, and pleasure boats with restaurants and geisha at night. This was the origin of the "floating world" of Kabuki and Japanese prints. Right up until the 1950s thousands of people still lived in houseboats along Osaka's canals.

As these cities modernized, town planners focused on cars and trains. They treated waterways as convenient empty space over which to build elevated expressways and bridges, and when buildings went up alongside the canals, they literally turned their backs to them, providing not a terrace nor a door, and often hardly even a window to the waterway just outside. The same process took place in Bangkok. Today, if you want to get some sense of what the old water-cities were like, you have to go to China, where small pockets have been preserved around Suzhou and Hangzhou.

The change from water to land was especially meaningful for Bangkok because *every* town of central Thailand was once a water-city. Boats, not carts or horses, are how Thais got around in the old days, and the image of the handsome lad poling his boat down a lily-pad lined river while his beloved sits behind him combing her long hair, is a stock cliché of period films. Philip Cornwel-Smith writes, "Thai water culture has always influenced land culture, since rain and flood governed agriculture, crops, rites, warfare, travel,

everything. Ayutthayan temples, furniture and utensils swoop up at each end like a boat. Plaited fish hang above babies' cots, seated dances evolved partly from boat-bound courting dances, and everywhere images of the Naga serpent symbolize his watery abode."[1] Philip concludes that even the weaving between lanes of Thai driving reveals nautical instincts.

Chinese-style square cities
left: Old Chiangmai
right: Old Beijing.

Thai-style oval cities
left: Old Bangkok
right: Old Phrae.

The ancient Chinese pattern for a capital city is a square, aligned along north-south-east-west axes. Most of the old capitals of East Asia followed this format. Beijing, Nara, Kyoto, Hue, Seoul, Mandalay, Angkor Thom, and Chiangmai, all took the shape of the cosmic square. In contrast, the cities of central Thailand form conch-like ellipses and ovals. The shape came about because these towns formed on islands in the rivers. Inside, canals sliced the city into a regular grid, as we can see in 17th century Dutch paintings of Ayutthaya. If you look closely you can still make out the outline of the Thai oval in the old royal center of Bangkok, defined by the Chao Phraya River to the west, and the Klong Lord canal to the east.

Thais sometimes call this shape a "heart," and it was considered an unlucky omen for Ayutthaya that a large canal ran right through the center, thus making it a *mueang ok taek* "a city with a broken heart." Mindful perhaps of this, for almost two centuries the original royal island of Bangkok never allowed another river to run through it, until 1972, when the provinces of Bangkok and Thonburi, located on the east and west banks of the Chao Phraya River,

merged into one metropolis. As a result, today the Chao Phraya flows through the middle of modern Bangkok making it too a *muang ok taek* "a city with a broken heart," and there are those who fear dire consequences for the future. On the other hand, this concept might have more to do with what appears artificially large on a printed map, for in reality canals flowed through every old town, making them all cities with broken hearts.

Important remnants of riverine life survive even now, notably the Royal Barges. While it has been three quarters of a century since the average Thai citizen owned a boat, the King still maintains his carved and gilded Royal Barges, a tradition going back to Ayutthaya days, and probably much further. Every few years the barges make a grand ceremonial procession down the Chao Phraya, in which hundreds of oarsmen dressed in brilliant costumes row in time with the rhythm of drums and stately chants. It must be one of Asia's

Mueang ok taek, "Cities with a broken heart"
left: 17th century Ayutthaya, bisected by a canal.
right: Metropolitan Bangkok, divided by the Chao Phraya River.

most dramatic spectacles, especially moving because it's not just a show – it's a living reminder of Thailand's ancient water-world. The King is lord not only of the land, but of the waters.

The Royal Barge procession, once reserved for royal merit making, and now for state occasions, is not something you can witness every day in Bangkok. It took me almost twenty years since I started visiting Bangkok before I finally saw it. But there is an

extensive network of canals on Thonburi, on the west side of the river, where one can still get a glimpse in a more modest way of what Thai canal life once was. Take a long-tailed boat, and within minutes of turning off the Chao Phraya onto Bangkok Noi Canal, you see houses on stilts built over water, hung with potted plants. As you go farther you'll catch a glimpse of an old grandmother washing in the river, or a troupe of shrieking boys diving off a verandah for their afternoon swim. Here and there a few old teak houses still remain, teetering at odd angles.

The floating markets near Bangkok, although a stock travel-poster image of the water-world, have become a travesty today, existing basically as tourist traps. But one tends to forget that Bangkok is situated in the middle of a vast delta. The central plains of Thailand drain into five coastal provinces, and Bangkok sits at the center. Canals run for many tens of kilometers, connecting all the way to the sea. If you're willing to go a few hours out of town, real floating markets still exist, notably the one at Ampawa in Samut Songkhram.

My favorite part of the canals has always been the stretch just north of Bangkok in Nonthaburi. Few tourists get this far, since by the time they reach the canal junction of Bangkok Noi and Klong Om, their 45 minutes of canal tour is over. Past this point, however, the scenery turns green, coconut and sugar palms sway along the banks, and teak houses with pointed eaves and sculpted windows appear.

But all that is far away, almost another world when seen from the modern downtown. Bangkok went from tree-lined canals to concrete shophouse city after World War II. The shophouse city consisted of strips of congested avenues behind which were wide shady spaces. Basically the city has spent the last fifty years expanding into marshes and farmland. One of the beautiful Thai houses of Bangkok, which belonged to former Prime Minister Kukrit, survives off Soi Suan Phlu near what is now the central business district of Sathorn. It stood amongst lychee groves until the 60s. The Prakanong district of Sukhumvit was klongs and rice paddies right into the 70s.

Bangkok's spread followed a pattern: First the early Kings marked off the central "island" of Rattanakosin, where they raised Bangkok's major temples and palaces. In the bordering areas, they pushed through the first wide avenues, which they lined with government offices and palaces of the royal children and grand-children. There were quite a few of these progeny, as Rama IV and Rama V both had dozens of wives and well over a hundred children. In later years, the few royal homes that didn't get torn down were taken over by businesses or UN organizations. The others disappeared into Bangkok's mishmash of shophouse and office tower blocks.

A few are still lived in by aristocratic families. One of these is Chakrabongse House along the Chao Phraya River, home of MR Narisa Chakrabongse and headquarters of her publishing company, River Books. Another is Devavesm Palace, originally built by the Devakul family. My friend Ping Amranand's grandfather acquired the palace, which consisted of two buildings facing each other. In the late 1970s the family sold one of the buildings (now a part of the Bank of Thailand), and Ping's older brother continues to live in the other.

In the second stage, Bangkok expanded beyond the Rattanakosin area. A big avenue like Silom, Sukhumvit, or Ladphrao would be cut through open farmland, sometimes preceded by a canal, other times bordering a canal. Soon it would be lined by shophouses. The canal would be filled in. Then small sois would extend like tentacles growing from the sides of these avenues, and along these, people filled in marshy land and built homes. However, behind it all the swamp remained.

As you fly into Suvarnabhumi Airport you can see in the countryside outside of Bangkok long narrow plots of land known as *sen kuay tiew*, named after a type of long flat rice-noodle. As *sen kuay tiew* plots like these were absorbed into the city, roads grew parallel to one another along the edges of the "noodles", so there were few crossover streets. The zigzags we see today in town today formed where the sois had to detour around plantations and rice paddies. This pattern of development accounts for why it can be so maddeningly difficult in Bangkok to get from one soi to another.

I remember looking out the window of the Dusit Thani Hotel when I began visiting Bangkok on business in 1990, and just off crowded Silom road I was amazed to see what looked like acres of palm trees and banyans. In the heart of the city, the jungle was still there. Even today, you can sometimes turn off of Sukhumvit or Ladphrao and suddenly find yourself among trees and large walled compounds.

Looking at a map of Bangkok, you'll see a huge green area cradled within a wide loop of the Chao Phraya River east of Taksin Bridge. Called Bang Kachao, it's as large in area as the entire central business district. I've never been there, and I don't know anyone who has. It's filled with fruit plantations, swamp and jungle, a protected area with hardly any roads, very few houses, no hotels or restaurants. Actually Bang Kachao belongs to the neighboring province of Samut Prakarn, not to the City of Bangkok, and only appears to be within the city limits because of the wide meander of the river. It's a matter of time before crooked politicians manage to

Bang Kachao
Satellite view of Bangkok. The dark "lung" is the greenery of Bang Kachao.

get beyond the restrictions, but for the time being this great swathe of green remains.

Bang Kachao is sometimes called the "Lung of Bangkok," and it's a reminder of what all of Bangkok's environs once were. However, the true lung of Bangkok was the jungle within. Although you wouldn't suspect it from the view afforded from its crowded main thoroughfares, until very recently, Bangkok was, behind the scenes, a green city.

This is now changing. Builders began with big plots on the main roads, such as the palaces in the old town, and the Chinese mansions in European colonial style that still lined Sathorn road in 1990 – within ten years all but one or two disappeared to be replaced by office towers. The next step was to take family estates on the side streets and erect apartment blocks. Now the developers have reached the long-empty plots behind the sois. The tree-filled back lanes that you used to be able to see from the higher windows of the Dusit Thani are fast vanishing.

I spent the year of 1990-91 working hard to convince my bosses at TCV that Thailand would be the only place where the Japanese could invest profitably. I made several more trips to Bangkok, and began to expand my contacts to professional real estate developers.

For me the most intriguing project involved an old palace on Phra Arthit Road. A big block of colonial architecture, with wooden louvered windows, tiled marble floors, high ceilings, and a grand wooden staircase, the house rose upwards to a picturesque "widow's walk" turret at the top. Built in 1932 just around the time when the coup abolished absolute monarchy, this building had been the home of Prince Issarasena and his family. From the 1960s through the late 80s it functioned as the Goethe Institute's headquarters in Bangkok until Goethe moved to its present larger grounds off Sathorn Road. The house had been empty for a year or so and was falling into disrepair.

I thought it would make a magnificent restaurant, possibly combined with a boutique hotel, in a street that, while near the Grand Palace and Khaosan Road, was at that time still quiet and undiscovered. However, the asking price, while fair considering the history of the house, was simply too high for any normal business venture. Phra Arthit Palace needed to be owned by someone who wanted it just as a showpiece. Years later, just the right person came along, Sondhi Limthongkul, entrepreneur owner of *Manager Magazine*, who restored it nicely and incorporated it into the Manager's head office.

In 2006 and 2008, the house played a leading role in modern Thai history, when Sondhi turned against Prime Minister Thaksin,

and used the Manager offices as headquarters for the opposition movement he helped launch. While I suppose what happened has been all for the best, every time I pass the old palace, I remember the day I first entered its dusty rooms carrying a flashlight, and I have a little twinge of regret for what might have been.

Looking back on it, the early 90s were the last time when one could easily find palaces for sale in Bangkok. Of course, Trammell Crow and our Japanese investors were not looking for historical romance; they wanted good returns. We looked farther afield, and met up with Khun Sukrit, and his island near Phuket. Unlike the Phra Arthit Palace, which could not be redeveloped, Khun Sukrit's land provided wide-open spaces to build and landscape as we saw fit. It seemed ideal.

Until that fateful afternoon in Khun Sukrit's office. There had been a few references, during our meetings, to the type of deeds that went with the island properties. "It's all fine, nothing to worry about," Khun Sukrit assured me. I pressed for more details, and learned that in Thailand you don't just own land or not own land. There are several grades in between. Firmest of all is *Chanode* (Full Land Title), but below this are a number of deeds referred to by their initials in the Thai alphabet (as are many official documents). These are expressed by adding an "*or*" sound to the end of each letter, plus a number. I found out that there are *Nor Sor 3* (certificate of land occupation), *Nor Sor 3 Kor* (the same as *Nor Sor 3*, but with more definite land boundaries), *Sor Por Kor* (registered deed of ownership, but untransferable), and three types of squatter's right: *Sor Kor 1*, *Por Bor Tor 6*, and *Por Bor Tor 5*.

The color-coded map on Khun Sukrit's wall reflected these differences, shaded in gray, blue, green, and pink. About half of the plots were colored pink, which, I found out, stood for "Don't know." One could see that developing this island would be jumping into a bottomless quagmire. Almost every aspect of it was semi-legal or questionably legal, or quite possibly illegal. These gray and pink areas haven't stopped other real estate developers in Thailand. In fact, quite likely the majority of resorts in the Phuket area started out in just this same way, not to mention plenty of office towers and

condos in Bangkok. But for the IRR bean counters in Dallas and the blue-suited salaryman investors in Japan, this was going to be a hard sell.

Meanwhile, it was becoming clear that Khun Sukrit had fallen into financial difficulties. Desperate to save himself, he was asking far more than his land, a patchwork of dubious ownership deeds, was worth. Talks began to unravel. Khun Sukrit looked more and more unhappy. One day Khun Sukrit changed offices, and the gold and silver *phanphum* disappeared.

Still optimistic, I took Phil Norwood to Phuket to see the property. We stayed at Amanpuri, and ate freshly caught fish on the beach of Khun Sukrit's island. I introduced Phil to a large residential property developer in Bangkok, and spent many hours explaining why Thailand was a secure and reliable place to invest.

On February 23, 1991, we were seated at the Royal Bangkok Sports Club meeting the developer who was showing us glossy brochures of luxury condos and pointing out Thailand's prime advantage in having political stability far beyond its neighbors. Suddenly the television came on, and it was announced that there had been a coup and the army was taking over. So much for political stability. With that, Phil Norwood declared that he'd had enough. He returned to Dallas, and ordered me back to Tokyo. By this time, the great Bubble had burst, and the flow of money from Japanese investors dried up. In 1992, Trammell Crow closed even its office in Tokyo. I returned to my original specialty, writing and traditional arts, and based myself once more in Kyoto.

From that time on, I made regular trips to Bangkok on my own, living in a small rental apartment off of Sathorn Road. As I watched, gnashing my teeth at missed opportunities, Bangkok went right on booming. In 1994, Yoshiki Shakuta, an architect from Tokyo, introduced me to one of the most glamorous figures I've known in Bangkok, ML Tridhosyuth Devakul. Tridhos, or "Tri" as he's usually known, carries himself with aristocratic grace, plus a gentle sense of humor. Tri is an architect, and a real estate developer. Some blame his Boathouse Inn in Phuket for unleashing the real estate frenzy on that island.

And maybe it did. But as Shakuta and I traveled around to Tri's properties, we came to appreciate the advanced side of development in Thailand. Schooled in America, Tri brought a modern sense of design to the use of classical Thai motifs: curving roofs, open-air *sala* (four-posted pavilions), redwood floors and teak pillars. By the late 90s, Tri was riding high, with a hotel completed in Chiangrai along the Golden Triangle, and a trio of residential towers along the Chao Phraya, conspicuous even now for their green Thai roofs on the penthouses.

Highrises with Thai-style hats
Trio of towers along the Chao Phraya River
designed by ML Tridhosyuth Devakul.

Then came the Great Crash of 1997. It started first in Thailand, and soon swept over the rest of Asia. Much has been written about its causes, but my own theory is that it was the final hiccup of the Japanese Bubble. Japan had boomed more or less uninterruptedly since World War II, and had never experienced a true business cycle – that is, people didn't know that markets could go down as well as up. Tokyo's real estate market functioned as large-scale version of the man with a suitcase of cash who bought fields on the weekend in outer Bangkok. If you could just acquire land, it would go up in value, so it was believed. When Tokyo's bubble burst in the

61

early 90s, Japan's bankers lived in the hope that they could transfer their approach to Southeast Asia, which would function just as Japan had always done: with prices only rising, never falling.

For seven halcyon years, it worked. Bangkok thrived as never before. But when the crash came to Thailand it hit much harder than it had hit Japan. It's because Japan lost its own money in the bubble, but Thailand lost money borrowed from others. Most of the loans funding the frenzied construction were sourced from abroad, and so when the baht lost half its value, Thai developers' debts doubled overnight. Dozens of banks went under, great fortunes disappeared in smoke. Tri told me at the time that he had lost 90% of his net worth.

By this time I had moved into my present apartment at Sukhumvit Soi 16, near the Asoke-Sukhumvit intersection. Three skyscrapers were rising at my corner, including massive Pornpat Center, which was almost complete. Overnight the work stopped, and so did hundreds of similar projects across Bangkok. Because Thailand had no proper bankruptcy law, banks could not repossess these properties, nor could they be auctioned off cheaply because powerful business families had too much to lose. Bangkok became for a decade a city of rusting hulks. You can still see a few now, including some really dramatic steel skeletons along the river at Rama III Road just to the east of Bhumibol Bridge. From my living room on the 14th floor, for eight years I enjoyed the sight of the sun setting through the open I-beams of the "ghost buildings" across the street.

In a repeat of what had happened in Japan, Bangkok was not able to purge itself quickly. What could have been an overnight bout of indigestion turned into one long eight-year tummy ache. Only in 2005 did the economy pick up again. Developers came in, finished off the long-deserted superstructures, and delivered them as expensive condos and office blocks. Pornpat Center, renamed Exchange Tower, opened with Fitness First in the lower floors, and blue chip office space in the upper ones. Meanwhile luxury condos were again sprouting across the city. Tri bounced back, as real estate developers often do; and Shakuta, after a few years of

absence, came again, bringing new Japanese investors with him. Bangkok was entering another boom.

In 2009, as the world reeled in response to the US's mortgage loan crisis, the bubble burst again. However, this downturn looked more like a "business cycle" than the truly disastrous collapse of 1997. Thailand is more of a mature economy today. It's richer than it was before and can absorb more office and condo space, and the money isn't all borrowed from Japan.

Bangkok and Phuket have changed almost unrecognizably from the early 1990s. As for Khun Sukrit and his island, I don't know if he survived his troubles or if the resort ever got built. Phil Norwood moved on to another company. Trammell Crow Company withdrew from Asia. On my side, despite rows of files containing glossy brochures, and countless hours of meetings and presentations over ten years, my real estate adventures in Thailand came in the end to exactly nothing. To this day, I haven't invested in a single *tarang wah* of Thai property.

Perhaps it's just as well that I didn't pour a lot of Trammell Crow's money into *Por Bor Tor 5* or *Sor Kor 1* property that nobody appears to clearly own. However, I did get to see a lot of empty swampland at the end of minor sois in Bangkok that I would never have gone to visit otherwise. I also went to inspect many a construction site for high-end condos aimed at the foreign market, and these, as much as any temple, taught me much about why Bangkok is what it is.

Thailand has always been the most "foreigner friendly" country in Asia, and it has found many ways to profit from this. Long before the crash, Thailand began producing a new export product: real estate sold or rented to foreigners. In 1998, the government lifted a ban on non-Thai owning condos. Meanwhile it has lured thousands of people to the country on "retirement visas," which make it easy for older foreigners to live here so long as they bring in cash for their expenses each year. In my own circle, many friends are asking me how they can take advantage of the "retirement visa."

It's especially appealing to longtime expats in other Asian capitals, which are now too expensive, too dangerous, or both.

International money is pouring into Bangkok and Pattaya fueling a market in homes and vacation rentals for Americans, Europeans, and Japanese. Wealthy Russians and Chinese are just behind them in the rush to find living space in this ever-hospitable city. Rents in Bangkok have been historically low, compared to almost any other world city, or even regional capitals such as Hanoi, Jakarta, or Phnom Penh. These have far lower standards of living than Thailand, but rents for foreigner-compatible housing can be astronomical.

It's fine to talk about art, culture, and *sanuk*, but the fact is that the *cheapness* of Bangkok is key to its appeal for expats. Tens of thousands of foreigners already live here, with thousands more arriving hard on their heels. Many don't reside full time but keep a condo in Bangkok for a girlfriend, boyfriend, or for occasional visits. As foreigners, we can live here at a level far beyond what we could achieve with similar means in our home countries. This is definitely not possible in most other big Asian cities; Bangkok is in this respect unique. Affordability has made Bangkok international.

Low real estate values arise from the fact that Bangkok was until recently a low-density city covering a huge area, consisting largely of klongs and farmland. Due to the haphazard and inefficient way that Bangkok grew, there were always stretches of empty land, and lots of single family homes in the deep sois available to build on. These await the day when they will be cannibalized by real estate developers. Land is still plentiful.

Also, Bangkok's openness to the outside world impacts the supply of high quality housing available to foreigners. Attractive and spacious apartments in Tokyo are rare, and therefore considered "special," with the result that the few luxury residences designed for the foreign market command huge premiums. A similar dynamic is at work in Hanoi, or Phnom Penh, or Beijing. Foreigners posted to these cities by big multinationals or NGOs are all chasing after a small number of attractive homes.

Not so in Bangkok. Thailand has been building for foreigners for generations, and the process has nurtured local designers such as Tri, with his sophisticated mix of modern and Thai traditional.

Bangkok revels in a stock of well-designed, well-equipped apartment buildings the likes of which Tokyo or Shanghai can only dream of. Supply has kept up with, or even outstripped demand.

Like everything else, this is changing, of course, and there is no doubt that Bangkok will eventually converge with world norms. We who've taken Bangkok's cheapness for granted, will one day

The Millennium Towers
Four giants loom over older buildings around Sukhumvit Soi 16.

find ourselves priced out of the market. Supply will dry up as Bangkok exhausts its land reserves in the back sois. And demand will burgeon as more and more expats move here, and increasingly affluent Thais enter the market. Meanwhile, the baht is slowly rising in value versus both the yen and the dollar.

The boom this time around, while it will have ups and downs, will go on for the foreseeable future. Back in 1995, my 28-story building stood proudly as one of the tallest structures on the street, but slowly we're shrinking as taller buildings go up around us.

At the depth of the 2009 recession, the four huge Millennium towers went up on neighboring Soi 18. At 53-stories each, they dwarf our now modest-looking condominium.

My landlord Khun Num grumbles, "They look like *pret*." And indeed they bear an uncanny resemblance to *phii pret*, a type of hungry ghost, with a tall, naked, skeletal body, topped by a tiny head with a little needle mouth. *Pret* are insatiably hungry, and specialize in sucking up the *boon* (karmic merit) of all they come across. Num warns that the four giant towers, topped by heliports, will start out as merely hungry for tenants. But their hunger will never be satiated until they suck all the *boon* out of Soi 16 and its surroundings, as the sois clog with traffic, and the shops brim over with the towers' thousands of residents.

Even knowing that our surroundings are about to undergo a drastic change, we're aware that we can't really complain: the Millennium towers are merely continuing a process in which our own building, once itself the giant of the neighborhood, has played its part.

In Thai ghost movies, the hero or the local abbot always find a way in the end to stop the *pret* and return them to the underworld where they belong. In real life, of course, they are indestructible. Over the long term, the skyline will rise, the sois will fill up, and the city will endlessly expand. Nothing can stop it now. *TSITL*.

BENJARONG

When moving your life to a new place, there are three things you cannot do without: First is a place to live, and second, friends. The third and most critical thing is to support yourself. Without that you might lose the first two.

So when planning my official move to Bangkok in 1997, I decided to set up a company. Tourism was booming and I felt that now was the time to establish a program of traditional Thai arts based on what I had been doing in Kyoto. In order to raise money, I went to see Trammell Crow, for whom I had worked in the 80s and early 90s. Trammell had an almost supernatural business instinct. A swashbuckling frontiersman of the old school, he was addicted to making "deals," to the extent that when I worked for him, his staff had to watch him at all times, or he would agree to develop a hotel with someone he met in the elevator. I was sure Thailand would appeal to him. Seated in front of Trammell's desk at the top of his skyscraper in Dallas, I laid out my plans. There was a long silence. Trammell sighed, reached into his desk drawer and pulled out ten thousand dollars in cash. "Here's my investment," he drawled. And added, "You know – if this was poker, I wouldn't bet on it!"

With Trammell's funds behind me, I approached a group of American and Japanese supporters who were willing to join me in business. One by one these old friends agreed to help fund a Thai company, and by the spring of 1997 I was ready to move to Bangkok. I prepared to transfer the investment money to Bangkok

and have it changed into baht. But before that could happen the company registration needed to be completed, as well as a work visa – and we ran into the most baffling difficulties. The problem was with the lawyers.

The first lawyer, Khun Somchai, who inhabited a dusty second-floor walkup in a shophouse in Chinatown, turned out to be a master of delay. He would register one document, bill us a fee for the next, and when that was finished, he would lose the first. Or perhaps it had been filed improperly and needed to be redone. Before ever opening its doors for business, our fledgling company ran into trouble. The tax office frowned on the fact that the corporate address Khun Somchai had submitted was merely a shell office (an empty room somewhere out on Ladphrao Road), so we had to remedy that. By this time it was heading into summer and the money had still not left Japan. Meanwhile, the clock was ticking away, and my investors were nervous that we were missing the boat. At which point Khun Somchai had a heart attack, and his office promptly lost *all* the papers.

I found a new lawyer, Mr Steve, a suave Filipino who spoke Thai and also Japanese because of having lived in Tokyo for some time, and who based his firm in a glossy office tower on Silom Road. Seated at his wide desk before plate glass windows overlooking the burgeoning Bangkok skyline, Steve made quite a contrast to down-at-heel Khun Somchai, and filled us with confidence. He started the filing all over again. When it came to "purpose of the company," I told him "arts and crafts." Just before we were ready to file, however, I asked a Thai friend to look over the documents, and we learned that "arts and crafts" somehow came out as "antiques," which is in fact a restricted occupation for a foreigner. Steve re-did the papers – and the same thing happened again. At which point I discovered that while Steve could speak Thai, he couldn't read it. We had to tear everything up and start again from scratch.

By now it was late summer. The business climate in Bangkok was white hot. Many were predicting that real estate had reached the top of the market, that a crash might be coming, and tourism would be affected in the process. We were losing our chance. This time we

contacted a mainline firm, Tilleke & Gibbins, and they got to work, racing against the clock, to register us as fast as it could be done. But about a week before the money was due to be wired, the Great Crash came.

For several decades the baht had held steady against the dollar at about 25 baht to the dollar. On July 2, 1997, it began falling, and by January 13 of the next year, it had reached 55.8 baht to the dollar. Currencies collapsed all over Southeast Asia, as stock markets swooned and real estate values evaporated. The fall in Indonesia was much more severe than in Thailand, with the rupiah shrinking at one point to less than a tenth of its previous value. Chaos ensued. Within eight months, Suharto's regime, which had lasted for over thirty years in Indonesia, collapsed. Thailand escaped with not much political upheaval, but the economic repercussions were drastic. They changed the face of the city.

It turns out I owe a great debt to Khun Somchai and Mr Steve. Because by the time we got properly incorporated in 1997 and I wired the money to Bangkok, the Crash had come, and the yen was now worth twice as much in baht. The smartest financial move I ever made was thus due not to clever foresight but to the incompetence of my lawyers.

With the investment doubled out of sheer good luck, I felt the fates were with me. The question now was what the new company would do. The original plan, as proposed to Trammell and the others, was to set up a program of traditional arts such as I had managed in Kyoto. However, it became clear in short order that I simply didn't know enough. I had no friends in the arts, and I wasn't even sure what the traditional arts would be. At this point, my Thai partner Khajorn stepped in and urged me to open a shop selling benjarong.

Benjarong (meaning literally "five colors") is an elaborately painted form of traditional Thai ceramic. Inspired in the 19th century by the bright colors of Chinese ceramics, Thais came up with their own patterns, with which they covered the surface of Thai-style bowls and *phan* stem-cups, using enamels in bright blue, green, red, yellow, and purple, outlined in gold. The fine detail and gorgeous

Benjarong lidded jar
Detailed patterns in bright
colors embellished with gold
cover the surface.

effect made it much prized by Thai elites, and to this day you'll often see pieces of benjarong in luxurious settings, such as wealthy homes or upscale hotels. Originally they sent *Lai Thai* (Thai design) patterns to be made in China, but eventually the production came to be done in Thailand.

Khajorn worked in a shop in River City run by our old friend Ying, a smart businesswoman who was making a fortune selling benjarong. Ying adapted benjarong to Western tastes, applying the patterns not to the sturdy thick porcelain used for old-style Thai shapes, but to thin and translucent Western-style "bone china" suitable for dinner plates, soup tureens, and coffee cups. Foreigners snapped it up at high prices, sometimes ordering whole serving sets of hundreds of pieces.

Before I knew what happened, my company became a benjarong shop. Khajorn and I sat down with Ying and she agreed to become Khajorn's supplier. We went looking for a location and quickly found a dream spot: a large glass-fronted store right on Sukhumvit Road, at the Nai Lert Building near the corner of Soi 5. It stood in the heart of Sukhumvit's tourist foot traffic, midway between the Ambassador, Amari, and Landmark hotels, and Soi 3 ½ where the Arabs congregate.

Rents at the Nai Lert Building were among the highest in the city. Taking the biggest financial risk of my life, I plunked down thousands of dollars in advance rent. More thousands went into fitting out the shop with marble floors, overhead spotlights, and chrome frames laid with glass shelving. We did this on the advice of the canny Ying, who had figured out how to make benjarong

look most appealing to customers. Intense spotlights bathed the ceramics with light, which, reflecting off chrome and glass, brought out the golden lustre of the surface decoration and dazzled tourists into buying.

The biggest expense of all was obtaining the stock of benjarong. Benjarong does not come cheap, even at wholesale prices. First we had to lay in boxes of "whiteware" (white bone china which serves as the base) – plates, bowls, cups in many sizes and styles. These were then sent to the factories where artisans painted them with gold and enamels, finished off by firing in a kiln at hundreds of degrees celsius. The process took months. Finally the shop's glass shelves were lined with gleaming plates, teapots, mugs, and lampstands, and on June 5, 1998, Chiiori Benjarong opened for business.

Although Khajorn managed the shop, in the early stages I took an active interest, especially since we soon ran into trouble with Ying. Ying had all the virtues and vices of a classic Chinese businessperson. She worked hard, invested wisely, bought low and sold high. Starting as a shop-girl, she ended up as shop-owner and at one point at her peak drove a Rolls Royce. Ying was also addicted to gambling, and used to play with the highfliers at their illicit casino on a rooftop overlooking the river. Soon she owed millions of baht to some very unsavory characters, and ended up living life on the run to escape her creditors. In the end, Ying could no longer be seen in her own shop, had to change its name, and hide her home address. She moved around town behind tinted car windows, mostly at night. We needed to find another supply route or we too would be caught up in Ying's underworld drama.

Khajorn found his own factories. Sometimes we'd drive out to visit them in Samut Sakhon, about two hours drive from town. A typical "factory" consisted of a tin shed on the side of a muddy klong, with six or seven workers – basically a family – mom and dad, the grandmother, and the children, sitting on the floor painting benjarong. It's a painstaking process, involving hours of work, as each thread-like gold line and each green, yellow, and purple enamel dot has to be applied by hand. After painting, they dry the enamels, then fire them in an electric kiln in the front yard.

Working with the factories was a full time job for Khajorn. The father of one household would get a mistress, his wife would storm out, and they would cease production for a while until things settled down. At another place, we knew that they would do no work for a week after payday, since the owner would go on a drinking binge and only come back after he'd used up all the money. Some factories are better at doing butterflies, some at flowers. Pieces get passed around; first family A will paint in the flowers, and then family B will do the butterflies. If the butterfly people stop working, then an entire line of production might be held up for months. Our customers in Frankfurt and New York did not appreciate this sort of thing.

Another problem was pattern stealing. Bangkok thrives on counterfeit brands and cheap copies. There's no telling how many Versaces, Versacci, and Versache shops you can find around the city. Friends of mine in the export business will not show their goods in Bangkok's big trade fairs – because everything new will immediately be mimicked. Low quality copies then drive the more expensive but better made products from the market. This is one reason why Thailand has not quite gained the international reputation for design that it deserves, despite numerous talented and original designers.

People were always trying to spy on us and steal our patterns, which they would duplicate on lower quality whiteware and sell at half the price. Rival shops would send people over to our factories to buy a few pieces as samples. On our part, we were as guilty as anyone else, since at the beginning we copied most of our patterns from Ying, who in turn had poached them from other shops. What with fending off industrial espionage and managing delays, Khajorn was always on the phone dealing with crises.

Then there's the matter of tax reporting. At first I did my best to follow it, but found that accounting rules in Thailand are truly byzantine. It appears that filing is done monthly rather than yearly, as I was accustomed to in Japan. The staff spent at least half of their time just preparing documents. After years in business, to this day I don't understand the logic of monthly tax reports.

So complicated did the finances become, that we needed to hire an office manager. This is how Khun Saa came into my life. Saa, who happened to live across the hall from me, is a typical Bangkok story. She came to Bangkok from Prachinburi province at the age of 13 in order to attend high school, and lived with her older sister in a little wooden house on the Thonburi side of the Chao Phraya River. The sister sold *som tam* (green papaya salad) and grilled chicken to put Saa through school. Eventually Saa entered Ramkhamhaeng University, Thailand's huge open college.

Open to all with no entrance examinations, and charging only a nominal fee (in Saa's day, it was 18 baht for one credit), Ramkhamhaeng is one of the world's cheapest universities. While it's easy to enter, it's not so easy to graduate, since passing the course requirements demands real effort. People know that a graduate from Ramkhamhaeng is someone who has really worked for his or her education.

Saa found a job with my neighbor, Num, who ran a television production company. Under his tutelage, she learned English, computer proficiency, and most importantly, the fine art of official Thai language. Listening to Saa dealing with bureaucrats and bankers, I felt the difference between Thailand and Japan. In Japan, formality trumps all. Be proper and correct, and all will go well. Thailand, too, requires formality, but you also need to amuse. It's the Joker that trumps even the Ace of propriety. While saying all the proper things, one must also draw a smile, combine politeness with *sanuk*. Saa is a master of this.

Around the time the benjarong company was starting up, Num retired from television producing, and Saa, finding herself at loose ends, came to work at Chiiori Benjarong. For the next six years, she served as office manager and acted as our ever-correct and ever-smiling interface with officialdom.

Finding sales staff for the shop was easy – hire family. Khajorn's brought in friends and relatives from his village in Phayao, a province in northern Thailand, once part of the old Kingdom of Lanna based in Chiangmai. Benjarong is expensive merchandise, and at times there would be large sums of money lying around.

Khajorn simply wouldn't trust anyone outside his village. The staff spoke strictly Northern dialect amongst themselves making us a little corner of Lanna in the city. It gave me an insight into the way family businesses are structured in Thailand (and across Southeast Asia) – around kinship groups.

The paradigm comes from China, for it is the Chinese who run and own most of the successful businesses in Thailand. If you drive around the streets of Bangkok, it's striking how many shop signs are in Chinese. The Chinese business mode, which could be called "highly opportunistic," has placed its stamp on companies in Thailand. Contracts and partnerships have a limited shelf life. You can never turn your back on any venture – employees will jump to another company without warning, taking clients and secrets such as our precious benjarong patterns with them. Or you'll have to deal with embezzlement or theft. All this is something of a generalization of course, and perhaps I was overly sensitive, coming from Japan, which falls rather at the other extreme. In Japan, "lifetime employment" was until recently the standard, and company loyalty held an iron grip on employees' souls, having taken the place of samurai fealty to the feudal lord. People are scrupulously honest, at least within their organizations.

Well, all this is changing. Japan is growing more fluid and crime more prevalent. Meanwhile, Bangkok is going the other direction: towards more predictability and professionalism. As the city modernizes and becomes more wealthy, the middle class is expanding, and business is converging on international norms. Even the Chinese are being slowly tamed.

Khajorn was an exception among shop owners along Sukhumvit road in that he was ethnically Thai – most of the others were Chinese or Indian. But his business style was totally Chinese. It had to be, because business in Thailand, especially for small enterprises, still basically follows the old Chinese mode, and it's wild and woolly out there. Which brings us to the character of the city itself. My Thai friends complain that Bangkok is becoming a Chinese city. They see the old politenesses and easygoing give-and-take of the Thais disappearing before the mercantile rush of Chinese.

Actually, Bangkok was a Chinese city right from the beginning. Aside from a Thai military garrison, the original town from which Bangkok developed consisted of a community of Chinese merchants. King Rama I displaced it south in order to build his capital at Rattanakosin (the old city center), and Chinatown dates from this time. Into the new royal center came the Thai court and its entourages, and later, the Westerners, Indians, and so forth. The Chinese are, in a sense, the true original inhabitants of the city.

Maybe because Khajorn never felt comfortable hobnobbing with other wealthy shopkeepers, his friends were mostly hawkers on the stretch of pavement in front of the shop. If there's one trait that distinguishes Bangkok from every other Asian city, it's the preponderance of street vendors. You can go out at any hour of the day or night and buy almost anything: suitcases, underwear, fruit, noodles, flowers. On Silom, as people pour out of the discos at 2am, they might stop to buy a jasmine garland, some fried grasshoppers – or a pet rabbit. Part of what first appealed to me as the taxi drove into town from Don Muang airport in 1990 were the vendors along the streets, and they contribute much to making Bangkok a pleasurable place to live.

At lunchtime, my staff go out to a nearby market, a makeshift gathering of vendors on an empty lot, and bring back all sorts of things to eat, wrapped in plastic bags: curries, noodles, rice, chicken, pork, beef, shrimp, mango salad, morning glory, corn, watermelon, papaya and other fruits, not to mention more odorous items such as *plaa raa* (fermented fish). There is surely no place on earth where you can always find such a range of delicious and healthy foods on the street. They also bring back T-shirts, jeans, cookies, soap, whitening cream, watches, iced coffee (also in a plastic bag), CDs, and mobile phone accessories.

In Singapore, the government has seen hawkers as undisciplined and messy, and restricted them to "hawker centres" to the point that most of the city now consists of sterile malls and office blocks, off-limits to vendors. In Jakarta, there never seemed to be so many vendors in the first place. It might have something to do with the

Thais' natural entrepreneurism. Thais mostly aren't happy working for someone else. They'd much rather run their own business, even if small. This stands in contrast with Japan where people are taught from childhood to value security above all, so that a faceless job in a giant firm is much to be preferred to the insecurity of running your own little place.

My experience is that Thais are dreamers. They love the lottery; young Thai friends of mine live in the hope that their little business will make them rich. In Bangkok, the Chinese merchant mind met up with Thai dreaming – and the result was an explosion into a million stands and stalls. At the low end of the scale are the street vendors, and a step above them are the booths that crowd giant markets such as Chatuchak, Siam Square, or Mahboonkrong, each selling something unique and quirky. It's a recipe for cooking up the zany and unexpected, which is why Bangkok, above all cities that I know in East Asia, is truly "colorful."

Policy-makers in modern Bangkok – some Sino-Thai business-men themselves, others bureaucrats or academics, but all of an authoritarian mode – hanker after squeaky-clean Singapore. There are increasing moves to rein in the vendors. When Bangkok hosts big international conferences, police sweep hawkers in the downtown areas off the streets until the meeting ends – the idea being that the vendors look un-modern in some way. The long-term trend will almost surely be a gradual decline. Some of this is inevitable in that for many vendors, their job is anything but a dream, just drudgery. For the old noodle-lady at the corner, her hot stand exuding clouds of oily steam is just a way to eke out a daily pittance in an unforgiving and expensive town. As the economy expands, more people will move indoors to work in air-conditioned offices and malls. This is Progress. Still, Thais are used to buying from the street. They know where good food is to be found – tastier and cheaper than any restaurant. This is where the mass of the city seek their food, fruit, drinks, clothes, and flowers. A strong need will keep the vendors alive for the time being.

The north side of Sukhumvit Road from Nana to Soi 19 is one of the most densely crowded vendor districts in Bangkok. Most of

what's on sale are the usual tourist trinkets: fake watches, T-shirts, printed pants and blouses, big wooden phalluses. My nephew Edan, when he lived with me for a summer when he was twelve years old, made friends with a watch vendor and subcontracted the business: when a group of hapless Australian teenagers would come along, blond and charming Edan was lying in wait for them with ten watches on each arm. He got a commission for each sale.

Several blocks are devoted to the deaf-and-mute, who seem to have the exclusive right to hawk in this neighborhood. You bargain by typing into calculators, unless you happen to know sign language in Thai. But then, one tends to bargain that way anyhow in Bangkok, because few visitors know spoken Thai. At least from the point of view of foreign tourists, the deaf-and-mute district is not so different from other vendor areas as one would expect.

The landlord strictly controlled the pavement in front of the Nai Lert Building, so the hawkers had to stay away during the day. At night, however, they encroached, with people spreading mats lined with bracelets that light up and rows of pink high-heeled shoes in front of Nai Lert's sheets of plate glass. Living together cheek by jowl, the vendors in our neighborhood got to know each other very well, and the street was rife with petty jealousies and arguments. Khun Daeng, who sold watches at the corner, became a good friend of Khajorn's and was often to be seen drinking tea inside the shop. He knew who was in trouble because of gambling debts, whose wife had run away to Khonkaen, and so forth. Daeng was the man we could call on as a "fixer" if we suddenly needed a carpenter, or a camera to be repaired. He could also introduce a bank manager or an insurance sales lady. For Edan's birthday party, we realized in the afternoon that we hadn't planned anything fun for the night; a word to Khun Daeng and he brought a troupe of magicians over to my apartment, complete with acrobats and fire-eaters.

Despite their gossip and competition, at a time of crisis all the vendors would band together. Woe betide the Dubai man who refused to pay the lady in the next block for a pair of rubber flip-flops. Words were exchanged, the CD seller at the next booth

stepped in, the Dubai man raised his fists – and all hell broke loose. At the end of the mayhem, he was lying bruised on the pavement, and then the police arrived. Per the unanimous testimony of the onlookers, they carted the Dubai man away to the police station as the "troublemaker," much to the delight of Daeng and Khajorn. Order had been restored to the street.

Part of what made the Nai Lert Building area so interesting was that it borders Sukhumvit Soi 3 (Soi Nana) and Soi 3 ½, the haunt of Bangkok's Arab population. Turn into Soi 3 ½ (nowadays sometimes called Soi Bin Laden) and suddenly the signs are in Arabic, you can hear Egyptian music, and spot rows of hookahs in front of the restaurants.

In the late 90s, the street was lined with shops selling strangely shaped bits of driftwood that turned out to be aloeswood incense. Nowadays not many people would have any idea what it is, since "incense" usually conjures up the smell of sweet Indian sandalwood. However, truly great incense, like great wine, is not sweet, but dry and astringent. David Kidd once described aloes as "dust from a luxurious tomb." It was one of the ancient world's most precious exports, which once moved west from the jungles of Indochina, along the Silk Road to Mecca, and north to Xian and medieval Japan. Even now, they still burn this incense in certain old temples in Kyoto and Nara. It's the scent of the Tang Dynasty. By the late 2000s most of these shops had disappeared, but if you look you can still find pieces of aloes on the back shelves of the few remaining perfume shops on the soi.

Bangkok boasts a number of enclaves like Soi Bin Laden, among the most prominent of which are Pahurat (the Indian market bordering Chinatown), Sukhumvit Sois 35-55 (favored by the Japanese), and Pratunam (popular with Africans). Bangkok has had extensive Asian populations since the 19th century. A. Cecil Carter, in *The Kingdom of Siam 1904*, writes, "The...foreign element [of the population] includes Chinese, Japanese, Koreans, Malays, Hindus, Klings, Pathans, Afghans, Burmese, Arabs, Cambodians, Annamites, most of whom are rendered conspicuous by their national dress, which they seldom abandon."[2]

Aside from Thais of Chinese extraction (who make up, by some estimates, as much as 60% of Bangkok's population), the largest resident ethnicities today are the Indians, Japanese, and Koreans. Plus smaller groups of Arabs and Africans. Indians, many of them Namdhari Sikhs, members of a cult of Sikhism based in Ludhiana, India, are well established here, dominating the tailor business in Bangkok. Indians own huge swathes of land along Sukhumvit Road, plus a number of hotels. They make up one of Thailand's richest communities, and they are often to be found in swank clubs and restaurants. Many have intermarried with Thai wives, but the distinctive rules of Sikhism mean that while they may have lived here for generations, they're less integrated than the Chinese.

One of Bangkok's distinguishing traits is that it has been so welcoming to outsiders, and this is why I was able to establish a business here in the first place. In Japan, high hurdles stand in the way of an individual setting up his own company and getting a visa for it. In Thailand, on the other hand, you constantly meet foreigners who have created their own business, and who run shops or restaurants. Some have succeeded fabulously.

Sadly, I was not one of them. Actually, I think it's the rule rather than the exception that foreigners put more money into Thailand than they take out. Often it's got to do with boyfriends and girlfriends. I remember poor old Bob Grevenbroek, a Dutch dealer in Tibetan antiques. He would show up every few months with a bag of Tibetan rugs and tangka paintings, set up shop in a hotel room at the Ambassador, stay until he'd sold everything, and then go back to Nepal for more. Living at the hotel with Bob was one of the most stunningly beautiful Thai women I've ever seen. Soon it became apparent that Bob would have to build her a house, the *sine qua non* for many a Thai-*farang* relationship. Then came the day when the house was completed and title transferred to her. That happened in the morning. In the afternoon, the girlfriend moved out from Bob's hotel room, and that was the last we ever heard of her. Poor Bob should perhaps have seen it coming.

In my case, it began promisingly. We made lamps for the Oriental and Le Meridien hotels. One day a fleet of black Mercedes-

Benzes pulled up in front of the shop, and military officers in white uniform marched into the shop. Khajorn thought, "Oh my god, they've come to arrest me!" It turned out to be a delegation from the Palace. A Lady-in-Waiting followed the white uniforms, and she ordered a set of lamps. This was the high point of the shop. However, no matter how much we sold, it all went to pay the rent, and at the end of the month, after paying salaries and taxes, there would be almost nothing left.

I can see now that the answer would have been to expand into new product lines. For example, at one point I got an Arab calligrapher to paint the classical Arabic calligraphy motif *Bism'Allah* (meaning "In the name of Allah") in gold in the center of benjarong plates, and since we were located so near the Arab neighborhood, these sold like hotcakes. But we never followed up on it. We also tried, but not very seriously, to sell benjarong in New York and Tokyo. However, the process of proving to the customs offices that the enamals weren't toxic was just too complicated. Actually, I suspect they probably are toxic. Nothing so bright and beautiful could be good for you.

Khajorn, like nephew Edan, was a natural salesman. He had irresistible charm, and anyone who walked into the shop was doomed to buy. Once somebody browsing in the shop knocked over a teapot, and Khajorn insisted that they pay for the piece, which was slightly chipped. "Now that you've got a teapot," he pointed out, "what use is it without cups and saucers?" So he got the customer to buy a full tea set in addition.

Despite Khajorn's abilities as a salesman, slowly the shop lost momentum. The benjarong business was changing; there were lots of competitors. After six years at the Nai Lert Building, we found another location on Silom, only a quarter of the size, but at far lower rent. We got a fast-food restaurant to take over the Nai Lert lease, and moved to Silom.

For about two years, Khajorn sold benjarong at this second shop, between Patpong Soi 2 and Silom Soi 4. Vendor politics here were even more colorful than at Sukhumvit, to the point of being scary. The sock lady got into an argument with the towel lady and cut her

with a knife – but the local mafia protected her and the police never said a word. At Silom, Khajorn kept a little more distance from the street vendors.

Even at Silom, however, we just couldn't make a go of it and weary of the daily struggle with the factories, clients, the landlord, and the street vendors, Khajorn began to lose his heart for the business. Although the Nai Lert shop had never made any money, it also hadn't lost any. At Silom, however, there was a slow but steady flow of red ink. In 2004 we finally gave up.

Giving up was amazingly difficult. In Thailand closing a company is far harder than opening one. This time we used no law firm; Khajorn and his accountant did the paperwork themselves. The tax office scrutinized all of our dealings for the previous five years, and we got hit with a huge tax bill. We had to spend money to rip out all the improvements we'd made to both shops when we left, and the filings and paperwork were endless, to the point that years after the company closed, it continued to live on in the shadowy world of officialdom. The pressures put a strain on my relationship with Khajorn, and finally we split up after many years.

In the end, after nearly eight years in business, I earned in the process precisely zero. Despite having made a killing on the exchange rate in 1997, I managed to lose the entire original investment and had to go back to my shareholders and admit to them that all the money was gone.

Like so many other foreigners, I came to Thailand and promptly lost everything. Trammell's instincts, as always, had been right when he foresaw that Bangkok for me would be a losing bet. But, like my Thai friends, I continue to dream. In 2005, Saa and I started all over again, founding another company. This one, called Origin Asia, is dedicated to managing programs in traditional arts – which is what I thought I would do when I made my move in 1997.

The benjarong business taught me much, from the society of street vendors, to the minutiae of tax documents. However, running a benjarong shop was after all, a detour. It's one of those things one never thought one would do in life, hence all the more precious as an experience. I never drive by the Nai Lert Building at Soi 5

without a twinge of nostalgia. I look at the fast food outlet, remember our gleaming glass and chrome Chiiori Benjarong, and think: "This was our shop!"

I came to Bangkok intending to do one thing, and got distracted and did another. Bangkok's a distracting place. Maybe it was a good thing because benjarong kept me in a holding pattern while I used those years to learn about the arts that I intended to run programs in. Meanwhile, Edan is talking about returning to Bangkok. If things don't work out, we can always go back to selling watches on Sukhumvit Road.

LADPHRAO

Every year thousands of people visit Jim Thompson's house on the klong, and go away dreaming of how nice it would be to live in an old teak home. I was one of them. I first made the pilgrimage as a 21-year old in 1973, and it came as a revelation.

Jim Thompson, the man who revived the Thai silk industry in the 1950s, put together several old teak structures to create a rambling mansion centered around an open-sided living room framed by tall slanting columns. Bedroom, dining room, study, corridors, and annexes, filled with antiques, radiate from this central platform. Famous from the day it was built, it became even more so after Jim Thompson's mysterious disappearance on a trip to Malaysia in 1967. When I first visited, before it got so crowded that they had to institute guided tours, you were free to roam the house as you wished. I spent hours there, lounging on the open deck of the living room, or seated in the study, gazing enthralled at the age-worn Mon statue, still my favorite artwork in Thailand.

I had been smitten with the love of old houses since I was a little boy in Japan, when my mother used to take me to the homes of her friends in Yokohama and Tokyo. It was in the days before they tore down all the grand wooden homes and replaced them with apartment blocks. In the summer of 1973 I had purchased Chiiori, a thatched farmhouse perched high on misty peaks in the center of the island of Shikoku. On the way to and from Shikoku from Tokyo where I was studying at the time, I would stop and visit for a few days at David Kidd's palace in Ashiya. This, with its vast

tatami-rooms and silver-leafed doors, was a dreamworld on a far grander scale.

At Chiiori, deep in the mountains, the dream could survive Japan's modern development, but not in the big city centers. In 1977, the owners evicted David from the palace (which he only rented), and handed the site over to a company called Urban Life to tear it down and replace it with an apartment building. Just before demolition was to begin, the president of Urban Life came to visit David. As they sipped tea in the living room, David commented, "Your company should really be called Urban Death." In this way most of the great old homes that I once knew in Japan slowly disappeared. Still, David in Ashiya, and I in Chiiori, had managed to live the dream.

That was Japan. Suddenly, with Jim Thompson, I saw that one could live the dream in Thailand as well, and from that day forward, I was determined to find an old house in Bangkok. Over the years I put a certain amount of thought into it. The problem is, of course, that the Jim Thompson dream has become nearly impossible in the megalopolis that is Bangkok.

Most of the canals on the eastern side of the river were filled in decades ago. A few remain such as Klong Saen Saeb, a major artery which runs west-east, from the Chao Phraya River, past Jim Thompson's house, and out many kilometers to the eastern edge of the city. Unfortunately, the downtown canals have lost the romance they may have held in Jim Thompson's day. Klong Saen Saeb is not very charming for most of its length, being mostly a line of stagnant water cutting through stretches of tin sheds, apartment blocks, and highway superstructure. In most other places where waterways survive, the city has no use for them at all, such as the channel running the length of Sathorn Road in the business district: a stark concrete chute in the middle of the road that was once a klong shaded with mango trees.

You have to go far out of the center city onto the klongs of Nonthaburi to find Thai houses surviving in critical mass. Here, alongside quaint older buildings, the rich have built some spectacular Thai-style villas. The older cottages look charming, but

rot and termites have infested them to the point that they're beyond repair. Already sagging on their tall supports, it's only a matter of time before they crumble into the water. Meanwhile, the wealthy have no need to sell their fancy holiday homes. You'd have to buy land to build over the mud, and what legal title to the mud consists of is a murky prospect. Then you'd have to construct a wooden house on stilts, which would be difficult because building in teak is tightly restricted these days. Much of the canal-side is unreachable by car, so in order to live up here, you'd need also to buy a boat and hire a full-time boatman. Locating along the northern klongs is the equivalent of moving to the countryside: it only makes sense to live beside Nonthaburi's canals if you're ready to retire from Bangkok itself.

So although I'll always love this area and think of it as the most beautiful part of Bangkok, I gave up on it. I turned my attention to the city center. Traditional Thai houses do still exist in town. To get an idea of how it was once possible to live in Bangkok, one can visit the home of MR Kukrit Pramoj on Soi Phra Pinit in the Suan Phlu area, which has been opened to the public. Kukrit was a noted writer and former prime minister. His house, with its own stage for masked dance performances, and grand raised pavilions, faces a wide grassy garden, Kukrit's private pleasure-park.

Another of my favorite Thai complexes is Wang Plainoen, a small teak palace near Klong Toei, belonging to the descendants of Prince Narisra Nuvadtiwongse (usually shortened to Prince Naris). Like the Muses and Graces of ancient Greece, eminent sons of Rama IV and Rama V took up a different art or science: Prince Mahidol, father of King Bhumibol Adulyadej, studied medicine; Prince Damrong founded Thai historiography. Prince Naris, the "artist prince," designed Wat Benjamabopit (the Marble Temple), and acted as patron of Thai dance and music. You can see this tradition alive in Bangkok today. King Bhumibol's sister, the late Princess Galyani, played the role of patron of Western classical music. Until her death in 2008, Galyani would almost invariably preside over concert performances at Thailand Cultural Centre. Likewise, the King's daughter, Princess Sirindhorn, has supported

classical Thai music, and even performs it herself at Wang Plainoen. Wang Plainoen, which was Prince Naris' retreat in his later years, is filled with precious antiques, including what may be Thailand's best Khon (classical dance) mask collection. An open room with a raised seating platform where Naris once held court, overlooks a garden where students of traditional dance perform in the open air – something you can go and see when the palace is opened to the public on Prince Naris' birthday on April 28th each year.

I knew that you didn't have to be prime minister or be descended from a prince in order to live this way. The memory of John Blofeld in 1973, and his teak study raised on stilts, stayed in my mind. Except for the golden Burmese Buddha image on the altar, John lived the life of a modest scholar, the house rising from a yard full of children and chickens. Going to see him felt almost like spending time at an upcountry farmhouse.

Of the Thai houses in the city center, one of the most remarkable belongs to Rolf von Bueren and his family, owners of the design firm Lotus Arts de Vivre. It's located only a few minutes' walk from the busy Asoke-Sukhumvit intersection. A nighttime visit there has a feeling of magic, almost a conjurer's trick. You turn off the busy soi into a long passageway that takes you past ferns and vine-covered trees to enter the main house, decorated with Thai art, traditional and modern. The high point comes later in the evening, when your host invites you outside, and you walk across a wooden walkway built over a pond to a raised Thai pavilion where dinner is served. Modern Bangkok is only feet away – but one has slipped into an air bubble of a time far away and long ago.

The von Buerens' little paradise would be very hard to duplicate today. Whether you think of it as urban life or urban death, traditional houses are doomed in modern Bangkok, as they are in most large Asian cities. Lack of protection for historic homes, and a feeling that these old places are old-fashioned and even an embarrassment, leave them naked and exposed to the harsh realities of urban real estate. Plain economic good sense dictates that single-family homes with spacious gardens make way for high-density apartment buildings.

In the novels of Proust, my favorite writer, his characters live for years pining after a longed-for ideal – gaining the heart of a lover, being accepted in high society, seeing a famous actress perform – and one day a magic moment comes, they step over a threshold, and actually experience it. One haunting line of Proust captured well my yearnings for the fast-vanishing Thailand of old photographs and paintings: "Like one who departs on a voyage to see with his own eyes a desired city, and who believes that he will be able to taste in reality all the pleasure of the dream."

Still seeking the dream, I shifted my focus outside Bangkok. The obvious place to build a teak house was my then-partner Khajorn's village, near the town of Chiangkham in the northern province of Phayao. It was a plan born of two burning desires: Khajorn, like every Thai who hails from the countryside, lived for the day when he could save up enough money to build a new house for his family. For my part, I saw teak houses all over Thailand being torn down and discarded and I thought I could collect some of this wood and build a house myself.

We explored the towns and valleys in the neighborhood of Phayao, and eventually purchased the wood of three houses, which we dismantled and moved by truck to Chiangkham. It was a nerve-wracking business because permits to move wood were hard to come by, and we had to pass through seventeen police districts on the way. Once the wood had arrived, carpenters set about raising the twenty teak columns on which the house would stand, planed flooring out of *mai daeng* redwood, and eventually crafted walls, roofing, kitchen and bath. On New Year's Eve 1998, my friends and I all converged on Chiangkham to celebrate the completion of the house, a symphony in golden teak pillars and redwood paneling, shaded by palms and banana trees, and overlooking a lotus pond.

And there, sadly, the story stops. Like many before me who've built their vacation palace up-country, I ended up almost never visiting it. Chiangkham is just too far away. I can count just a few times since then when I stayed in this lovely house. Khajorn himself, after his father passed away, moved away from the village to a shophouse along the main highway, leaving the house

abandoned. In 2009, he dismantled it and used the wood to build a new home in town. My country house lasted just over ten years.

After all the work and expense of building the Chiangkham house, my dream of living in a wooden house in Bangkok finally faded away. I gave up on the idea and settled into a condo on the 14th floor of an apartment building off Sukhumvit. If Bangkok had gone tall and modern, then I would live tall and modern.

Students of the occult learn that the First Law of Magic is: "It only happens after you've given up on it." That's why when the rainmakers come and do their dance, it always stays bone dry while they're still dancing. Eventually the onlookers tire and slip away in disappointment and the rainmakers are sent home in disgrace, at which point it begins to pour.

True to the First Law, it was shortly after I'd moved into the condo that the miracle happened. My cousin, Thomas Kerr, an architect also living in Bangkok, works for an NGO involved with slum housing, and in order to live near his office he rented a small apartment near Ladphrao Soi 60. One day he was walking to work when he noticed a long wall pierced with three high-eaved gates. Within them seemed to be a traditional compound, and above the walls could be glimpsed the beveled wooden windows and peaked roofs of old houses, surrounded by flowering branches that spilled out over the wall. Tom was intrigued and knocked on the door of the first gate.

Inside turned out to be a spacious compound covering nearly a full city block. The owner, Khun Santi Svetavimala, was an essayist, song lyricist, and food expert – a renaissance man of traditional culture – who had erected a series of Thai-style houses and pavilions. Some were old structures that he had found in his ancestral base of Ayutthaya, dismantled and brought to Bangkok; others he had built new. Santi seems to have once thought that his wife and daughters would drape themselves in hand-woven sarongs and lounge elegantly on the verandahs like mythical Thai ladies of old. But of course, what they wanted to do was to learn piano and travel to Paris. The family lived in an air-conditioned concrete edifice in one corner of the property, while

the wooden pavilions moldered away, and Santi worried about what to do with them.

Tom and Santi hit it off immediately. Tom offered to move in and look after the houses, and Santi agreed to lease a wing of the

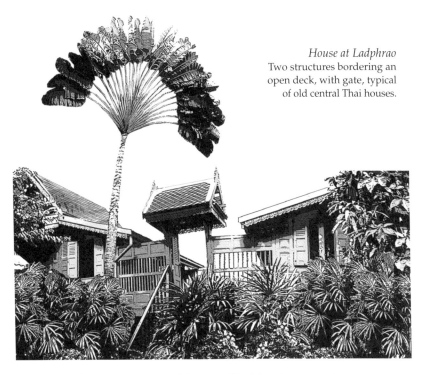

House at Ladphrao
Two structures bordering an open deck, with gate, typical of old central Thai houses.

property for a very reasonable rent. For him, it was a chance to see his darling houses properly cared for at last. There was more here than Tom could handle on his own, and knowing my love for old houses, Tom called me in to join him. So thanks to the passion of Khun Santi, and the sheer luck of Tom's walking down Ladphrao Soi 60, we ended up as tenants of Khun Santi's secret garden.

Our part of the complex has its own gate, and when I enter that gate I always feel as if I've stepped through a hidden door into an alternate universe. You start out at hot and smoggy Ladphrao Road, with its multiple lanes of unmoving traffic. You turn onto Soi 60,

zigzag a few times until you reach our quiet soi, and soon you find yourself standing in front of a Thai-style gate.

You push open a low door cut into the gate, ducking as you enter, and when that door closes, modern Bangkok has disappeared. Ahead is a mossy brick courtyard, shadowed deeply with flowering trees and one tall fan palm outlined against the sky. To the right is a double-winged wooden house on stilts, and to the left a single-story pavilion. The double-winged house (two houses joined by an open wooden deck) takes the classic form of old central Thai homes. A flight of wooden steps, flanked by potted palms, leads invitingly up to the deck. Both houses are painted the same dark red that one

Sala at Ladphrao
Open-sided room with raised central floor,
for relaxation and dance performance.

sees at Jim Thompson's – originally made from crushed mineral pigment, it protects against sun and insects.

At the far end of the courtyard a tall pyramidal roof shelters an open area where we've arranged lounge chairs and a table, bordered on one side by a kitchenette and counter. Beyond all this, the property rises a few feet to another level on which stands a stone and concrete Chinese-style chalet. This is where Tom lives. Nearby, another flight of wooden steps leads upwards to the *sala*, or

open-sided dance pavilion, and above all of this towers a shady banyan tree with down-hanging roots. Even though you are still very much in the city, you can hear birds twittering by day and frogs croaking at night.

Houses like this were once merely the humble abodes of villagers everywhere in Thailand. The fact that the two main houses and the dance *sala* stand high on stilts is a reminder of these houses' watery origins. The stilts were to raise them above river floods or the dampness of the forest floor. But as composed by Rolf von Bueren or Khun Santi, these houses take on an otherworldly air. Khun Santi added to his complex a Chinese chalet complete with glazed green tiles, and several small *salas* (open-sided pavilions), in addition to the main dance *sala* with its elevated central platform of polished wood, like one from a palace. The compound is really Santi's dreamworld.

The quest for fantasy is supremely Thai. You can see it in the glitter of the Grand Palace or Wat Pho, with their golden spires and the long thin *chofa* finials. It shows in the whimsy of royal villas such as Bang Pa-in just north of Bangkok, where a Chinese pavilion, a Buddhist temple built in the style of a Gothic church, and Thai palaces all co-exist in an oddly appealing whole.

In contemporary art, fantastical forms mark the work of Thailand's two most popular modern painters: Chalermchai Kositpipat and Thawan Duchanee. Chalermchai paints Dr Seuss-style trees waving swirling branches above multi-tiered palaces, whose rooflines twist and turn from Thai into Chinese and back again. Temples fly through pink and turquoise skies on the backs of birds, turtles, and fish. In Thawan's darker vision, the curving forms of Thai design emerge from the black-outlined beaks and claws of ravenous animals. Not content merely to paint fantasy, Thawan is in the process of constructing it in three dimensions in the grounds of his pleasure park far north in Chiangrai – studios and showrooms like farmhouses on stilts, crowned with super-steep wooden roofs, and beams tipped with buffalo horns.

One could say that a taste for fantasy is what decides whether a person is going to love Thai art or not. For those enamored of

international minimalism or conceptual art, Thai art and architecture will never truly satisfy. It's just too outlandish. For me, coming from years in severely elegant Japan, with the emphasis on simplicity and monochrome, I found Thai exuberance a great release. My Sinologist friend Jeremy Barmé, on hearing that I was moving to Thailand, said to me, "You'll love it, Alex. Therapy! After Japan – Thailand is therapy!"

While the Ladphrao house is relatively plain as Thai structures go, there are plenty of quirky fantasy touches, things you certainly wouldn't see in a modern apartment building – well, Thailand being what it is, maybe you would see them in a modern Bangkok apartment building. Stone sculptures of frogs, lion-dogs, and griffins, gingerbread trellises, garden steps edged with *naga* serpents, and gilded peacocks made of perforated foil perched over the doors.

Charming as all this may be, there was of course a reason for the reasonable rent. When Tom and I first took over, the houses were almost unlivable. All the roofs leaked, there were no fans or air-conditioners, the kitchens were primitive, the electrical wiring utterly baffling. The right wing of the Thai house had subsided over a foot into the soft ground below, so that the whole complex tilted to the side, like one of those cottages teetering on skewed pillars along the Nonthaburi canal.

Thus began a long process of renovation, lasting continuously since 1999. With the help of Khun Santi's carpenters from Ayutthaya, we jacked up the right wing of the Thai house. We replaced the timbers of the central deck with fresh hardwood planks, glazed the windows and installed air-conditioning, modern comforts that I, at least, can't live without. Meanwhile, the electrician re-wired the buildings, installing lamps and spotlights. Gardeners brought the unruly garden under control, pruning branches, hanging pots of orchids, laying flower patches, planting trees. In the end, as anyone who has restored an old wooden house could have foretold, Ladphrao turned out to be very expensive.

Partly because it took years before the house became habitable, I have never actually lived at Ladphrao. From my condo in

Sukhumvit, I commute to Ladphrao for the occasional event. Sometimes I go out there with friends and we picnic on the central platform. We buy food at the local Chokchai 4 Market, bring it back, and eat by candlelight as the moon rises from behind the fan palm. Sometimes we watch a performance of Khon or Lanna dance. Other times we sit under the porch as rain sweeps over the wooden deck, accompanied by a chorus of frogs.

More than a place to live, Ladphrao gave me the space I needed to realize my dream of establishing a program of traditional arts such as I had managed in Kyoto. When I established a program for Thai arts in 2004, calling it "Origin," the house finally came into its own.

I've always believed that the traditional arts need to be taught in a traditional setting. This is why culture classes in hotels and rented rooms in office buildings never quite "take." When I was a little boy, our family lived in Naples, Italy, and my first language, even before English, was Italian. After the family moved back to the States, my parents made an effort to talk in Italian to me and my little sister, hoping that way to keep up our language. We would listen and understand, but we would respond in English. It's because we knew that this wasn't Italy. It's the same when you're trying to teach traditional arts in a modern setting. At some deep level, people realize that the location and what they are learning just don't match.

Ladphrao was an obvious choice for the Origin Arts Program, and the variety of spaces built by the eccentric Khun Santi was a real help. When we hold an arts program here, we use every room on the premises in one form or another: *Maarayaat* (etiquette) and dance in the *sala*, martial arts in the courtyard, and so forth. The only space unused by the program is cousin Tom's Chinese chalet, which remains his sanctuary amidst all this activity.

Seen from the perspective of Japan, Ladphrao feels familiar. After all, the archetypal Japanese house came from Southeast Asia, not China. Old Japanese farmhouses are built of wood, raised up on stilts (although only a few feet, not a full story like Thai houses), roofed with thatch or baked tiles, and floored with polished wooden

planks. Inside, open ceilings reveal exposed beamwork, and despite having windows, somehow there's never enough light. All of which describes Khun Santi's houses to a tee. Another trait that Thailand shares with Japan is the lack of furniture. I call this the "ethos of the empty room." China and Korea filled interior spaces with furniture: chairs, tables, beds, bookshelves, cabinets, and boxes. People with means added *objets d'art*, each resting on its own stand: ceramic jars, jades, bronzes, and spirit stones. But the Thai and Japanese tradition, even for the wealthy, calls for an open floor with little more than a mat and a cushion. I wonder some times what the effect of the "empty room" had on people's psychology. Could it be related to the fact that both Japan and Thailand have focused so much on transience, detachment, meditation?

Over time Ladphrao has seen many performances of dance and music. In this I feel a bond with Kukrit and Prince Naris, who loved above all viewing dancers perform in their gardens and pavilions. In Chinese ink paintings, if there is a cottage in the mountains you can always peek through the window and glimpse a scholar with his books, scrolls, and writing brushes. Chinese architecture is just not complete without a resident philosopher. Thai fantasy complexes, on the other hand, demand dancers and musicians, such as you might see beside and within the palaces in temple murals. In using Ladphrao for Khon performances and musical concerts, I feel I'm turning the house to its truest use. Khun Santi once told Tom that when he came home at night, and saw light emanating from the Thai pavilions, and heard the gongs and chimes of gamelan and the squeal of Thai oboes, he felt that the houses had finally come alive again.

One basic fact of old Thai houses is that the rooms are so *small*. That's the biggest reason I never lived at Ladphrao. There just wasn't enough space to put all my things. The stark simplicity of traditional living is something you wouldn't suspect, guessing from vast halls of temples and palaces, carved and painted over every inch and crammed with Buddha statues. But these are where rituals took place, not where people lived.

Jim Thompson's house, with its open-sided living room, study, dining room, guest rooms, and so forth, is highly misleading. He put three or four houses together to craft his spacious mansion. Even royal residences in the past were modest in size as you can see from Phra Tamnak Daeng (Red Mansion) on the grounds of the National Museum, or Rama I's youthful home preserved at Wat Rakhang. Inside these spaces, not much larger than a standard hotel room, the mark of luxury for royalty would be a gilded Chinese bed – and the rest was mostly empty. Most striking is the small Thai villa that Rama V built for himself in the gardens of his imposing colonial-style Vimanmek palace. This little house with its bare interior was where he went to relax.

Small sparse rooms lend a mood of intimacy to an old-style Thai house. This is why King Rama V was at his happiest when he had left his ladies to formal tea in the plush Victorian drawing rooms of Vimanmek, while he went to chat with friends in his little bare cottage in the garden. The empty space makes Ladphrao a good place to have a picnic, and it also helps with the arts program. In this house, you slow down and adapt to a different space and time.

Ladphrao is no Shangri-La. For one thing, there is the basic discomfort of living in an old Asian house. It's not for nothing that hundreds of millions of people, from Japan down to Java, all suddenly decided in the last few years to tear down their charming wooden houses and rebuild in concrete, steel, and plastic. The intimacy of the "empty room" may be nice, but there comes a point when people crave space, especially when they begin to acquire material goods. You need a place to put your TV, refrigerator, DVDs, books and magazines, clothes closets, and tables and chairs. People once lived simply on the floor and that was that. But with modern life, old houses suddenly feel cramped. And indeed they are. Ladphrao requires constant "object control." Bring in one too many things and you find you have no room to move.

Just as in Japan, the eaves and doorframes are all too low. I'm relatively short, so I can manage fairly well where tall foreigners, and increasingly taller Thais, are always bumping their heads.

Modern Thai-style houses have raised the eaves higher, but in older houses like Khun Santi's, the frames are so low that even I am constantly cracking my forehead against something. Then there is having the bathroom located down a flight of stairs and across the courtyard. It's quite a trip to make in the middle of the night, and I'll confess, a bit scary too, if you're spending the night all alone.

Plus you can never relax and just "be" in a house like this. The maintenance is endless. Bits and pieces from the trees rain down on the garden night and day requiring constant sweeping. As he surveyed his moon-viewing platform, littered with leaves and debris from the surrounding trees, David Kidd grumbled, "Really, trees have the most disgusting sex lives."

The restoration work never ends. The best we could do about the leaking roofs of the double-winged house was to cover them with green canvas. I'm waiting for the day when I can afford to have the roofs properly redone with baked red tiles which Khun Santi says he can supply from Ayutthaya. Meanwhile, something is always breaking down. The steps rot and have to be replaced, the house subsides some more and the floor tiles crack. The water pump shuts down, the electricity shorts, the lower rooms flood, the red paint flakes away in the hot sun, the gutters get choked with leaves, and now even the green canvas sheeting has started to leak. The other day a huge branch fell off one of the trees after a storm and smashed the fretted woodwork along a corner of the *sala*. Repairing it all involves pouring in more money.

I experienced this in Japan with the thatched farmhouse I bought in Iya Valley on the island of Shikoku in 1973. In those days all the houses in the mountains of inner Shikoku were thatched. Every fall the villagers cut thatch and stored it; and in the spring they gathered to redo the roofs in sequence: this year it would be Mr Omo's roof, next year it was Mr Takemoto's turn. As long as they kept doing it, the price was cheap and the process easy. However, once people stopped thatching roofs, a vicious cycle set in. Thatch, which had been the most common thing in the world, became rare and ended up as an expensive luxury. A similar process has happened in Thailand.

Houses like Khun Santi's were once relatively easy to maintain because the materials and skilled craftsmen were plentiful. Nowadays everything about these houses is "special", and so the costs have skyrocketed. Ladphrao was no bargain. I suppose this was only to be expected in a rapidly modernizing city like Bangkok. Old houses like Khun Santi's place run so completely against the thrust of the city's new development, that it's natural that their upkeep would be a challenge.

The amazing thing is that this house exists at all. I can never get over this little miracle. Old-style Thai houses always had something fantasy-like about them, and against the backdrop of the modern city, they feel all the more unreal, a mirage of the old Thai life that disappeared only recently in Bangkok.

Outside the walls of the house at Ladphrao, the busy dusty city and congested highways stretch far and wide. Inside, orchids bloom under the sun-speckled shade of palms and the great banyan tree, birds twitter, peaked roofs soar into a blue sky, and shadows drift over red-painted pavilions. It's a taste in reality of all the pleasure of the dream.

Soi 16

In Thai soaps, the rich dwell in a colonnaded mansion approached through filigreed cast-iron gates and a circular driveway lined with sculpted hedges. Inside a vast marble-floored living room, the family cowers at the feet of a fascinatingly evil mother-in-law with truly amazing hair. In real life, relatively few people in Bangkok live in single family homes these days, even the best coiffed and most evil matriarchs. Increasingly Bangkokians are moving into apartments in high-rise buildings, and as the leveling of old homesteads continues, the trend will surely endure. Bangkok is taking to the sky. There's nothing exceptional in this, of course, since the same process is well advanced in almost every large metropolis, aside from a few old city centers in Europe.

My life in Bangkok has mirrored this process. Right from the beginning, I've never lived in a house here, only apartments. The first was a one-room apartment of about 8 square meters that I rented for 2,500 baht per month with my partner Khajorn back in 1990. It was on Soi Rongnamkaeng ("Ice Factory Road") just off Sathorn, a soi so narrow that even *tuk-tuks* couldn't get down it. To get there, you had to alight from your taxi or *tuk-tuk* by a crowded market, and then walk or take a motorbike past a mosque (it was a Muslim enclave and you could hear the calls to prayer broadcast five times a day), and a mix of walled compounds and empty lots with vines growing over old wooden fences. About two hundred yards down this narrow lane rose V.P. Apartment, the six-story apartment block where we lived on the third floor. Although just

off the roaring avenue of Sathorn, it had a relaxed feeling, like living in a small town or in the country. During the day children played in the soi; at night, people wearing sarongs sat outside in the cool of the evening chatting or playing music.

It didn't last long. Word was out that the city had plans to build a new road through the market, although it was a long-established slum and many of the shopkeepers and squatters refused to move. We soon learned how brutal the process of eviction in Bangkok could be. One morning we woke up to find the whole market burned to the ground. Several people died in what the police determined was a "tragic accident." Soon thereafter the road building began, and most of the district vanished. I suppose V.P. Apartment must still exist, but I wouldn't even know how to find it these days.

After the burning of the market, we moved to another apartment, this time on the fifth floor of dilapidated Indra Condominium, one of Bangkok's older large condos, behind the Indra Hotel in Pratunam. The rent rose to 4,000 baht per month for one room of about fifteen square meters.

In a colorful city, Pratunam must be one of its most colorful neighborhoods. In the center rise two skyscrapers: Baiyoke 1 and Baiyoke 2. When I moved to Pratunam, there was only Baiyoke 1, at the time Bangkok's tallest building, which had a restaurant at the top from which I would show guests the vastness of Bangkok spreading in a low jumble of buildings to the horizon. Later they built Baiyoke 2, nearly double the height of the first one, and with its elongated "empire state building" shape, topped by a circular drum, it towers as a landmark over north-central Bangkok.

At the ground level, these two buildings stand smack in the middle of a warren of small shops and shipping agents. It's one of Bangkok's busiest garment centers. Buyers with shopping bags cram the streets all day long, and these include not only Thais but wholesalers from all over the world, such as wide Russian babushkas carting off huge bags of T-shirts, almost as wide as themselves, for export to Uzbekistan. Most notably, Pratunam is the center of Bangkok's African community. Nigerian ladies arrayed in yards of colorful fabric and regal headdresses, parade majestically

through the streets, which also feature restaurants serving African favorites.

Pratunam was an easy place to live because you could go out onto the street at any time of day or night and buy food, clothes, cosmetics, flowers, just about anything. The neighborhood brims with hotels, from 5-star to cheap flophouses; there was every kind of eatery; and nearby they were converting a failed department store into Panthip Plaza, which in a few years became Bangkok's premier electronics emporium. There were certain disadvantages, notably our soi flooded so badly after heavy rains, that I sometimes found myself wading home in knee-high, or even waist-high water.

The next move took us up into the sky. In 1996, a friend introduced me to Khun Num, a wealthy young philanthropist who lived in a condominium tower on Sukhumvit Soi 16. Just how wealthy Num was I could only guess from our first conversation in which I asked, "And what do you do?" "Oh, I work with my family," he answered diffidently. "What do they do?" "We buy and sell things." "What sort of things?" "Airplanes," answered Num. I asked no further.

Num owned two apartments, of 350 square meters each, together making up one floor of the condo tower. He invited me to take over one of them – at a rent which was affordable. A rent, in fact, that would only be possible in Bangkok. I was getting ready to finally make my move from Japan to Thailand official, and I needed a space large enough to store my books and art collection built up over the years in Japan. In 1996, I moved in, and in 1997, shipped everything from Kyoto. It was a joy to have space, for the first time in decades, for all my books, which I'd never been able to fit into paper-walled Japanese houses.

The Soi 16 condo is a dramatic space. Floor-to-ceiling plate-glass windows curve around stretches of wooden parquet floors. For the first year, before the furniture arrived from Japan, the apartment was almost vacant, except for one sofa and some pots of lotuses. My cousin Tom, who stayed there for a short time while house hunting, said it was like living in a skating rink. Later I decorated it with art works brought from Japan – and folding

screens and Chinese tables took on a glamour they'd never had when displayed in the moldy living room of Tenmangu, the caretaker's house of an old shrine where I live outside of Kyoto. I've learned over the years that people rate art works according to the quality of your kitchen and bathroom. In the early days in Tenmangu, city plumbing had not yet reached my neighborhood, so visitors had to use a rickety wooden outhouse in the back. Japanese guests would look at the folding screens, and ask, "Where do you get this stuff? Out of old trash piles, I guess?" They didn't mean to be rude; in their eyes these things really looked like junk. Later, when plumbing arrived and I built a flush toilet and tiled bathroom, guests looking at the same screens sighed, "We can never find treasures like this in Japan any more. You must have bid for them at international auction at Sotheby's or Christies'." Soi 16 works the same magic. Every bit of driftwood or a lacquer bowl that I picked up at the weekend market, bathed in the glow from the wide windows, looks like a masterpiece of modern design

It's the sheer space that's deceptive. Space is *the* luxury of big cities. I've had guests remark, "Well, it wouldn't be the same for a millionaire like you," or something to that effect, assuming that I must be a person of great wealth. They're unaware that the rent for the Soi 16 condo is just a fraction of what my friends pay for their cramped apartments in Tokyo. In Honolulu it would get me a one-bedroom apartment, and in Manhattan, I'd be able to afford, maybe, a broom closet. It's the cheapness of Bangkok real estate that makes it possible for someone like me to live the way I do. And I live in the uneasy understanding that these days are numbered.

Just below us is the floor with the pool. Lit up bright blue at night, it floats on the 12th floor rooftop like an alpine lake in the sky, a cool refuge in this ever-hot city. A breeze usually blows, and at night we sit out here sipping wine by candlelight. I like to float on my back and gaze upwards at the night sky, framed by soaring buildings on all sides. Sometimes we come down to the pool to watch fireworks. Bangkok must surely have more fireworks displays than any place on earth. It's the sense of *sanuk* that's so core to Thailand, expressing itself in constant celebrations.

Fireworks seem to be going off somewhere in the city almost every week.

The sky-floating pool represents an aspect of Bangkok high-rises that differs sharply from what I was used to in Japan or America. That is, even at great heights, there are outdoor spaces open to the sky. In most northern cities, chilly-to-freezing weather half the year is enough to make this unfeasible. In Singapore, safety concerns make it illegal. But in Bangkok, many a high-rise features a pool or recreation area on upper floors; and some boast rooftop restaurants at truly dizzying levels.

The most spectacular of all such venues is undoubtedly Sirocco restaurant, located on the rooftop of the State Tower at the foot of Silom Road. You ride up to the 63rd floor, then walk outdoors to the top of a broad flight of stairs. Your designer dress and styled hair swirling in the stratospheric winds, you descend like a 1940s Hollywood star down the illuminated staircase to a candle-lit dining space, mysteriously dark in the evening sky. At the end of the dining area is the bar, a circular extension softly aglow with changing rainbow colors, perched over the edge of nowhere. Far below snakes the curve of the Chao Phraya River, busy even at night with river-craft, and all around gleam the lights of the skyscrapers of new Bangkok.

The changing view from my various apartments has mirrored the growth of the city. From 1990 to 1996, Khajorn and I went from the 2nd floor at Soi Rongnamkaeng, to the 5th floor at Pratunam, to the 14th floor at Sukhumvit Soi 16. For the first year or two, from the Soi 16 windows we had a clear view of the lake at Queen Sirikit National Convention Center, although the office buildings going up in the pre-1997 boom were beginning to obscure it. Traditional family compounds, complete with lawns and pleasure ponds, surrounded our building, and even from the 14th floor in the heart of Bangkok, you could hear frogs croaking during the rainy season. In the distance you could see the skyline of the Sathorn business district.

Today the view is long gone. We're hemmed in by high-rises, the walled family estates disappeared one after another, and I

haven't heard a frog in years. Semi-transparent gauze curtains now cover the plate-glass windows, to protect us from the too-close gaze of our high-rise neighbors. If there is any benefit to the loss of the view, it's that the new buildings shelter us from the blistering sunlight of a south-facing exposure. One welcomes almost anything for the blessing of shade.

The Soi 16 apartment stands a three-minute walk from the Asoke-Sukhumvit intersection. If you drew a circle around greater Bangkok and aimed a dart at the middle, it would fall roughly near this point. One of only three places in the city where the SkyTrain and the Subway cross, this junction is about as convenient a location as one could hope for in a basically inconvenient city.

I date "new Bangkok" from the opening of the SkyTrain in 1999. It made it possible, for the first time, to jump over the horrific traffic of Sukhumvit, the Victory Monument, and Silom. Bangkok benefited from building its public transport rather late, so the designs are sleek and clean, as compared with the funky old look of Tokyo, or worse, New York. The new ease of getting around made it possible to do much more in a day. That very ease of movement, however, created within a few years a whole new class of busy commuters. I remember when Khajorn first visited Tokyo in 1994. He stood in the vast underground concourse of Tokyo station watching as tens of thousands of commuters tramped by, and appalled at the busy-ness and inhuman scale of it all, he sighed and said, "I hope Thailand never becomes this way!" A few years ago I was changing trains at Siam Station, and as I struggled through rush hour crowds, I thought, "It's happened, just as Khajorn had foreseen."

Part of the change was psychological. Stations and train lines put bones and sinews into the geography of the city. Until then, we had only a rough idea of where we were. Now, people are quite precise about their location, and the time it takes to get anywhere. Another side effect of the SkyTrain was that it allowed us to see the city in a way we hadn't before. The fact of being elevated means that while riding in the SkyTrain you can see into gardens and estates that formerly stood invisible behind high walls.

104

The Subway, which came along a few years later, is quite the opposite. You go underground, sit for a while, and pop up somewhere else, without seeing a thing except your fellow passengers. Mass transit inculcates a sense of location into commuters. You've got to have a clear idea of where you are and where you're going, north, south, east, or west. The problem in Bangkok is what happens when you do emerge from the Subway. Then chaos sets in again. While the trains and stations are state-of-the-art, the planners haven't thought much about how they would link to their surroundings. For example, the Subway station called "Thailand Cultural Centre," exits a hazardous fifteen-minute walk from the Centre. From there you walk up a highway, around a corner and back again, across a roaring junction with no sidewalk or pedestrian crossing, maneuvering through stretches of mud and rubble along the way. You see society matrons in high heels staggering over this obstacle course – which they could have bypassed in three minutes if there were a tunnel or bridge leading from the station to the Cultural Center.

These are quibbles; we're lucky to have the SkyTrain and the Subway, and you feel this acutely when you have to visit the old town in Rattanakosin Island, which lies off the SkyTrain and Subway grid. As a densely populated historic district, there are impediments against pushing public transport through. This has effectively isolated the traditional culture of the old city from the modern culture of the new. Venues like the National Gallery and the National Theatre, located in what used to be prime locations near the Grand Palace, wither on the vine, because it's just too difficult to get there.

Sukhumvit in general, and my neighborhood in particular, are very much enclaves for foreigners, and so we're surrounded by expat amenities: a Foodland supermarket (open 24 hours) across the street, with its attached restaurant Took Lae Dee ("cheap and good"), always crowded even at 3am in the morning; Kuppa restaurant, one of Bangkok's finest, just a block away; the Siam Society, an historic cultural venue just north of the intersection, complete with a traditional northern Thai house in the garden;

Little Italy Italian restaurant (also open 24 hours) just east of it; and Emporium, the posh shopping center, one SkyTrain stop away.

Our area features another type of expat amenity: Soi Cowboy, a street of go-go bars just off of Soi Asoke. Local expats frequent the red-light district of Soi Cowboy, as opposed to the better-known Patpong, which largely caters to tourists. Soi Cowboy is not something to be particularly proud of, but it does lend a bit of color to what is otherwise a relatively staid neighborhood. After we moved from Pratunam, Khajorn suffered badly his first year or so of living at Soi 16 at not being able to go out late at night and buy his favorite type of northern noodles from his friend, the lady who

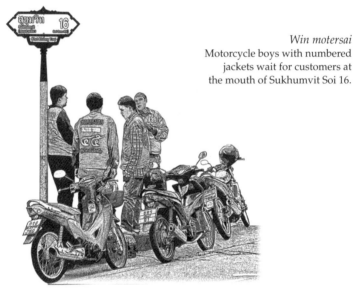

Win motersai
Motorcycle boys with numbered jackets wait for customers at the mouth of Sukhumvit Soi 16.

ran a street stall at the corner. A market opens at noon on Soi 16 for the lunchtime crowd emerging from nearby office buildings. You can find a little clutch of food stands wherever there is a large construction site, and on this soi there has been no end to building. However, compared to the crammed allies of Pratunam, there is relatively little street life around here. For better or for worse, it's a harbinger of the bland bourgeois Bangkok that's approaching.

Bland as it may be, there are many things to remind us, even in our glassy tower, that this is Bangkok and that the surroundings are Thai. To begin with, nobody goes in or out of our building without paying respects to the golden statue of Brahma enthroned in a tall white-plastered shrine. Instinctively people *wai* as they walk past.

Just up from the shrine, at the mouth of the soi, lounge a little flock of motorcycle boys, dressed in their distinctive monogrammed jackets. The soi boys provide the solution for getting in and out of deep side streets, because public transportation only covers the main avenues. Wearing regulation jackets indicating their neighborhood, they lounge at *paak soi* "the mouth of the soi," waiting for customers who need to be carried inside the soi – or to some other part of Bangkok. They're known collectively as *win motersai* (from the English word "win," it is said, because the customer arriving at the top of the queue soonest "wins" the right to use a motorcycle boy's services). *Win motersai* are a cheerful but naughty lot, who gamble, drink, laugh, and shout wisecracks at pretty girls walking by. Or sleep in a makeshift tent.

Many a real-life soap opera unfolds in the grounds of Sukhumvit estates. The neighborhood supports thousands of maids, drivers, apartment guards, gardeners, and housekeepers, most of them immigrants from the hinterlands, and not all with valid Thai passports. A friend of mine hired a hill-tribe boy from Burma named Kaw to look after his unoccupied house on Sukhumvit Soi 31, but ran into problems when Kaw struck up an affair with Chanphen a maid from the neighboring property. Chanphen would crawl through a hole in the fence for their daily trysts. Hailing from Surin, an eastern province bordering Cambodia, Chanphen was Kaw's chance to finally obtain Thai citizenship.

One day my friend received a delegation from Chanphen's parents angrily demanding that Kaw marry her immediately and pay compensation for damaging her maidenly virtue. It transpired that she too lacked a passport, since she actually came from Cambodia, and she'd been assuming that Kaw came from Chiangmai and could therefore provide her with a national ID card.

It was like a shipboard romance where each party assumes the other is a millionaire only to find back on shore that both are penniless. My friend parried the parents' demands by pointing out that Chanphen was guilty of trespassing when she crawled through the fence. After this, as often happens in Bangkok, the issue quietly faded away, and I never learned how much further the romance went. But my friend did repair the hole in the fence.

Despite the wealth of the neighborhood, poverty is not far away. Only a few blocks south of our apartment building is Klong Toei market, adjacent to one of Bangkok's most notorious slums. My 18-year old niece Tasi, Edan's more serious sister, spent six months working as a volunteer for the Duang Prateep Foundation, a charity NGO based in Klong Toei.

Tasi's first days at Duang Prateep were traumatic: they assigned her to the AIDS ward, where she came face-to-face with helpless patients dying in filthy hovels. Later she shifted to performing puppet shows for children in the slum, which was less stressful. Although Tasi always found the children smiling and cheerful, the daily contrast between the air-conditioned comforts of Soi 16 and the odorous poverty of Klong Toei was almost surreal. It's a reminder of another reality for foreigners living in Bangkok (certainly most Westerners and Japanese): huge income gaps.

Of course, they're huge in New York too. The difference is that here the poor and the rich still live cheek by jowl. My cousin Tom, who works with slum housing in Bangkok, has explained the value of slums: they allow poor people to live in the city center, where the jobs are. Otherwise, they get pushed farther and farther out. In Barbara Ehrenreich's book *Nickled and Dimed*, the author describes how she "disguised" herself as a lower-income American, and went to live in various cities where she worked as a cleaning lady or a waitress. She found that poor people's lives in America are hugely influenced by the hours they spend commuting to the wealthy suburbs or city centers. America has effectively segregated rich from poor in its cities.

As Tasi saw, life in the slums is hardly easy. At the same time, visitors from abroad often get a distorted view from the extensive

literature on the living hell that is Bangkok's slums. There seems to be demand for this among foreign tourists, as there is for another genre, books by convicted drug smugglers describing the ghastly goings on in Thai jails. *TIME* correspondent Andrew Marshall writes, "Wherever you go in the country, you find foreigners sipping cocktails on beautiful white sand beaches and reading about how horrible the place is."[3]

In fact slums in Bangkok, relative to many neighboring countries, are something of a success story. While as much as half of the populations in cities like Mumbai, Manila, Dhaka and Karachi live in slums, only about 10-15% do in Bangkok. One key difference is that Bangkok has a thriving market of rental housing that reaches every corner of the city, offering a variety of rooms with rents in the 1,000-4,000 baht range – cheap enough for even a low-paid laborer or market vendor to afford. If a poor family (or even a middle class teacher) migrates to Mumbai, though, their only option will be to take a room in some miserable slum.

This is partly the result of India's old rent-control laws, which make landlords afraid to rent out anything because they may never be able to get rid of the tenants. It's also related to colonial land ownership, which left huge tracts of the city under public owner-ship – land which remains effectively out of the market and under-used. Bangkok never underwent a period of control by a colonial power and has relatively little land under control by public agencies.

While Mumbai was a huge city even a century ago, Bangkok has exploded in size very recently into a sprawling mega city. As the city expanded, it has swallowed up swamps, rice paddies and durian orchards that were already broken up into small family-owned holdings, and so housing construction has followed the bones of this land ownership system. This development of Bangkok – in thousands of tiny bits instead of a few big chunks – has made for a planner's nightmare but a city that allows small-scale landowners to identify a housing niche market and cater to it.

Every Mom and Pop can rent out their bit of vacant land to poor migrants to build shacks on, or develop a few rental rooms. If they've got more cash to invest, they can build a 3-4-story building

with one-room rental units, which is the city's standard low-income housing type. The minute the building is finished, it will be full of tenants, guaranteed.

Because Bangkok expanded into empty swamps so quickly, the city is full of pockets that the high-end developers have passed by: vacant lots, rows of crumbling town-houses, tin-roofed huts on stilts along the edges of canals, construction sites, and even fields and marshes. Nestled in the shadow of sleek modern towers, these are the nooks and crannies where the poor find a place to stake their claim.

Bangkok benefits from its relative disregard for rules and from what Tom calls "the culture of negotiation." When conflicts arise between landowners and tenants or squatters, most pay little heed to the letter of the law and resort instead to working out a compromise. In India, slum-dwellers will pour into the streets to defend their squatters rights and shopkeepers will wage war to defend their rent control laws. In Manila or Jakarta, landlords can insist on the legal fact of their ownership, calling the police in with bulldozers and riot gear to brutally evict slum-dwellers to make way for shopping centers and upscale housing developments. "In Cambodia," says Tom, "it seems half the country is being evicted as real estate booms."

In Bangkok, while there have been painful exceptions, it's generally considered a loss of face to evict poor people from your land, especially by using force. At the same time, Thai slum-dwellers are aware that if they want to upgrade their houses and get legal rights to their land, they'll have to give up something. So Thailand has come up with an innovative approach to housing for the poor, called the Baan Mankhong ("Secure Housing") Program. The Baan Mankhong Program capitalizes on the energy of the wheeling and dealing in the culture of negotiation, setting poor communities free to finagle their own land deals.

If a slum occupies land facing a major road, for example, and the people refuse to budge, the landlord might be persuaded to sell or rent part of the land cheaply to the community, if they agree to give him back the commercially-viable part of the land along the main

road. The owner can then make his money on the road-front bit, and the people can rebuild their houses on this smaller piece of land. It's a win-win situation. This strategy for resolving land conflicts, which has been picked up by development agencies all over the world, is called "Land Sharing" and it was born in Bangkok. The government subsidizes the plumbing and utilities infrastructure; the slum dwellers build new houses with cheap government loans. In the process, Bangkok's slums are being slowly but surely upgraded.

What's unique to Bangkok is the fact that all of this slum-upgrading is taking place on a local and do-it-yourself basis. The Thai government's National Housing Authority does build some large public housing projects, which are as prone to corruption and misuse here as in other cities around the world, but most of the upgrades take place neighborhood by neighborhood, with the residents cutting their own deals with the landowners. That's why Bangkok has so many small two or three story shop houses and apartment buildings, and not so many of the massive Soviet-style housing towers you see in a city like Beijing.

This unusual process is to housing what the street stalls and Chatuchak market are to business: small-scale, neighborhood-oriented, flexible. It can happen peacefully because of the Thais' ability to negotiate compromises. It's behind-the-scenes processes like Baan Mankhong's quiet redevelopment of the slums that make the city of Bangkok uniquely "Thai," and not like other places.

Tom calls the sensationalist writing about the horrors of slums "the pornography of poverty." The writers of this stuff revel in lurid descriptions of teenagers overdosing on drugs, children being raped, women being knifed, and so forth. It's all part of the dime store novel "sexpot Babylon" approach that has given Bangkok such an unsavory reputation abroad. While drugs and crime and domestic violence certainly are problems in Bangkok, these things happen in any densely populated urban area. Tom remarks, "People who live in slums are not some strange species living in a nightmare world. They are normal people just like the rest of us. But because their jobs as construction workers, *som tam* ladies, market vendors or masseurs don't pay enough to

get their families into decent housing, they're forced to live in a shack in a slum."

Despite Bangkok's relatively humane approach to slums, sudden clearances such as the one that erased the ill-fated market of Soi Rongnamkaeng do sometimes still happen. At the end of 2006, a portion of the Klong Phaisingto slum neighborhood – about fifty houses – just a block from the Soi 16 condo, mysteriously went up in flames one evening. Other slums are better protected, with vigilant advocate committees and NGOs who fight for squatters' rights. There's even a coalition of two hundred canal-side squatter communities in Bangkok, who have won from the government the right to rebuild their settlements right where they already are, along the klongs.

Meanwhile we're starting to see the human casualties of stressful urban life appear in unexpected places. The southwest corner of Asoke Station, at the heart of wealthy Sukhumvit, has become the haunt of the homeless, with all their classic hallmarks: unkempt, unwashed, shaggy haired, wrapping themselves in newspapers. They sleep on the steps of closed shops in the evening. This is new to Bangkok. Homeless such as we know them in Japan or the West are a byproduct of the strains of urban development rather than poverty per se. The smell of urine at Asoke corner is a warning sign of social ills yet to come.

Although the bastion of the affluent, Sukhumvit mostly looks as shabby as the rest of the city. It's all a matter of degree. In any case, you could hardly say that these are beautiful surroundings. Grimy shophouses line much of Sukhumvit, fronted by tangles of electrical wires. Sometimes I look at the convolutions of those wires and muse how many lines are actually functional. Many seem to start nowhere and lead nowhere; you'll often see a nest of loose wires hanging down a few feet over pedestrians' heads. One wonders if the electric and phone lines will ever be unraveled and rationalized. Some day Bangkok will have to simply turn off all the lights, rip away the snaking, twisted wires, and start over again.

Trees were once plentiful in Bangkok, but they've fared badly in recent years. There's hardly a tree in my neighborhood that hasn't

had branches lopped off because they interfere with the electric lines. Scraggly plants along the roadside seem doomed never to rise above a few feet before they too get lopped off; or they simply wither away from lack of proper tending.

Bangkok pavement is terrible. Even in fashionable Sukhumvit you really have to watch your feet, or you might stumble over a patch of rubble, or step into a drainage ditch. In 2006, contemporary artist Navin Rawanchaikul did a huge painting of modern Bangkok for the 100th anniversary of the birth of Jim Thompson. Called *Lost in the City*, it portrayed in the intricate detail of temple murals, palaces with golden roofs, highways crowded with vehicles, fat foreigners in careening *tuk-tuks* – all the mad disharmony of the city. In front of the mural the display featured a narrow shelf. You realized that this represented the sidewalk, and here and there you could see discarded plastic bags, half-eaten fruit, and a dog turd.

You also need to watch out for piles of food (left-over rice with a few vegetables) that pious residents put out for the dogs. Bangkokians love their dogs; they are the "sacred cows" of the city, wandering everywhere unhindered. It's a relic of the villages from which Bangkok developed; and also an expression of Buddhist compassion. Unfortunately, as with India's cows, being loved doesn't mean necessarily well-treated. Sick and mangy dogs are one of the city's nagging problems. So important is care for abandoned dogs, that King Bhumibol Adulyadej himself adopted a stray, named Thong Daeng ("Copper"), about whom he wrote a best-selling book. To underscore the point, he even granted Daeng the royal title of Khun: Khun Thong Daeng.

Actually, you have to watch much more than your feet. You need to keep a good lookout for utility and sign poles standing right in the middle of the walkway, food vendors, and motorcyclists detouring from the clogged roadway. At the Asoke-Sukhumvit intersection, jagged metal signs veer over the sidewalk just at head level. Crossing the street can be a life-threatening experience, since vehicles charge unexpectedly from all directions, sometimes even running against the traffic.

What all this adds up to is an all-enveloping chaos and ugliness. Tokyo too is ugly, but at least it's largely clean and neat: a sterilized clutter. Singapore is not only clean and neat, but also at times beautiful with vast rain trees spreading their branches over the avenues of the downtown shopping district. However, with a few special exceptions, such as the Grand Palace area, Bangkok is just a mess. One wonders why this is so, given the Thais cleanliness (surely Thais are among the most meticulous about their personal hygiene and dress in Asia) and the traditional social ideal of *riaproy*, which means "proper," "correct," "everything in its place."

Yet the city is an unrelieved jumble. Bangkok has a bad reputation abroad as a slummy traffic-choked megalopolis. One friend visiting from America called it "Hell's Kitchen." True perhaps, but one must keep in mind the simple fact that *no* modern Asian town is beautiful, with the exceptions of Singapore and Hong Kong. Fragments of old city centers survive with much charm, as in Hanoi's Old Quarter, or Gion in Kyoto. But the new cities surrounding these are bleak conglomerations of blocky concrete buildings, power lines, and clashing signage. In the old city centers, historical preservation is only managed haphazardly, so even Hanoi and Kyoto, beyond a few lovely central blocks, basically look like *Bladerunner*.

Modern city planning – zoning, signage control, caring for trees, burial of utility wires, road planning and traffic control, creative re-use of historic properties, heritage preservation, design and management of sidewalks and parks – is a "technology" from the West. The British were the supreme practitioners of city planning, bringing with them a tradition of civic administration to Hong Kong and Singapore that Bangkok never experienced. Being colonized did have at least this advantage.

India, of course, also had the British, yet failed to build good-looking modern cities. The reason may be the lack of means. Singapore and Hong Kong had the magic combination: wealth, plus the British. India had only the British; Japan had only wealth. Most of the other modern Asian cities – Tokyo, Seoul, Osaka, Manila, Jakarta – all look unattractive, although each in its

own way. Beijing is the saddest case, as a ruthless administration has flattened the old town and replaced it with grim industrial offices and apartments straddling massive plots fully a city block in size – bounded by avenues of eight or even ten lanes. The effect is of a kind of brutal grandeur – but there is little to please the eye, and you can walk for blocks without seeing so much as a cigarette stand.

Bangkok is thus not unique in being ugly. Tokyo is, however, much cleaner and better organized. The filthiness, the rubble-filled roadways – these are the marks of a third world country. Which is, after all, where we live. Despite its growing wealth, Thailand has only recently risen from being a very poor place. Part of what my American friend is objecting to is simply the fact of living in the "third world." For Americans and Japanese who've rarely stepped off the smooth sidewalks of their wealthy developed societies, the chaotic sights and smells of Thailand come as a shock.

It creates for Bangkok a persistent image problem. Foreign visitors loudly decry the smog in Bangkok, but they seem less troubled by the same thing in Chicago or Los Angeles – even though statistics show that these cities have roughly the same amount of pollutants in the air. Again, they are appalled at, even tormented by, the sex industry of Bangkok, but blissfully unconcerned with larger sex industries in other countries, such as India or Japan. There seems to be something disturbing about Bangkok – maybe it's the vibrant "in your face" energy of the place – that makes people think the city dirtier and more sinful than it really is.

As a supposedly "third world" country, Thailand comes rather high on the scale, far above most of its neighbors (Cambodia, Myanmar, Laos, Vietnam) in wealth, education, and social infrastructure. Friends arriving back in Bangkok after a trip to India, sigh with relief on arrival at clean and efficient Suvarnabhumi Airport. Some aspects of the city are already well-advanced, such as the SkyTrain and Subway, superior to public transport in many American cities. Over the next decades Thailand will at some point cross the line that Korea and Japan long ago crossed, and become a "developed country." *Riaproy* will have its victory. But in the

meantime, rubbley pavement, chopped up trees, snarled wiring, and random building sites define the reality of Bangkok.

I'm often asked, how it is that I, someone who has devoted so much of his life to art, could be happy in such an ugly place. This question points to a big difference between my life in Thailand and in Japan, where I'm directly involved in activities that impact beautification and city planning. I write books and articles on these subjects, go around the country speaking about them, and consult with regional towns. It results from of my decades of living in Japan, and a social system that allows foreigners, at times, to take a visible role. In special circumstances, some of us can get away with declaring in public what Japanese feel but cannot openly say.

In Thailand I don't have this sort of background. So I know that even if I wanted to do something about my surroundings, I couldn't. In a way, that's a liberating thought. In Bangkok I'm free to see, record, experience, and enjoy – without feeling the responsibility to change anything.

Meanwhile, even New York would be challenged to offer the variety provided by my neighborhood: hawkers' stalls, motorcycle boys, Brahma shrines, *tuk-tuks* overloaded with Western tourists, the bars of Soi Cowboy, the posh shops of Emporium, lavish restaurants finer than anything in Tokyo or Shanghai, stylishly dressed girls on the SkyTrain tapping messages into their cell phones, street markets at lunchtime, a traditional Thai house on stilts in the garden of the Siam Society, walled neo-colonial mansions on back streets wherein dwell evil matriarchs, grimy Chinese shophouses, swimming pools and open-air restaurants floating in the sky, Klong Toei slum, chic glass skyscrapers, and soi dogs. Sometimes the neighborhood next door goes up in smoke; sometimes we have fireworks.

It's no paragon of aesthetics. But there's too much going on for anyone to care.

ORIGIN

My friend Ping Amranand attended the Oomoto School of Traditional Japanese Arts with me in Kyoto, back in 1977, and together we had studied Tea Ceremony, Noh drama, calligraphy, and martial arts. Twenty years later I sounded out Ping on the idea of setting up a similar program of Thai arts in Bangkok. "Well, we certainly have traditional arts," commented Ping. "But what are the foreigners going to learn from them?"

Since his youth Ping showed an avid interest in Buddhism and had a love for old ruins and village life. By this time, Ping was a published photographer with coffee table books to his credit. His mother and her sisters were experts on gardening, textiles, and flowers. Coming from someone who had grown up steeped in Thai culture, Ping's words took me aback.

"What about masked classical dance, like Khon?" I asked. "Just a performance," he replied. "And the elaborate *baisri* flower arrangements offered at temples?" "Just a ritual," said Ping. Talking with Ping, it dawned on me that for him these things didn't seem special because they were simply the air he breathed. They were merely "life," not "art."

I realized that for both of us, the shadow of our experience in Kyoto lay heavily over our sense of traditional arts. Dance, flowers, and so forth in Japan are organized into hereditary "Schools," presided over by Grand Masters, with prescribed manuals of procedure, and a complex structure of ranks and levels. Tea Ceremony has its slogan: "Harmony, Respect, Purity, Solitude."

If you don't know what those things mean, the Grand Master, or one of the licensed teachers of his School, can explain it precisely. It's all in the rulebook.

The Thai situation is much more vague. Traditions of flowers, design, dance, music, and martial arts trace down from master to disciple, from Ayutthaya to the early Bangkok court in the 1790s, and then, through two centuries of modernization, to today. However, so drastic was the destruction of Ayutthaya in 1767, that we can only guess what went on before. Nor do we really know how close what we see today is to what was done in Bangkok during the times of King Rama I and King Rama II, because in the ensuing two centuries, the arts evolved considerably under the influence of China, Japan, the West, and modern Thai tastes. Today you can find plenty of manuals that describe the arts, but nobody can guarantee that what we're seeing is the "real thing."

Help came from outside. One of the first friends I made on moving here was Zulkifli Bin Mohamad, a Malaysian dance theater artist. In his early 30s at the time, Zul was part scholar, and part mischief-maker, stirring things up at an arts organization set up by the Southeast Asia member states to which he had been posted by the Malaysian education ministry. Zul made it his business to know everyone in the arts in Bangkok, and it was through him that I made many friends.

Zul approached Thai arts from the perspective of the South, the long peninsula connecting Thailand with Malaysia. He hails from Kelantan, the northernmost and most strictly Islamic state of Malaysia, but also the home of old arts and traditions now lost in the rest of the country. At one point I made a trip with him to Kelantan, and we took a boat to an island in the delta where the last practitioners of Kelantan shadow puppets performed for us.

From Zul I learned of the legendary kingdom of Langkasuka, which had once controlled the peninsula, and which had funneled traditions, such as gamelan, oboe, puppets, and angelic dances, up to the Ayutthaya court. The term "Langkasuka" is much debated among scholars. Some see it originating as early as the 6th century; others define it more narrowly as the high point of the court of

Pattani which thrived in the 17th and 18th centuries. In any case, I saw how Thailand sat in a continuum, a vast melting pot of influences that stretched north-south from China down the Malay Peninsula to Java, and east-west from India, via Burma and Cambodia, to Vietnam. Particularly fascinating to me was the fact that most of this is so little known. Who has ever even heard the word: Langkasuka?

Zul taught me a healthy skepticism about Thai history. Pattani paid tribute to the Ayutthaya and Bangkok courts, and you can still see the small gold and silver trees which were sent in tribute on display at the museum in the Grand Palace. In the 19th century, the colonizing British drew a line across the peninsula. North of that, Pattani and several other old Malay states were absorbed by Siam, while Kelantan and other states went to the British, becoming part of Malaya, and later the nation of Malaysia. That was the end of old Langkasuka.

As to how this happened, the official Thai view of peninsular history differs from other versions. It's an especially sensitive issue now that the insurgency in the Muslim south has flared up in recent years. That's just one grey area. I've never lived in or visited any place where it is so difficult to get hold of the historical truth as it is in Thailand. Earlier rulers rewrote history at will, and the cultural bureaucracy today goes right on creating myths to suit the purposes of Thai nationalism and the tourist trade.

What we see today in the ruins at Sukhothai and Ayutthaya has been so drastically restored and rebuilt that we will never know what the originals looked like. After the fascist period of the 1930s through the 1950s, when the name of the country changed from Siam to Thailand and dictator Field Marshal Phibunsongkhram decided to establish a Thai ethnic identity, the myth-making picked up steam.

What could be more quintessentially Thai than the greeting *Sawasdii*? But actually this expression is something cooked up by Phibunsongkhram and instituted in the late 40s. The problem was that the Thais didn't have at that time an expression equivalent to the Western Hello. Thais said *pai nai maa?* ("where have you been?"),

a relic of Thailand's fluid semi-nomadic history; Chinese-Thai said *gin khao rue yang?*, a literal translation of the Chinese *chi fan le ma?* "have you eaten rice?" Phibunsongkhram took the Sanskrit-based word *savasti* (which means roughly "everything in good order") changed the final *ti* (or *di*) to *dii* (meaning "good") and came up with the greeting that people now think of as hallowed tradition.

Today the Thai state is still engaged in shaping traditional arts. The government stepped into the vacuum created when Phibunsongkhram and his fellow coup plotters abolished absolute monarchy in 1932 and the arts lost the royal family as their primary patron. Since then, the bureaucracy has become a giant Grand Master putting pressure on institutions across the country to standardize in the name of "Thai culture." Numerous offices wield fiat over the arts: the Fine Arts Department, the Tourism Authority of Thailand, the Ministry of Tourism, the Prime Minister's Office, the Ministry of Culture, the National Identity Board, and for a final Orwellian touch, the Cultural Surveillance Committee.

As a sign of how the Ministry of Culture wields control, in 2006 there was a contretemps over the fact that Somtow Sucharitkul, Bangkok's resident opera composer and musical genius, had written an opera *Ayodhya* based on the *Ramayana* epic, in which Ravana, the demon dies on stage. The *Ramayana* sprang from India, but in its millennium-long spread across Southeast Asia, it took on national characteristics in each country. After the fall of Ayutthaya, King Rama I rewrote the Indian *Ramayana* in Thai format, calling it the *Ramakien*. Presumably Rama I used the Ayutthaya tradition for his model, but with the loss of all records in the sack of Ayutthaya, we can never know for sure. In the meantime, certain "extra-textual" traditions have colored the Thai version.

One of these requires that the death of the demon Ravana (called Totsakan in Thai) must never be shown. It's believed that should Totsakan die on stage, evil will befall the Kingdom. Nothing could better illustrate the Thais' love of balance, their instinctive sense that neither the good nor the evil should have the final say. Totsakan never dies, he's just "transferred to an inactive post." Certainly the

history of Thai coups and business scandals has shown that the bad guys never completely disappear. Deposed dictators flee for a while, and then return again to power. This is one reason why the governments after the 2006 coup were so worried that deposed Prime Minister Thaksin would try to stage a comeback. It has happened many times before. In Somtow's case, the government forced him to restage the opera, under threat of closing down the whole production. At the climactic moment, the wounded Ravana dragged himself off to die invisibly (although, this being opera, not inaudibly) in the wings.

Mask of Totsakan
The Demon King of the *Ramakien* epic has bulging eyes, tusks, and ten heads.

It's hard to think of another country where the traditional arts have such a political dimension. In Japan, things like tea ceremony and Kabuki are well and truly irrelevant to the bureaucrats and even to the Imperial Family, whose involvement in culture is minimal. The Grand Master in Kyoto did respond badly when one tea master in the early 1980s staged a "Beyond the Reef Tea," dressed in Hawaiian muumuu and lei, while playing the ukulele. However, this tempest in a teapot took place all in the family of tea specialists; as far as the government was concerned, no one could care less.

In Thailand, on the other hand, the symbolism of the *Ramayana* epic underlies the legitimacy of the realm. It goes back to the 14th century Ayutthaya kingdom, which took its name from the mythical capital of the *Ramayana* in India, Ayodhya. A number of Ayutthaya kings had Rama, the hero, as part of their names. King Rama VI (1910-1925) standardized the usage when he styled himself Rama VI. He appears to have been influenced by the

European tradition of naming monarchs Henry VIII, Louis XIV, and so forth. Since that time it has become the tradition to designate each King of the present Chakri Dynasty as Rama I, Rama II, and so forth, with King Bhumibol Adulyadej being Rama IX. Rama is an avatar of the Hindu god Vishnu (called Narai in Thai), whose mount is the divine bird-man Garuda. The attributes of Narai crown many royal temples and palaces, and the image of Garuda tops government documents and buildings. In Bangkok, we have roads and bridges named for the Kings from Rama I to Rama IX. In short, the *Ramayana* epic is not just a performance, it's an affair of state. This gives bureaucrats an excuse to meddle. And meddle they do, sometimes jumping into surprising arenas. In 2008, there was a perfluffle when the authorities criticized a popular television drama series called *Songkhram Nangfaa* "War of the Angels." The series centered around the love affairs and intrigues of stewardesses and pilots. This was thought to reflect badly on the nation's professional air service staff and so attracted the ire of the officials.

In ways large and small the Thai government ever since Phibunsongkhram has been building up a national identity, leading to an obsession with "Thai culture" that shapes the very look of Bangkok. In China, one hears about the "great Chinese nation," whose glory expresses itself in massive projects that impress by sheer scale such as the Great Wall, the skyscrapers of Shanghai, or the Three Gorges Dam. But as to what Chinese culture really consists of, people are rather vague, aside from maybe the color red, which one sees quite a lot of in environments that are supposed to be "Chinese." The communists spent decades trying to destroy traditional culture, and they largely succeeded. What's left are the great Chinese people who build patriotic skyscrapers.

In Japan, rather than Chinese-style zeal toward the state (discredited because of the disaster of World War II), the focus lies on racial mystique: the "unique Japanese," whose language, ears, and brains, are supposedly different from other human beings. But with Japan having modernized so thoroughly since the War, most people would be hard put to describe an image of something

inherently Japanese that's relevant to them now. Kimono, geishas, and gardens – it's all the past. "All that has nothing to do with Japanese today," people say. "Now it's animated films and quality manufacturing that make us so unique."

In Thailand, the external forms of traditional culture do still matter. Thainess lies in curving filigree and sparkling decoration, heavenly maidens wearing golden crowns, rising temple eaves, the prayer-like *wai* greeting. The new Suvarnabhumi Airport was not deemed complete until it had installed a huge sculpture of Thai gods and goddesses cavorting in a purple, green, blue, and pink panorama of *The Churning of the Sea of Milk*. It's a scene from an ancient Hindu creation myth in which the gods and demons pull on a vast snake entwined around a mountain to churn the nectar of immortality from the Sea of Milk. The most famous image of the story is carved along the gallery of Angkor Wat in Cambodia, not in Thailand, but never mind.

The airport features a Thai version with gods and demons dressed in classical costumes – it's always crowded with people taking their final souvenir photo of Bangkok before they fly out. You will not find such a strong cultural reminder in the airports in Beijing, Tokyo, Hong Kong, Phnom Penh, or Jakarta. It's not just the airport. Similar visions greet you as wall paintings or installations in hotels, restaurants, shopping malls, and banks. The effort to be Thai is accelerating. The earliest bridges in Bangkok looked "Beaux Arts" European; later ones "international industrial." However, the newest bridges over the Chao Phraya River were designed to appear noticeably Thai.

Across Asia, government bureaucracies revel in bridges, as they are a visual symbol of modernism, but typically these structures suffer from an "industrial mentality." No matter how clothed in beacons and spotlights, they still look basically just functional. But in Thailand, the imperative to include "national characteristics" (which often leads simply to kitsch) succeeded with Bangkok's bridges. The Rama VIII Bridge north of Phra Arthit, and the Bhumibol Bridges to the east, with their suspension cables flaring outwards from Thai-style pinnacles– they're part of a new cityscape

that is modern and yet distinctly Thai. Everywhere in Bangkok, decorations and public design announce "Thai Culture."

And yet, despite all this, it's remarkably difficult as a visitor to experience real traditional culture in Bangkok. It's a pan-Asian problem. Many foreigners come to Japan or Thailand and would love to know something about the traditional arts. It's easy to see a demonstration or show – in Bangkok they're everywhere. But it's hard to hear an explanation that makes sense. You ask the Japanese tea master why he turns the bowl first to the right and then to the

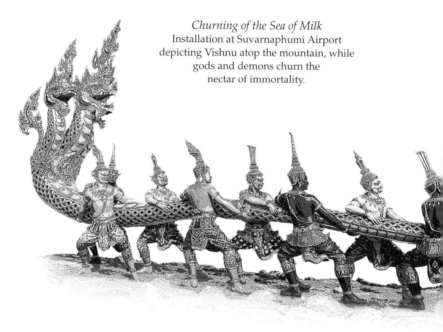

Churning of the Sea of Milk
Installation at Suvarnaphumi Airport
depicting Vishnu atop the mountain, while
gods and demons churn the
nectar of immortality.

left, and he answers, "Because that's the rule of the Urasenke School." Which leaves you back where you were before, namely baffled. There is, of course, a reason, with deep philosophical nuances. But the tea master is not trained to explain it to outsiders.

In Bangkok, the situation is worse because the infrastructure of writing and thinking about the arts is less developed. The arts

express spiritual values, as profound as anything you would find in tea ceremony. But these ideas and feelings lie hidden in the minds and hearts of practitioners, unspoken. What really are we supposed to get out of the excruciatingly slow poses of Khon? If you don't know this, after the initial pleasure in the glittery costumes wears off, it's largely boredom. That's the unspoken truth of most people's introduction to Thai or Japanese traditional arts: lovely, but a bore.

Intellectually curious people would like to "touch" these inner wellsprings. They just aren't given the chance. What's the point of the *wai* greeting? One might say, what's the "Why of the *wai*?" It isn't very useful to hear an academic lecture on

the subject. You've got to take off your shoes, put on a *jongkrabane* (traditional lower garment), get onto a wooden floor, and practice those movements of hands, head, and feet, because these are things that can only be felt and understood through physically doing them.

That's the logic of the traditional arts program that we developed in Kyoto and which I sought to adapt to Thailand. When

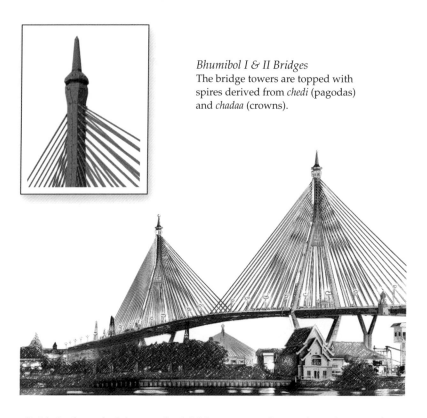

Bhumibol I & II Bridges
The bridge towers are topped with
spires derived from *chedi* (pagodas)
and *chadaa* (crowns).

I think about it, it's a typical 21st century mix: an American, trying
to bring a Japanese approach to the arts, to Thailand.

In late 2004, seven years after my move to Bangkok, the stars
swung into alignment. I started my second company. This time my
assistant Saa took care of the paperwork so we dispensed with
lawyers. When it came time to name the company, I got to thinking
about Oomoto, the Shinto foundation near Kyoto where the arts
program began three decades ago. Oomoto means "The Great
Origin." Back in the 1920s, its philosopher-founder, Onisaburo,
preached the importance of looking beyond the surface to the roots
of things. One day, as I was crossing the busy Asoke intersection,
the name for the Bangkok program came to me: simply, "Origin."

"Origin" teaches technique, but only as a window to something
deeper. David Kidd, who created the Oomoto arts program and

brought me there to run it, once remarked, "Suppose somebody studies Tea Ceremony at Oomoto, and afterwards, inspired by what we've taught them, she goes on to devote her life to tea. She studies for years and learns all the fine points. She knows just how many centimeters inside the tatami mat to place the tea scoop. Finally, decades later, she gains a license as a true tea master. Then we know we've failed!"

What David was getting at is that the purpose of studying traditional arts – for most of us – is not to become a professional. Actually, this is one problem that besets traditional arts everywhere in Asia: it's been taken for granted that the student must give up everything and devote his or her whole life to the art. The masters usually teach on this assumption. So they often cannot explain what they do to outsiders.

However, "outsiders" make up most of humanity. The idea is for people to experience Thai flowers, dance, etiquette and so forth, hopefully touching something deeper in the process, after which they go back to their normal lives working at the bank or in an internet company, or raising kids. They learn the spiritual origins of the arts, not the arts themselves.

With that concept as our basic approach, Origin Asia Co., Ltd opened for business at Khun Santi's Thai house at Ladphrao in early 2005. Meanwhile, up north, Professor Vithi Phanichphant of Chiangmai University had obtained permission for us to use a complex of old houses on the grounds of the University for a Lanna arts program. Back in Japan, I was able to revive the old Oomoto School in a new program based in Kyoto, also called Origin. So it happened that Origin Kyoto, Origin Chiangmai, and Origin Bangkok all got up and going at the same time.

In each location, our program rests on "four pillars," the essential arts of each culture. In Bangkok, these are: *Maarayaat* (etiquette), flowers, *Lai Thai* patterns, and Khon masked drama. These four pillars became the gateway for my appreciation of the city. It's hardly an obvious way to approach a modern metropolis from the point of view of traditional arts, especially in a town like Bangkok, which would seem to revolve more around shopping

malls and skyscrapers than flowers and old masks. But the arts proved to be a useful guide, providing insights in the ways that make this modern city like no other.

Key to Origin is the question of how societies such as Japan, Thailand, China, Indonesia, and others, have adapted ancient ideas about how to live, with modern technology and social freedoms. Of course every country in the world wrestles with these things, but in the West we have it easy because so much of what people take for granted as "modern" came directly out of our own history. Here in Asia it all arrived from somewhere else, and quite suddenly.

The result has been, by and large, cultural collapse. While we hear a lot about "Asian values," this disguises the degree to which, almost universally, Asian cities and countryside were transformed in the 20th century, leaving an industrial wasteland in their midst. Mao and his heirs tore down the great walls of Beijing, and while preserving the Forbidden City and a few blocks of old neighborhoods, they razed most of the rest. The new Beijing, epitomized by the "Birds Nest" and "Watercube" of the Olympics, and the "Crystal Egg" Concert Hall (all designed by foreigners) denies the style of the old city in every possible way. The new buildings and boulevards stand as a paean to the nation's mastery of Western technology.

Bangkok, likewise, bears little resemblance to the water city it once was. Outside of Rattanakosin (the old town with palaces and temples), it mostly consists of rows of concrete shop houses, condominium towers and office buildings, shopping malls, electric wires, and billboards. Even Kyoto, beyond the walls of the temples at the town's edge, looks like any other Japanese city: a conglomeration of gray concrete blocks. Nothing remotely like this happened to Rome, Paris, or Florence.

A few air pockets like Bali and Bhutan miraculously survived. But generally speaking the changes in East Asia were drastic – far beyond anything we can imagine in the pampered West – and Bangkok is no exception. Key to the essence of a city like Bangkok is that it's a phoenix rising from the ashes of an older Asian culture.

In the West, we were pampered because we had hundreds of years of industrial revolution and revolt against the church and feudalism – and in the process traditional culture modernized incrementally. It happened so slowly and so naturally that most of us in the West would hardly think that our modern arts and societies have a traditional base. Jeans and running shoes trace back to trousers and footwear worn by peasants in medieval Europe. The forms of our libraries, universities, parks, and theatres have changed little in five hundred or even two thousand years.

In contrast, there was nothing slow and natural about the process in Asia. There's hardly any aspect of modern life that emerged from within Asian tradition; modernization came too fast, and worse, the thrust of it came from the West. Hence foreign writers in this part of the world tend to dwell on the contrasts between traditional and modern. Photographers love "juxtaposition-of-old-and-new" images: a boy riding a water buffalo while speaking into a cellphone; an orange-robed monk on a motorcycle. If it were Europe, we wouldn't be so fascinated by a farmer on his phone, or a priest on his bike. It's because it's Asia that these things appear to be so incongruous.

Each Asian country then faced the challenge of how to integrate this alien influence with its native culture. China went through a massive paroxysm that lasted over a century, culminating in the trauma of the Cultural Revolution in the 1960s, when Mao simply wiped the old civilization away.

Japan was luckier. Unlike China, Japan kept its Emperor, and early success as an imperialist power made the country proud of itself. Starting in the 1920s and 30s, artists and performers began a process of modernizing the tradition which continues today. Yet Japan suffered a huge setback with the loss of the Pacific War. So drastic was the shock of the War (pre-war ideology rested on the idea that Japan was "divine" and could never lose), that the public responded by rejecting everything old. By the early 2000s, Japan was thoroughly urbanized, the Emperor all but forgotten. The old fabric of life had faded so far away that most people can hardly imagine today what it was all about.

In his book *Peking Story,* written about his life in Beijing around the time of the Communist takeover in 1949, David Kidd described the decline and fall of the family he lived with in an old Ming palace. On the family altar in a secluded inner room, stood fourteen incense burners that had been kept warm with hot coals buried in the ash for hundreds of years. They were made of a rare alloy that glows with a golden sheen so long as it stays warm, but once it cools, the molecules chemically bond and the surface turns gray. One night, inflamed by Communist rhetoric, one of the serving girls stole into the family shrine room and threw water over the fourteen incense burners. The next morning, the family rushed to re-light them, but it was too late. No heating could ever recover the original luster. The moral of the story, according to David, is that artistic and spiritual traditions only survive if they manage to "stay warm", through the masters who practice them and the community of people who love and appreciate them. After they've gone cold they can be revived, but only as lifeless copies of the original thing.

David used to talk about his "Dream" which led to the founding of the Oomoto program in Japan, the precursor of Origin. He first met old Madame Naohi, the Spiritual Leader of Oomoto in 1976. Mme Naohi explained to David that Oomoto had taken a successful art exhibition of tea ceremony, calligraphy, pottery, and so forth, to Europe, but now after three years, the exhibition had returned. What should Oomoto do next to forward her father Onisaburo's idea that "Art is the mother of religion?"

David retired to his bedroom in his palace near Kobe (which was easy to do because he spent most of his daylight hours in bed), and thought about it for a week. Finally a dream came to him. This is how he later spoke about it:

> I am in a burning house. It is the inner mansion of some Chinese palace. It seems to be a library or a study, a repository of some sort. Towering shelves bearing countless ancient scrolls line the walls. The furniture in the room, made from the wood of an extinct kind of tree, is actually

perspiring. The roar of the flames is growing. At the end of
the room are a pair of elaborate decorative shelves. They are
of exquisite lacquer with mother-of-pearl inlay. On each of
the shelves is a carved shape of white jade, unrecognizable
figures of unspeakable refinement.

Then some gusty voice calls out, "Take all you can carry!"
Impossible, I think, to take only what I can carry. Falling
columns shake the floor. I realize these figures, separated,
become meaningless. Bereft of their context, they can only
take on another value.

Faced with the unsolvable problem of two realities, I
realized: all or nothing. Objects can't be saved.

Then I wake up. The unsolvable problem always wakes
me up. It's a nightmare, really. But I'm used to it by now. A
kind of calm terror, you might say.

Living here in the midst of the great East Asian meltdown, you
get used to the "calm terror": you can't save objects, houses,
old towns, or even landscapes. They have already, or will largely
disappear (with some precious exceptions). The answer to the
"unsolvable problem" is to find the spiritual ideas that still remain.
Which means finding the masters in whom these ideas live on.

The Origin program in Bangkok was especially hard to put
together, because the arts of central Thailand are such a hybrid.
Under threat from colonial powers in the 19th century, Thailand's
kings westernized their country as fast as they could, bringing in
French gothic arches and Italian neo-classical domes, along with
British table manners, and German railways. All this got mixed up
with Thai tradition, and the mixing just continues.

Meanwhile, ancient kingship went on, not much changed
from Ayutthaya times. Thais are proud to say that their country,
unique in Asia, was never colonized, and this is largely true
(excepting the brief wartime Japanese occupation). It makes an
important difference, because unlike Myanmar, Thailand kept its
monarchy, and unlike China and Korea, Thailand kept a solid
faith in its traditional Buddhist religion. Those things it has in

common with Japan. But unlike Japan, Thailand also kept (until today) its village life, which is still not far out of people's memories. A high percentage of Bangkokians – it's likely the majority – hail from the countryside. Many an immaculately dressed young lady or stylish young man on the SkyTrain came to the city from somewhere "up-country" and until only recently played in the rice paddies with water buffaloes. They still might play in the rice paddies on weekends or on holidays, when they go home to visit their parents, uncles, and cousins. Not a single one of my staff at Origin is Bangkok born. They return to the village regularly, and come back to the city laden with mushrooms, mangoes, and fermented fish. Traditional life lies close to the surface, even here in Bangkok.

Reveling as they do in the latest fashions at the latest malls, nevertheless nostalgia still rules – for a simpler sweeter life back home. The largest contingent of immigrants to Bangkok is from Isarn, Thailand's northeast hinterland. Daniel Ziv, in *Bangkok Inside Out* writes, "a favorite phrase in Isaan folk songs is *kit teung baan* ('to miss home') – like a giant pall of yearning rising out from taxis, food stalls, hotels and brothels, looming above this alien city before drifting slowly towards the Northeast."[4]

Thailand, so welcoming to foreigners, is in many ways the most international country in all of Asia. But the trains, nightlife, and markets don't look or function as they would elsewhere, and it's because of old values that still survive in people's minds and hearts.

In seeking to understand what these old values really are, you've got to go beyond Bangkok and its culture centered on the royal court. Bangkok culture has taken court elegance as its standard, and so sometimes overlooks the human qualities of art from other regions. There's a tendency, as there is in all great capital cities, to look down on country yokels from the provinces. Professor Vithi comments, "Bangkok people basically see all the others as hill tribes. Above Nakhon Sawan is Lao. Below Nakhon Sri Thammarat is *Khaek* (Muslim). Beyond Prachinburi is Khmer."

Looking on a map for the three cities mentioned by Vithi, you find that the town of Nakhon Sawan sits right in the center of

Thailand, not far north of Bangkok; Nakhon Sri Thammarat is situated just halfway down the Malay Peninsula; and Prachinburi is located not far to the east of Bangkok. Most of the hinterland stands well beyond these three provinces. What Vithi is pointing out is that just a few miles outside the capital, the culture of the locals is no longer seen by Bangkokians as truly Thai. This dismissive attitude underlies the discontent that erupted in the feud consuming much of the decade of the 2000s between the supporters and enemies of Prime Minister Thaksin.

In fact, of course, it's the influences from these various peoples within Thailand – as well as neighboring countries – that make Bangkok what it is. When I think back to the "origin" of my experience here, it began with those trips I took as a backpacker in the 1970s. In those days Bangkok was a place I passed through on the way to Rangoon or Katmandu. In a sense it still is.

When the Japanese philosopher Okakura Tenshin penned his influential 1904 book *The Ideals of the East*, he opened with the phrase: "Asia is One." There was a time in the 8th century when the same form of esoteric Buddhism held sway from Borobodur in Java, to Angkor, across China and Korea, all the way up to Nara in Japan. In ancient times, the world was in some ways more international than today. Borders were more fluid, races mixed freely, and religions had not settled into the strict catechisms that define them now. Yet despite all the fragmentation and divisions, traces of that old unity still exist. Attitudes survive across East Asia that are as linked as they were in the 8th century.

One of the great fascinations of Thai arts is to try to pull out the strands of what is Lao, Cambodian, Javanese, Chinese, Indian, or Burmese within them. Living in Bangkok has led me to a fascination in Southeast Asia in general. So starting in the early 90s, I picked up where my backpacker travels of the 1970s had laid off. I began journeying again to Laos, Burma, Cambodia, Indonesia, and Vietnam, this time looking more closely to see where they were the same and where they differed.

Bangkok is the natural jump-off point for those destinations. My friends in Bangkok are constantly coming and going from

nearby countries. From this point of view, Bangkok is like a typical European capital, just a short hop across boundaries to other small-to-medium sized countries that share similar backgrounds, but differ dramatically in ethnic makeup and language. This contrasts with America and China, continental empires happily content within their vast hinterlands, or Japan, a group of islands still largely cut off from the world.

It's not just a matter of being a convenient airport hub. Bangkok is the nexus where all the cultural threads tie up together. This is where you meet people like the Malaysian dancer Zul who opened my eyes to the larger sphere of Southeast Asian culture. Zul talked about "Solo" (Surakarta) and "Yogya," (Yogyakarta), cities in Java with ancient royal courts that in my years of Asian Studies I'd never even heard of. Much later, after I'd started visiting Indonesia and discovered the wonders of Javanese music and dance, I ended up holding a birthday party in Solo, centered around gamelan and Solonese dance. Without the initial interest in Bangkok, I doubt that I ever would have done any of this.

All across Southeast Asia, they dance the *Ramayana* epic. The sultans of Yogya and Solo prefer a softer, flowing mood, the dancers swaying as though floating on waves of the south seas. The dance in those courts feels almost Polynesian. In contrast, Khon in royal Bangkok has a static quality. Actors move in jerks and sudden halts; often all action comes to a complete stop as the actors pose in a tableau, still as a temple wall painting. In Bali, dance is frenetic: legs splayed, hands trembling and twitching, eyes rolling. An electric thrill runs through Balinese dancers from start to finish.

The differences are obvious enough. More interesting, really, are the similarities: curved-back fingers, a love of headdresses and elaborate robes, painted faces, the mingling of male and female, love of the abstract over realism, the idea that these are not humans but gods and goddesses dancing – this goes all the way up from Bali to Thailand, and then through China to Japan.

Okakura wrote, "Asia is One" in 1904 as the tide of Japanese nationalism was sweeping in, and others later used his words to justify Japan's colonial ambitions in World War II. "Asia is One"

can be a misleading, even dangerous concept. Nevertheless, Okakura was basically right.

In ancient Europe it was said, "All roads lead to Rome," and the equivalent in classical China was "The Great Way leads to Chang'An" (the Tang dynasty capital). These were grand imperial centers whose influence spread far and wide. All roads led to Rome and Chang'An because you had to go there to find the highest and best of everything. In contrast, Bangkok, and Ayutthaya before it, have been mercantile ports, absorbing much from other places, but exerting only a limited influence outwards. In Bangkok you can enjoy the mad fusion of far-flung cultures. But to find the highest and the best of what went into the mix, you've got to leave Bangkok and seek these treasures out in their remote places of origin. Bangkok is a starting point, not an ending point for a journey. One might say, "All roads lead out of Bangkok."

WALKING SOFTLY

In the West, "etiquette" sounds silly and old fashioned. It's about crooking your little finger when drinking tea, or knowing how to emboss a wedding invitation, the sort of thing that ignited passion in your great aunt, but that was trivial even then, and largely useless today. However, it's crucial in Thailand, to the extent that when I did set up a program of traditional arts in Bangkok, etiquette (called *Maarayaat*) took first place. It's the equivalent of Tea Ceremony in Japan, queen of all other arts.

The importance of rituals of respect goes back thousands of years in East Asia. Hierarchy: relations between senior and junior, commoner, monk and king – getting these right is what Confucius called "The Rites," and he saw these as basic to being civilized. Confucius' *Analects* says of him, "If his mat were not straight, the Master would not sit down." Everything should be in its proper place. That's the idea behind the Thai greeting *Sawasdii*, since its root word *savasti* derives from the swastika. The perfectly balanced arms of this ancient Hindu symbol imply that "everything is in order."

Japan elaborated the old Confucian idea of the Rites into *reigi saho* ("rituals and ways of doing things"), which reaches its apotheosis in the complex rules of the Tea Ceremony. In modern life, you find *reigi saho* everywhere: how high or low to bow to someone, what seasonal greeting to use at the opening of a letter, or which seat the visitor should take on entering a corporate reception room.

In Thailand, likewise, *Maarayaat* spreads its tentacles deep into the society. Schools teach *Maarayaat* to grade school students; you can buy manuals and posters showing how to sit, stand, or make the prayer-like *wai* greeting.

The *wai* is core to the whole system. A gesture of respect that came from India, it symbolizes (depending on which interpretation you follow) either a lotus bud or the peak of Mount Meru. The Thais took this simple gesture of two hands clasped together and then embellished it, creating four basic *wais*, depending on the

Four kinds of wai
left to right: Receiving a *wai*; *wai* to an equal;
wai to a superior; *wai* to a monk or respected elder.

relative social positions of those offering them, to be offered in order of precedence: the junior person *wais* first as a sign of respect, and the senior *wais* later as a sign of acceptance. However, monks *wai* nobody, not even the King, because, as members of the Buddhist *Sangha* (community of monks), they stand highest on the scale of respect.

Pimsai Amranand, writing about her dreaded return to Bangkok in 1951, after having grown up in Britain, recalls, "My parents and sisters were full of advice. 'You mustn't talk too much; they'll put you in prison.' ... I practiced hard the various ways I should greet someone. When we greet people in Siam we do not say anything but we put our hands together in front of our faces and bend our heads,

not very low if it is someone of the same age, lower for someone in a superior position either of authority or age or in the social scale. This is called a 'wai.' It gets lower and lower until you are prostrate on the floor before very senior members of the family or kings and queens, and for the uninitiated, it is full of potential social pitfalls."[5]

The *wai* is just the beginning. There are ways to receive and give things, a way to walk in front of a senior person, and so forth. In very formal situations, the *wai* is subsumed into the *kraab*, or prostration mentioned by Pimsai, in which the offerer lies outstretched on the floor with hands reaching in front of him.

When Japanese come to Bangkok and study *Maarayaat*, they find Thai rituals familiar as just another form of *reigi saho*. For Westerners, however, they can come as a revelation, because the easy Thai smile fools people into thinking that there are no rules. In fact, complex rules and severe consequences for ignoring them make Bangkok a serious place. For all its ethos of *sanuk*, people spend a lot of energy figuring out how best to act according to their position in the social hierarchy. Even the young staff members in my company scrupulously address each other as "younger," "older," and so forth, though their age differences may be only a year or two.

Kraab
Prostration with one leg folded under the other, head to the floor, and hands in a *wai*.

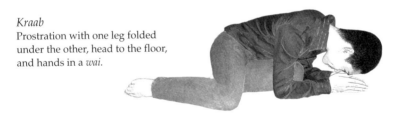

This, of course, is not unique to Thailand, since paying close attention to age differences, and using words like "aunty," "uncle," "grandpa," "older brother," can be found across Asia. In Thailand, you can establish who is younger or older in various ways, such as asking someone their Chinese zodiac sign. From the answer – Dragon, Horse, Cow, and so forth – you can figure out who is senior. In any case, in *Maarayaat* there can be no such thing as

"equal." One must be higher and the other lower. Japanese go through a similar process when they meet and must make decisions about how deep to bow and what kind of honorifics to use. So do Javanese, whose language contains up to seven levels of social distinction.

For Thailand, one can extrapolate from this classic behavioral patterns, such as the "patron-client relationship" much commented upon by sociologists. The higher, more powerful figure (the "patron") bestows favor on a lower and dependent person (the "client"). Such patterns exist in any society, but seem especially common in places with highly developed rules of etiquette. As foreigners living here we would often wish for a more equal relationship with the Thais around us. But the very grammar of the language works against that.

The Siamese kingdoms of central Thailand, culminating in Bangkok, inherited all the ritual of the Angkorian court. Plus, they devised a far-reaching system of ranking the citizenry, called *sakdina*. *Sakdina* was a measure of rank, denominated in terms of *rai* (an acreage of rice fields). Japan had almost exactly the same system during the Edo period, which graded samurai according to their rice entitlement in bushels. A low-end samurai might merit only twenty, while the mighty Lord of Kaga styled himself the Lord of a Million Bushels.

Siam carried *sakdina* much farther than Japan did. In Japan, the system only applied to samurai, who amounted for 5% of the population or less. In Siam, *sakdina* covered almost everybody, including Buddhist monks, housewives, and Chinese merchants. Rankings were: a slave, 5; a peasant, 25; a craftsman, 50; and lower officials, 50-400. Above 400 were the ruling officials and nobility, the *khunnang*, rising up to ministers of state at 10,000.[6] As the nation modernized in the 19th century, *sakdina* declined and became increasingly irrelevant to society. But it was only officially abolished in the coup of 1932. With the memory of *sakdina* so recent, the effects on people's psychology still show today. People are acutely aware of fine, even razor-sharp differences in their relative social status.

In the new society of the early 20th century, the concept of *phudii* (meaning literally "good people") took root in the cities, especially Bangkok with its growing middle class. *Phudii* means "decent people", "ladies and gentlemen", with an implication of "high class" versus "low class." In 1903, Chao Phraya Phrasadet Surentrarthipbodi (MR Pia Malakul) compiled a book of proper manners called *Sombat Khong Phudii* "The Qualities of Decent People," which came to have immense influence. It's the first manual of *Maarayaat* as we know it today, and over a century later, still in print.

Sombat Khong Phudii consists of ten chapters: being orderly, refraining from obscene acts, being respectful, maintaining loveable manners, possessing grace, performing one's duties well, being kind, avoiding selfishness, maintaining honesty and refraining from evil acts. It was quite an elaborate system, verging on a philosophy. Writer Supawadee Inthawong comments, "Each chapter describes what a person must perform 'physically, verbally and mentally' in order to acquire that particular *phudii* quality. For example, the chapter on being respectful suggests a proper way to sit and walk when the person is near someone who is more senior (which is action), and how the person should talk to the senior (which are words), as well as the thoughts the person should have regarding the senior (which is mind)."[7]

To this day, even for people who haven't read it, *Sombat Khong Phudii* stands as a symbol of proper behavior. Supawadee notes, "We often hear the elderly scold youngsters with something like 'Why don't you have some *sombat khong phudii*!' or something like 'I will cook some *sombat khong phudii* books for you to eat so that you will behave more like a *phudii*.' Or even something like 'You need to sleep with your head on a *sombat khong phudii* book so that your brain will absorb some of it.'[8]

Phibunsongkhram, military dictator during the 1930s through the 1950s, launched the second wave of "manner control." Phibun-songkhram tried to modernize Thailand's customs, dictating that ladies had to wear hats, and husbands and wives were supposed to kiss each other when leaving for work in the morning. While the

hats and the kissing (or at least the hats) disappeared, Phibun-songkhram set the pattern for the government telling people how to behave, which endures today.

This brings us to an aspect of Bangkok sometimes overlooked by foreign commentators, namely that far from being from a happy-go-lucky carnival of freedom and fun, it's a city ruled by duty and propriety. Your great aunt would be happy here. People who write about Bangkok love to talk about how zany and chaotic it all is. However, the emphasis on *riaproy* (propriety), *Maarayaat*, and being a good *phudii*, is in fact a defining feature of Bangkok culture. The gentleness that makes Thai life seem so attractive arises from the fact that people are taught from childhood to walk and speak softly, and above all, never to forget *krengjai* "reserve," or "consideration." Reserve hardly covers the complexity of *krengjai*, which requires that one speak indirectly so as never to offend, take precautions so that others don't lose face, show deference to superiors, avoid becoming obligated, and never impose yourself. Thais walk and think with care.

Some civilizations have one iconic text that goes straight to the core of the culture. For China, it's the *Analects* of Confucius; for America, it would be the Declaration of Independence. For Thailand, it's the *Traiphum Phra Ruang* ("Three Worlds According to Phra Ruang"), one of the country's oldest surviving texts, written according to tradition by King Lithai of Sukhothai (reigned 1347). The *Traiphum* cosmology describes in painstaking detail a hierarchy of worlds, expanding outwards geographically, and upwards and downwards in the spiritual realms. MR Chakrarot Chitrabongs, grandson of artist-prince Naris and doyen of Thai culture experts, declares: "The *Traiphum* is the supreme conceptualization of the Thai people."[9]

Thirty-one levels in three worlds revolve around the central axis of Mt Sumeru (another name for Mt Meru). In our world, there are four continents, thirty-six cities, twenty-one country areas, and seven rings of oceans and mountains between the four continents and Mount Sumeru. Each being finds his place in one of the many levels according to the merit he has achieved in the cycle of rebirth.

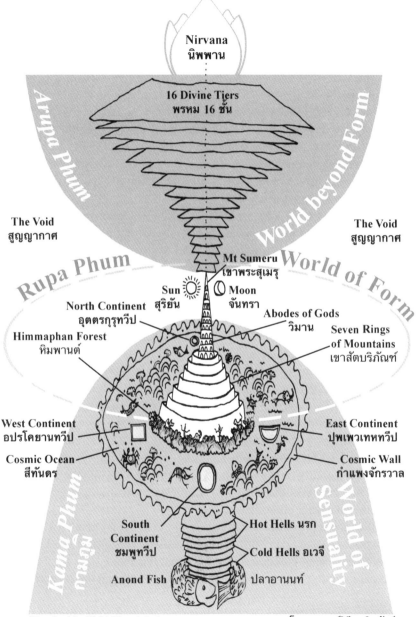

ไตรภูมิ
Traiphum
Three Worlds Cosmology

Nirvana
นิพพาน

16 Divine Tiers
พรหม 16 ชั้น

Arupa Phum

World beyond Form

The Void
สูญญากาศ

The Void
สูญญากาศ

Rupa Phum

World of Form

Mt Sumeru
เขาพระสุเมรุ

Sun
สุริยัน

Moon
จันทรา

North Continent
อุตตรกุรุทวีป

Abodes of Gods
วิมาน

Himmaphan Forest
หิมพานต์

Seven Rings
of Mountains
เขาสัตบริภัณฑ์

West Continent
อปรโคยานทวีป

East Continent
ปุพเพวเทหทวีป

Cosmic Ocean
สีทันดร

Cosmic Wall
กำแพงจักรวาล

Kama Phum

World of Sensuality

South
Continent
ชมพูทวีป

Hot Hells นรก

Cold Hells อเวจี

Anond Fish

ปลาอานนท์

Sketched by Vithi Phanichphant

วาดโดย อาจารย์วิถี พานิชพันธ์

It's an extremely well-ordered system, and the fact that the *Traiphum* survived so long during the rise and fall of many dynasties, shows that it appealed strongly to something deep in the Thai psyche – or at least, the Thai rulers' psyche.

Professor Vithi says, "The *Traiphum* explains your position in the universe. If you're a good person you move step by step upwards in reincarnation. Instead of being born as a stupid dog, you move on to being a clever dog, and then super-dog. It tells people to be satisfied with their karmic position. If you behave well in your position, everything is *Sawasdii*. But if you start to rock the cosmic mountain by trying to be what you're not supposed to be, it creates commotion and you will surely be punished by falling back down to an even lower level than where you started. It's a very old concept of keeping everything in order."[10]

You can see the way even small things are organized in a detail such as the numbered jackets of motorcycle-taxi drivers. At social functions, you feel the deference paid to the rich and titled in the awe-inspiring clout wielded by diamond-clad matrons with big hair. You can sense the appeal to authority in photos of politicians arrayed in pure white uniforms overlaid with sashes and decorations. If involved in academia and the arts, you'll learn how heavy the hand of orthodoxy lies upon them. Hard times befall anyone who dares question the system.

In short, Bangkok is a well-behaved city. At the SkyTrain ticket window, people queue. Compared to Jakarta, Manila, or even Shanghai, Bangkok has a low level of street crime. This means that, as in Tokyo, one can walk around most parts of the city at any hour of the day or night and feel reasonably safe. It's not accidental, perhaps, that both Japan and Thailand fell into military rule in the early 20th century (and in Thailand it continued right into the 2000s). Both had a history that disposed people to know their place and to follow the rules.

If one were to draw a difference between Japan and Thailand, it would be the grace and effortless ease with which the Thais practice their etiquette. It all looks so natural that unless someone points it out to you, one could easily fail to notice that there are four

types of *wais*, for example. To me, the paradigm is the formal Thai way of sitting, with legs folded under the body, but slightly sideways, called *nang phap-phiap*. Elegantly off-balance, *nang phap-phiap* looks so much more informal than *seiza*, the Japanese sitting posture, which is firmly vertical, with legs folded directly back under the body. Just looking at someone sitting *seiza* can make you feel uncomfortable. But try sitting the classical Thai way for any length of time. It's much harder on the back, even excruciating. You never would have guessed it from the external look of relaxed poise. Children are told that it's a way to keep them from falling asleep.

Thai and Japanese formal sitting posture
left: Thai *nang phap-phiap; right:* Japanese *seiza.*

Nobody really knows who the original "Thais" are, as they trickled down over millennia from the highlands of Vietnam and the mountains of Southern China, and then merged with the Mon, Khmer, Malay and other indigenous peoples of the lowlands. This mix of races that became the people now called "Thai" combined ancient tribal taboos with the culture of India and China, forged that in the crucible of the Angkorian Empire, and came up in the process with a quality that nobody else has.

For lack of a better word, I call this "Thai grace." Some unknown ingredient went into the racial and cultural melting pot in

which Thai culture formed, and from this was distilled a softness, a tendency to swerve and elongate, prizing the feminine over the masculine, gentleness, smoothness, polish. In social interactions you see it in the seamless grace of the way people greet each other, sliding in and out of a *wai* almost imperceptibly. Even a virile sport like Thai kickboxing begins with a swaying and elegant dance, the *wai khru* "paying homage to the masters", which is a world away from the acrobatics of Chinese martial arts or the stomping of *sumo*.

The movements of *Maarayaat* all partake of this sway. I once saw a ritual performed at Ise Shrine (dedicated to the Sun Goddess, ancestress of the Japanese Imperial family), where the Grand Priest, descended from an old royal line, bowed so that his ramrod straight back was held at a perfect parallel to the ground – and he held this posture for thirty minutes. My Japanese friends were much impressed, as this rigid straightness of form is now hard to find, an aristocratic relic. In Thailand, by contrast, there are no straight lines. Unlike the Japanese bow – up-and-down in a simple vertical motion – a *wai*, properly done, is a subtle swirl of interlinked curves. The elbows bend and fingers turn in alignment with a slight curve of the neck.

The exquisite curves of *Maarayaat* arose from the royal court. Somehow – perhaps it trickled down through the *sakdina* system – courtly refinement made its mark across society, right down to the village level. Even in peasants who've hardly been out of their hamlets in Isarn or the North, you can see a natural grace of movement that parents have inculcated into their children.

Thai schools even sponsor *Marayaat* contests in which children compete just as Americans do in spelling bees. One friend tells me that she once appeared in a *Marayaat* contest back in her school days. "I only came in second," she recounts with regret, "I guess because I didn't sit *nang phap-phiap* gracefully enough."

Maarayaat gives the Thais a "vocabulary of elegance," which is denied to their brothers and sisters from other Asian nations who lost their royal courts. Some years ago, I went to Helsinki to attend an Asian Theatre Festival. There were a troupe of Myanmar dancers

and Bangkok puppeteers. We went to visit the historical mansion of a local Finnish notable, and when we entered the reception room to take a commemorative photo, the Bangkok group instinctively formed themselves into a charming tableau, some reclining in attitudes of princely repose on chairs, others with their legs crossed sideways on the floor in the style of *nang phap-phiap*. It had beauty, a sense of period, and wit. Sadly, the Myanmar contingent, accomplished as they are at their traditional dance, simply didn't know what to do with a room like this. The British deposed Burma's King over a century ago, and a ruthless military dictatorship has thoroughly repressed arts and culture since the 1960s.

The Thai smile has become such a tourist cliché that one tends to forget that it's a reality. In my travels I've never come across a society as gentle as this one – on the surface. Thailand has its terrible injustices and shocking upheavals, such as the massacres of protestors in the 1970s and early 90s. On New Year's Eve 2006 Bangkok experienced its first wave of terrorist bombings, and there will surely be more. Thousands of people have died since 2000 in the troubles of the far south. Everyone knows about Thailand's poverty and prostitution, to the extent that foreign journalists focus heavily on these issues. Desperate slums, gangsters, viciously brutal prisons – all these things exist in Bangkok. This place is surely no paradise.

That was underscored in 2007-2009 when the battle between the Yellow Shirts and Red Shirts convulsed Bangkok. First, the Yellow Shirts, opponents of exiled Prime Minister Thaksin, rallied in the streets to oppose Thaksin's proxy cabinet. After the Yellow Shirts brought the government down in the fall of 2008, the Red Shirts (Thaksin's supporters) then massed in the streets to attack the successor Abhisit government. In general, one could say that the Yellow Shirts represented the urban middle and upper classes, fighting what they saw as the endemic corruption of Thai politicians. The Red Shirts drew strength from the poor, who have seen the dictatorial but populist Thaksin as a savior.

A turning point occurred in the summer of 2008, when the PAD (People's Alliance for Democracy), wearers of the yellow shirts,

147

captured and occupied the grounds of Government House for 193 days. I went to Government House one day in summer of 2008 to see what was going on. Far from explosive political mayhem, the PAD rally struck me as closer to a *ngan wat*, a temple fair. People strolled down lanes lined with food stands and stalls selling anti-Thaksin hats and bags, the ubiquitous yellow shirts, and PAD'S signature "hand-clappers" in bright colors. During the day, PAD's leaders stood on the stage they had erected in the gardens and gave political speeches; late at night bands would play, and people got up to dance.

Half a year later, the Red Shirts adopted similar tactics, organizing huge marches that called for the dismissal of Prime Minister Abhisit and the holding of new elections. Although the Red Shirt gatherings had an angrier tone to them, the mood was still basically festive, and given the turmoil of the times, remarkably peaceful. The Red Shirts even mirrored the Yellows in their political props: red shirts instead of yellow, foot-shaped clappers instead of hand-shaped clappers, satirical T-shirts of Abhisit and PAD leaders, rather than of Thaksin and his wife.

During this period of unrest, the striking thing about the rallies of both sides was the feeling of *sanuk*. There was lots of humor and dancing. Nevertheless, in both cases there was also an undercurrent of menace, and at times it broke through to violence. A number of people died during PAD clashes with the police. As the grand finale of the PAD campaign, thousands of Yellow Shirts took over Bangkok International Airport, shutting down the country for over a week. The Red Shirt protests, likewise, involved fights with residents in the neighborhoods where they marched, leading to several fatalities, and culminated in the storming of the conference hall in Pattaya where Thailand was hosting the East Asian Summit gathering of regional leaders.

It's true to say that political demonstrations in Thailand are much more *sanuk* than elsewhere. But it would be a big mistake to just focus on the *sanuk*. Beneath the colored shirts run deep wellsprings of anger and bitterness. Thailand's violent struggles will continue.

Art critic Apinan Poshyananda warns, "Behind the façade of the Thai smile, trauma and turmoil are part of the Thai psyche."[11] It's the dark side of the Thai moon. It underlies much of contemporary art, which focuses on social injustice, greed, grief, loneliness, anger. Nevertheless, the day-to-day style of ordinary human contact is uniquely soft. After living for a while in Bangkok, a visit to Shanghai or Beijing jars the senses. Businessmen shouting on their cellphones, old ladies shrieking across the street – everywhere strident voices assault the ear. I have some Bangkok friends who say that they just won't fly to Hong Kong because the harsh language grates on their tender Thai nerves.

In its love of the placid surface, Thailand stands much closer to Japan than to China. Both languages contain a range of polite expressions to indicate who is higher and lower, more intimate or more distant, and so on. These are so ingrained that to speak without them is to be not only rude, but ungrammatical, even unintelligible. The bowing and politeness is one of the things that wins people's hearts when they visit Japan – that is, until they discover the inflexibility that often lies behind the bow.

Move on to India or the Middle East, and the level of pressure, if not aggression, in human encounters ratchets up another notch. You don't easily get through the day in these countries with just a *wai,* a bow, or a smile. As for us Americans and Europeans, we insist on our individuality, and we often go too far. Conversation can be bruising, casual interactions brusque. Plus, we eat too quickly, walk too loudly. We're bulls in a china shop. My Thai staff constantly chides me about how quickly I eat, or how loudly I walk, even in my own home. *Bao-bao*, they say, meaning "softly!" I think it must be one of the first lessons that Thais learn as children: *Bao-bao*. Gentleness is the first of all the virtues here. I've been told that it arose from living in old Thai wooden houses, where the creaking floors registered every slight footfall. From this grows the idea that humans walk lightly; *yak* (demons) and *phii* (ghosts) are noisy things that go bump in the night.

Busy and chaotic as Bangkok streets seem, there's an undercurrent of gentleness, something that each Thai carries with

him or her as they commute to the office or even dance in a late-night club. The Thais bring grace to the surface of daily life, in a way that few other peoples could match, and this goes far to explain the mysterious appeal of Bangkok, an otherwise far from attractive city.

There are, of course, big exceptions to the rule of gentleness. One would be pushy taxi drivers who prey on innocent tourists. New visitors complain that taxi drivers can be quite aggressive in steering the hapless rider to a tailor shop or jewelry store. In fact, Bangkok does seem to be the home of many bold and ingenious scams aimed at foreign travelers.

Wondering how this happens endemically in a country devoted to politeness, I can only think of anthropologist Ruth Benedict's explanation for how the punctiliously civil Japanese could carry out the Nanking Massacre. Writing in 1946, Benedict argued that the rules of Japanese decorum only applied to society in Japan; other people were aliens, and thus soldiers in China found themselves with no rules at all to guide them, and they went crazy. Where this might be relevant to Thailand is that so much of the rudeness and scamming seems aimed at freshly-arrived foreigners. That is, at people who stand outside all the Thai hierarchies and rules.

However badly they may be fleeced in diamond shops, Westerners and Asian visitors from Japan or other wealthy nations get wonderful treatment in contrast to poor immigrants from Burma, Laos, and Cambodia. Periodically the newspapers reveal horror stories, such as the reports in 2009 that Burmese migrants were reputedly put on boats without food or water and floated out to sea. So much for the Land of Smiles.

A more playful exception to Bangkok's peaceful veneer would be the water-throwing frenzy of Songkran, the Thai New Year, which takes place in early April. For two or three days the city goes wild, with boys and girls throwing buckets of water and smearing oodles of talcum powder over anyone who dares go out in the street. For people who ordinarily have to repress any urge to act spontaneously, Songkran has become an outlet for frustrated emotions. Even so, most of the madness is concentrated into a few

popular hotel and entertainment districts, notably Khaosan Road, with its large contingent of young foreign backpackers eager to join in the fun, and Silom Road, another mecca for foreign tourists. Stay away from these places, and while you may not escape entirely undrenched or unsmeared, the streets are relatively quiet.

Some years ago, one Thai academic came up with the idea of "cultural capital," meaning the ability to make money from selling culture. He had in mind the export of crafts and the creation of money-making tourist spectacles. But the biggest cultural capital Thailand has is the cult of gentleness. Each time a doorman or restaurant hostess charms a visitor with an unaffected, even heart-melting *wai*, Thai grace is making itself felt. Commentators in Bangkok newspapers wring their hands that Bangkok will lose out to Singapore or Shanghai as an international hub because of poor infrastructure, or the lack of good managers due to Thailand's backward educational system. While these things are obviously important, Bangkok will always have something that neither Singapore or Shanghai could ever provide, and it's the sheer niceness of daily life. That will continue to make this city a place where foreigners will want to visit, to live, and to set up businesses.

Of course, it's all about the surface. I once asked the president of a leading PR firm, who oversees branches of his company in all the capital cities of Asia, which place was the most difficult to deal with. I thought he would say Tokyo (caught in the grip of local monopolies) or Shanghai (notorious for broken contracts, and lacking a proper legal system). Instead, to my surprise, he instantly replied "Bangkok!" He launched into a diatribe: "People in Bangkok are treacherous, two-faced, you can't turn your back on them, they'll steal your know-how and your clients, and you'll never realize what's going on until it's too late. I really hate trying to do business in Bangkok!"

Anna Leonowens (of Anna and the King of Siam) summed up the paradox of the Thais with the sweeping gusto of 19th century Europeans: "In common with most of the Asiatic races, they are apt to be indolent, improvident, greedy, intemperate, servile, cruel, vain,

inquisitive, superstitious, and cowardly; but individual variations from the more repulsive types are happily not rare. In public they are scrupulously polite and decorous according to their own notions of good manners, respectful to the aged, affectionate to their kindred, and bountiful to their priests..."[12]

In short, the grace is a reflective sheet of ice covering a deep black water. Underneath lies cunning and lots of unhappiness. If "courtier" is the default mode of Thailand, then byzantine stratagems are also part of the paradigm. Pimsai Amranand, describing her blue-blooded cousins when she returned to Bangkok after growing up in England, writes: "There were so many cliques, so many intrigues in those sprawling families we went to call on. Outwardly everyone seemed to love everyone else. It was only gradually that I noticed that some aunts were not on speaking terms. No one ever acted impulsively. Every move was thought out."[13]

Office politics can be devious anywhere, but I've been struck by the amount of backbiting that goes on in offices in Bangkok. Work may appear a charming harmonious Thai environment, full of giggles and endearing nicknames. Later gossip rages about how A raids the refrigerator, how B is always late, and how long C spends in the bathroom. Everyone is busily undermining the others. As Pimsai pointed out, no one acts impulsively, every move is thought out. The undermining is done with real finesse. It's useful because you learn quite a lot about people. On the other hand, you wonder what is being said about you.

Mont Redmond writes, "If *you* are the problem, their approach will be as polite, tentative, and indirect as the human attention span can tolerate. You may not know that all their conversation with you constituted a complaint about you until an hour afterwards. Or you may never know, period. You could have been so artfully lathered up with the sweet soap of small talk as to have never felt their razor."[14]

As *farang* (Westerners), we tend to miss the point because we get the benefit of the hierarchy, which is what *Maarayaat* is all about. Out of politeness Thais generally place *farang* in a "higher" role, and the *wais* get even nicer if you are also well off financially.

152

Life may not seem so rosy to those lower on the scale, such as the poor, who suffer harsh scoldings from their bosses, or are preyed upon by low life in the slums. *Maarayaat* is thus the producer of a Great Illusion, and the more privileged your position in society, the more you can get lost in it.

The expression one hears so often in Thailand *jai yenyen* ("keep a cool heart") exists for the very reason that Thais can be so hot-blooded. The subtle calculus of rank and hierarchy means that human relations are rarely what they seem to be. Friendships don't stand on a clear or permanent footing. You never can tell how much a gracious smile is due to one's simply being a generic *farang*, or perhaps due to one's money. As a businessman in Bangkok, you had better watch your back. In love, well, all sorts of things go on! Especially true, as poor Bob van Grevenbroek found out, after you've bought the apartment or built the dream house for your lover.

People pay a heavy price for having to constantly guard their feelings. Pimsai Amranand describes how hard she struggled to make her return to Siam a success. But whatever she did, it was never enough. Her grandmother scolded her: "And while we're on the subject of your behaviour I might as well tell you everything. You talk too loudly, and you must not sit up so straight and stick out your bosom like that. It's disrespectful to older people to sit with your head higher than theirs. And when they say something to you and you don't agree with it, please don't argue. I wish you wouldn't look them straight in the eye. Especially men. They'll think you are so forward." I burst into tears of frustration and homesickness. It hadn't been a success after all."[15]

The stress felt by each citizen of having to guard his or her feelings is reflected in society at large in the restraint on public discourse. Censorship is far reaching, although few foreign visitors would suspect it from the easy-going surface of daily life. It's just like the strict rules of *Maarayaat* that can be overlooked in the graceful Thai smile.

In its gentler forms, censorship works through informal "guidance" from state ministries; more scary is the danger of

offending powerful people who might take revenge. Journalists and politicians also watch their words for fear of being caught in the net of lèse majesté suits. Over time, everyone learns how to self-censor, expressing ideas through innuendo, metaphor, and rumor. In order to read the newspapers you have to learn how to decipher the code: *phuu mii itthiphon* "influential persons," may mean "gangsters"; *yaai pai chuay ratchagarn* "transferred to assist official duties" (often translated as "transferred to an inactive post"), can be read as "fired"; *ramruay phit pakkati* "unusual wealth" implies that it was gained through corruption; *bok phrong dooy sutjarit* "honest mistake" suggests that someone has been found guilty but is too powerful to be punished. Some topics are so sensitive that there are simply no words for them. Thailand finds itself riven with deep social and political problems that nobody can talk openly about. Much is unexpressed, powerful emotions, with possibly volcanic eruptive power, lie hidden below the censored surface.

As for the young Pimsai and her critical grandmother, things have changed quite a bit from the 1950s. Bangkok is getting richer, more globalized, and more middle class. Proust pointed out that the nobility and the peasants share the same approach to life: they're bound to the land, and they value old places such as temples or churches. They respect social differences, which they indicate in their speech and body language, and at the same time they're free spirited about sexual morality. Pimsai, who was from an aristocratic family, shared much in common with immigrants from the rice fields of the North and Northeast.

The middle class opposes both these groups. They care little for old places; they don't much value social ranks because for them, it's the money that counts. On the other hand, they favor a prim and Victorian morality. This is the group that supports the closing of nightlife by 1am, and a proposal in 2006 that the drinking age be raised to 24. While strong on "moral" issues like drinking, they are less concerned with the fine points of etiquette that troubled Pimsai's grandmother.

Even more than Bangkok, the countryside is also undergoing drastic change. The flood of migrants who bring their peasant

(read: traditional) values into the city are the last generation to have grown up in wooden houses surrounded by water buffalo. In just ten years my partner Khajorn's village in the northern province of Phayao went from teak houses on stilts to concrete; where the villagers used to buy most necessities from their local market, now they go shopping at the giant Tesco Lotus store on the highway. Migrants will continue to flock to Bangkok. But the next generation of farmers will start out basically as "middle class" themselves.

Thailand is inevitably losing some of its "Thainess," especially in the great impersonal metropolis that is Bangkok. Philip Cornwel-Smith, when he chronicled the colorful details of Thai fortune-telling, tuktuk painting and so forth in *Very Thai*, noted that much of this is likely to disappear, leaving his text and photos as a documentary of a vanished way of life.

Mont Redmond writes, "It is against this wasteland of the spirit that we should view the struggle of Thais to remain Thai. Thai culture grew up with moral limits; the cosmopolitan lifestyle disdains them. The Thai social system was founded on solid and obvious family-based roles; urban business culture replaces them with desiccated economic relations. Thai family life could be warm and forgiving because communal censure controlled so much outside the home. With that external censure gone, all you get are spoiled children and debauched adults."[16]

That's the pessimistic view. On the plus side, millions of people now lead lives of relative comfort and even luxury, that could only be envied by their parents and the peoples of neighboring countries who still remain poor. The middle class is well educated, better informed, and linked to the world via the internet. They're politically savvy; hopes for Thai democracy rest on their shoulders. Their disdain for old-fashioned hierarchy is a form of freedom. From a cultural point of view, the middle class in Bangkok is going to create the next fusion, which we can see happening already in Siam Square. They call it *inter* for international, and *indie* for independent.

The middle class will have the final victory in Bangkok. Their culture will be mall-culture; it's the unstoppable trend of history.

Professor Vithi relates that when he took a busload of his students around Thailand, one of the young staff, Thongdii, suddenly asked to leave the bus when they reached the town of Nakhon Pathom, not far from Bangkok. Thongdii hailed from a village near Kengtung in Myanmar north of the Thai border. "Why are you getting out?" asked Vithi? "I'm going to Bangkok," replied Thongdii, "to see the opening of Siam Paragon shopping center!" Even a boy from a farm in the distant Shan states of Myanmar knew that Paragon mall is where the action is.

No matter how *inter* and *indie* people get, the instincts of politeness, introduced from early childhood, and reenforced in the school, survive. They even thrive in the middle class, as people try to act and look more genteel. Today *Maarayaat* is thoroughly manualized, taught to children with diagrams, textbooks, and posters. Despite Redmond's gloomy view, I think that all the shopping centers and Tesco Lotuses will hardly make a dent in the cult of politeness. It will take centuries to change this. The voices on the malls' PA systems, surrealistically soft and polite, whisper sugary encouragement to be nice. One shouldn't forget that it was the urban middle class that originally took the book *Sombat Khong Phudii* to its bosom and instilled in its children the idea that they should behave like proper young ladies and gentlemen.

Even polite Japan is no match for Thailand when it comes to gentleness. The politeness is there, but at critical moments Japan's fatal flaw, rigidity, spoils the effect. A flexible and ad hoc approach to life gives the Thais the extra wit and endurance to remain unfailingly pleasant, even in painful or unhappy circumstances. It's a huge achievement, for there simply is no other country that manages it. From that point of view, every society in the world could take lessons from the Thais.

Sensational novels teach us that Bangkok is a dangerous wild-east sort of place dominated by drugs, prostitution, and an exotic underworld. For many Westerners, appalled at the bad air and bad traffic, it typifies the unsavory and backward Third World. Above all, the deep rift within society that leads now and then to

upheavals such as the battle between the Red and Yellow Shirts, is a sobering reality. Anyone who lives in Bangkok cannot help but feel the steady drumbeat of social conflict. In the late 2000s, the drumbeat was getting louder and faster.

Yet behind all these problems, the broad river of "Thai grace" flows steadily. You find it in tuktuk drivers (yellow or red), shopkeepers, elderly professors and tattooed youth at Siam Square, powerful businessmen and restaurant waiters, everywhere. Citizens of Bangkok habitually speak and walk softly, smile as much as they can, move with natural refinement, and fine-tune their interactions in order to cause others the least possible discomfort. From this point of view, one would have to call Bangkok the world's most civilized city.

TILES AND FLAMES

The other day I invited a Finnish and a Thai friend over to my apartment, and as it got late, we ordered in pizza for dinner. With the pizza came little packets of ketchup. The Finn and I dabbed a few blotches of ketchup here and there on our pizza slices. That was enough for us. The Thai, however, took pains to squeeze the ketchup out in narrow lines, zigzagging and crisscrossing from top to bottom of the slice.

In that pizza slice you can witness *Lai Thai* at work. Meaning literally "Thai patterns," *Lai Thai* are the swirling motifs that we see everywhere around us in Bangkok; they're what make the city look distinctively "Thai." Whenever you see a twisting *chofa* temple finial, or a heavenly maiden draped in golden ornaments (and we see a lot of those in Bangkok), you're viewing *Lai Thai*. So ingrained is *Lai Thai* in the fabric of Thai life, that we don't usually stop to think about what these designs really are.

I first began to give some thought to *Lai Thai* when I opened my benjarong ceramics shop on Sukhumvit Road in 1998. Benjarong (meaning "five colors") is a kind of porcelain decorated in great detail with brightly colored enamels and gold. Repetitive patterns link together in row after row, and circle after circle, eventually covering the whole surface.

After we had been selling benjarong for a while, I found that I was seeing this decoration everywhere. The same motifs cover the Grand Palace and Wat Pho, with their walls, columns, and *chedi* spires inlaid with shards of Chinese crockery and mirrored glass.

Similar designs are embroidered onto the robes of masked Khon dancers. This approach of building up a pattern by repetition underlies *baisri* flower offerings: fold one banana leaf into a triangle, and then add another and another. Eventually an intricate green structure emerges.

The desire to cover every square inch with detail seems to have been there right at the start, as we can see from Ban Chiang pottery from northeast Thailand, thought to be among the world's oldest. Its distinguishing trait is lines carved or drawn on the surface in a repeating pattern, sometimes squares and triangles, and other times fingerprint-like whorls.

Ban Chiang pottery
Late period Ban Chiang pot with
swirl markings, ca 300 BC.

The Ban Chiang Period was thousands of years ago, and nobody knows how the people of that time are really related to the people who live in Thailand today. Nonetheless, there's something about those prehistoric patterns that feels a lot like *Lai Thai* – the spirit of Siam's ancient inhabitants is still with us.

The actual shapes of *Lai Thai* that we see today trace to Thailand's neighbors in more recent eras. As they did with architecture, food, and religion, the Thais borrowed. The patterns carved on the lintels at Angkor Wat became the basis of *Lai Thai*. The Siamese court took the Angkorian motifs (which themselves had come from India via Java), and slowly refined them. They made them more and more detailed, adding at the final stage, flower and vine designs from China.

The curious thing about Thai forms is that no matter where they originally came from, there is something about them that makes them instantly recognizable as Thai. I began to wonder what the secret is. This is one of those areas where the Origin program turned

out to be invaluable, because certain realizations about old arts can never be put across in a lecture or a book. You've got to physically do them. When you do, you suddenly understand what is going on.

In the process of practicing *Lai Thai* in our course at the Origin program, it emerged that there are two types of *Lai Thai*. No one to my knowledge has yet defined these in English, so I've given them the names: Tiles and Flames. Both of these are formed by drawing simple shapes, and then elaborating on them.

"Tiles" are designs inscribed within a square or circle, which fit together to cover a larger surface, like tiles on a wall. You can see the process at work in the buildup of the *prajam yam* design, a simplified version of which has been adopted as the Logo of Bangkok in a recent city campaign.

Draw a circle inside a square, and then add four petals. That's the basic structure. Then start elaborating, by indenting and doubling the petals, adding extra rings to the circle, and further adornments. Link up a series of these designs (each fitting within a square or diamond lozenge), and you get a "tiled" surface of *prajam yam* patterns, such as you might see covering a temple column or a benjarong plate.

My Thai friend's zigzags on the pizza were basically a form of Tiling.

"Flames," on the other hand, are what you find at the edges of things, wavy snake-like patterns that flare upwards and outwards. They dissolve into arabesques, such as the ear flanges of a dancer's crown, or the swirling train of an angel's robe portrayed on a temple wall. The simplest and most striking prototype of this style are pairs of *chofa* finials, the curving wooden pieces that rise from the eaves of Thai temples and palaces. Trace the line of the ins and outs of the *chofa* and you're touching the essence of *Lai Thai*.

The primal shape, from which most Flame Patterns are derived, is called *lai kranok*. It's the shape of the *kranok* leaf, which looks like a lopsided spade. After you've drawn one *kranok*, draw smaller *kranoks* inside it, and even smaller *kranoks* inside of them. Or you can add wavy lines inside the *kranok*.

Now take these *kranok* and triple and quadruple them, extending the tapered ends into many a flickering branch. Like Japanese calligraphy, once you've learned the rules, you can play with the lines, allowing them to grow outside the neat triangles and squares within which they're theoretically drawn. Soon you have what look like twisting flames and tendrils, an extremely elaborate design – and yet in its overall shape, as well as in the details, you can still see the basic *kranok* leaf at several levels of enlargement.

As I practiced drawing these patterns in our arts program, it dawned on me that what is going on is "fractal." It's a term describing what happens when you start with a small set of rules and then repeat them, giving rise to systems of surprising complexity. In mathematics you start with "1+1=2", and a handful of rules about multiplying and dividing, and pretty soon you've generated all the chaotic infinitude of numbers, including the mysterious unpredictable occurrence of primes. Repetition of a limited set of basic instructions allows minute packets of DNA inside a germinated egg to unfold into a complex human being.

Modern science has found that fractals are the key to the way things are shaped in nature, whether it's a quantum wave or river valley systems. All such fractal patterns share a characteristic look, and it's exactly the look of Thai "tiles" which link up to cover a surface (fish scales, crystals, skin cells), and "flames" which uncurl or branch outwards (ferns, shells, lightning). There's a deep reason why Thai patterns are so satisfying. What seems on the surface to be trivial decoration bears within it the seed of how the cosmos works.

Because they grow out of repetition, fractal patterns have the curious trait that no matter at what scale you look at them, the patterns appear roughly the same. So tiny fibers in a corner of a leaf look like the veins of the whole leaf, and this pattern is in turn reflected in the spread of the twigs and branches of the whole tree.

When, in building a *baisri* floral arrangement, you take bits and pieces of leaves and flowers, and make them into one large imaginary flower – you've created an object in which the parts mimic the whole and the whole reflects the parts. The very idea of that is fractal.

In exploring this fractal approach to line drawing over the centuries, the Siamese came up with many an ingenious technique, and in recent years these have been codified into books that show the right proportions for all the basic forms, and rules about how to draw them. Just as *Maarayaat* (Etiquette) seems on the surface so free and easy but is rigidly circumscribed by rules that are taught in schools and published in books and posters, so is *Lai Thai*. There's a proper way to do things.

Next after line comes color. Japan's paradigm color is brown, the shade of aged temple columns, or a tea master's bland kimono. Unpainted wood, unglazed pottery with a dull surface, pale natural dyes – these things are all part of *shibui* "low key", which is Japan's highest aesthetic. In Thailand, the concept of *shibui* is nearly unthinkable, except perhaps in the context of old ruins. Thailand revels in a scintillating rainbow of colors: gold, blue, orange, purple, and pink. In China or Tibet, the interiors of temples and palaces also gleam with color. But the exteriors tend to plainness, such as the long maroon-red walls of the Forbidden City, lending them a sober grandeur, a gravitas that comes from being strong and serious. In Thailand even the exteriors sparkle with brilliant inlaid glass and gold filigree. Philip Cornwel-Smith once declared, "In Thailand, pink is a primary color."

Fractals in nature
Fractal principles at work in the shapes of leaves, shells, and cactus.

However, the primary color is really gold. According to legend, a kingdom known as the Golden Land, or *Suvarnabhumi*, once ruled

Prajam Yam

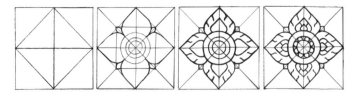

Formula for creating Prajam Yam design
Within a square, draw four petals
radiating from a circle, then add details.

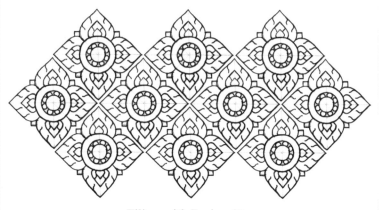

Tiling with Prajam Yam
Multiply the units, and link them
as adjoining "tiles" to cover a surface.

Complex Prajam Yam tiling
Prajam Yam design carried to a higher degree of complexity.

Kranok

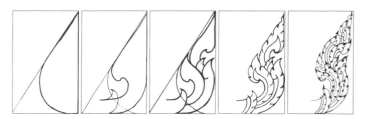

Formula for creating Kranok design
Inside a triangle, draw a "lopsided spade";
repeat and elaborate at different scales.

Kranok design applied to decorative art
Kranok patterns flare from the griffins' heads and manes,
and define the shape of the tails and tufts of hair at the hooves.

over the basin of the Chao Phraya River. Suvarnabhumi has since become the name of Bangkok International Airport. "Golden Land" is appropriate, because one can hardly think of Thai art without seeing gold everywhere: golden pagodas, gold-leafed Buddhas, and the golden outlines of *Lai Thai*.

As the Eskimos are said to have a dozen words for "snow," so the Thais have many ways of saying "gold." There is *kham*, as in the town Chiangkham ("city of gold") in northern Thailand, where my partner Khajorn hailed from, *thong* (derived from the Chinese word for bronze), and *urai* (as in my friend Taw's restaurant, called *Ruen Urai* ("House of Gold"). Other words for gold feature in the names of cities: Suphanburi and Kanchanaburi both mean "city of gold."

Other colors, however, have their day. Literally. There has long been a tradition of wearing different colors for the different days of the week, an idea that comes from Indian astrology. Every school child learns the colors of the days (red for Sunday, yellow Monday, pink Tuesday, green Wednesday, and so forth), but until recently few except some old grandmothers or hidebound professors paid much attention to it. Come 2006, the 60th anniversary of the reign of King Bhumibol Adulyadej, and suddenly the tradition revived: everyone was to wear yellow on Mondays, the day of the King's birthday. And indeed they did. Bangkok became a sea of yellow for the next two years.

In November 2007, yellow yielded to pink. The King was seen leaving the hospital, wearing a bright pink jacket. Some said that the King, in his illness, was relying on the power of his ancestor King Rama V, who was born on a Tuesday, and whose color was therefore pink. For whatever reason, Princess Sirindhorn designed a pink T-shirt for the occasion, and Bangkokians swarmed the shops, which soon sold out of pink, making front-page news.

In January 2008, Princess Galyani, the beloved sister of King Bhumibol Adulyadej died, and suddenly all the color disappeared. For a month funereal black filled the streets, but black soon gave way to festive red celebrating Chinese New Year. By spring, the war between the Yellow Shirts and the Red Shirts (the enemies

and supporters of Prime Minister Thaksin) engulfed Bangkok. As emotions ratcheted upwards, people had to think carefully before going out into the street dressed in either yellow or red. By mid-December, when the government fell, the new Prime Minister and his Cabinet, careful not to show favor to either side, appeared in the newspaper all wearing bright pink shirts. Pink had by then become a subsidiary color for the King, a way of wishing him good health.

I think you could say for sure that in Japan and China's modern history, not to mention Europe and America, you will not find a photo of a Prime Minister and his Cabinet all wearing pink. Perhaps Philip was right after all about pink being Thailand's primary color.

The colors became so politicized that when Hillary Clinton visited Thailand in July 2009, and was asked in an interview by *The Nation* newspaper why she'd chosen green as the color for her dress, she replied, "Actually I consider this turquoise. Is that wrong? Well, it's funny because I know there are certain colors that I should not wear."[17]

The emphasis on color might have arisen from the tropical forest and its flowers. But not every tropical country went this way. More likely it has to do with the Thai love of *sanuk*, which also inspired the other distinctive element of Thai design, namely transformation. The eddying patterns of *Lai Thai* never stay put. One moment they are vines and leaves; then they look more like flames; these fuse into tails, beaks, wings, or claws; at the end they emerge as vines again.

The lines and colors of *Lai Thai* are hardly things that belong to a forgotten past. They go on being important in modern Bangkok for the same reason that calligraphy remains relevant to modern Japan and China. *Lai Thai* is the defining decorative feature of the city; you can hardly walk a block without seeing *Lai Thai* somewhere.

Although different on the surface, Japan and Thailand share many similarities. Maybe that's why, in the end, I didn't move to China or to Bali. I chose the closest thing. Both nations still stand

on a solid base of old belief and customs – and this is why the cultures in these two countries are endlessly fascinating. While modern, they are not modern like everybody else. Bangkok commuters on the SkyTrain wear yellow on Monday, and hip-hop girls in Tokyo slather their faces with makeup as thick as Kabuki.

There's another way in which Japan and Thailand are similar: they're both the ultimate copycats. China, India, Angkor – these were "primal" places where religion and the basic forms of Asian civilization originated. Japan and Thailand, on the other hand, can hardly claim a single thing in their traditional cultures that didn't come from somewhere else. Look closely at anything Japanese, even something as ancient and local as Shinto religion, and you find Taoism in disguise. In Thailand, likewise, architecture came from Angkor, Buddhism from Sri Lanka, lower dress from India, upper dress from China. And yet both countries thoroughly transformed those foreign influences to the extent that Japanese things look immediately and distinctively "Japanese", and the same is true for Thailand.

If one were to describe the difference, it would be that the Japanese approach is to refine and strip away the non-essential, whereas in Thailand it's just the opposite. Japan abstracts; Thailand elaborates. The Japanese took Chinese temples, did away with green glazed tiles and red lacquer, reducing roofs to gray-black and columns to unpainted brown wood. The Thais took Khmer motifs from Angkor, repeated them at large and small scales and intertwined them until they grew into the incredibly complex efflorescence of *Lai Thai* design.

For Japan, the fact that so little originated there has been a source of mortification, and there's a huge literature devoted to proving that Japan is "unique." Thailand seems less troubled by this, and it might be the result of having always been a busy crossroads, rather than an island.

Despite the similarities in their cultural history, when it comes to design, Thailand and Japan are truly opposites. Japanese art focuses Zen-like on the moment, on the matter at hand. As flower master Toshiro Kawase points out, all the effort goes into making

things appear real. That is, to make things look more intensely, beautifully, and ideally "real" than they actually are. The emphasis is on purity, on isolating each entity and savoring it for what it is.

In Thailand, in contrast, there's a deliberate blurring of boundaries. Professor Vithi says, "Everything is stylized, idealized. *Lai Thai* is nature twisted to Thai taste. Everything transforms. Hedges are pruned to look like *naga* serpents. Meat is pounded, soaked, mixed, and ends up as something else. Fish are strung up like fans or flowers. Nothing can remember where it came from."

Khmer "artichokes" transformed into Thai "corncobs"
left: Angkor Wat in Siam Reap, Cambodia
right: Wat Arun (Temple of the Dawn) in Bangkok.

Vithi continues: "People are always striving for the *sanuk*, the funny, the esoteric. It's especially good when there's a good explanation for it, as in the making of Thai flower offerings. These are celestial flowers. If you were God, you would make things that look like that."

Here Vithi has handed us the key to the appeal of *Lai Thai*, namely the point is to create temples, hedges, and flowers that come from an imaginary heaven, not real earth. I call this approach "etherealization." The effect of *Lai Thai* is to make things feel light and airy. The Thais have been doing this to foreign-imported culture for a long time. They took the squat bell-like stupas of

Sri Lanka, and stretched them out to produce the bud-shaped *chedi*. In the Sukhothai Period, they took the somber seated Buddha in meditation, and lifted him up so that he was walking (descending from heaven). His soft androgynous figure treads so lightly he appears to float.

In the Ayutthaya Period the Thais took the chunky "artichoke" towers of Khmer temples and lengthened them into the slim "corncob" *prang* that surmount temples and palaces in Bangkok today. Over time the slimming process continued as temple walls grew higher, the multi-tiered roofs steeper. Meanwhile, inside the dark interiors with their tall slatted windows, Ayutthaya artists craved light. They crowned statues with tiaras and draped them with jewelry; they covered walls and columns with glass mosaics and frescoes. By the time Bangkok was founded, gilding and filigree swallowed up every flat surface.

As everything stretched and tapered, the right angle disappeared. No country in the world avoids a 90-degree angle as Thailand does. In ancient times Thai houses were built with a natural lean to them, the walls tilting slightly inwards or outwards, to create stability. What started in wood eventually transferred to stone, brick, and plaster, and from this point onwards Thai temples departed radically from the stolid strength of Indian or Chinese buildings. Every angle henceforth was skew.

In Ayutthaya they bowed the bases of temples inward, to create a so-called "elephant's belly" which looks like the long concave deck of a ship: high at the bow and stern, low amidships. From these curving boat-like bases, walls rose at an inward tilt. Doors, window frames, thrones, and book chests followed suit. The tilting affected things at smaller and smaller scales, to the point that even pillows and jewelry boxes all took the shape of a trapezoid. In this land of no-right-angles, euclidean geometry is banished; two parallel lines will always meet. Everything is slightly thinner at the top end, and the effect, a trick of perspective, is to make things look elegant and lightweight.

The result of all this is that Thai objects and buildings took on an "ethereal", and fantastical quality, as if they were delicate

objects that angels had dropped from heaven. It wasn't just an accident of decoration; it reflected a Thai idea of what heaven on earth must be.

Lai Thai is all about a beautiful surface, not necessarily about inner meaning. Japan and Thailand share the fact that both countries value surface beauty greatly, and this also applies to the

"Elephant's belly"
Temple bases in Ayutthaya slope downwards like the sides of a boat.

calm and pleasantry of society. As long as everyone keeps properly bowing, *wai*-ing, and smiling, injustices and misery disappear from view. While neither country is more just or gentle than its neighbors – in some ways, they can be harsher – they feel like happy, sweet places because the surface mood of daily life is so "user-friendly".

Beguiled by deferential bows, foreign visitors easily fall into a utopian illusion about Japan and Thailand, whereas robust, modern China and Vietnam never allow you to relax for a minute. Few imagine utopia there. But in Thailand or Japan, it's easy to float away on the pleasant

Trapezoidal door
Door and window frames taper inward

surface. Both countries are "Lotus Lands," like the land of lotus-eaters that Ulysses visited, where the visitor, once he has imbibed

the local lotus liquor, forgets his former life, and indeed forgets about the basics of human nature. Such as the fact that common sense tells us: there must be more behind that Thai smile.

In the sphere of art, the surface details of *Lai Thai* came over time to so predominate over "form" that they became form itself. The Buddha dissolves into the golden filigree that encrusts and enthrones him.

All this baroque glitz runs directly against our modern point of view. In the West we spent the twentieth century stripping away the ostentatious frippery of earlier centuries, and today we value pure and abstract forms above all. Japan, for all its love of pretty surface, was ideally suited to be "modern" because the primal mode for Japanese shapes was simple and abstract. Thailand falls at the opposite end of the scale.

In the West, therefore, Thai art has been seen as "decorative," and thus has never commanded high prices in the global art market. Western museums and private collectors vie for Khmer art and will happily spend millions of dollars for a fine sculpture. It's because of the simple and noble strength of those Khmer torsos. But I can hardly think of a major museum that has specialized in Thai. If they have a good piece, it's because an eccentric collector like Doris Duke left it to them. Thai art is just not seen as important, and Thai culture has thus had little impact internationally.

There are "important" countries and unimportant countries. Americans know all too well that we're important, and so do the British, French, Chinese, and Japanese. But what about the Poles or the Finns? In Japan, we take for granted that the history of Japanese art, Tea Ceremony, and so forth, will be taken seriously by the world. Not here. Thailand – for scholars in prestigious universities, for the nabobs of culture in New York and Paris – is an insignificant place, a tourist curiosity.

When Ping Amranand said, "Yes we have arts, but what are the foreigners going to get out of them?" he was touching on this point. The arts we study at the Origin program in Bangkok are not those that have, or probably ever will widely influence global culture. The world sees Thailand's culture as "minor" – it's one of those things

one must accept when you are living in Bangkok. That's fine by me. For those of us who have come to love Thai arts, we feel we've found a jewel that everyone else overlooked.

It's back to "Thai grace," which we first encountered in *Maarayaat* etiquette. The process of "grace-ifying" has been going on for centuries. Tribal taboos, such as that against raising a roof toward the sky, as explained by John Blofeld, were refined and refined until they reached the inexpressible elegance of the *chofa* roof finials. The fingers of sculpted Buddhas stretched, and their eyelids curved; headdresses rose like pagoda spires and wavered like flames; the right-angle disappeared; *Lai Thai* twisted and flowered until it reached fractal dimensions. The Thais took their ancient sense of man and universe, and polished the surface until they raised the surface itself to the plane of

Buddhist sculpture
Curved eyelids,
eyebrows, and fingers.

heaven. Hence the official Thai name for Bangkok: *Krung Thep* "City of Angels." However un-angelic Bangkok sometimes seems, this is what the city's founders intended it to be.

Contemporary Thai artists have not been able to escape *Lai Thai*'s power. Even in the array of modern paintings that flank the corridors and luggage belts at the airport, you'll find liberal use of *Lai Thai*. Yet in fact, for contemporary artists, the preponderance of *Lai Thai* is as much a burden as a blessing. The curlicues and pretty gilding don't lend themselves well to conceptual art, which dominates art on the global scene.

I've had an ongoing argument for some years with an Australian museum director about the merits of Thailand's great artist Thawan

Duchanee. For me, Thawan is truly a genius, a modern master of fractal line. Into that line he brings raw, powerful emotions, and I believe that a century from now, Thawan will still be revered for his unforgettable images that combine *Lai Thai* with eagles, horses, human body parts. But for my director friend, Thawan is just more Thai kitsch. He prefers the conceptual approach of Montien Boonma (1953-2000) whose gutsy edgy installations broke away from the usual Thai concern with surface beauty, and thus look more "international."

In my view, fractal Thai art is of interest in itself. This is especially true for artists like Thawan or another *Lai Thai*-based artist Thongchai Srisukprasert, who have found ways to ally the squiggles of traditional design to modern ideas. I have a painting at home by Thongchai of two circles. One is a doughnut, the other a circular comma shape, both filled with fiery *Lai Thai* in gold against a black background, like exploding supernovas. They take the shapes of the Thai numerals "0" and "1", and hence are digital.

Professor Vithi once said to me, "Speaking very personally, I have this feeling about the old peoples of this region. They go by many names: Luwa or Wa in Lanna, Khmu in Laos, Mon in Burma, and Khmer in Cambodia, and many others. They were here long before the Thais came down from the northern valleys. But, whatever names they go under, these people have within them a unique artistic feeling. The soul of art. Think of the Angkor and Khmer sculpture – magnificent forms. Their art has such deep power."

"The Thais, in contrast, are good at surface decoration. That's what they brought with them when they came down from the hills of southern China. The Thais gave us all the *sanuk* and gorgeous fancy extras."

If Vithi's insight is true – the Mon/Khmer created strong primal shapes, and the Thai tribes brought the *sanuk* decoration with them – then one promising direction for modern Thai artists who want to free themselves from *Lai Thai* might be to explore their Mon/Khmer roots in Thailand's Isarn hinterland. The next generation of powerful forms might come from there.

On the other hand, modern artists have only begun to explore the expressive richness hidden within *Lai Thai*. They stand in a position similar to Chinese and Japanese artists who faced the challenge of revitalizing their tradition of calligraphy. A Japanese critic in the late 19th century once famously commented, "Calligraphy is not an art." That's because, in the eyes of eager modernizers of the times, it didn't look new or Western enough. Only in the late 20th century did inspired calligraphers appear, such as Japan's Toko Shinoda and China's Xu Bing, who rediscovered the abstract force of the brush and the conceptual nuance of calligraphic words, earning themselves international renown in the process.

I remember as a student coming to Bangkok for the first time and being haunted by the ins and outs, the unexpected twists and turns, of the *chofa* rising from temple eaves. The words to describe that quality go beyond the obvious decorative appeal of "elegance," "refinement," and "fantasy." They would be: "rich symbolism," "mastery of color and line," and "the power of cosmic fractals."

In any case, trying to be minimal and conceptual misses the point. They can do that in Beijing, New York, or Tokyo just as well, or usually much better. But nobody in the world (with the exception perhaps of Thailand's neighboring and related cultures, Laos and Cambodia) can even begin to accomplish the ethereal miracle of *Lai Thai*. The flickering flames of *Lai Thai* are in fact Thailand's great contribution to world art.

The struggle between the two camps of the Internationalists epitomized by Montien, and the *Lai Thai* Drawers led by Thawan, will only intensify as Thailand's artists try to break into the world art market. But we can leave those issues to the curators and galleries. For me, living surrounded by *Lai Thai* motifs is one of the pleasures of Bangkok, just as seeing calligraphy everywhere is part of the fun of Beijing or Tokyo. So specific are these patterns that one glance at just a fragment of *Lai Thai* is enough to tell you, "This is Thai."

175

SAEB

What follows is the record of a conversation about Thai food that took place one night at my apartment.

The cast of characters was: Vithi Phanichphant (Professor at Chiangmai University), Dr Navamintr "Taw" Vitayakul (owner of *Ruen Urai* restaurant in Bangkok), Num (my neighbor), Saa (my assistant), Cameron "Cam" McMillan (guest from New Zealand), and myself. We set ourselves the task of defining Thai food, but as happens often in Bangkok, the evening ended up far from where it started. It began innocently enough.

Vithi: When you boil it down to essentials, there are three things that make up Thai food: Curry from India. Coconut and jungle flavors from the Mon. And Chinese stir-fry.

It's a mix, a variety. You could call it the primitive taste, the curry taste, and the stir-fried taste, and often they overlap. For example, Chinese-based food can have spiciness, curry can have the consistency of Chinese watery soup (instead of thick as in India), and curry also might have lemongrass (the jungly taste).

Num: It's like having sex with every part of your body at the same time.

Vithi: There's no monotony. It delivers a variety of senses to the taste buds, so all your taste buds are stimulated at once.

Alex: What is the Thai food mystique? It brings millions of visitors to Thailand, and you can hardly find a city anywhere in the world without a Thai restaurant.

Vithi: Zesty. *Saeb*. That's an Isarn word meaning *aroi* (delicious). But the Thai word *aroi* does not just signify something generically pleasant to eat, like the Japanese *oishii*. *Aroi* has oomph. It makes you sweat.

Alex: What makes a great food culture? Why does Thai food rank as a world cuisine?

Taw: (1) Flavor, (2) Regional food, (3) Fusion. This is the most important. We were one of the first to fuse, before people knew about fusion food. Can you think of any food in the world that gives you so many flavors in one mouthful?

Taste: sweet, salty, sour, slightly bitter, sometimes spicy, slightly oily.

Texture: sometimes crispy and soft in one mouthful.

Temperature: hot and cold.

Think of the hot crispy catfish fried rice overlaid with strips of cold stringent green mango we're eating now. That's so typically Thai.

Some people use the word "primordial" to describe Thai food; it comes direct to your senses. Flavor, texture, and temperature, all combined in one go. Vietnamese comes close, but lacks certain zing. Thai explodes in the mouth.

Alex: It seems to differ a lot by region.

Taw: Thai food is like Chinese or French or Italian – basically one thing, although there are many regional cuisines and variations. There is no Thai food per se, just food from Thailand. There's the food from the four regions, the Northeast, North, Central, and South. We mix it all together in one meal.

Cam: Where did the fusion take place?

Num: It happened in Bangkok, the capital.

Taw: I think it started long ago, many hundred years ago, long before Bangkok. For thousands of years we've been living in this piece of land sandwiched between China, India, and the southern islands. We take the best out of everything and use it. The north is influenced by Lao & Burmese. They use different spices, use different types of

meats, especially pork. The Northeast is influenced by Lao and Khmer, concentrating on fresh grilled things. Cooking methods also differ. The Khmer approach is salad, or something fresh. The Isarn approach is *som tam* (papaya salad with tomato, dried crabs or shrimps, and crushed garlic or chili). It's salad, grilled food, steamed things.

Vithi: Be careful of what you call "Isarn." *Som tam* came from America. Look at all the ingredients: we never had most of them. Papaya, tomato, and *phrik* (chilies) – they all came from the New World.

Taw: Yes, *som tam* is questionable. Is it really Isarn, or what is it? And *pad thai* (fried flat noodles with dried shrimps, peanuts, bean sprouts, and egg), even though it uses the word "Thai" in its name, is really Chinese, although some say Vietnamese.

Vithi: The only thing that's truly Isarn is *plaa raa* (fermented fish).

Alex: How did they put it all together?

Vithi: In the case of *som tam*, they had the concept of it long before. They had the *som*, which means literally "sour" – it meant sour fruits such as *ma muang* (mango), *ma fueang* (star apple), *ma yom* (star gooseberry), *ma gawk* (thai olives). *Tam* means "crushed." All of these were crushed in a small mortar and mixed to make the original salads. They got replaced by American ingredients.

Taw: Another aspect of the fusion is that Thai food is larger than just Thailand, because we took food from all over Southeast Asia, going as far as Muslim food also.

Cam: Muslim food?

Alex: We know that King Narai in the mid 17th century loved Persian food.

Vithi: In the south, they have *kaeng lueang* (spicy yellow curry).

Taw: They also have *khaomok kai*. That's Islamic food, a sort of casserole with meat inserted in the rice, often saffron rice. Like rice biryani.

Vithi: We don't eat it that much, at least in other regions of Thailand. But we do have Southern specialties such as *kaeng lueang*, *kua gling* (roasted chicken with curry paste), *kaeng tai plaa* (bamboo shoots, shrimp paste, dried fish and fish innards), *khao yam* (rice with condiments of dried shrimp, coconut, lime, dried chili, and fermented fish), and *khanom jiin* (rice noodles with curry, vegetables, and pickles). *Khao yam* is Indonesian and *khanom jiin* is Mon.

Taw: All of these are from somewhere else, basically.

Num: We're like the crossroads of the kitchen.

Taw: We fused everything. We fused the dishes, the style of cooking, and we fused the ingredients. Of course you know the new world ingredients, which we got from South America via Spain, Portugal, and India: we get potato, we get chilies, we get egg deserts – that's Portugal. And tomatoes, papayas, corn, coffee, peanuts, sugar cane, and pineapple – all from South America.

Vithi: We never had anything like that. The only thing we knew was mango and coconut.

Num: We didn't eat anything, that's why we were so skinny before. Fusion made us obese!

Taw: Now there are new things available. We have salmon, but when we prepare it at my restaurant, it becomes salmon in *jaeo* (powdered chili sauce with lime). Also we serve soft-shelled crab, but it's stir-fried with spicy stuff. That makes it Thai food; it's made with new ingredients.

Num: It's Thai food gone *Inter*.

Taw: One of the basic flavors is *nam phrik* (chili paste).

Vithi: But just imagine, we didn't have the *phrik* chilies before, either! That too came from the New World.

Taw: I've heard we used *phrik thai* (pepper) in the old days.

Vithi: But the oldest taste is *nam plaa*, the fish sauce – the very distinctive ingredient of Thai food is *nam plaa*.

Alex: Like soy sauce in Japan. Everything Japanese has soy sauce in it somewhere.

Taw: That's the basic thing. After that, we have something left over, and what are we going to do? You can do various things. You boil something, and it becomes like a *tom yam* soup. Boil it more, add some Indian influence, with fresh herbs and coconut milk, and it becomes a *kaeng* of some type.

Alex: I thought that a *kaeng* had to have curry.

Taw: Not at all. Without the curry paste you have *kaeng liang* (peppery mixed vegetable soup), or *kaeng som* (sour soup made of tamarind paste). That's quite Thai.

Cam: Why would you call *kaeng som* "quite Thai"?

Taw: It's sour, it's spicy. It's a very odd combination: sour and spicy. Then you have fried food. Anything that's done in a wok is Chinese: fried, stir-fried, sautéed, all Chinese. And then you have Muslim food, such as potato in so-called *massaman* curry.

Saa: But it's strange, the potato comes from America. I wonder what would happen if we hadn't found America?

Num: Alex wouldn't be here.

Vithi: You have to realize that we didn't eat this way before. This kind of texture of a clear soup was new to us. We didn't have *kaeng jeud* (clear soup), which is basically Chinese soup.

Cam: Speaking of soup, why is it that they never serve the soup with little bowls to serve yourself?

Num: Because it's a shared thing.

Saa: Thais don't like to divide things up. At my family, there is only one large soup bowl, and everybody eats together.

Vithi: I call the people of Lanna and the Mekhong area the "*khao niao* (sticky rice) people." The "sticky rice people" *jim nam*, that is, they *jim* (dip) into *nam*, which means water, but refers to anything watery. They did not use a spoon to scoop. Roll up the ball of *khao niao*, stick it into the soup, the *kaeng*, and eat the juice first, and then the vegetables and meat comes later. They don't really have spoons.

Num: It's like a little sponge.

This reminded me of my cousin Tom's theory of the Thai dinner table. It always has at least three, and sometimes four condiments, and people flavor their food as they like, to make it sweeter (sugar), saltier (fish sauce), more sour (vinegar) or hotter (chili powder). Tom finds this to be symbolic of Thai society in general, in which everyone is allowed to be what they are and do more or less what they want. One might say, people have the right to have things the way they like them: sweet, salty, sour or hot.

Tom also talks about "the principle of the empty plate." Thais take a helping from a common dish, put it first on their own plate of rice, then eat that, before taking a bite from another dish. Their plate remains more-or-less empty throughout the meal, except for the rice. A meal with friends becomes a "negotiation," with each person making sure he takes just his fair share, and maintaining an awareness of the others' likes and dislikes. You see small gestures of give and take: someone offering a companion a delicacy he enjoys and receiving something else in return.

Tom's friend Navig told him a story from his childhood, growing up in Isarn. The family was dirt poor, and often, all six of them, including Navig's brothers and sister, would make their meal of sticky rice and a single roasted *plaa thuu* (Thai mackerel). The family would somehow share that little fish, each one taking only the tiniest bits of it to flavor their ball of sticky rice, until the thing had been reduced down to its feather-like bones.

Tom relates this to Thailand's "culture of negotiation." The application of law is flexible, rules are made to be bent, you can negotiate anything. Organizations who in other countries compete to the point that they don't even speak to one another, in Thailand manage to sit down at the same table. They work together with grace – even if underneath the smiles they may disapprove of each other. It's all part of that inbred sense of give-and-take that Thais experience each time they sit down to eat.

Alex: You say that the Thais traditionally didn't have spoons. But they certainly do now. It was one of the differences I noticed when I started coming here from Japan:

Thais rarely use chopsticks; they eat with spoons and forks. When did these come in?

Num: It was *Jomphol Por* (Field Marshal Phibunsongkhram) in the 1930s.

Vithi: No it was earlier than that; it was King Rama VI. He brought it back from public school in England. We have changed our way of eating so much. That's why *khanom jiin* (fresh rice noodles with saucy curry, vegetables, and pickles) became popular.

Alex: I used to think *khanom jiin* was from China because of the word *jiin* (China). But later somebody told me it's really Mon. So what really is the core Mon food?

Vithi: Anything with coconut is Mon.

Saa: What about *khao chae* (cold rice with ice)?

Vithi: It's the Mon imitation of *khao tom jiin* (Chinese boiled-rice soup). The Mon didn't eat *hua chai poh* (pickled turnips), which the Chinese ate with their rice. The Mon saw the Chinese eating rice soup with turnips. The Chinese original wasn't iced, just cold; they put *phim sen* (camphor) in the water and that made it cool. Later on, the Mon did away with the camphor and put ice in it.

Saa: Who was coming up with these ideas?

Vithi: The Mon who made the fusions were ladies at the court in Bangkok. They had nothing to do, they had leftovers from this and that, and they made it into nice things. They had some left over vegetables, left over *kapi* (shrimp paste), left over red onions, anything left over they would think up ways to use it to make something unusual. The royal people would say, "Oh this looks good, we'll have it." But actually it was just leftovers.

Alex: And the taste for the unusual.

Vithi: The palace adopted what was originally Mon cuisine and then eleborated it into more varieties, and then they beautified by adding decorative carved vegetables in the form of flowers. Thai food is basically a mix between Chinese and Mon.

Alex: Thai culture in general seems to have resulted from a collision between Chinese and Mon.

Saa: What about all the dishes in the poem *Kap hey rua chom kruang khao wan*?

Cam: What's that?

Taw: *Kap hey rua chom kruang khao wan* are a set of *kapyani* (a form of classic poetry) by King Rama II. They describe about thirty or forty dishes, talking about everything from savory things, fruits, desserts, to smoking cigarettes after dinner. We all learned about this in school. These are barge songs, to be chanted. The gist of it is, he equates food to love. Food and love, loving caring from the woman (possibly women) who cook this for him. The first list of savories is about twenty things; back then just a few wouldn't do for the King. He would have them laid out like a northern *khantok* tray, and would pick them one by one. The first item is *kaeng massaman* (yellowish-brown curry), and it's not Thai. It's Muslim food. And the second one is *yam yai* ("large salad"), a Thai version of chef's salad, with Japanese soy sauce. Grand chef's salad with shoyu. This is not Thai food.
But the fifth one is, *koi kung*, which is like prawn salad, half cooked, with herbs. This is Thai.

Vithi: Well, this is not Thai either. It's Mon-Khmer, primitive.

Num: Shaman food.

Vithi: In Mon food, the raw taste is always there.

Alex: Chinese food is always processed. Indian and Chinese are very cooked, not many simple or raw flavors.

Cam: For me, Chinese food is what really boring Thai food would taste like.

Taw: Thai technique is not as fanciful and sophisticated as the French, but it's about creative use of ingredients. Substitution. If the right vegetable isn't available, use another. We're not too strict about using a particular ingredient. If we can't find unripened papaya, then we'll use unripened mango. That's how the fusion started.

184

Alex: It's such a difference from Japanese food, where the emphasis is on perfectionism about ingredients. Chefs make sure that a particular leaf of the season arrives at just the right time. It was this perfectionism that so impressed the Michelin Guide people, to the extent that they gave Tokyo more gold stars even than Paris. That upset a lot of people. I don't think Michelin would appreciate the Thai easy-going approach.

Taw: Some things can be substituted. If the fish or vegetable is not in season, find something that is. On the other hand, there are certain ingredients that you can never substitute. For example, fish cakes or fish balls made from *plaa krai* fish. The consistency, the gluey texture is perfect for certain dishes, and nothing else will do. Generally speaking, meats are variable. You can have a green curry with chicken, beef, pork, or fish, and it doesn't matter. But spices and herbs are important. You've got to get these right.

Vithi: If you think of a typical Thai meal that most of the population would prefer to have: you have a *kaeng* of some kind (curry, a watery thing); a bowl of *nam phrik* and a vegetable (something raw and fresh, like salad); and then you have a *phad* (something stir-fried) a *neung* (steamed thing) a *thawt* (deep fried), or *yaang* (grilled), or even a light soup like *kaeng jeud*, which is very Chinese. So you have primitive food, the Indian style, and the Chinese style. Those are the three.

Taw: Something from every region.

Alex: It seems that almost everything the Thais eat today is new in some way. Things that I thought went very far back turn out to be recent creations, thought up in the 19th or even mid 20th century.

Cam: You've all left one thing out. What about the insects, grasshoppers, ant's eggs, and so on that you see Thais eating?

Vithi: Not everything is so new as Alex says. Insects are really

old, part of the original menu. It goes back before human beings were "hunters and gatherers," to when we were just "gatherers," living on berries and roots and insects in the forest. Like the Mlabri [*Phi Tong Luang* primitive tribe] in Nan province still do.

Cam: Yes, but most developed societies in the world stopped eating insects long ago. Why do they continue in Thailand?

Vithi: Because they're so good! Delicious and crunchy. Think of the tangy flavor of juice from the *maengda* water beetle.

Num: It tastes a little like apricot essence.

Vithi: Plus, bugs are a source of protein.

Alex: I guess I should amend what I said about the newness of Thai food. Even with all the mixing and mingling is going on, the Thais seem at one level to have a deeply conservative strain. Somehow really ancient things survive here when they've died out elsewhere.

Vithi: It's the same with *baisri* flower arrangements. It's something very old.

Alex: Yes, but *baisri* are something you see at rituals, not every day. Did people ever actually decorate their homes with flowers?

Taw: We have potted plants.

Vithi: That's Chinese bonsai.

Cam: You mean even the potted plants aren't Thai?

Taw: In Thai houses, there isn't much to decorate. There's hardly any furniture, a few chairs or tables, or sometimes nothing. Maybe a *tang* (low table).

Vithi: *Tang*, too, is Chinese. If you're a scholar, you had a *Tang* to write on.

Alex: So we're fusing Chinese furniture and bonsai with the interior of Southeast Asian houses.

Num: Siam is the crossroads of everything.

Taw: Even patterns. You have patterns originally from India or China that go to Cambodia first, and then come to us.

186

Vithi: Everything is inherited from Angkor. Most of what makes up classical culture in Bangkok, that is. A long time ago, someone once said, "Bangkok is the last gasp, the last breath of Angkor".

Taw: The classic form for traditional *Lai Thai* design is the Khmer *kranok*, and it's been modified into many different forms.

Alex: *Kranok* looks like a sort of lopsided tear shape. What does it derive from?

Saa: Some say it comes from a lotus bud, some say jasmine flowers, some say from the little leaf-buds that sprout at the joints of bamboo or sugar cane. Some say it's a fire flame.

Alex: However it started out, it's the quintessential Thai design: lopsided and wavy, drawn out to an elegant point, infinitely extendable. But actually, the original of the *kranok* shape is already there in classical Khmer art. You see it in the flanges at the end of draperies and bronze utensils. The Thais just elaborated on it.

Thep phanom
Praying angel
arising from vines.

Taw: It's not just a matter of what's drawn or painted. You have things that are three dimensional, like petals on architectural bases, things that become architectural elements

Vithi: Those petals at the feet of columns, they're protective petals.

Num: Columns fusing with flowers now.

Vithi: Actually, think of *thep phanom*, the premier decorative and protective motif which you see all over Bangkok.

It's the upper torso of an angel, hands clasped in prayer, but the lower body is vines and leaves. A fusion between angel and vegetable.

Num: Sounds delicious. Are we still talking about food here?

Vithi: The ultimate fusion motif is the *chofa* finials of Thai temples. They are derived from the divine elephant-bird, *nok hatsadiling*.

Taw: I thought the *chofa* of Thailand came from Garuda.

Vithi: Not Garuda. It's a triple combination of Bird plus Elephant plus *Nak* (serpent). Temples are believed to be standing in the foothills of Mount Meru, and in these foothills is the sacred forest Himmaphan, full of legendary mixed-up animals.

Himmaphan creatures transform into architecture
left: Theppaksi, angel with human head and bird body
center: Nok hatsidiling, combining elephant, bird, and snake
right: Chofa finial derived from nok hatsidiling.

Alex: You can see statues of some of them in the grounds of the Grand Palace: angels with human heads and bird bodies, half-lion half-male and half-lion half-female angels, or a bird with the upper body of a *yak* (demon).

Vithi: *Nok Hatsadiling*, the elephant-bird, has the beak and wings of the parrot, the curl of the elephant's trunk, and then the tail of the *nak* serpent. It's the representation of three states of animal: earth-bound, water-bound, and air-bound.

188

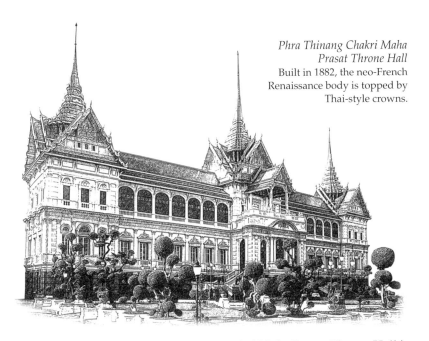

Phra Thinang Chakri Maha Prasat Throne Hall
Built in 1882, the neo-French Renaissance body is topped by Thai-style crowns.

Num: Like the Phra Thinang Chakri Maha Prasat Throne Hall in the Grand Palace, which has neo-French Renaissance-style marble columns and staircases down below, but Thai roofs at the top. It was called at the time, "a *farang* wearing a Thai hat." A European building with *chadaa* (Thai-style crowns) on top – that's quite a combination.

Vithi: There were various ways of adapting a foreign import to Thai style. One way is simply to stretch it out. Like the elongated *prang* [Angkor-style tower with squared-off sides] such as you can see at Wat Arun in Bangkok. We took the *prang* from Angkor and stretched it out to look more like a *chedi* (Thai-style stupa with a tall pointed spire).

Alex: They took the Khmer artichoke and made it into a Thai corn cob.

Vithi: The Khmer prang towers were Shiva *linga*. We stretched out the Shiva *lingam*.

Alex: Made it longer and thinner

Vithi And added texture. Covered the whole surface with shards of broken dishes.

189

Num: Ouch!

Alex: Speaking of Shiva *lingam*, why do the Thais focus so much on Indra instead of Shiva? Indra is supposedly King of the Gods, but he doesn't seem to have been very popular, either in India or in Angkor. However, in Thailand, he's supreme. You see Indra mounted on, or represented by, his elephant, on a hundred temple façades. Both Shiva and Indra hold a trident, so I wonder if somehow the two gods got mixed up. In Thailand even the Shiva *lingam* is more connected to Indra, not Shiva. Especially when it comes to the *lingam*-like City Pillars. In Chiangmai, they call their city pillar *Sao Intrakin* (the "Column of Indra").

Num: Imagine having your *lingam* mixed up with someone else's *lingam*.

Vithi: Indra evolves with the worship of Buddha. Indra is a guide of Buddha. So it comes down to two things, Indra and Rama, and they're closely related. The Rama cult starts out from Ayutthaya already. The Ayutthaya kings were named Ramathibodi, Rama-this and Rama-that. All the way down to Bangkok, it was always Rama, Vishnu's avatar. You notice that both Indra and Rama are green.

Alex You're saying that in the end it comes down to color.

Vithi: That's why King Rama I had to sack Vientiane to get the Emerald Buddha.

Cam: You mean the Emerald Buddha that's in the Grand Palace?

Saa: Yes, it's the most important Buddha image in Thailand.

Vithi: The name of the city of Bangkok contains the word *Rattanakosin*, which means literally "gem of Indra." Since Indra's color is green, then his gem would be emerald.

Alex: So Bangkok is the original Emerald City.

Num: Dorothy, you're not in Kansas anymore!

Vithi: References to Indra occur at least three times in the name of Bangkok.

Cam: The longest in the world, I've heard.

Saa: Yes. This is it: *Krung Thep Mahanakhon Amon Rattanakosin Mahinthara Yuthaya Mahadilok Phop-Noppharat Ratchathani Burirom Udomratchaniwet Mahasathan Amon Piman Awatan Sathit Sakkathattiya Witsanukam Prasit.*

Cam: How could you say all that?

Saa: Most Thais have the name of Bangkok memorized by heart.

There was a pause at this point. I went into the office to do a quick wikipedia search for the name of Bangkok.

Alex: The translation goes like this: "The city of angels, the great city, the eternal city of Indra's gem, the impregnable city of God Indra, the grand capital of the world endowed with nine precious gems, the happy city, abounding in an enormous Royal Palace that resembles the heavenly abode where reigns the reincarnated god, a city given by Indra and built by Vishnukam."

Vithi: The gem, of course is emerald. So the Emerald Buddha had to be brought here.

Taw: The city of *Phra Kaew Morakot*, the Emerald Buddha.

Num: We had the city, so we needed the Buddha. So we got the green Buddha for the green city.

Vithi: But why green? Because it's Rama and Indra. As with Rama and Indra, the core of Bangkok culture, including most of the court language, is coming from Angkor, not from the north.

Alex: When it comes to language, I have this feeling that any word with a *kra* or *pra* sound in it is going to be Khmer in origin. It's common enough that languages have a classical base from somewhere else. Where would we be in English if we only had four letter Anglo-Saxon words, and no Greek or Latin additions like "philosophy" or "circumambulate?" If you look at Vietnamese, Korean, and Japanese, they are filled with Chinese borrowings.

Easily 90% of the words have a Chinese base. But here, most of the foreign borrowings seem to be Khmer, Mon, Sanskrit, and Pali.

Vithi: And Chinese, too. I think you can find plenty of Chinese words.

Alex: Not many that I've noticed, except for food words and counting.

Vithi: You have to look for it. Some words are really hidden.

Alex: Obviously the numbers are from China. But I was disappointed. I came here thinking I could use more of my Chinese. I thought there would be more cognates. But there are very few, so in learning Thai I had to really start at zero.

Vithi: The words might not come from China, but the accent in Bangkok does. The Thai language as it's officially taught, the official Thai language of Bangkok, the Bangkok pronunciation – it's Thai language with *taechiu* accent.

Cam: Who are the *taechiu*?

Vithi: A group of Chinese settlers who came from Chaozhou, a town in the eastern part of Guangzhou. They make up a big part of the Chinese community in Bangkok.

Alex: We haven't talked much about the role of the Chinese in the Bangkok fusion, aside from cooking. But I see Chinese touches everywhere. For example, in clothing. Like the "fisherman's pants" Khun Taw is wearing.

Cam: I think of those as totally Thai. In fact, I thought they were called "Thai pants". What's Chinese about them?

Vithi: The name for them is *kangkeng* (trousers) plus *talay* or *lay* (sea), or plus whatever. It has many names, but in any case, it was the Chinese who brought the notion of loose long trousers. Before that the Thai, at least the men, had loincloths. As for the *talay* "the sea", it's because the Chinese arrived by sea. Nothing to do with fishermen.

Saa: What about women's dress?

Vithi: The ladies, the women of the court wore *jongkrabane* (baggy pantaloons consisting of one long cloth wound

192

around the waist, and then pulled between the thighs and tied at the back). The *jongkrabane*, with roots in India, was the classic costume of Angkor, and the people of the court were more inclined to Angkor style. Before the founding of Bangkok, in Ayutthaya they wore the more Thai-style *phasin* (sarong) but when the court moved to Bangkok, there was a vogue for things Khmer. It felt more classical.

Alex: Like the Romans trying to act like Greeks.

Vithi: They cut their hair short like the Khmer, and wore *jongkrabane* like Khmer.

Alex: But I thought that short hair for women was quite Thai. In the Lanna temple paintings, the women's hair is all very short.

Vithi: No, the short hair came later. The Khmer had short hair before us. The women of the court wore pantaloons, *phajong* (short for *jongkrabane*). At first it was just a simple wrap. And then came Victorian influence. The short hair started to grow a little bit, to look like *dok kratum* (a lotus bud). At that time, this was the height of fashion. Not quite the beehive hair-do "*khunying* look" we're familiar with in Bangkok today.

Windswept hair
The short hair of court ladies began to grow longer into a lotus bud shape.

Cam: What's *khunying*?

Alex: It's an honorary title, like the British "Dame." *Khunyings* tend to be wealthy powerful women, and their hairstyle tends towards "power hair." Great masses of hair brushed back into a beehive or egg shape.

193

Vithi: Back in the Rama V era, it was still short hair, but high. That was the look of a chic Parisienne. The Parisiennes, in turn, had been inspired by the Japanese, geisha hair. The geisha hair swept all before it in Paris. It was the love for things Oriental, whatever Asian country it actually came from, so they had hair bundled on top, geisha style. But in Bangkok, all these ladies of the court, they had very short hair and couldn't manage the full geisha effect. They

1920s Gatsby - Male	1880s Princess	1920s Gatsby - Female
Rajapataen jacket, *jongkrabane*, and hat worn at a jaunty angle.	European mutton sleeves, fan, *jongkrabane*, and white stockings.	Headband, flapper-style blouse, Thai *pasin* skirt and high heels.

couldn't do it, so they put oil or wax and just combed their hair up like that, so it was like a small wave of hair, windblown, windswept. They had the mutton sleeves of a typical Victorian blouse, combined with the *jongkrabane*, and below that, stockings and the shoes.

Taw: Mutton sleeves with *jongkrabane*.

Vithi: This is how fashion went: in the early period, it was the Western top and the Thai *jongkrabane* at the bottom.

Num: So it's the inverse of the architecture. Because in the case of the Throne Hall, the top is Thai, and bottom is *farang*. But for people, the top was *farang*, and the bottom was Thai.

Vithi: It's the Rama V look. Chao Dara Ratsami (Lanna princess who became a consort of Rama V) had long hair, so she could do her hair like the *farang*, in the so-called "Japanese style", although actually it was only Japanese via Paris.

Alex: But Lanna ladies had their own style, the *dok mai wai* (golden hair ornaments in the form of fluttering flowers).

Dok Mai Wai
Delicate flower-shaped hair ornaments made of gold, typical of Lanna women's costume.

Vithi: King Rama V went to Java and saw all the women putting delicate golden flower ornaments, in their hair. He picked up some and brought them back with him, but nobody could wear them, because all the ladies of the court had short hair, except Chao Dara. She had the bun. So he gave them to her, and these became the *dok mai wai* of Lanna.

Taw: The ladies during King Rama VI's reign used to wear Thai *phasin* textiles for their lower garment, but shorter.

Vithi: That was a fashion also. The fashion for that period was Gatsby. Rama VI tried to be a little bit nationalist, so let's wear the *phasin* (sarong), because it felt more "Thai" than the Khmer *jongkrabane*. While the *phasin* used to come down to the ankles, now it came up and showed off the stocking and the shoes. The striped *phasin* like the Lanna one was out; it had to be very plain looking. It looked like skirts. So all the weaving of court textiles tended towards very plain color. Even though they had design and weaving and all that, seen from a distance, you didn't see any stripes, any design on it. Rama VI's

ladies had hair done in waves, and had ribbons going around like that. It was the full Gatsby look, very flat, everything hanging straight down; the *phasin* going down straight, and with high-heeled shoes.

Taw: The Rama VI and VII looks are similar, and then from Rama VIII on, it's full-on Western.

Alex: But then there is a new development, post 1970s, when Queen Sirikit worked to revive traditional textiles such as *madmi* [ikat weave], and she commissioned international designers to design dresses for her using Thai fabrics. She made it *de rigeur* for society ladies to wear these textiles. So now the emphasis is on Western forms and styles, but using Thai weaving, embroidery, and traditional coloring. So it didn't end up as completely Western after all.

After this, we talked about other Thai-*farang* mixtures such as the *rajapataen* (official uniform for civil servants) for men, a starched white jacket with high collar, often combined with the *jongkrabane*. You see it at official functions, or worn by valets in traditional hotels such as the Oriental. *Rajapataen* comes from the word "raja pattern," but it's not Indian; it's Russian, as it turns out. It appeared after Rama V went to visit Czar Nicolas at the Russian court in Saint Petersburg.

After *rajapataen*, we rather lost the thread of thought, so I've cut off the transcription here. Having started with food, we talked about flowers, *kranok* patterns, architecture, the name of the City of Bangkok, and fashion. As usual, when people start talking about Thailand, you run into more and more complications, and it all ends up a muddle. Bangkok is like a *thep phanom*, a smiling angel with hands clasped in prayer above – and twirling vines and leaves below.

Everything is negotiable. One thing that did come across consistently was "fusion," and the more I think about it, this would be key to Bangkok's appeal. Right at the beginning of my Thai adventure, when I was spending time in the 1970s with the Anglo-Thai Savetsila/Birds and the British educated Svastis, I was dealing

with one aspect of that fusion, which is not only between cultural forms, but between peoples. The big fusion, the one between the native Mon-Khmers and the Thai-Chinese, goes on and on. But there's also a fusion with the West, and in some cases, Westerners. Bangkok is full of mixed-blood Western-Thai children and their families.

Fusion is of course not unique to Thailand. Every civilization on earth has absorbed influences from elsewhere, even the great mother cultures of China and India. However, maybe due to their sheer size, in China and India it's harder to see and feel the foreign influences even when they're undoubtedly there (especially in India, with two centuries of British colonization on the subcontinent). The foreign influences make up what in Japanese cooking they call *kakushi-aji* ("hidden flavor"): a dash of spice within the overall soup that you can hardly identify. They're just not strong enough to make a difference.

Japan has absorbed plenty of foreign influences, but it does this by watering the foreign imports down, until they're denatured, lose their original character and come to feel properly Japanese. Japan is an oyster, coating foreign objects until they become pearls – exquisite, but all equally round and smooth. It's hard to see the shape of the grain of sand inside.

Rajapataen
Royal pages, ca 1920,
wearing *rajapataen* jackets
and *jongkrabane.*

In Thailand, in contrast, somehow you can still see and taste the original ingredients, as in Thai food: sweet, salty, sour, bitter, crispy, and soft – all in one mouthful. Or like Bangkok's Grand Palace:

197

Khmer, Javanese, Lao, Lanna, Thai, Chinese, Indian, Sri Lankan, and European, all in one view. Thailand is a bowerbird, collecting bits of ribbon, twigs, iridescent insect wings, blue bottle caps, all sorts of shiny and pretty things, and weaving them together as decoration for its nest.

In the end, that's probably why I made this city my home. Japan, despite its ready adaptation of foreign things, remains resolutely Japanese. It's part of the strength of the culture, because the Japanese have carefully preserved their core traditions. Think of the many changes that Thai women's dress has gone through, from *phasin* (native Thai sarongs), to *jongkrabane* (Khmer-style pantaloons) with mutton-shoulders, and finally *madmi* silks sewn into Western fashion. The kimono, during all this time, remained remarkably stable. The sense of purity that results has much appeal to foreigners and Japanese alike. In Japan, it's easier to get to the roots of things.

Yet, for all the great achievements of Japanese culture, one quality it cannot lay claim to is *saeb*, the word that Vithi used, the Isarn word for "delicious". Delicious plus zing. The zing comes from the lack of purity, from substitution, invention, and play – all those *sanuk* things that make up the Thai fusion.

Novelist Lawrence Durrell used a slew of jaw-splitting adjectives to describe Alexandria, another fusion-city which was the playground of the Mediterranean in the 1930s and 40s. The same words could apply to Bangkok today. "The country is still here," wrote Durrell, "everything that is heteroclyte, devious, polymorph, anfractuous, equivocal, opaque, ambiguous, many-branched, or just plain dotty. I wish you joy of it."[18]

FLOWERS

The whole world knows of Japanese *ikebana* and Chinese *bonsai*, but it comes as a surprise to many people that Thailand has its own complex flower tradition. People live here for years and never notice it.

Flowers have long been an interest of mine in Japan, and I was a bit disappointed when I began revisiting Bangkok again after 1989. Thais didn't decorate their homes with flowers in vases as I was used to in Japan. Flower decor in public spaces, like hotels, tended to copy Western floral bouquets and to be masses of things stuffed in a jar, or they mimicked the "Balinese spa look," with petals strewn in basins of water and scattered over bed covers. There seemed nothing very Thai about flower arrangements in Thailand.

Then, in 1990, I made the first visit to my partner Khajorn's village in the northern province of Phayao. As a ceremony of welcome, the villagers prepared for us a *baisri* flower offering. Women and children gathered round, cutting and folding banana leaves into intricate patterns which they linked together into a structure – a sort of tower with wings or claws on the side. Along the edges of the wings they pinned tiny white flowers, and surmounted the tower, which was about 30 centimeters high, with an egg and a spire of more little flowers. The village elder intoned prayers, and at the end of the ceremony, all the villagers tied *sai sin* (sacred threads) around our wrists.

That was the first time that I witnessed Thai flowers in action. Still, I saw the *baisri* as an upcountry custom, not as something

important to Bangkok as well. The turning point came almost a decade later, when I made my first experiments in creating a Thai arts program for a group of Japanese architects in 1998. Suan Pakkard Palace offered me their grounds to use for a one-day program. Suan Pakkard, created by Prince Chumbhot, remains today as Bangkok's premier example of a princely estate, complete with raised Thai-style pavilions, an art collection, the "Lacquer Pavilion" (a gold-lacquered building, unique of its kind, brought from Ayutthaya), and a modern art gallery. I sought out teachers of *Maarayaat* (Etiquette) and Khon (classical dance). Based on what I was familiar with from Japan, I also included Flowers.

The problem was: what would these "flowers" consist of? I already had my doubts about Siamese gardens. As far as I could see, these mainly consisted of *bonsai*-like plantings in pots. Except that, unlike *bonsai*, where great care was taken to make them look poetically natural, as if they had escaped from a hanging scroll, in Thailand they looked more like Western topiary. Everything was trimmed to look like an ostrich or an elephant. Pimsai Amranand, mother of my friend Ping who had attended the Oomoto seminar, was a great expert on gardens. She wrote, "Whereas the Japanese tried to imitate Nature, the Siamese tried to make their trees into odd, fantastic shapes. They had names for each style in which a tree could be clipped. Sometimes they trained and clipped the branches, and sometimes they used the roots because these looked more grotesque."[19]

Nunie, my unofficial "Thai auntie" with whom I spent so much time in the 70s, was Pimsai's sister. I asked Nunie to give the Japanese group a talk about Thai gardens. Nunie walked us through the Suan Pakkard grounds, pointing out how this tree was known for its scent, that one for its medicinal quality, the one over there because it appeared in a classical poem; while other plants were valued as roots and herbs that could be used for Thai cooking. That said, I couldn't quite see what was Thai about the layout of the garden, since it basically consisted of trees surrounding a wide lawn of British-style mown grass. Later I found that Pimsai had already stated the dreaded truth. "Except for this feature of dwarf trees

trained into special shapes, there is really no such thing as a Thai garden," said Pimsai. "The best people could do, is, while laying a garden out according to Chinese, Japanese, and English landscape-gardening principles and ideas, they have tried to have around the house plants mentioned in Siamese poetry."[20]

For the grand finale of the Suan Pakkard program, I engaged Paothong Thongchua to cater the dinner. Paothong is one of the colorful figures of Bangkok's cultural renaissance of the late 90s and early 2000s. A professor at Thammasat University, he's a scholar of textiles, a caterer of gourmet cooking, an expert on flowers, an impresario of cultural events, and owner of a string of antique shops and boutiques. Plus, he was a model in his younger years, and is still considered to be one of the better looking men of Bangkok – which is no small part of his appeal to upper-class *khunying* ladies.

Paothong's dinner, served on the lawn of Suan Pakkard Palace, was the surprise event of the day. Each plate came accompanied by rings of folded banana leaves, layered and folded like the *baisri* I'd seen up north. The dinner display featured a variety of *phuangmalai* (garlands) and several *baisri* for the dance performance that concluded the evening. These *baisri* were infinitely more complicated than those I had come across before. So intricate and fascinating were Paothong's floral creations, that I took home some of the "plate ruffs", pressed and dried them, and I have them to this day.

What I realized at that dinner was that I had been looking in the wrong place for Thai flowers. I thought they would look like flowers. But actually they look like geometry. Flowers and plants here, as Pimsai had noted, are raw material for the creation of fantastic shapes.

Every Japanese traditional home has a *tokonoma* alcove, and the alcove must always have flowers in it or the house feels strangely empty. In Thailand, there is no *tokonoma*; no place to put flowers in a home. I think it might be that in a land of eternal summer, always blooming with lotuses, orchids, and jasmine, there was never any reason to bring flowers indoors. In any case, after that first Origin

event, I changed the focus of the flower component of the program – away from gardens and room decor. Those concepts were irrelevant in Thailand. I asked some teachers to come over and show us how they create the *baisri*.

What emerged in the Origin programs was that the basic structure of the *baisri* is a *krathong*. The word means a "leaf vessel," and it refers to a bowl or container made from folded and cut leaves (usually banana leaves). These can be as small as a three-centimeter square container for a Thai sweet, to extravaganzas of leaves folded into cones, pin-wheels, and sunflower shapes, carved fruit, and threaded flowers, many feet tall. The folded leaves surrounding Paothong's plates at the Suan Pakkard dinner event went right to the origin – *krathong* are basically vessels.

The *krathong* is a quintessentially Southeast Asian object, unknown in China and Japan, but found everywhere from Thailand south to Indonesia. In Bali, you see local versions of *krathong*, three or four inch little trays made from coconut leaves containing a few blossoms or petals, set out every morning as offerings along the roadside. The *krathong* seem to have grown naturally from living in the southern rainforests. The tropics produce plants with tough waxy leaves, from the large pendulous leaves of teak trees, to coconut, banana, taro, lotus, and savory leaves such as *bai toei* (pandanus). They lend themselves to wrapping and covering things. For example, the thatch on the roof of Thai farmers huts is typically made of long overlapping strips of *bai jak (nipa* palm leaves), while an overlay of dried teak leaves, looking like big brown tobacco leaves, covers windows and gates.

These leaves, which are fairly waterproof, and therefore can be used as wrappings to keep the contents dry, came to feature in food as well. Banana leaves envelope Thai sweets, and *bai toey* leaves wrap grilled chicken.

Thailand benefited from the especially virtuosic qualities of banana leaves: wide, water resistant, foldable like paper, they can be cut into strips or folded into patterns like origami. *Krathong* "leaf vessels" thus form the basis of "flower arrangements," not flowers per se, which are merely pretty additions to the folded leaf base.

Here Thailand diverges far from the flower traditions of North Asia. In China, flower arrangement began with blossoming trees such as peaches and peonies, and this led in time to miniaturizing trees themselves: *bonsai*. The success of an arrangement or a *bonsai* depends on the beauty of the stems or branches on which the flowers are blooming. If you look at any old Chinese painting of a home or palace interior, you will see flowers in a vase, or a *bonsai* in a corner, and the fascination lies in the calligraphic line of the branches.

Japanese *ikebana* centers more on cut flowers and stems, rather than potted *bonsai* as in China, but *ikebana* also concerns itself with lines. Although not symmetrical, there's a center branch, a left, and a right, and these should balance each other. As a reaction to *ikebana*'s emphasis on perfect alignment, the tea masters came up with a different approach. They favored humble wild-flowers and grasses, which they threw haphazardly into bamboo baskets. But none of this is like a *krathong*. You're still looking at stalks.

Basic kratrong
A simple *kratong* vessel made from a piece of folded banana leaf.

You're also looking at vessels. The flower art of North Asia is bound tightly to the art of containers, so much so that you can hardly think of one without the other. Again, in those Chinese paintings, the artist lavishes as much care on the shape and color of the vase as on the flowers themselves. Tea masters in Japan keep large collections of containers made of woven or cut bamboo, glazed or unglazed pottery, bronze, or glass, which they use according to season, the type of flowers, or the status of the occasion. The container comes first, and determines what shape the flowers will take.

With *krathong*, there's no need for a container because a *krathong* is a container. You start on a flat plate or a bowl (or a slab of sliced banana tree trunk), and you build upwards. It's incremental, put together leaf by leaf, folded edge by folded edge, like the bricks forming the indented pedestal of a Khmer temple.

Baisri are, in fact, a sort of architecture. In the flower class of the Bangkok arts program, we learn that the architecture being created, whether large or small, is always the same: a re-creation of sacred Mount Meru, a pan-Asian theme that stretches from India (where it originated) through China and up to Japan. As codified in the *Traiphum* (Three Worlds Cosmology), Meru is the center of the universe, at the peak of which sits Lord Indra with his trident. Around the central mount lie four continents, encompassed by four seas, and encircling them, the cosmic wall. In *baisri*, rising cones and multi-layered extensions of folded bamboo leaves create the details of Mount Meru and its surroundings. One finishes it off with embellishments of flowers, garlands, and symbolic foods such as cucumbers and eggs.

This is the layout of Angkor Wat and also the layout of Wat Arun in Bangkok, which, with its flowery surface of colorful crockery and folded indentations, actually looks like a giant *baisri*. Even the simplest little *baisri* is still a Mount Meru, and as such something vaguely religious, a shadow of Indra, hovers over it. Every time someone creates a *baisri* offering, they're rebuilding a palace or a mountain that symbolizes the mystic center of the world.

Baisri and their related art, flower garlands, grow from the repetition of many tiny details – a typically Thai approach to art. You can see the same approach in benjarong ceramics, where an artisan painstakingly covers the entire surface in ring after ring of small flower-like patterns combined to make one large geometry.

The same thing happens with *baisri*: leaf folded on leaf, interspersed with bits of red, white, purple, and yellow from flower petals or tiny buds. Eventually the ensemble grows into an elaborate organic form. It's as if Thais were stitching leaves and petals together to form huge imaginary flowers. Unreal flowers, such as never were seen on land nor sea.

Toshiro Kawase, Japanese *ikebana* master, explained to me the essence of Japanese flowers: "Artifice piled on artifice, giving you in the end the illusion that it's natural – that's art." In Thailand, you also pile artifice on artifice, but the aim is to produce an object that's way beyond nature. Flowers from an alternate universe.

Making a baisri flower offering
left: components made from
folded banana leaves.
right: completed *baisri*, central
spire topped with hard-boiled
egg and flowers.

The Thais apply their taste for turning nature into fantasy even with a single flower, when they take a lotus bud, and fold back the petals, one after another, until the luscious interior of the flower is revealed – surrounded by a collar of folded petals. No lotus ever naturally grew this way.

People vie in national competitions for the finest and most elaborate *baisri*, and at certain Bangkok temples and celebrations you can see truly magnificent ones that must have taken dozens of people hours to create. Within the Grand Palace, a group of ladies labor daily on producing hundreds of floral objects consumed by Bangkok's many royal establishments.

On the street, garland sellers feed a voracious public appetite for offerings for homes, altars, portraits of the King, temples, and shrines, as well as *tuk-tuks*, cars, and taxis, where you will often see a garland dangling over dashboard. Flowers feature in dance, where Khon (classical theatre) performers suspend garlands from their crowns; and explosively, once a year, on the autumn festival of Loy Krathong, when millions of people float *krathongs* (many made at home) in rivers, canals, and lakes.

Folded lotus buds
left: Lotus bud
with outer petals
folded under.
right: Folded lotuses
float in a basin of water.

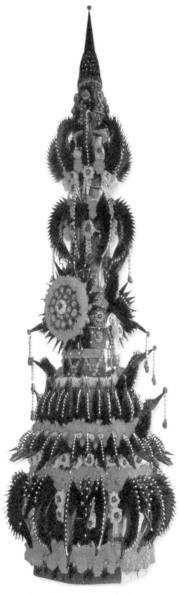

Grand baisri flower offering
Created for 2002 ceremony at
the Shrine of the City Pillar.

On Loy Krathong night, as you wander the streets you come across a bewildering variety of *krathong*, each more elaborate and colorful than the next, with tall central spires, flanked by spiky and feathery additions. The only other Asian nation with a similar love of flowers is Bali, yet compared to Bangkok's attention to detail and its wild flourish of originality, Bali finishes only a distant second.

Closely related to flower arrangements would be "food carving", beloved of tourist restaurants. Cliché though food-carving may be, it's another grace note, and can rise to a virtuoso level. Here too, the idea is to turn vegetables and fruit into something else. Carrots masquerade as marigolds, and tomatoes blossom as roses; pineapples reveal themselves as dragons. Even the slicing of coconuts into five-sided icosahe-drons (with lids), which you see on the street or on supermarket shelves, is part of this unstoppable instinct to turn one thing into another.

I can't think of any other city where arrangements of flowers (which includes leaves, fruit, and vegetables) play such a role in

206

daily life. Not that Bangkok could ever be called a "garden city". That name belongs deservedly to Singapore, which plants trees along roadways and then tends them with loving care, unlike in Bangkok, which has spent the last few decades busily cutting down trees and lopping off branches. In the place of greenery, Bangkok is busily erecting concrete structures that quickly blacken with mold in the damp tropical climate, making them appear even shabbier than they really are. Even the elegantly designed SkyTrain is looking slightly worn after its first decade. Nevertheless, sprinkled over the grimy clutter of the city, is a fairy dust of *baisri*, *krathong*, *phuangmalai* garlands, and carved fruit.

Loy Kratong night
A group of girls get ready to float an elaborate kratong on the Chao Phraya River.

As we can see from the word *baisri*, which is originally Khmer, Thai flowers originated outside Thailand, linking to ideas from India (via Java and Angkor) that are thousands of years old. Yet while the origins are ancient, Thai flowers have been the most successfully modernized of all the arts. This is because of the structural nature of Thai flowers, like playing Lego with natural materials. Out of Bangkok comes one of the world's pre-eminent flower artists, Sakul Intakul. Sakul trained as an engineer, and he uses this as the basis for his modern approach to tropical flowers. Sakul takes materials like banana leaves and orchids, and builds them into "structures" that can fit in with either a minimalist apartment or a vast banquet table for state guests. You can see his signature work in the lobby of the Sukhothai Hotel: a tall

framework of open bronze rectangles, inspired by the pagodas of Sukhothai, inset with changing arrangements of lotuses, rushes, and tuberoses.

Flowers tell us instantly where we are in the world. Hawaiian plumaria, Scotch thistles, Dutch tulips, Japanese cherry blossoms, Chinese peonies – they're more distinctive, because less transferable, than man-made objects. They can only exist in certain temperature, seasons, and rainfall, which, in the case of Bangkok, is the tropics. This brings us to a definitive aspect of Bangkok life, so obvious that writers and guidebooks mention it only in passing: It's hot.

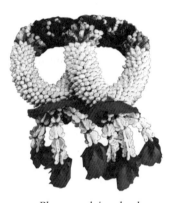

Phuangmalai garlands
Garlands are a symbol of respect, offered to the Buddha, monks, and revered elders.

It's even hotter than it should be. Singapore manages an average temperature lower than Bangkok, even though it's several hundred kilometers south and sits right on the equator. The high thermometer readings arise from the swampy delta in which Bangkok sits, not quite close enough to the sea to be cooled by ocean breezes; plus a "heat island" effect caused by the cutting of trees in the city center and replacing them with reflective glass and concrete. Residents here take the heat for granted, but it can come as a shock to a visitor. My friend Dui Seid, an artist from New York, fell in love with Bangkok and contemplated a move here. He was on the point of renting an apartment when he realized that Bangkok is too hot; he just couldn't stand it. Dui now works out of Tokyo.

One of the first things that every tourist does in Bangkok is to visit the Grand Palace. In its museum you can see the three sets of golden raiment with which the King adorns the Emerald Buddha: one for each of the three seasons: hot, rainy, and cool. Having just three seasons is alien to Westerners, and verges on shocking to Japanese, for whom the concept of four seasons has almost mantic

value. Many a scroll or screen painting is divided ritually into spring, summer, fall, and winter, and leaving one season out feels not right.

The three seasons themselves are just an artificial distinction in Bangkok because there's really just one never-ending season (warm), with varying degrees of heat and damp. In November and December the temperature dips now and then a few degrees, and on those days the locals gambol in long-sleeved shirts, jackets, and scarves. It's the only time they can show off their winter fashion. My staff all come down with terrible fevers and colds.

When rain comes it's never the slow drizzle that hangs darkly over Tokyo or London. Suddenly the heavens open and giant droplets of rain fall so fiercely that you can hardly see more than a few feet ahead. Within minutes the streets are flooded (although Bangkok seems to be draining better these days). I remember once after an

Contemporary baisri
Sakul Intakul's modern intepretation of *baisri*.

evening out on the town with the dancer Zul, returning late to my apartment during one of these storms. His hot Malay blood stirred by the tempest, Zul sang wildly as his car careened down Sarasin Road behind Lumpini Park, until the water, which had flooded to the point that it was leaking through the floorboards, rose so high that the car finally gave up and stopped. We sat there, Zul still singing lustily, until the waters receded.

While the rain is pouring down, you have no choice but to sit it out. An hour or two later the storm winds down, then all a sudden the rain lifts, and the city goes back to normal.

The heat means that Bangkok is not much of a walking city, despite the delights promised by many a Bangkok guidebook. There's not enough shade and a few hours under the blazing sun is enough to leave you exhausted and wilted. Thais seem to have adapted to it. I'm always amazed at how crisp and fresh my Thai staff look after they've been out on a hot day; five minutes outdoors and the sweat is running down my face, and my clothes are hopelessly wrinkled.

The Japanese horror of the idea of just three seasons points to something important, namely life in the tropics does differ fundamentally from the world's temperate zones. I believe that the simple fact of the heat lies behind much of what people most hate or most love about Bangkok.

The legendary bad traffic, for example, is in fact not much worse than Tokyo, but sitting in that traffic for hours in the glaring sun makes it seem much worse. On the other hand, apartment buildings with rooftop pools, breezy restaurants at the top of skyscrapers, the marketplace of Chatuchak with thousands of open-air shops, streets lined with vendors stalls selling anything you want to eat at any time of day or night – it's all only possible because of the heat. My New Zealand friend Cameron says, "If there are coconuts and bananas with long wide green leaves and it's warm – I could live anywhere that has those things." Add an extra wintry season, and it would kill all the *sanuk*.

The only way to beat the heat is to avoid going out in the afternoons, if you can. When we ran our benjarong shop on Sukhumvit Road, we found that the foot traffic (at least of foreign shoppers) picked up sharply around dinnertime. When the sun goes down people venture out on the street. In the old days, the Palace took this into account by scheduling audiences in the early pre-dawn hours, when the air is coolest, and it is said that much important business in the Palace is still conducted at night and in the early morning.

It's no accident that much of the fun and celebration in Bangkok takes place at night, whether it's the fireworks of New Year's Eve, the waving of candles at Sanam Luang for the King's birthday, or the twinkling lights of the floating *krathongs* on Loy Krathong. One of the hallmarks of Bangkok is good building illumination. Restaurants and hotels light up pathways and windows with a sophistication you would find in few cities of the world. People take pains to create a special effect, from the candle-lit niches in the street-side wall of The Face restaurant on Sukhumvit Soi 38 to the avenue of trees draped in fairy lights leading from Sathorn to the Sukhothai Hotel. It works because Bangkok as a whole is a rather dark city, so good lighting stands out. The drab concrete-and-wire conglomeration that makes up most of the city disappears into the shadows.

Recent governments have been cracking down on Bangkok's late night ways, on the grounds that going to sleep early is a hallowed Thai tradition. Actually, it's a hallowed Chinese businessman's tradition. Bangkok, and royal capitals before it, always functioned most effectively at night.

My favorite market in Bangkok trades mainly at night. Naturally, it's the flower market at Pak Klong Talad. Plants do not well survive the heat of the day, so, like the palace courtiers of earlier days, flower vendors do most of their business after the sun sets. Pak Klong Talad is huge, running for several city blocks, surely the largest daily flower market in the world. This is where you will see piled up on the curbside the flowers that reappear across the city the next morning as *baisris* in temples, and floral arrangements in hotels, shops, and homes.

When I give a party at my apartment as Soi 16, I go out the night before to Pak Klong Talad to buy flowers. Vendors start opening their stalls in the afternoon, but the market really comes alive after nightfall, and is at its best around midnight. Heaped high are bundles of lotuses wrapped in wide lotus leaves, piles of orchids in every color (not only basic white and purple, but dyed day-glo oranges and blues), bunches of roses large and small bound in newsprint, plastic bags of jasmine kept cool with crushed ice,

hanging curtains of strung marigolds, clusters of leaves (banana, *bai toei*, staghorn and other ferns, taro, cat's tails), antheriums, chrysanthemums, dahlias, gardenias, and towering ginger plants two meters high with pink and orange spiky flowers dangling down on droopy tendrils.

Amongst this "urban jungle," ladies set up stands where they weave flower petals into garlands simple and complex. You can buy slabs of chopped up banana trunk (the traditional base of a *krathong*), decorative fruits such as dragon-fruit and squashes, and all manner of forest produce in the form of twisting vines, or *krajiab* ("rosella"), a carnivorous purple flower that looks like it came out of *The Little Shop of Horrors*.

I bundle all this into one (or two) taxis, bring it home, and then spend the rest of the night arranging it – which in Thailand means cutting, folding, bending, or floating in water basins. Friends come over in the middle of the night to try their hand at it. One of my Thai staff, a young man named Soe, has become our resident Thai flower designer. In Soe you can see the Thai decorative instinct at work. Like Sakul, he approaches flowers as raw material for a geometric pattern or structure.

Soe fills a white bowl full of water to the brim, and in the center sets a white lotus with folded-back petals. He surrounds that with a floating layer of orchids, rose petals and four slim pandanus leaves, almost like setting a jewel in a ring. Each arrangement is like a new turn of a kaleidoscope, with petals and leaves shifting to reveal new patterns, each one a weird new flower in its own right.

Soe's sunflowers gone psychedelic hail from the mythical Himmaphan forest. Full of hodge-podge flora and fauna, Himmaphan lies at the foothills of Mount Meru. Sometimes I reflect on why it is that the Thais chose Himmaphan, above all other places, as the ideal locus for their art. Himmaphan exists as a concept in India and China, but nobody paid much attention to it. Yet in Thailand, out of all the many realms of heaven, earth, and hell described in the *Traiphum* cosmology, artists chose Himmaphan as their favorite place to sculpt and paint. The exotica

of Himmaphan surround us wherever you see traditional decor: elephants with wings, deer with demon masks, horses with fins, angels growing out of vines, hallucinatory flowers. Somehow the mythical forest suited the Thai temperament. It's a moderate place: out of this earth, but not quite heaven. It's not the lonely high peak of Meru, but a colorfully populated fantasy world on the way up.

Professor Vithi remarks: "Himmaphan allows many things to be possible. You can be angelic or sexy, crude or refined. It could happen in Himmaphan. Because it's an intermediate, an in-between transition world. Any concoction is acceptable there. It's a wild place. Bad and good, beautiful and ugly, together at the same time. Vicious animals can look graceful, sexless trees can be very

Imaginary Himmaphan flower
Floating arrangement by Soe: folded lotus at center, surrounded by rose petals, orchids, symbidium, tiny *dok phut* buds, and four pandanus leaves

sensual. Like the *Ton makariphon* tree that bears fruit in the shape of ladies. You'd better enjoy them fast, because they wilt away after just one day. The *rishi* (sages), it is said, especially enjoy this fruit, which is one reason why the *rishi* are to be found in Himmaphan."

The next night, when guests arrive, the house has taken on the "Thai look." It also takes on the sweet smell of *jampi* and *jampa*, large and small varieties of fragrant flowers originally from India.

As Pimsai and Nunie noted long ago, the Thai approach to flowers is to focus on scent, taste, and medicinal qualities. Thai flowers are to be sniffed as well as seen.

Over by the windows stand the tall ginger stalks with drooping blossoms; garlands dangle in front of things with spirits in them such as dance masks and Buddhist paintings; Soe's colorful creations bloom on stands and tables. During the evening some of the guests might reveal themselves as composites of graceful animals and naughty angels. For one night, with a little extra help from music and wine, we can believe that we're dwelling in Himmaphan.

Not that we ever really left it. Vithi's vision of Himmaphan feels much like everyday Bangkok.

THE DANCE OF
YIN AND YANG

Whenever I see any sort of dance – ballet, Kabuki, Thai Khon, Chinese opera, Hawaiian hula, auditions for *Dancing with the Stars* – it makes me feel I've had a wasted life. I think it's because I've never developed any skills in sports or physical activities. Dance – watching it, because I could never perform it – has been a lifelong passion.

In Japan, this led me into the Kabuki world, and I spent years lurking around the backstage soaking up everything I could about dance, costume, music, and the actors themselves. In Bangkok, I discovered dance rather late. Like many tourists, my first memory of seeing Thai dance is of the girls who perform at the Erawan Shrine to Brahma. Later a friend took me to see the dinner show at the Oriental Hotel restaurant across the Chao Phraya River, and this is when I first heard the word "Khon," Thailand's old masked drama, centered on the *Ramakien* epic. The shimmering costumes and headdresses lent these dances a glamorous air, but I couldn't quite grasp the intent of what seemed like just pose after pose.

Sure that I was missing something, I went to see formal Khon at universities and gala shows at Sala Chalermkrung Royal Theatre, complete with laser beams and dancers flying through the air. Yet, even with all this stagecraft, Khon never seemed to lose that static quality. Feeling guilty as my eyelids began to droop, I looked around and noticed plenty of other people nodding off to sleep too.

It was only after 1998 when I rented Khun Santi's complex of wooden Thai pavilions at Ladphrao, that Khon finally made sense

to me. One evening Anucha Thirakanont brought his dancers and puppeteers to perform on the wooden platform at the Ladphrao house. He also brought with him the dance master Khru Kai, and costume designer Peeramon Chomdhavat, and this time, Khon worked its magic.

Khon's stately gestures certainly don't captivate like the lively twists and leaps of Balinese dance. Arising inside the palace, Khon was performed in confined spaces before a small audience so close that they could almost touch the artists. As a result, all the effort went into restraint and refinement. The eye is drawn to tiny detail, whether it's threads of embroidery on the costume, or the fine poise of a wrist and the turn of the head. That night, seeing Khon in the intimate setting of a small wooden pavilion, I finally could understand why the kings and princes of old took such a passionate interest in their dance troupes.

I set out to learn more. It wasn't easy. In Japan, there are clear roadmaps to the arts. When you go to see a Kabuki or Noh performance, you'll receive a detailed program at the door, with the history of the piece and a synopsis of the story. At Kabukiza Theater in Tokyo, they lease "earphone guides" that explain, as you watch, the fine points of costume and gesture, as well as the background of the actors and their families. In Thailand, by contrast, one sets out into unknown territory without a map. English-language explanations rarely get beyond basics, such as "The one wearing a white mask is the monkey Hanuman," and when they do, it's largely unintelligible. Mostly there is no explanation in any language, even Thai.

Nor is Khon easy to see. The schedule of the National Theatre is a closely guarded secret, next to which the whereabouts of Bin Laden are probably easier to discover. There is no regular venue, such as the Kabukiza, where one can reliably go and see Khon, so finding it is a matter of hit and miss. The old Sala Chalermkrung Royal Theatre near Chinatown periodically stages elaborate Khon productions that are sometimes announced in the papers, sometimes not. Or they publish an article about a Khon performance, beautifully illustrated – the day after.

That's the situation for classical Khon. At the same time, traditional-style dance is found everywhere in Bangkok. Dance, which once served royalty, now caters to tourists. The city overflows with dance performances, which you can see as dinner shows at restaurants and hotels, or as a Las Vegas-style spectacle at Siam Niramit. All of these represent themselves as hallowed "Thai tradition."

Khru Kai and Peeramon Chomdhavat became my guides to finding the real thing. Their partnership dates back to the early 2000s, when Peeramon (nicknamed "Big") set out to revive old costume. Big was an unlikely candidate for this role, since his background lay in Western ballet, not Khon. However, in addition to being Thailand's leading male ballet dancer, Big had made a career in contemporary dance and choreographing stage production. He had loved Thai dance since childhood, and it disturbed him when he saw the stiff and tinselly-looking costumes of present-day Khon. He knew it must once have been better.

Khru Kai (Surat Jongda) hails from Khonkaen province in the northeast (the word Khru, derived from the Sanskrit *Guru* meaning "teacher" or "master" is used as an honorific for artists or professors). Kai started dancing at 14, came to Bangkok at the age of 19, and rose eventually to become a teacher at the Bundit-patanasilpa Institute, specialty college for dance and music.

Big teaches contemporary dance at the same institute. Big and Khru Kai became inseparable partners, and together they researched old photographs and pored over jewelry, masks, and brocades surviving in private collections. Big began embroidering in fine detail, with gold and silver threads, patterns inset with iridescent beetle wings. Eventually Big founded a dance troupe *Arporn Ngam* ("Beautiful Costume") and with Khru Kai's dancers he began to turn Khon onto a new path. It was those beautiful costumes that I saw that first night at Ladphrao.

Under Big and Kai's tutelage I went to see quite a lot of Khon, and I learned that the very thing that seemed so sleep-inducing to me at the beginning – the slowness and repetition – is key to Khon's appeal. Khon dancers enjoy only a limited repertoire of movement.

Over centuries, the artists evolved a small set of stylized forms of how to sit, stand, and walk, which were thought to epitomize courtly beauty, and the dances consist of an endless series of variations on these few forms. In a sense Khon really is pose after pose.

Noh drama in Japan gave me a way to think about it. Noh drama, like Khon revolves around a small set of *kata*, meaning "forms" or basic poses. The repetition of these *kata* in subtly varying tempos can lead the viewer to an almost hypnotic state, which they call *Yugen* ("mysterious beauty beyond forms"), for it was believed that the Noh stage was a numinous place belonging to the gods, not to people. Khon likewise leads the viewer – if he or she can stay awake – into a mythical realm. The closest Thai word to *Yugen* would be *Khloem*, a sense of being drawn into something slow and gentle, a day-dreaming state not quite in this world.

While similar in their slowness and abstraction, Noh and Khon, however, part ways when it comes to their relationship with the past. Noh drama is one of the world's most stable and conservative forms of drama; at a prescribed moment in the dance the *kata* for the raising of the fan has hardly changed an inch in three hundred years. On the other hand, Khon as we see it now differs widely from Khon of the early 19th century, and we can only guess what form it took before the fall of Ayutthaya.

As Big and Khru Kai struggled to explain the niceties to me, I gathered that in the 19th century there had once been a clear difference between Khon proper, which was masked drama performed by male troupes inside the palace, and two additional types of mostly unmasked drama, *Lakhorn nai* ("inner drama") and *Lakhorn nohk* ("outer drama"). All-female troupes performed *Lakhorn nai* inside the palace, and all-male troupes performed *Lakhorn nohk* outside the palace. However, by the mid-20th century Khon and *Lakhorn nai* had merged, producing what most people call Khon today. The details of who wore a mask and in what era, or which genres men or women performed and in what venues, are all hideously complicated. What did come across is that the art form, far from being unaltered from antiquity, has been in constant flux, with major changes taking place quite recently.

At first Khon seemed "special", not much related to the modern city. But over time I began to see its typical forms and costumes in almost every situation that's officially "Thai," beginning with the *Churning of the Sea of Milk* installation at Bangkok International Airport. Actually, it's difficult to get through a day in Bangkok without running across some reference to dance, either an advertisement with a model wearing a golden Khon-style crown, or a tourist poster of dancers posing in front of ancient ruins. From this point of view, Khon carries far more weight in Thai culture than Kabuki or Noh drama do in Japanese.

Khon's pivotal role traces back to ancient India. Thailand, after all, belongs to "Indianized Southeast Asia," in contrast to Vietnam, Japan, and Korea, where China exerted the primary influence. For dance this makes a drastic difference because India, unlike China, loved the human body.

In India, naked male and female dancers cavort in temple friezes; Lord Shiva whirls ecstatically with one leg raised as Lord of the Dance. Dance and the body are divine. This was not true in China or Japan, where the human body disappears in layers of robes and kimono, and dancers rarely feature in high art. In the old days the Chinese and Japanese authorities viewed dance performances as vulgar. They ranked Peking Opera performers and Kabuki actors as lower than beggars.

Reverence for dance – the idea that dancers brought divine sanction to the court – went from India to ancient Java and Cambodia. Heavenly dancers feature at Borobudur and hundreds of glorious *apsara* pose elegantly on the bas-reliefs of Angkor Wat. Along the way, possibly beginning in Java, something new happened: the fingers bent backwards. Thailand later carried this to the ultimate extreme, with the *fon leb* fingernail extensions that so typify Thai dance in the eyes of the world. There are many explanations for the curved fingers, but the best seems to be that they symbolize that the dancer is not human; he or she is an angel.

Emphasis on hands and fingers is perhaps the single biggest difference between dance in the West and the East. Think of ballet, and basically hands are just extensions of the body. But in India,

each finger gesture, or *mudra*, expresses the power of a god. These *mudra* speak to us like code-words in a language. As Indian dance moved east and north, and the fingers bent backwards, most of the meanings of the *mudra* disappeared. But the emphasis on curving fingers remained, and this is what gives dance from Japan down to Java its distinctive lilt.

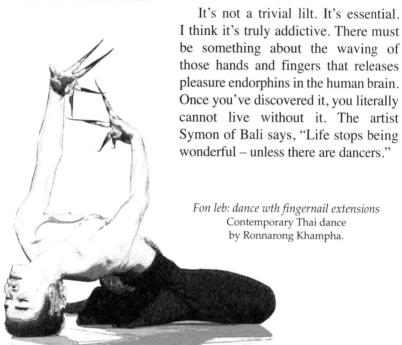

It's not a trivial lilt. It's essential. I think it's truly addictive. There must be something about the waving of those hands and fingers that releases pleasure endorphins in the human brain. Once you've discovered it, you literally cannot live without it. The artist Symon of Bali says, "Life stops being wonderful – unless there are dancers."

Fon leb: dance wth fingernail extensions
Contemporary Thai dance
by Ronnarong Khampha.

We don't feel this so much in the West, where dance has become something special, seen only on a big stage. However, in Japan and in Thailand, dance remains a part of life. At Japanese festivals, especially around the *Bon* period in July and August, millions of people get dressed in cotton kimonos and dance the night through. In Thailand, students dance for the annual *wai khru* (homage to teachers) ceremonies at their universities; kick-boxers perform a dance-like *wai khru* routine before starting their matches. Mourners

commission Khon for funerals. At shrines such as the Erawan Brahma and the City Pillar, supplicants whose wishes have come true, engage a troupe of dancers to perform in gratitude. Meanwhile, in Bangkok and upcountry resorts, hundreds of dancers perform every night at restaurants and hotels.

And occasionally, dancers perform for me. I love to invite a troupe to the old Thai house complex at Ladphrao where they dance against the background of pointed roofs and a giant fan palm. As you watch, lulled by the rhythms of a *piphaat* orchestra, you fall into a state of meditative *Khleom* and you really do feel that you're in the presence of angels. That's what old Thai dance was designed to do.

Mudras (sacred hand gestures) from Indian sculpture
left: vajra (thunderbolt) *mudra; right:* tolerance and patience *mudra.*

One of my favorite pieces is *Mekhala and Ramasuun*. The story is that Mekhala, a heavenly goddess, is playing with her magic Gem, which flashes as she twirls it. Ramasuun, a demon, tries to take it from her, and at the climactic moment, he hurls his jeweled Axe, which crashes onto the floor. The crash of the Axe and the sparkle of the Gem, are thunder and lightning. That's the folk tale. The higher metaphor is of the interplay between female and male, *yin* and *yang*. Beyond that, at the highest level, they say that the Gem's sparkle is a glimpse of the divine.

When Indian dance moved across Southeast Asia, it ended up focusing on the *Ramayana* epic, which was important in India, but

never to the degree that it became in Southeast Asia. Especially in Thailand, where the kings identified themselves with the hero Rama, the *Ramayana*'s tale of the war between good and evil became the saga of the nation.

Another change from India was the emphasis on masks and crowns; and yet another was the influence of puppets. To a greater or lesser degree, Southeast Asian dance bases itself not on human movements but on puppetry. Hence elbows and fingers that curve backwards, necks that swivel in impossible angles, and dramatic poses that stop motion at the height of the drama.

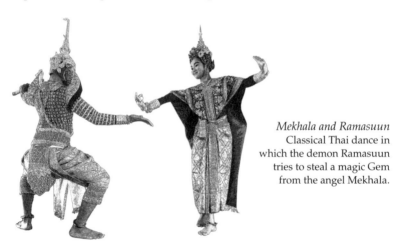

Mekhala and Ramasuun
Classical Thai dance in which the demon Ramasuun tries to steal a magic Gem from the angel Mekhala.

Since dancers represent the power of the king, they came to be draped in gold brocades and spangled with bejeweled rings, bracelets, anklets, chains, and earrings. The effect of the curving fingers, puppet-like gesturing, the masks and crowns, and the glittering costumes, was to make dance more abstract and un-earthly.

I may be biased because of my love of theater, but I believe that dance is Thailand's ultimate art. It's the key to all the others. This is most obvious in painting. Practically the first thing that visitors see when visiting Bangkok is the *Ramakien* murals at the gallery of the Temple of the Emerald Buddha inside the Grand Palace.

Angels, gods, demons, and monkeys wear not human faces, but masks; they sit and stand in the poses of the stage, their fingers twisted backwards, legs folded in the triangular position of a dancer offering respect.

At the same time, dance is painting in motion. The costumes, embroidered in gold thread, and the crowns with extending flanges, are basically *Lai Thai* designs in 3-D. In lavish venues such as Sala Chalermkrung Royal Theater, Khon performances reach their climax in tableaux of golden chariots with dozens of actors posed in arrested motion, just like scenes from the *Ramayana* paintings at the palace.

Chadaa crown
A miniature temple or palace spire rises from the crown of a Khon dancer.

You can see links to architecture. On their heads, Khon dancers wear *chadaa* crowns, which are basically the spires above a palace or a pagoda, while from their shoulders rise epaulets evoking rising temples eaves. The dancer is a pavilion in motion, a moving Mount Meru.

Khon has a *yin* and a *yang*. The *yin* is the delicately turned head and curved fingers of the gentle hero and heroine; the *yang* is the virile outstretched legs and muscular hand gestures of the demon or the acrobatics of the Monkey. These come from the martial arts practices of the palace guard, who were the first, according to tradition, to perform Khon. Only later were the corps of palace ladies drawn into the art form. As a result, Khon's basic poses have much to do with swordsmanship and even *muay thai* kickboxing.

Khon, of course, accounts for only a tiny fraction of Thai dance. A huge range of folk forms exist, from the *fon phii* (shaman dances) of the North, to *ramwong* ("circle dancing") which you find

universally across the country. In *ramwong*, often performed at festivals, parties, and temple fairs, people dance in a circle, waving their hands while making the two basic gestures of Thai dance: *wong* (thumb bent inwards over the palm, four fingers curving outwards), and *jiib* (thumb and index fingers touching, three fingers curving outwards).

It's no accident that *yin* and *yang* come together in dance, because dance and music are so closely linked to sex, as the ancient

The two basic hand gestures of Thai dance
left: *Jiib* – thumb and index finger touching,
 three fingers extended.
right: *Wong* – wrist and fingers curved backwards,
 thumb turned inwards.

Indians well understood. That's why upper-class Chinese and Japanese disapproved of actors – they saw theater as one step away from selling sexual favors. In fact, in pre-modern times, Kabuki dancers and Chinese opera singers did sleep with generous patrons. In Thailand, by contrast, dancers in the palace had a high status, often being courtiers or royal concubines. But by the simple fact of being the human body in motion, dance everywhere in the world carries erotic overtones.

The expression of Eros in dance, across East Asia, differs sharply from the West in that it tends to be androgynous. Kabuki has its *onnagata*, Peking Opera has its *dan* (male players of female roles), and Burma has its transvestite actors and shamans. The Javanese courts of Yogya (Yogyakarta) and Solo (Surakarta) contended against each other as artistic centers, and so in response to Yogya, where an all-male troupe played women, Solo had women playing men.

Bali has *gandrung*, the so-called "transvestite dance" in which boys play women and invite men in the audience to dance with them. Meanwhile, in modern Japan, the all-woman Takarazuka troupe, in which women play romantic male heroes, remains enduringly popular. In some traditions, actors specialize quite early, such as the Four Roles of Khon: Hero, Heroine, Demon, Monkey. Yet from Japan, through Thailand, and down to Java, students of dance often study *all* roles as part of their curricula.

As for Thai classical drama, *Lakhon nai* started out as drama performed by women inside the palace, with women performing male roles. Khon, on the other hand, which had been all-male at its origin, came over time to include women and the techniques of *Lakhon nai*. With all this mixing and blending going on, lines between *yin* and *yang* blurred. Female roles took on masculine strength and male roles took on feminine delicacy.

The lower garment of male roles, the *jongkrabane*, filled out until it became a wide stiff "bustle," exaggerating the hips and thereby making the men appear slightly feminine in physique. Old paintings and photographs show that the jongkrabane originally hung much more softly, clinging loosely to the hips. Only later did the *jongkrabane* swell up into the wide hips we see today.

Makeup in Khon was once more abstract and mask-like, but in recent times it has become more and more feminized, with the application of lots of eye-shadow and thick red lipstick. A "beauty queen" principle seems to have taken over. When I first saw Rama, the hero of the *Ramayana* (known as Phra Ram in Thai), perform a solo Khon dance, I didn't know the difference at that time between men's and women's costume, and so I thought this lovely creature with wide hips and narrow waist, with glistening red lips and flowers in her hair must be Sita, the heroine!

When I watch Thai dance, I can't help speculating about the way that *yin* and *yang* mingle. In classical Khon, a man puts on his mask and proceeds to stamp and posture as a Demon full of virility. Nothing androgynous in that role. The hero, Phra Ram, however, waves his hands as softly as a delicate maiden. In fact, the actor who plays Phra Ram might actually be a delicate maiden, if not a

lady of mature years, since women sometimes perform the role of Phra Ram. Either a man or a woman might play the heroine.

One is tempted to extrapolate beyond Khon to the androgynous nature of Thai society in general, another similarity shared with Japan. The hero in Kabuki plays wears white makeup like a girl and speaks with a soft voice. Likewise, as Philip Cornwel-Smith writes, "The model of Thai manhood isn't sweaty, musclebound Rambo, but refined, soft-spoken Rama. Chetana Nagavarjara notes a 'disregard for male robustness, and a bent for 'effeminacy' on

the construction of the hero figure' in classical literature. Make-up in *likay* folk opera must emphasize the prettiness of the *phra ek* (leading man), which the largely female fans demand. Similarly, youths are happy to primp like Japanese boy bands in order to please their girlfriend."[21]

Phra Ram
The hero of the *Ramakien* epic,
in classical Khon dance pose.

So do many young "metrosexuals" in London and New York. But go a few steps further and you arrive at the *katoey* (male-to-female transsexuals). I don't know if their absolute number is higher here than in other countries, but if you live in Bangkok, *katoey* make a uniquely visible mark on society. Many work as sales staff in hotels and restaurants. Large theaters such as Tiffany and

Alcazar in Pattaya, and Mambo and Calypso in Bangkok feature all-*katoey* cabaret revues, much frequented by Chinese and Korean tourists. *Katoey* star in their own beauty contests, judged by famous society figures. Surely no country in the world gives such a prominent and even honored role to its "lady-boys" (as they are often called in Thailand).

If you walk along Sukhumvit Road late at night you'll sometimes catch sight of a foreign man walking hand in hand with a *katoey*. Of course you can't know what's really going on, but on occasion you wonder if he's fully aware that his partner is not – originally – a woman. The *katoey* are a favorite subject for Western novelists writing about Bangkok, and many a mystery plot turns on a twist of gender identity. My friend Bodhi Fishman, a colleague from Japan who lived for a while in Thailand, had a young surfer friend, Luke, from California visit him in Bangkok. The two would explore the city's nightspots. Luke had a taste for tall Junoesque women, and frequently Bodhi had to warn him, "Luke, I'd think twice before approaching that one." Bodhi could easily spot the telltale signs of masculinity, but poor Luke never got good at it.

From one point of view the idea of transgender expressed through "cross-dressing" did not come easily to Thailand. How can you dress like the opposite sex if both sexes dress the same? They both wore their hair short, a sarong for the lower body, and often the upper part unclothed. George Bacon, writing in the late 19th century, declared, "as the climate is mild and pleasant, and the majority of the people poor and careless, their usual dress consists of a simple waist-cloth adjusted in a very loose and slovenly manner; while many children until they are ten or twelve years old wear no clothing whatever. When foreigners first arrive in Siam they are shocked almost beyond endurance at the nudity of the people."[22]

They were also shocked at the lack of distinct dress for men and women. Edmund Roberts, an American visitor to Bangkok in the 1830s, wrote concerning an official dinner: "As I cannot tell a Siamese man from a woman, when numbers are seated together, so it is out of my power to say whether any females were present

[amongst the audience].... The hair of the Siamese women is cut like that of the men; their countenances are, in fact, more masculine than those of the males."[23]

Peter Jackson, specialist in Thai gender and sexuality studies, concludes: "Unlike the case for some other Asian countries such as Japan and China. ... rather than being inhabited by a visible minority of cross-dressers, the entire population of Siam was seen as androgynous and lacking in the 'civilised' distinctions that separated men from women."[24]

Perhaps because of these permeable boundaries between genders, not only *katoey*, but also gay life seems more prominent in Bangkok than elsewhere, adding to the city's dubious reputation abroad. In China and Japan, paternalistic Confucianist thinking makes it more difficult for gay people. Back in 1949, David Kidd was once at a dinner in Beijing with his friend, the renowned literary critic Sir William Empson. The topic of homosexuals came up, and David turned to a Chinese lady seated at the table and asked her what she thought of them. She answered, "You see Sir William Empson? He very famous, great writer, very rich. Be like him, OK. Be like you, not famous, not rich, not OK." In short, only having a lot of money could excuse it.

While money and social position do matter in Bangkok, this city takes a gentler view than the ever-practical Chinese. Maybe it's part of being in the Himmaphan forest. If trees in Himmaphan sport fruits that grow into ladies, and angels that spring out of vines, why shouldn't men become women and vice-versa? Or it could be due to the Thai sense of the cycle of rebirth and inevitable karma. You were born to be what you are, so you might as well enjoy it. As David Kidd once remarked, "We've all been boys before, and we'll all be boys again." Of course, we've all been girls before too. Lesbians (often called *toms* and *dees*) also make a strong presence in Bangkok, as you can see if you spend an afternoon at the popular youth area of Siam Square.

For whatever reason, Bangkok unquestionably has the most extensive and international gay scene in all of Asia. Discos accommodating hundreds, or even a thousand people, pulse until

late in the night. Cameron McMillan, a young Kiwi friend of mine, on his first visit to a gay disco in Silom Soi 2, took one look at the crowds of men, and could barely contain himself. "When I die, I want to come here!" he said.

One of the many legends associated with Himmaphan has it that inside the forest there is a magical *Chommanat* tree, whose blossoms are so intoxicating that all who inhale them must immediately go off and have sex with whatever is closest at hand. That's what gave birth to the cross-beings found in Himmaphan: bird-monkeys, lion-snakes, angel-beasts, and so forth.

Sometimes I feel that there's a great *Chommanat* tree looming over Bangkok scenting the air and driving us all to outrageous behavior. As to why the *Chommanat* tree flourishes here more than elsewhere, one could list many factors: The lack of a Judaeo-Christian-Islamic tradition of moral disapproval. Less emphasis on Chinese-style paternalism and the Confucian work ethic. Fuzzier lines between genders. Bangkok's place as a crossroads in Southeast Asia with a broad mix of races and ethnicities.

The list of ingredients goes on: Bangkok is a big holiday destination filled with hordes of lusty foreign visitors from all over the world. The city has a standard of living that is rising fast, already far above the hand-to-mouth poverty of many other developing nations, and therefore people have the time and means to enjoy themselves. The "culture of negotiation," that tends not to stick to the letter of the law, allows all sorts of venues to exist that might have a harder time in a stricter society. It would be difficult to find such a fertile mix in most places of the world. Top these off with the Thai smile and warm weather, and the combination makes Bangkok – for men, women, and everything in between – the sexiest place on earth.

This is not news. You can hardly pick up a book about Bangkok by a foreign author, American, European, or Japanese, that is not strongly colored, if not obsessed, by this aspect of the city. For many Westerners, especially women, the ready availability of commercial sex makes Thailand seem anything but "sexy," even for some, abhorrent.

Yet despite the festival atmosphere at Silom, Thai society is hardly the open sexual paradise that many foreigners imagine. This is another of those illusions propagated by the constant surface smile of *sanuk*. Young ladies of good families are educated to be sexually quite conservative. Gays usually do not come out to their parents, and many stay permanently in the closet for fear of being discriminated against at work.

In fact there's a strong streak of puritanism running through modern Thai society. Austere Chinese morality, which frowns on sensual indulgence, plays a role, due to the large share of Bangkok's population with Chinese roots. You can also see vestiges of colonial Western values from the 19th century, which Thailand took to heart in the process of modernization. The biggest influence of all is the long decades of military rule, when rulers insisted that people conform to officially mandated social standards, like wearing a hat to work. In any case, you won't find in Bangkok the open flaunting of sex that you find in Japan, such as shops selling sexual paraphernalia, or newspapers sporting pages of photos of adult video stars, which blue-suited salarymen peruse in the train on their way home from work.

An active anti-alcohol movement exerts pressure on politicians, which results in alcohol-free nights on Buddhist holidays and on the nights before elections, as well as the mysterious law that limits the hours that one can purchase alcoholic beverages from stores to 11am to 2pm, and 5pm to midnight. Periodically the Thai ministries of education or culture, or one of the other boards in charge of mandating "Thai identity" starts up an anti-sexuality campaign, which could, for example, take the form of a crackdown on "immodest behavior," which has been interpreted to mean strapless dresses.

Underlying this is a sense of revulsion that society at large expresses against the more obvious signs of Bangkok's booming sex business. It gives the city an unsavory air, and is a source of embarrassment internationally. Prostitution continues to thrive anyway, partly due to poverty, of course, and partly due to the fact that the Thais don't take it as seriously as Westerners do. They see

it (as do the Japanese) as a male biological urge, and they don't much concern themselves about it, so long as it keeps a low profile. Prostitution is a loaded issue that each culture approaches with its own bias. The Thai and Japanese bias is about being seen doing it. In the West and the Muslim world, moral imperatives derived from Judaeo-Christian-Islamic religions, judge it wrong from the start. So it can strike many visitors to Thailand in a very conflicted way.

Part of what excited Cameron so much at the disco were the smiles all around. He had the feeling that he was welcome, a feeling he hadn't much had when he lived in Tokyo. In another part of town, fat old Westerners with slender young bar girls on their laps were getting the same feeling. The big welcome makes Bangkok famously a lodestone for males (not only aging, but young as well; not only white, but Japanese, Chinese, Nigerians, Koreans, Arabs). When they die, this is where they all want to go.

Ironically, openness to foreigners works against Bangkok in the eyes of the world. Prostitution is just as large a business in Japan as it is in Thailand, maybe even larger, but it bothers foreign visitors and journalists much less, if at all. One doesn't often see an outraged article about the scandalous sexuality of modern Tokyo. This is because most of the sex is not accessible to foreigners; they just don't see it. In fact, much of Thai prostitution is also hidden. Far more goes on in restaurants, massage parlors, and hairdressers than meets the eye in the go-go bars of Patpong and other obvious sex venues – and the customers are in the vast majority Thai, not foreign.

I have what I call "the Weimar Republic theory" of Bangkok. As dramatized in the movie *Cabaret*, there was a brief moment of sinful freedom in Berlin during the Weimar Republic (1919 to 1933). It was the era of Kurt Weill's bittersweet music and Christopher Isherwood's novels and stories. By the mid-1930s the Nazis had stamped it out, and eventually all that remained was a legend of "Berlin in the 20s." Those who experienced it spent the rest of their lives telling others of the wild days that were now gone forever.

231

In time, the more outrageous forms that prostitution takes in Bangkok (sex shows, go-go bars with half-naked boys or girls with numbers on their panties gyrating on tables) will disappear. For those things, Bangkok stands far out on the scale of what most cities in the world see as acceptable. I don't believe it will last. Slowly but surely we are seeing a clampdown, and it's a matter of time before the "sinful" Bangkok we see today fades away into legend, just as 1920s Berlin did. One day we'll tell our children or grandchildren, "This is what you used to be able to see in Bangkok...."

This doesn't mean that commercial sex will disappear away in Bangkok. It does mean that we're seeing a steady shift in the balance between prostitution and non-commercial venues. Patpong is no longer where the action is. The tourists who throng Patpong are there mostly to buy souvenir trinkets; relatively few venture beyond the doors of the sex establishments. I foresee a time when Patpong will be lined more with coffee shops and galleries than with go-go bars. Or – quite possible given rising real estate values – the Patpongpanit family (who own the whole block) will simply sell it all off to be redeveloped as a mall.

Meanwhile, there's a new open sexuality among the youth, which also alarms conservative elements in government and society. Back in the 80s and early 90s, Rome Club on Silom Soi 4 was one of the few places where young urban professionals hung out. Since then nightlife has exploded into a wide range of venues all across town. Youngsters dance the night away at the huge discos at RCA (Royal City Avenue) or the clubs in the Ratchada area; gays go to Silom Soi 2 or to dozens of venues clustered in entertainment districts around the city; and a mixed crowd fills the pubs on Silom Soi 4. Sophisticated venues like Bed Supperclub on Sukhumvit Soi 11, or the fancy nightclubs on Soi Thonglor attract a well-heeled clientele. Thaniya road appeals to the Japanese, but also features British pubs. Meanwhile, young Thais and foreigners mingle in the nightspots of Banglampoo, the backpacker district.

As late as the mid-90s, boys and girls rarely held hands in public. Handholding was mostly a boy-boy or girl-girl thing. Outside their homes, people shunned physical contact in general.

Now this is all changing, and dance in the discos has a lot to do with it. Politicians and bureaucrats therefore see dance as dangerous and have done their best to restrict it, by granting few dance licenses, tightening the zoning for entertainment districts, and requiring clubs to close earlier and earlier. Bangkok is already far more restrictive than Singapore or Tokyo, when it comes to officially mandated closing times and permitted age limits for entry. Of course, this being Bangkok, the restrictions have plenty of holes in them. Somehow, certain clubs manage to evade the rules and stay open until morning.

Here the authorities are fighting a losing battle because of what I sense is a fundamental change in the sexual role of women. Nightlife in Bangkok has always been more structured for males. An Australian woman friend of mine complained, "Bangkok is Boy's Town." This is certainly true historically because women had little choice. Thai men were free to have a wandering eye; women were not. The laws changed to favor monogamy, but the culture lagged.

In the process, to redress polygamy, Thai laws became increasingly feminist. The drift has been to treat women better. Over time this has had an effect, and today Thai women play a stronger role in the society than their counterparts in Japan. They are going to universities and running companies. Women are working away from home, and millions have migrated from villages into the city where they escape prying eyes of neighbors and family.

This has led to the *gig* phenomenon. A word of recent popularity, *gig* refers to a sex-friend or lover, but not to one's main lover, husband, or wife. It would hardly be worth remarking if it were just men taking *gigs* (as they always have), but nowadays young women also enjoy a *gig* or two. Impacted by Western ideas of the equality of the sexes, and liberated by the circumstances of living in a big city, women are taking their lives into their own hands.

Many books have been written about Thai sexuality. My own guess at what is going on is that we see in Bangkok a lingering remnant of the old matriarchal society that the Thais brought down with them through the valleys of the Mekong. The female principle

233

dominated, and in some way continues to do so. Previously, the female principle (the *yin*) ruled the household, and the male principle (the *yang*) dominated society. Nowadays, however, the power of women extends increasingly into the public realm. Combine the growing freedom of women in Bangkok with the tradition of androgyny, add the penchant for *sanuk*, and nearly anything goes.

The dance of *yin* and *yang* will continue in all its permutations. Out on the street, Thais and foreigners alike emerge each night in the Bangkok dusk to seek *sanuk* wherever they may find it. Older foreign males gravitate to their haunts on Patpong, Soi Nana, and Soi Cowboy, where the go-go girls will continue pole-dancing for some time to come. The younger crowd find their way to the clubs on Silom, the discos at RCA, or other nightspots fitting their particular tastes.

Some people, addicted to dance like me, or Khru Kai and Big, might choose to go and see a theatre performance, perhaps *Likay* comedy in the park at the top of Phra Arthit Road, or contemporary dance staged at Patravadi Theatre along the river. For most of us, our evening out will be fairly straightforward. For poor Luke, dancing the night away might hold a big surprise.

AUTUMN
MOUNTAIN PAINTING

As a night person, I avoid early mornings at all costs. I go to extreme measures to book afternoon or evening flights and avoid pre-lunch meetings. On my first trip to Beijing in 1980, my friend had arranged an excursion for us to visit the Great Wall of China, something I'd always dreamed of seeing. But when they came to wake us up at 5:30am, and I faced the choice of napping for a few more hours, or never to see the Great Wall perhaps for all my life, I unhesitatingly chose sleep.

Yet in Bangkok, for several years, I found myself leaping out of bed every Friday morning at daybreak, concerned only that others might have woken up before me. I was on my way to Chatuchak Weekend Market for the dawn gathering of pot collectors.

Most people naturally assume that the "Weekend Market" is open only on the weekend, and by and large this is true. But certain specialist activities take place during the week, such as the plant market held on Wednesdays and Thursdays. On Friday morning, the antique dealers quietly open for business. It's part of the weekly caravan of antiques brought down in trucks from the Burmese or Cambodian borders, from southern China, and from holes in the ground around Sukhothai and prehistoric sites in Isarn. In the early pre-dawn hours they start unloading parcels wrapped in newsprint and spreading out dirt-encrusted pots in stalls located in certain discreet corners of the market. A small coterie of Bangkok's ceramics collectors are there, vying with each other to snatch the finest pieces as they come unwrapped.

By the time I arrive, the usual group has already gathered. There's Harold, who first introduced me to Chatuchak's Friday morning ritual, and beside him, polite and smiling Mr Soong from River City antiques center along the river. A little later, arrive some rich Chinese connoisseurs, a Japanese exchange-student, and sometimes Harold will bring along an art-dealer client. There's a pecking order: the dealers respectfully offer Mr Soong the best pieces first. As he is by far the biggest spender in the market, it's essential to keep him polite and smiling. Then come Harold and the others, and after they've taken their pick, the market continues throughout Friday afternoon, and on into the weekend, when the hordes of tourists and Bangkok day-trippers arrive looking for trinkets. A week later, you can see the best pots on view at Mr Soong's shop in River City, gleaming behind glass show-windows for five or ten times the price.

Prehistoric Thai pot
Black earthenware pot
with incised patterns, ca 500 BC.

Curiously, what's missing on Friday morning at Chatuchak, are archaeologists and museum curators. Curious, because this little gathering is the ultimate learning experience. I arrived in Bangkok in 1997 convinced that I knew quite a lot about the traditional culture of East Asia, only to find that the vast world of Southeast Asian art and history was in fact largely a mystery to me. I embarked on a process of study, and my first teacher was Harold.

Harold is an Australian who came to Thailand and discovered a side of himself that he never knew existed. Active as an architect, he continues to run a successful design firm. But one day in the mid-90s, he was shown a black prehistoric Thai pot. It had a flared and fluted, strangely contemporary shape, carried striking zigzag patterns, and he was told, was three thousand years old. Price: 500 baht. Harold was hooked, and by the time I met him, was

several years into putting together a world-class collection of Thai ceramics.

In Japan, my mentor in the art world, David Kidd, made his fame as a shrewd art dealer. As a youth of nineteen he moved from Kentucky to Beijing in 1946, right after the end of World War II. Old Beijing was still intact, but by the later 40s people realized that it was a matter of time before the communists would take the city. It was a *fin de siecle* period, and the residents of the city danced the nights through past red lacquer columns in their decaying mansions, because they knew the end was nigh. One of those residents married David, and he ended up living with her family in a four-hundred room Ming palace.

Then came the day, in 1950, when the family lost the palace, and David and his wife fled to New York. A year or two later David returned (minus wife) to Japan, and started collecting. He had only to sift through the mountains of Chinese art which the Japanese had been bringing over from China since the 19th century, but which was now forgotten in the aftermath of Japan's loss in the War.

David had no money to start with. But he had the knowledge that could only come from being in the last generation ever to have lived in a Ming palace. Even with this head start, in Japan he learned the hard way about collecting and its perils. David once said to me, "Collectors will always know more than curators because we pay money out of our own pockets to buy things that have no label attached to them. When we make a mistake we feel the pain, and this is how our senses get trained."

Unfortunately for me, when it came to Southeast Asian pottery, my senses weren't trained. Harold and a lady dealer named Mui took me in hand. I learned to my delight that the little 15th century incense box that I'd bought as a student from the street-market at Sanam Luang was actually a genuine piece. I also learned that this was pure good luck.

The first thing I discovered at Chatuchak, and one of the first words I learned in Thai, was *som*, which means "repaired." Most prehistoric pots are found in burial sites, and thousands of years of accumulated earth have crushed them into shards large and small;

it even appears that people purposely smashed some pots at the time of burial. Finding a complete and undamaged pot is rare. The dealers take the shards and put them back together, like solving an enormous jigsaw puzzle, gluing the pieces together, sometimes crudely with cement, and other times ingeniously with resin or synthetic PVA, painting the surface with perfectly matched acrylics.

Repaired pot
Thai earthenware pot, ca 1500 BC recreated from broken shards.

When it comes to ceramics of later eras, such as 15th and 16th century Sukhothai pots, resin and acrylic technique is truly exquisite, producing exactly the same textures and tones as ancient greenish-blue celadons and white glazes. Only the most expert eye can see the difference, and I never really acquired the skill. I relied on Khun Mui, who would kindly show me where the repair was. Often, when I thought I had found the perfect Sukhothai bowl, Mui would turn it over in her hands, pronounce the dreaded word *som*, and I would learn that only the foot was original; all the rest was resin.

Outright fakes – of which *no* part is original – are also common, especially of Khmer vases, with their noble forms shaped like Roman amphoras. It was a matter of honing one's instincts. After weeks and months of attending the Friday vigils, I found that thoughts of pots burrowed inside and went unconscious – I'd have a revelation about a northern Thai jar while in the shower or at the supermarket. Not every revelation was a happy one. Once, David

238

Kidd acquired at great expense a superb set of Ming vases that slipped out of China during the Cultural Revolution. We all gathered at his house in Ashiya to admire. A week later, David was sipping champagne in an airplane somewhere over the Pacific, when he suddenly turned to his partner and said, "We've been had!" David's inner instincts knew what his mind did not. It later turned out that every single piece was a fake.

At one point I fell in love with Vietnamese ceramics, some of the best of which are to be found in America and Europe. I sent some money over to a friend in England, who bought two spectacular finds, a large plate, and a blue-and-white jar from a reputable London dealer. I displayed them at home as prized pieces until one day, when the afternoon sun fell on them at a certain angle, I noticed something odd about the glaze of the jar. It nagged at me for some months until finally I took some solvent to the jar, and sure enough, the entire surface bled away, revealing a base of plain white clay. All the impressive blue-and-white designs had been latex. I don't blame the dealer because he was probably fooled as well as my friend and I had been. But it was a cold reminder that there is, in the end, no such thing as a reputable dealer.

On the other hand, the plate was good. You just never know.

Gradually I learned. Every Friday was like attending a seminar in some little-known branch of Southeast Asian ceramics. Sometimes the stalls would feature cardboard boxes filled only with what are called "kiln wasters," collected from ancient kiln sites. When a piece failed in the kiln, the potter would throw it aside, and eventually the rejects formed huge mounds, inside of which one could find clay and glaze of every period, not to mention conglomerations of bowls and jars that had melted, fusing into grotesque forms that made them works of abstract art.

It would happen that large caches of pots, in styles hitherto unknown, would flood the market. At one point hundreds of spouted 7th century vessels in white and orange clay from southern Thailand filled the stalls, so many that one might have thought they were mass produced fakes. But they were real, all unearthed from one site, and a few weeks later the vessels were gone, never to be seen

again. Some years later the market was awash with 18th century Vietnamese jars stuffed with bronze coins, fused together by seawater, which seemed to have come from a shipwreck. It was as if an ancient bank had gone down to the bottom of the ocean. These money pots too were like nothing anyone had seen before. Each collector in Bangkok got at least one, Mr Soong and Harold of course skimming off the best, and then the money pots disappeared.

Part of the interest of a place like Bangkok is that there's still so much lying undiscovered and unstudied. You can be a true adventurer. For example, the markets sometimes feature tall Lao water jars, similar to Khmer jars but with a pronounced lip and a glaze with brighter luster. Some say they're 16th century, others 19th century. Moreover, it's not clear what people really mean when they say "Lao." Sometimes they mean the country that now is called "Laos," and other times they're talking about the parts of northeast Thailand where Lao-speaking people live. There's room here for someone to carve out a career as a Lao ceramics specialist – so far, to my knowledge, there are none. This contrasts greatly with my experience in Japan where every obscure glaze has a library of specialist books written about it.

Words like "Lao," "Burmese," "Khmer," and "Thai," are highly artificial, since the boundaries of kingdoms and the domains of different ethnic groups shifted constantly over the centuries. Antique collecting in Kyoto was like peering into a crystal ball wherein the mysteries of the past gradually revealed themselves; but in Bangkok, it's like looking into a kaleidoscope. Each turn of the tube displays a completely new combination.

The treasure appearing from under the earth and water seems almost inexhaustible, and is a reminder that people have been living in Thailand and its surroundings for a very long time. Thai prehistoric ceramics are among the world's oldest, and burial sites will surely continue to be found for hundreds of years to come. I once calculated that if one thousand potters produced three pots per day, that would be about one million pieces per year. That's a conservative estimate, because in prehistoric times, every village

would have had an artisan firing vessels in a heap of burning rice husks; in Sukhothai and Ayutthaya, vast multi-chambered kilns supplied a ceramics business that exported all over Southeast Asia and as far away as Japan. At one point in the late 16th century it is believed that the ceramics exports of Thailand rivaled those of Ming China. Anyway, calculating one million pots per year, after three thousand years, that's three billion, and if just a tenth of one percent survived, it means there are three million pieces of ceramic waiting to be discovered.

Of course it's not just pots that flood into the Bangkok art market. Furniture from China and Tibet, textiles from Laos, wood and marble Buddhas from Myanmar, and most importantly, stone and bronze sculpture from Cambodia, make Bangkok into one of the worlds' leading art emporia. While I was just dipping my toe in the water, considering whether to buy a few antique pots, I was suddenly thrust right into the deep end, when I encountered Cambodian sculpture dealer Marie.

Marie, about seventy years old at the time we met, hailed from a French Indo-Chinese family that had lived in this region for generations. She had worked in Thailand since the 1950s and had once been a friend of the legendary Jim Thompson. At the age of 25 she purchased her first Khmer bronze, from a burial hoard that turned out to be one of the finds of the century – and this started her on a career as one of the world's major dealers in Khmer art.

Really important antique art works – the sort that can command millions on the international art market – never go near Chatuchak market. A true masterpiece would rarely even appear in the posh shops of River City. When something wonderful is found, the underground network spirits it from a muddy pit in Cambodia and over the border to Thailand, and offers the statue first to a tiny coterie of elite dealers in Bangkok.

Among them, Marie has become the supreme arbiter of quality in this field. Risking hundreds of thousands of dollars over a piece that she may be able to inspect for just a few minutes, Marie's nerves are honed to extreme sensitivity. With thousands of objects

having passed before her eyes over the decades (even though she acquired only a few of those on offer), she knows intimately the history of every fragment.

Renaissance art expert Bernard Berenson made a name for himself when he deduced from a few telltale details that a group of early Italian paintings attributed to other artists were actually all painted by the same hand. He figured out that this imaginary artist must have been active in certain Italian cities at certain times – Rome for five years, Padua for seven years – and some years later historians following these clues found that such a man had really existed. Marie has the same sort of photographic memory. Once, when she and I visited the Conservation storage rooms at Angkor, she pointed out to the curators that a certain stone hand on view on a long shelf of dozens of disembodied hands, belongs to a certain torso in the possession of so-and-so, and by the way, the head is in the Guimet Museum in Paris.

With so much money at stake, fakery is a huge problem, and the artisans who forge Khmer sculpture have access to technologies far beyond painted resin. They mine stones from the original Khmer quarries near Mt Kulen, they copy the fine details visible in lavishly illustrated coffee-table books of Cambodian art, and they age their artifacts by burying them and coating them with cocktails of mud and chemicals. Above and beyond these techniques, a good counterfeiter must be akin to Marie herself in that he must truly love Khmer art. As with the genuine sculptors of old, he must have an instinct for what is beautiful. Among these, the genius is a man named Nok.

Many of the lovely Khmer sculptures admired by museum-goers around the world are Nok's handiwork. Each is a true original, never a simple copy, and the historical details and elegance of line have fooled experts again and again. Marie is a great friend of Nok, and I had the chance to visit his workshop in a back street of Bangkok. There, in a cluttered yard surrounded by chickens, Nok, dressed in T-shirt and shorts, was carving a female figure at the request of a European dealer. He showed us the photographs from a museum catalogue that he was using as his guide, and after explaining which

chemicals he was using, he mixed up a vat of "aging solution" to show us how he was going to give the finished piece its patina. Familiar now with Nok's handiwork, I think I can identify it. Like the "guilty ones" in a Kafka novel, the guilt is all in the lips. Nok's sensuous lips are his signature, plus the sheer beauty of his creations. Nothing original is ever that overtly beautiful.

As I was straining to absorb the arcane knowledge of Marie and her world, I came face to face with a different kind of learning experience. It began early on, when I had borrowed some Khmer statues from a River City dealer to decorate my apartment. An old friend who works for UNESCO came to visit one day, and taking one look at the stone torsos, he recoiled in horror. "How could you lend your hand to the despoiling of Cambodia's national heritage?" he asked.

It came as a rude jolt because in all my years in Japan it had never entered any of our heads that art collecting could be anything but a good. Connoisseurship of the relics of the past was the key to the cultured world of the Chinese and Japanese literati – it was through studying old bronzes and calligraphies that they refined their inner souls. The literati believed that art from the past connected one to the minds of people in the past.

In Asia, where philosophy is often unspoken, and especially in the case of Thailand and Cambodia where so much was lost in the sacks of Ayutthaya and Angkor, it's only in mute carved figures and the shapes of jars or lacquer cabinets that the secrets of the ancients survive. A Khmer sculpture speaks worlds about the nobility of kingship and an ideal of graceful power that still influences Thailand today. A Sukhothai *phan* stem-cup – raising up on its stem an offering of grain or flowers – reveals in its shape an attitude to the divine. It's not enough to just see these things behind glass in museums, because as the literati knew, it's living with art works over time that slowly teaches us their lessons.

But what if these objects have been sawed from shrine façades, chopped from Buddha images, stolen from temple altars, or smuggled out of archaeological sites before they could be studied and their provenance known? In wealthy Japan, the government and

museums have a chance to purchase important objects before they leave the country, but this has not been true in poor Southeast Asian countries. During the Khmer Rouge regime and into the mid 90s, the pillage that took place in Cambodia knew no bounds.

I once visited the home of Vichit, a River City dealer who lived in the outskirts of Bangkok. Vichit prided himself on sheer quantity. He had filled his backyard with massive stone carvings: porticos from temple fronts, torsos three meters high. You could only move this sort of thing with cranes, and in fact the larger pieces had been sawed or smashed in order to get them across the border. "It's a pity

Phan stem-cup
16th century Sukhothai celadon.

that piece is missing its left arm," I commented, and Vichit answered, "Oh, we were in a hurry and had to leave it behind. I suppose it's still there somewhere."

The carnage culminated in a notorious case in the late 90s when a Thai collector arranged to have an entire wall of the ancient city of Banteay Chhmar in northern Cambodia transferred to his residence. Using army cadets, they sawed the wall into hundreds of blocks, but the truck convoy was stopped as it entered Thailand. Only part of the wall was recovered, but later the Thai government returned what it had to the National Museum in Phnom Penh, where this portion of the reconstructed wall can be seen today.

Against this background of theft and knavery, art collecting – which was the benign hobby of tea masters and a classical form of

self-improvement in Japan and China – took on a darker tone here in Bangkok. I returned the borrowed torsos to River City and began to think about what the limits might be, and the more I thought about it the more complex it appeared.

There are those who say that no object should ever leave its country of origin. But this overlooks an important aspect of collecting, which is that art objects transferred to other countries and displayed in museums or private collections, serve as "cultural ambassadors." Many a love affair with China began when a little boy or girl saw their first ceramics or paintings in a museum in France or Australia. Without this first-hand contact with the artifacts of other nations, our understanding of other cultures would be truly poverty-stricken.

At the same time, it seems reasonable that the important pieces should remain in their countries of origin as cultural patrimony. It's a question of balance. Japan, has a far-reaching regime of rating art works, which dates back a century by now. At the top of the list are National Treasures, which cannot be owned by private individuals; next come Important Cultural Properties, which can be freely bought and sold within Japan, but cannot be exported; everything else is free to be bought and sent anywhere in the world. The advantage to this system is that it allows for a legitimate art market, while protecting the pieces that are truly treasures of the nation.

The problem in China and Southeast Asia is that there is no legitimate art market. Thailand, for example, prohibits by law the import and export of *all* Buddhist sculptures. This blanket ban means that even the most innocent trade in plastic Buddha replicas is illegal – there is no distinction between a souvenir gewgaw and the export of a rare Sukhothai bronze – hence chaos rules.

It seems a bit much to insist that every shard of antique ceramic must stay in Thailand when there are three million pieces yet to be discovered. In the case of Cambodian bronzes and statues, tens of thousands, maybe hundreds of thousands were created during the millennium of the Khmer Empire. What the market needs is regulation that would differentiate between what's more important and what's less so.

245

Another argument for a legalized art market is the store of knowledge that it brews. As David Kidd pointed out, dealers and collectors will always know more than curators, and this is undoubtedly true of Harold and Marie. Marie's encyclopedic knowledge is so important that the world of Khmer art will suffer grievously if someone doesn't write it down while she's still alive.

My friend Emmy Bunker, consultant on Southeast Asia for the Denver Art Museum, and scholar specializing in the preservation and study of Khmer art says, "If nothing can come out from its country of origin, and everything must go back, what will we have in museums? What's going to make people really know about other cultures? I'm not sure that a picture, no matter how digitally perfect, would draw you the same way. Are we going to slide back into provincial ignorance of other cultures? It's going to be like living in the 18th century, when people knew of art from other countries from books of etchings, or like little boys reading the National Geographic for a glimpse of naked breasts. Antique art is part of the real world that won't happen again. Having these things available to see at close range brings us a wonderful camaraderie with the people who made them. As for me, if I'd never seen anything Cambodian, I never would have come here."

Recently there's an unspoken rule in the art world that architectural fragments are frowned upon because they despoil buildings in situ; and of course anything known to be stolen, or that has been previously published or photographed is out of bounds. But if the statue is unknown, and comes fresh out of the ground somewhere – it's considered fair game. This approach is hypocritical perhaps – since what really is the distinction between a known work and an unknown one?

There is much to be learned about where and how a piece was found. If the statue was shattered and cast down a well, then we can ascertain that it was a casualty of one of the Khmer empires' occasional turnarounds between Hinduism and Buddhism. The king would order the idols of the contending faith destroyed and replaced with images of his own. If a statue is found in the grounds of a royal temple, then perhaps it was modeled after the face of the king or

queen. Much knowledge is lost when smugglers yank a piece from the earth and ship it off to Bangkok. Nevertheless, at least a rule such as this draws some limits. It's the beginning of an organizing principle, which is what the art market here has lacked.

In the case of Khmer art there's also the problem: What's "Cambodian?" It's similar to the problem of "What's Lao?" A large part of Thailand was once part of the Khmer Empire, and in fact most of the "Khmer" pots I saw in Chatuchak actually came from kiln sites in what is now Thailand. In Beijing you have a clear sense of what is "Chinese," and in Kyoto, "Japanese," but Bangkok is more of a blur.

The knotty issues facing me in Bangkok made me think for the first time about what antique collectors and dealers really do. When it comes to Southeast Asia, on the one hand you have the Vichits, responsible for unrestrained pillage in Cambodia and Myanmar. On the other hand, spending time with Marie I could see that this woman had real love for the art she dealt in, and it led her on a passionate quest to understand it. She followed the rules (questionable though they are) of the international art world: nothing stolen from a known site or removed from standing architecture. If a piece was missing, she'd send her people back to dig around until they found it. Marie's concern went beyond the pieces she was directly involved with – she made herself a nuisance at museums where she would get into arguments with curators. Marie takes it personally if a genuine artwork has been dismissed as a fake due to lack of knowledge. On more than one occasion she managed to locate stolen objects and had them returned to a museum. Although there is no doubt that Marie has been mining Cambodia's past, she is in this sense a relatively benign influence.

Art collectors stand guardian at the point where the past funnels into the present. The better ones sift through the mass of material swirling by, select superior quality, restore and research it, and direct it to institutions where it will be preserved for others to appreciate. Quite often they save pieces that would otherwise be lost or destroyed.

This has especially been true in Asia, where modernization has swept all before it and villagers think nothing of chopping up old houses for firewood, smashing pots that they've been using for generations and replacing them with concrete vats, tossing lacquer utensils into the garbage, re-gilding or even re-shaping bronze Buddhas so drastically as to efface all signs of the original, and leaving precious textiles to mice and rot while clothing themselves in T-shirts from Tesco. Nor is this just the practice of poorly educated villagers in the Southeast Asian countryside. The same is true of advanced Japan, where people continue to tear down old homes and throw away antique lacquer trays and *tansu* chests because these aren't "modern" enough. In countries such as China in the 60s and 70s, where the state itself set out to destroy the past in the Cultural Revolution, and in Tibet where that process continues today, treasures smuggled out to international collectors are among the few that survive. Collectors and dealers snatch what they can from the jaws of the great compactor crunching up Asia's cultural heritage.

Institutions housing what had once been private collections are part of what make Bangkok a cultural capital in the true sense of the word. Jim Thompson put together a small but choice collection of Thai antiques in his canal-side complex of old Thai houses, and today his home is an inspiration and resource for countless visitors to Bangkok. Lawyer David Lyman has amassed hundreds of Thai and Lao textiles, some of which are on display in the offices of his Bangkok law firm, Tilleke & Gibbins.

Actually, the biggest buyers active in the antiques market have been Thai. Thai princes collected avidly in the early and mid-20th century, and their acquisitions form the base of our solid knowledge of Thai art today. Prince Chumpot's collection, now housed in the Suan Pakkard Palace, preserves among other things a priceless pavilion from Ayutthaya with early gold-lacquer painting. Another example of a private Thai museum is the Prasart Collection, housed in spacious grounds in the eastern suburbs of Bangkok. Temples such as Wat Benjamabopit (the "Marble Temple") also display groupings of important Buddhist sculpture taken from temples

around the country, which might otherwise have been lost or dispersed. Bangkok owes much to its collectors.

Vichit with his garden of stone plunder was art dealing at its worst. But Jim Thompson, Prince Chumpot, and Prasart represent art collecting at its best: finding and preserving what the Vichits would have mangled and destroyed, and in the meantime adding to the world's stock of artistic knowledge.

The way the trend is going, collectors in the future will have few chances to make such contributions. As often happens in rarefied academic fields, extreme ideologies take hold. For example, there's a vocal group amongst non-profits and academia who disapprove of *all* collecting, even crafts from villages. It "disturbs the community". Villagers may well be inclined to cast their old jewelry and textiles into the dust-heap – but the paying of money to collect or save these things inherently puts villagers at a disadvantage, the argument goes. Hopefully the community will save their treasures and keep producing their crafts – even if there are no outside buyers. But if not, nobody should interfere.

From moral disapproval, the next step is frenzy. In America, in the spring of 2008, the IRS investigated dealers in California who were allegedly helping their clients to donate Thai prehistoric pots to museums at inflated prices for tax write-offs. Zealous agents, eager for a coup, carried out highly publicized raids of major art institutions such as Los Angeles County Museum. Overnight, Thai prehistoric pottery everywhere came under a cloud, even though its possession and import into America was not illegal. Finally agents arrested Roxanna Brown, Director of the Ceramics Museum in Bangkok, who had returned briefly to Seattle to give a talk. They must have believed that they had finally caught a really big fish. However, frail Roxanna was neither a dealer nor a collector; she was a meek "pure scholar". Caught in the net, she couldn't stand the shock, and she died in prison, victim of a witch-hunt.

Raids of major museums, a colleague arrested and dead in jail – the nitty-gritty of collecting Thai art was worlds away from the pure and spiritually uplifting realm of the Chinese literati which I had always idealized. Where was I to draw the line? While I was

mulling these things over, I got up less often for Friday morning at Chatuchak, and drifted away from Harold and Marie. Despite the fact that I had come to love Thai and Khmer art, perhaps even more than Japanese, I never built a collection in Thailand. We're living at a point in human history when the break with the past is absolute. I've often asked myself why antique art works have the power to captivate so strongly, and I think it must have something to do with natural rhythms of life and the spirituality that arises from these – which in the buzz of our electronic modern world we can never recapture.

As the world enters the twenty-first century, we're experiencing one final shower of detritus from the past. Here in Bangkok, the shower is especially rich because Bangkok sits at the head of a vast cultural hinterland extending from Yunnan to Java. As a place to learn about East Asian culture Bangkok is perhaps supreme in Asia. I still prowl Chatuchak now and then, and I can't resist a stroll around River City, because the flow continues. Recently the stalls all seemed to be featuring Burmese illustrated palm-leaf manuscripts, delicately painted with gold on red lacquer. That got me looking at Burmese lacquer, and pretty soon I found myself making an excursion to Kyauk-ka, traditional center of lacquer making in northeastern Myanmar.

There's an old story about a Chinese literatus who sees in his youth a precious painting called "Autumn Mountain Painting." So struck is he by the painting that he spends the rest of his life trying to find it again. But when he finally tracks the scroll down, he discovers that it's a fake. Where's the original? What if the painting he saw so long ago was itself a fake? Maybe there never was an original? And then he realizes that it doesn't matter because the Autumn Mountain Painting is engraved in his heart; he has long since absorbed its essence and so he has no need for the real painting itself. Hearing which, his fellow sages, who have been listening to his story, clap their hands in delight.

I feel this way about the Thai and Khmer art I studied so fervently under the tutelage of Mui, Harold, and Marie. Their hard-earned knowledge will always be a treasure to me, but I'm now more content to look at originals than actually to own them. Even

with Burmese lacquer, I buy something new made by the craftsmen of Kyauk-ka rather than an antique. The fact that these artisans are still producing lacquer in their original village, in ways that haven't changed for centuries, is as precious as any antique, and almost more rare and fleeting. Come back next month and they'll have switched to making blue plastic buckets.

As it turns out, traditional craft is the middle ground where collectors can amuse themselves and not feel too guilty about it. Items of medium age, 50 or 100 years old, cover most of what's available in perishable materials such as textiles and lacquer. And it's also where the old meets the new in modern Bangkok. At one end are esoteric groups such as the Thai Textile Society, a group of connoisseurs who meet regularly to share information on topics such as "Textile Traditions of the Tai Groups in Nghe An Province, Vietnam." At the other end are the ubiquitous shops and stalls selling modern textiles, lacquer, and woodcarving – thanks to the tourists, you can hardly walk more than ten feet in the city without seeing these in some form or another. Much of it is mass produced souvenir chachkas, but at the same time, the tourist trade is also sparking a design renaissance that is making Bangkok into the design hub of Southeast Asia.

Which brings us full circle to Chatuchak. Antiques actually make up only a tiny fraction of the market, which features everything from puppies to teak houses, but it's especially rich in traditional crafts and contemporary Thai design. Look carefully and you'll find something in silk, bronze, bamboo, or straw with the same grace and instinctive power of line that so impressed Harold when he saw the zigzags on his first prehistoric pot. Thailand, only a few decades into modern development, remains close to its roots and you can still catch glimpses of that in Bangkok.

My relationship with Thai antique art did not turn out the way I thought it would in 1997. I had dreamed of building a grand collection; now it's clear that this will never happen. Nevertheless, my home in Bangkok is still not complete without a major piece of Khmer sculpture. I'm saving up to commission Nok to carve me something truly spectacular. No one but me will ever notice the lips.

NEO-BANGKOK

I've been lucky in my life to witness two cultural renaissances. One took place in Japan in the 1970s and 80s. The second is happening now in Bangkok.

It's the same process in both places, and it has to do with money. Historian Kenneth Clark proclaimed, "Poverty is the patron goddess of beauty." He was referring to Venice, which lost all its money in the 19th century, and therefore didn't have the resources to tear down the old town and build a modern city, as Paris and London did. Hence the wonder that is Venice survived.

In Asia, money plays a dual role. As nations rush to modernize, money at first destroys and ravages old cities and nature. Much of modern business and science came from the West, so people naturally confuse "westernization" with "modernization." They fall in love with everything Western and see their own tradition as backward, something to be ashamed of.

Later a turning point arrives. Once people have reached a comfortable standard of living, they start to revalue their native culture, and money then enables a cultural rebirth. In the 1960s when I was a little boy in Yokohama, Japan was just a decade removed from the American Occupation. Most roads in the countryside were still unpaved; most houses did not have central heating, a refrigerator, flush toilets. In other words, Japan was not so far from Thailand in the early 80s.

Then, after the mid-60s, Japan entered its era of fast growth. At first, the flow of money into the country only speeded up the

westernization. In the performing arts, Kabuki went into severe decline. In the 60s and early 70s, if you went into the Kabukiza Theater in Tokyo, except for a few foreign tourists, all you saw was old ladies. Kabuki had lost its relevance to the new society. In the mid-70s, the change began to happen. People (at least the citizens of Tokyo) had by this time a refrigerator, heating, a car and much more. Japan was on its way to becoming a world-level wealthy economy. As people gained the leisure to look back at their own culture, they stopped to catch their breath in the chase after things Western – and they had the means to seek quality. Kabuki revived, new stars appeared, and today you can hardly get a ticket for popular performances.

In other fields far beyond Kabuki (music, cinema, fashion) artists such as movie director Kurosawa Akira and designer Issey Miyake appeared who were to leave a lasting mark. What they all had in common was that rather than simply slavishly following the West, they turned back to their own tradition – and learned how to make it modern.

Thailand, when I started visiting back in the 70s, was still in the traditional phase, despite the fact that Bangkok was already a busy commercial city, and the Kings of Thailand had been westernizing the country for a century. For better or for worse, the Goddess of Poverty still ruled, and held her protecting hand over wooden towns and pristine rice paddies. I remember going to the floating market in 1973 and being so overwhelmed by the placid beauty of the scene that I wept. Now, of course, one could only weep at the tourist frenzy that it has become.

Taking the train from Bangkok to Chiangmai, just outside of town rice paddies came into view, and from there you saw an almost uninterrupted landscape of green fields, interspersed with villages and temples, all the way up to the north. The sois off Bangkok's main roads had a leafy, even rural feel to them.

Then, like Japan, it all began to change. In Thailand, the big economic growth started about two decades later than Japan, picking up steam in the 1990s. Overnight the city went from verdant sois and quaint shophouses to a conglomeration of highways,

hi-rise condos, and malls. In the process, traditional arts suffered much the same fate that Kabuki suffered in 1960s Tokyo.

That was the situation when I began to try to learn about dance and music in Bangkok in the 1990s. The traditional arts were reaching their nadir, and Khon, in particular, was hard hit. Its audience shrank even more than Kabuki's, because while Kabuki always appealed to the public, Khon relied heavily on the court. When the princely households disbanded their drama troupes after the 1930s, support declined. By the early 90s, Khon relied on a dwindling coterie of gray-haired matrons and academics, and in the process, Khon froze. "Freezing" is a common syndrome that happens when a traditional art survives only as a form and people start to forget about its original purpose.

Once upon a time, princes draped their dancers in brocades woven from the finest gold threads. They commissioned masks from masters who meditated at each step of the creation, and they adorned the performers with jeweled accessories that were marvels of the goldsmith's art. In the postwar years, embroidery degraded in quality and the costumes took on the cheap tinselly look that Khon usually has today. As performers drifted from their roots, they gravitated towards "beauty queen" makeup; mask-makers applied bright Western paints instead of old-style mineral pigments, so the masks too came to look more like cartoons than what they had once been: eerie avatars of the gods.

Meanwhile, the dance petrified. A few masters persevered in the Palace and in the universities, but Khon in general fell into formula, and as a result became a bore. Both foreigners and young Thais turned away, being unable to find anything of value, and so Khon's audience shrank even further.

By the early 2000s, Thailand began to cross the line from being simply a poor third-world country to being a developed modern state. Of course you can never put an exact date to these things, but I like to think that the magic moment was April 21, 2002, the day celebrating the 220th anniversary of Bangkok, when my friends and I walked in the parade with Paothong Thongchua, carrying flowers to the Shrine of the City Pillar.

The transformation is, of course, far from complete. Millions still live in poverty, not only in the countryside but here in Bangkok. Nevertheless, millions have now joined the middle class, and like the Japanese in the 1970s, they enjoy a refrigerator, an air conditioner, maybe a car, and certainly a cellphone. Thailand is ripe for a rediscovery of its own culture.

To do this you can't just maintain the arts as they've been practiced in recent years. That's not revival; it's just conservatism. New times call for a radical rethink of traditional culture. Onisaburo, founder of Oomoto, taught that the way forward was to go back – way back – to overleap recent eras and return to the arts at their ancient starting point. He insisted that we need to brush away the "dust" of recent years in order to go "back to the origin."

Big and Khru Kai, in scrupulously researching the past to create their new Khon costumes, are doing just that. Their costumes, while based on old forms, transcend them, for they have the advantage of modern technology, and an ability to pick and choose the best from old archives. Big has access to a wider range of textiles than even the wealthiest prince would have had in the old days. He can easily fly to Singapore to acquire a particularly fine Indian brocade. *Aporn Ngam*'s costumes look old but are creatively new, quite likely more beautiful than anything seen in earlier times.

One of those in the vanguard of the Thai arts revival is Anucha Thirakanont, the friend who opened my eyes to the appeal of Khon when he brought his troupe to perform at Ladphrao. A specialist in journalism, Anucha returned to Thailand from studying in the United States in 2001, and turned his attention to Thailand's neglected classical music. Anucha had grown up in a traditional family. His father collected Khon masks and his mother was a regular patron of the National Theatre.

Typical of many modern Asians, Anucha's youthful interests centered more on things Western, and he chose America as the place to get his education. But the dance and music he'd been steeped in since childhood was in the blood. On returning from his studies, Anucha found himself haunted by those memories and he set out on a mission of rediscovery of Thai culture. He built himself an

old-style wooden house, founded a puppet troupe, and acquired a collection of old instruments.

It's natural that Anucha would turn to puppets, because Thai puppets, as we now see them, blend old and new. Thailand once had a number of puppet traditions, but by the mid 20th century, all of these were on the verge of extinction. In 1974, a puppeteer named Liew acquired one of the last surviving sets of *hun lakhon lek* (old-style movable puppets), and brought to them a radical innovation. Seeking a way to make the puppets' movement more fluid, he came up with an approach similar to Japanese *Bunraku* puppets, which are manipulated by three people

Hun lakhorn lek puppets
Three black-clad puppeteers manipulate the puppet while posing in step with the music.

dressed in black in full view of the audience. He adapted his *hun lakhon lek* so as to be controlled by two or three black-clad puppeteers. Then, in contrast to *bunraku*, in which the puppeteers keep their movement to a minimum in order not to be noticed, Liew trained his puppeteers to dance and pose with the rhythm of Khon so that puppeteer and puppet became one, joined in the dance.

Liew acquired the nickname Louis in his early days as a *likay* comedy performer, from which, in admiration of the boxer, he took the name Joe Louis. And so the improbably named Joe Louis Puppet Theatre was born. Today the troupe he founded, now renamed the Traditional Thai Puppet Theatre, performs nightly in downtown Bangkok, winning international prizes for its innovative choreography and gaining fame as one of the cultural gems of Thailand.

The interesting contemporary artists in Asia take an essential quality from their tradition, and create something modern out of that. Otherwise they're just aping the international style dominated by New York, London, and Paris. My Malaysian friend Zul first opened my eyes to the possibilities. Zul trained in classical Malay dance, but he was at his best as an improvisational performer. Zul did contemporary dance with a traditional flavor. At various venues in Bangkok, I watched Zul climb and descend concrete staircases, balance on I-beams, wrap himself in plastic sheeting, gyrate with half-naked girls and boys – all while holding his shoulders high and twiddling his fingers like a Balinese dancer, or sliding his feet like a noble in an old Malay court. From Zul I saw how rich the resources of tradition could be for a modern dancer.

A hot-spot for such experimentation in Bangkok is the Patravadi Theatre, standing on spacious grounds across the river from the Grand Palace. Founded by legendary actress Patravadi Mejudhon, the theater sponsors a wide spectrum of Thai drama, from student shows to Manohra dancing from the South, plus visiting artists from Japan, Singapore, and many other places. It's always a pleasure to go there because it involves a boat ride across the river, and once you arrive you can enjoy a drink or dinner in the garden before the show or during the break. The theater is roofed, but not walled. Huge fans blowing misted air cool the audience seated in rows of steeply rising seats.

Running this venue hasn't been easy, because theater-going is new to the Thai public, and few people appreciate esoteric things like contemporary dance. The performances here tend to be experimental – which is just what Bangkok needed. Wealthy through her mother who ran the express boats on the Chao Phraya River, Patravadi has subsidized the whole thing for years. She had no obligation to spend her fortune on the arts, and she's unusual in doing so; in fact, arts suffer badly in Bangkok for lack of patronage. In the history of Thailand's modern stage, Patravadi will go down as a heroine.

Amidst all the experimentation, Pichet Klunchun succeeded in making Khon truly contemporary. Pichet trained as a *yak* (demon)

character in Khon, and he took the stamping and forceful arm gestures of the *yak* as his starting point. This was a "return to the origin" in the sense that he bypassed the pretty feminine side of classical dance and went straight back to Khon's martial arts

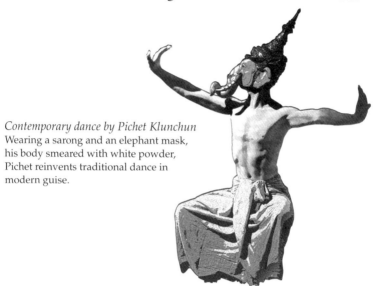

Contemporary dance by Pichet Klunchun
Wearing a sarong and an elephant mask, his body smeared with white powder, Pichet reinvents traditional dance in modern guise.

beginnings. With his athletically-tempered body, and stoic frame of mind, Pichet had the qualifications to strip Khon down to its essence.

And that's exactly what Pichet did. He stripped. Wearing only a loincloth and an elephant mask, he painted his body white like a Butoh dancer, performing Khon choreography in stark modern settings. Suddenly you could see beyond the costume to the core physicality of the art. Which takes us all the way back to India's naked gods and goddesses where the whole thing began thousands of years ago. In focusing on Khon's martial arts aspect, Pichet has found a way to make strong statements about Buddhist spirituality. Martial arts, of all arts, are the most supremely spiritual, because they balance on the knife-edge between life and death. In Pichet's case, his contemporary Khon is like a moving Buddhist meditation.

At other times, Pichet manages to insert a potent political message into what looks on the surface like nothing more than classic Khon movements. Basing himself in tradition, but electrifying relevant to today's issues, Pichet has gone on to appear at theater festivals around the world and is on his way to becoming one of Thailand's best known performing artists.

The Thai renaissance, most of which bubbles up out of Bangkok, is by no means limited to performing arts. Sakul, the flower artist, has made an international reputation. Thai film, never taken seriously by world film critics, has broken through in recent years with a series of world-class films, some of which won major prizes: *Tropical Malady*, *Hom Rong* (The Overture), *Ong Bak*, *Last Life in the Universe*, and *Thirteen Beloved*.

Unfortunately, Thailand suffers from one drawback that Japan largely escaped in the post-war years: censorship. The government meddles more and more, not only with political messages, but even with the look of the art itself. In this, Thailand differs from China, where censors are concerned mostly with politics, not aesthetics (with the exception of sex, to which they can be very sensitive). For example, in 2006 somebody allegedly stepped over Pichet's mask in an avant-garde performance in New York. Cultural officials objected to this apparent act of disrespect – although it turned out that it was not a Khon mask, nor was the play a Khon performance.

In recent years, bureaucrats are becoming ever more vigilant in imposing their idea of "Thainess" on the nation. Central authorities smooth out regional styles in favor of standardized forms created and disseminated from Bangkok. Where traditional art once reveled in quirky variations, now it's being "cleaned up" and homogenized – and the process impacts contemporary art as well. With his usual pithiness, Vithi remarks, "It's true that we were never colonized. We colonized ourselves."

Apinan Poshyananda, Thailand's leading art curator and critic, said in December 2007, "The sinking feeling in the Thai contemporary art scene today is not healthy. Thai artists and filmmakers simply have to grin and bear it. The freedom of

expression previously enjoyed, even during the time of tension of Thaksin government, has been sorely missed."[25]

For the moment, despite that "sinking feeling," Thai artists and directors are in fact flourishing as never before. Censorship has even had a sharpening effect, as artists find ways to evade, or subtly ridicule officialdom. Repression keeps artists' eyes focused on social injustices that they might overlook in an easygoing bourgeois environment. Chinese film directors in the 1980s, poets in communist Eastern Europe, ballet dancers from the Soviet Union – they all did their best work when struggling under an authoritarian regime. Kabuki actor Tamasaburo once said, "Every artist should have a Moscow in their background."

The power of censorship in Bangkok lies in its ambiguity. Standards, kept vague, open up lots of room for anyone to accuse or criticize the artist. One might say, they leave the maximum scope for people to take offense. As a journalist or artist, one must always keep alert to the idea that people could take things the wrong way, especially in an environment of increasing emphasis on "Thainess". That makes censorship much broader and more pervasive than a surface study of Thai laws or governmental institutions would indicate. Self-censorship rules, and the trend is towards everyone becoming more careful, not less.

Censorship – both official and self-applied – restrains "high art" in the realm of painting and performance, but so far modern design has largely fallen under its radar, because designers usually have no interest in putting across a grand concept, political or not. Of all sectors, it's design that really thrives. Youth fashion at Siam Square can be fairly said to lead the Southeast Asian region. I have a friend in the fashion world from Jakarta who flies regularly to Bangkok to check out the latest in what Thai youth are wearing, which will later be re-packaged and re-labeled back in Jakarta and Singapore.

At Chatuchak Weekend Market, or at upscale Gaysorn Plaza, you can see really inventive Thai design in the making. Some designers take traditional craft (natural materials such as bamboo, wood, lacquer, wickerwork) and reshape them in modern form. Others take the lines of *Lai Thai* patterns, and the exuberant pinks,

yellows, and greens that Thais so delight in, and transfer these to modern devices in plastic, aluminum, or glass.

Bangkok offers a wider range of goods than in many other Asian places, because modern design has stronger traditional roots. Thai designers have a deeper well to draw on, and this contributes to Bangkok's reputation as a shopping paradise. Thailand shares with Japan a fascination with surface beauty, and both nations preserved their native culture better than their neighbors. As a result Japan and Thailand regularly come up with quirky new ideas you can't find in homogenized global culture. In this sense, Thailand is the Japan of Southeast Asia.

Speaking of going "back to the origin," Bangkok is finally beginning to rediscover the Chao Phraya River, the artery around which the original city first formed. For decades, Bangkok treated its great river shabbily. Most of the shoreline degenerated into slums. Unless you stay at one of the big hotels on the river such as the Oriental, it has not been easy to find an attractive place to eat or enjoy a drink along the river. This is changing as small boutique hotels, such as Arun Residence (with its attached restaurant, The Deck) have popped up along the banks, and the city has built some truly spectacular bridges.

The Thai renaissance is more about "tourism" than it is about "art." This differs sharply with Japan where tourism is still a minor part of the economy. The Japanese authorities believed that great modern nations made things in factories, while poor and backward countries relied on tourism. So the infrastructure to welcome foreign visitors never developed, and despite a sharp rise in inbound visitors in the late 2000s, today Japan still ranks just a bit above Morocco and below Croatia. The opposite happened in Thailand, which is swamped all year round with tourists from every corner of the globe. Resorts and restaurants have found a voracious appetite for "Thai-culture" events and amusements, and a thriving industry has grown up to feed that.

In the process, Thai culture has been chopped up and reassembled as "show." The apotheosis is Siam Niramit in Bangkok, which boasts one of the largest stages in the world.

Here, in one evening, you can witness seven centuries of history, four cultural regions, the realms of heaven, hell, the mystical Himmaphan forest, and the Pleasure Realm of Lord Indra, finishing up with the major festivals of Thailand, complete with animals parading on stage and dancers springing on bungee ropes through the air. It's outrageous, but why not? The choreography could be better – but everyone loves a good show.

Bangkok hosts an endless parade of dance and culture spectacles, *son et lumiére*, beauty pageants with Thai culture reviews, dance and historical dramas with casts of hundreds. It's where the real energies of the culture now flow, because this is where the budgets are. In the process, Thailand has become rather good at it. 2006, which celebrated the 60th year of King Bhumibol Adulyadej's reign, saw some truly grand performances. One took place at Impact Arena, the convention and exhibition space at Muang Thong Thani north of Bangkok, which staged a production of *Mahajanaka*, a play about one of the former lives of the Buddha, written by King Bhumibol. Choreographer Naraphong Charassri designed the production, making use of hundreds of army cadets lined up in *Lai Thai* patterns on the floor of the football field-sized hall.

Bangkok is the tourist city par excellence of East Asia. A lot of Bangkok culture *is* tourist culture. Millions of travelers also visit Hong Kong or Singapore, but one feels their impact less, perhaps because Chinese societies are better insulated against outsiders. In any case, tourists have created thriving enclaves in Bangkok: Patpong and the Silom nightlife, the backpacker mecca of Khaosan Road in the Banglampoo area, the row of high-end hotels and antique stores along Charoenkrung Road by the river, the stretch of shops and hotels along Sukhumvit Road from Soi Nana to Soi Thonglor, which is a veritable 24-hour foreigner promenade. It's because of the tourists that we have so many world-class restaurants and hotels to enjoy; not to mention the fun at Khaosan Road, and entire industries of crafts that would otherwise barely exist.

The Benjarong ceramics that Khajorn and I sold on Sukhumvit Road are a case in point. Benjarong, modeled after multi-colored Chinese pottery, was once a favored luxury of the royal court.

However, because of its expense (due to the gold enamel and fine detail requiring hours or days to create each piece), and the fact that it has a "traditional" look (i.e. not modern and Western), it fell out of favor with Thais. Meanwhile, tourists are delighted with the traditional motifs and exquisite detail of benjarong, and they are willing to pay the price. Thanks to the tourists, Benjarong has survived – even thrived – in modern Bangkok.

Until I began spending time regularly in Bangkok in the early 1990s I had hardly ever given tourism a second thought. In Japan it's largely irrelevant. However, tourism is now the biggest industry in the world, and its global impact is just beginning to be felt. Bangkok lies right on the front lines of the world tourist explosion; here you can observe the new global fusion taking place before your eyes. Bangkok first made me feel tourism's power as an industry, and then made me think about its impact on culture.

It's a double-edged sword. As we all know, tourism cheapens and degrades. Especially when the "real thing" dies and tourist trinket-mongering takes its place – as in the floating market. The most extravagant shows on the biggest stages can never take the place of the profound meditative beauty that was refined over centuries in classical Khon. That's why, in the end, it's important to preserve the real thing. It's a wellspring, the "origin" to which modern artists can always return for inspiration.

At the same time, tourism supports artists and builds up expertise. The Origin art program itself has grown out of tourism, since most of the people who walk through the gate at Ladphrao to take our program are foreign visitors to Thailand. I can foresee a time when this might change. In Kyoto, a group of college students came to stay at one of the old wooden houses my company renovates, and we passed around a questionnaire to see what they had found most interesting. One student wrote, "Sleeping on a *futon* on the floor." Even something as basic as a *futon* was an exotic experience for this Tokyo boy who had grown up sleeping on a bed and had hardly ever stepped on a *tatami* mat. From this point of view, young Japanese have become foreign tourists too. It's all new to them.

This is not peculiar to Japan; the same process is at work across Asia. In China, where Mao's Cultural Revolution struck a massive blow to the old lifestyle, relics of the past exist everywhere – often refurbished and repainted in fire-engine red, and fitted out with museums and souvenir shops. However, it's hard to find monuments that serve their original purpose. Temples harbor few if any monks; old courtyards house families of squatters who moved in when the Cultural Revolution drove out the original owners. As David Kidd told Sinologist Geremie Barmé years ago, "They've moved everything around so often that now nobody knows where anything should go anymore." It's not easy for modern Chinese to get in touch with their historical culture, even though the façade of old heritage stands everywhere around them.

In Thailand, fewer things were moved around. The tourist hordes tramp through Bangkok's Grand Palace, but the Temple of the Emerald Buddha is still a place of worship, and the Throne Rooms are there to seat a living King. Young Thais are taken sometimes to pray at the temple, and they study *Maarayaat* in school. It's still common for young men to spend some time as a Buddhist monk, when they experience meditation and spiritual teachings first hand. Many children, at least in villages, learn how to cook, how to make flowers, and how to dance. That said, the bond is definitely weakening in Bangkok. For the kids with orange hair who cluster around Siam Square, the village may not be so far away, but the classical culture is so alien as to almost come from another planet.

Until recently, aside from the loyal old ladies at the National Theatre, the largest group of people who went to see traditional dance were foreign audiences at tourist venues around the city. However, by the late 2000s, one could feel a new stirring within Bangkok. "Thai culture" events, some on a massive scale, produced for the anniversary celebrations for the King in 2006 and 2007, may have had something to do with it. You began to see younger people mixed into the audience at Khon performances. Certain dance shows, such as the Royal Khon staged at the Thailand Cultural Centre in winter 2007 got a "buzz," and Queen Sirikit attended as a sign of the revival of royal patronage. Thousands of enthusiastic

Thais filled the theatre. That's truly a new phenomenon for Khon, and it's starting to feel like the Kabuki revival of the 80s in Japan.

Meanwhile, Khru Kai, Anucha, and Big are much in demand to take their dancers and puppeteers around the world. Living here in Bangkok I sometimes don't see them for months, because they're off performing in Argentina, Japan, or Britain. Aside from its domestic impact, tourism builds a community of support around the world, and this in turn engenders an appetite abroad for "Things Thai."

At the same time, dance and all the arts are evolving to reflect the taste of the new patrons. Once it was only kings and courtiers who were the arbiters of elegance. Now, it's also busloads of Korean and German tourists. Hence the popularity of all-in-one "Thai culture" shows like Siam Niramit. Like it or not, that's the way Bangkok is going.

The plusses and minuses of tourism make themselves felt in unexpected ways. In the design of houses, restaurants, and resorts Japan suffered because, not needing to appeal to foreign tastes, it failed to innovate, and eventually fell behind world standards. Thailand, inundated with foreign visitors, went the other way. The quantity of elegantly designed apartments and restaurants in Bangkok contrasts strongly with the plastic-and-fluorescent-light approach of Tokyo. In this respect, Thailand is the "advanced" country, and Japan a "developing nation."

On the other hand, traditional arts in Japan benefited by not having to pander to busloads of ignorant outsiders. Japan largely escaped the tourist glitz we see at Siam Niramit. Kabuki and other forms of theater had no choice but to think up new ways to attract audiences within Japan. In the process they stayed closer to their classic forms, while coming up with innovations that are truly original.

Given Thailand's propensity for *sanuk*, it's only natural that the culture should evolve towards glamorous shows. To some degree this has had an invigorating effect. In Lanna (Northern Thailand), spurred by the show phenomenon, Professor Vithi has led a revival of Lanna arts that has come to be dubbed "Neo-Lanna." Vithi and his students freely adapt costumes, dance gestures, and music from the cultures that have influenced Lanna – Burma, Shan, Laos, Cambodia, China, central Thai, and Hill tribes – and make of these

something that never really existed – a Lanna as it should have been. Just about anything goes. Even Vithi can be taken aback by the antics of his students. I saw one performance in which Bia, one of Vithi's disciples, appeared as a Khmer *apsara* (heavenly dancer), with four-foot flames spouting from his headdress, which housed a tank of kerosene. "*Apsara* barbecue," quipped Vithi.

The Bangkok establishment views Vithi's lighthearted approach with a jaundiced eye. Lanna, in their opinion, should be more decorous. They prefer a well-behaved Lanna, a row of elegant ladies waving their hands in unison. Vithi, they say, is mixing up so many ingredients in this pastiche called "Neo," that the real thing is getting lost in the process. My personal experience, from working with Vithi's artists, and traveling with him all over Northern Thailand, Laos, and Burma, is that he has done his homework. Vithi makes excursions along the Mekong and sleeps with the villagers in rickety huts along the shore. He stays up all night sharing anecdotes with the old grandfathers about how they would serenade their sweethearts with the *phinpia* (a stringed instrument with a coconut shell as resonator, pressed against the young man's chest). Now in his sixties, Vithi has spent a lifetime researching the rainbow quilt of cultures that formed Lanna.

It turns out that Lanna was always a pastiche, always a fantasy. According to Vithi, "words like 'decorous'– that's royal Bangkok speaking, not the shamanistic and matriarchal north. It was always more wild up here." Vithi is doing, in his way, what the Bangkok artists are doing: reaching back to the origin, seizing on basic principles, and recreating the whole thing anew.

The thing is, Bangkok culture, too, is Neo. It has changed so much over the previous two centuries, that trying to figure out what its true and proper form should be is nearly impossible. From the beginning Thailand's rulers freely mixed Khmer, Thai, Chinese, and Western motifs. In Bangkok's palaces, Gothic arches and Corinthian columns vie with Chinese porcelain, carved *naga* serpents and *chofa* finials. In the process everything got thoroughly mixed up, and the mixing continues. At the Royal Khon performance of December 2007, touted as a true return to the origin, the purest and finest Khon

since the 1932 revolution, the music was performed not by a traditional *piphaat* orchestra of wooden xylophones, ivory flutes, and chimes, but by a Western-style brass marching band.

This, too, had roots going back a century. Prince Naris, brother of Rama V, commissioned the band music for an event in honor of the visit of the Governor-General of French Indochina in 1899, in which dancers posed frozen in *tableaux vivants*, like giant paintings, as the band played. In the 2007, the modern change was that this time the dancers moved in time with the music of trumpets and tubas.

Khon, and its related dance forms *Lakhon nai* and *Lakhon nohk* – try to find someone (besides Big and Khru Kai) who can tell you what these things really are. There's the official explanation, and there's the reality of classical dance today, which is that in the eyes of the general public it all looks the same and nobody can tell the difference any more. It's increasingly irrelevant anyway, when most traditional dance in Bangkok takes place on giant stages accompanied by synthesizer music. As for Thai puppets, when it came to setting up his own troupe, even a traditionalist like Anucha was quite happy making use of Joe Louis' *bunraku*-style system of two or three black-clad manipulators.

It may have been influenced by Japan, but there's nothing Japanese about the seductively elegant movements of Thai puppeteers, almost more riveting to watch than the puppets themselves. By now the two or three-man puppeteer system has become thoroughly Thai. Focusing too much on the Japanese source is futile; it's like reviving the eternal argument over whether Thai or Khmer dance is more pure and original.

It just doesn't matter because in the hands of Vithi, Patravadi, Big, Khru Kai, Joe Louis, Pichet, Anucha, and Naraphong, and whoever it was who designed the modern Thai-motif bridges over the Chao Phraya River, the Thais are doing what they've done for a millennium: taking their core culture and fusing it with influences from outside. In the process, no matter how "Neo" it gets, they reproduce in a new form the elusive Thai qualities that have always been here. These are the true Origin.

EXPATS

It was three days before my housewarming party in 1996, and the phone rang. A female Voice of Authority demanded, "Why didn't you invite me?!" I had no idea who it was. Gentle questioning elicited that she was a local journalist whom I'd met some weeks earlier. She was not going to stand for people giving parties and not letting her know about it. And so I made the acquaintance of Jennifer Gampell.

Jennifer came to the party, and with her short steely grey hair, a row of five silver earrings in one ear-lobe, and a wide-brimmed black hat, she cut quite a figure. She was among the first of my journalist friends in Bangkok, part of a close-knit community of writers who make Bangkok their home. She's typical of a phenomenon you'll see wherever expats gather, as epitomized by Gertrude Stein in 1920s Paris: people re-inventing themselves. Nobody really knows much of who Jennifer was before she came to Bangkok. It's irrelevant really, since Jennifer as we know her is simply unthinkable outside of Bangkok. Once here, she learned excellent Thai (unusual among Westerners), and found that she had a talent as a writer. Her colorful persona once kept the expat circle stirring with gossip, but that didn't hurt her; it only fed the myth. In the end, Jennifer proved to be one of the best writers in the city.

Another journalist friend whom I met early on was Philip Cornwel-Smith, who turned out to be a boon companion and the person with whom I shared many epiphanies about Thailand and Bangkok. Philip came here in 1994 from a job as a listings editor for

Time Out and *The Guardian* in London. Four days after his arrival, he was offered a job as founding editor of what was to become Bangkok's leading city magazine, *Metro*, and over the next years, he steeped himself deeply in every aspect of Thai popular culture. Philip was curious about the colorful things we see around us in Bangkok, which, although similar to what we see in the West or in other Asian countries, are so very "Thai."

Philip began inquiring into the Thai fusion, the way this country takes things from abroad, merges them with its traditional culture, and sprinkles the result with the spice of *sanuk*. The result is something ineffably Thai, whether it's the big hair of *khunying* socialites, the little pink napkins served in roadside restaurants, *tuk-tuks* or the etiquette of pouring whiskey and Coke. Philip researched and photographed all these things, and many more, and published them in his book called *Very Thai*. I followed Philip on his journey of discovery into the small things of daily life that most other writers had overlooked, and I found that the joy of Thailand lies in details such as the magic diagrams on taxi dashboards or the paintings on sides of trucks and *tuk-tuks*.

It's no accident that both Jennifer and Philip are writers. Thailand supports a well-established community of journalists and creative writers because for decades it has been the hub for reporters on Southeast Asia. Dean of the writers is William Warren, who came to Thailand in 1960 and proceeded to author dozens of books about Bangkok and Thailand, from gardens to elephants. Today many of the leading photographers and correspondents of East Asia make Bangkok their home.

The international appetite for scandalous and titillating writing on Bangkok has been good for novelists, who thrive on the city's reputation for sex and drugs. Several friends of mine have written Bangkok novels – in fact the "Bangkok novel" has become a genre unto its own. So irresistible is the concept that, like everyone else, I've also developed an idea for a Bangkok novel. But sadly, John Burdett, author of *Bangkok 8* and its sequels, has already beaten us all to worldwide fame with his intricately scripted thrillers, centered on Soi Cowboy.

The most prolific and literary of the Bangkok novelists is Canadian Christopher Moore who lives just down the street from me on Soi 16. His best known novels are the "Land of Smiles" series: *A Killing Smile*, *A Bewitching Smile*, *A Haunting Smile*. Obviously, the theme is the famous Thai Smile, that thing that makes life in Bangkok so pleasant, and wins the hearts of millions of visitors every year. At the same time, there is, as Gore Vidal said of these novels, "the revelation of the razor teeth behind the Smile."

Christopher Moore wrote a non-fiction book, *Heart Talk*, which lists in detail the hundreds of ways that Thais use the word *jai* ("heart"): *jai rawn* ("hot heart," hot-tempered), *jai yen* ("cool heart," patient), *noi jai* ("small heart," to feel mistreated) and so forth. It's a natural extension of the Land of Smiles series, because behind the Smile (and the teeth) is the even more enigmatic Heart.

One genre of journalist came as a surprise. I found after making my official move in 1997 that Bangkok is full of "Japan refugees," writers who have lived first in Japan and then moved here. I think it's because in Japan you usually just write about Japan. In Bangkok, hub for all of Southeast Asia, a journalist has the choice of numerous publications funded by the region's booming tourist trade.

I noticed that there was quite a contrast between how expat journalists wrote about their adopted country. In Japan, foreigners often undergo a "conversion experience," after which they build careers celebrating everything Japanese: the bureaucrats are elite, the banking system is superior, the architects and artists live on a higher moral plane, and so forth. The phenomenon is so strong, that this group of writers has even earned a name: the "Chrysanthemum Club." In Thailand, in contrast, there doesn't appear to be an "Orchid Club." Thailand-specialists are well aware of the country's problems and their writings tend to be sharp. The closest thing to the Chrysanthemum Club type of literature would be the breathlessly gushing squibs that appear in tourist magazines.

There is quite a market for effusive travel writing, and plenty of people make their living from it. However, what doesn't exist is the really big money that pours into think tanks, symposia, and

university chairs, funded by the Japanese government and big businesses. These create an environment where favorable writing about Japan is a stepping-stone to real success. Thailand, for better or worse, doesn't offer the same carrots to foreign journalists and academics.

Another factor behind these different attitudes lies in Japan's wealth. Foreigners come to Japan already impressed with the fact that as an Asian nation it rose to compete on equal terms with the West. For many, that leads them to believe that Japan is something of a promised land, a place that does everything differently, and yet with magic success. Thailand, still relatively poor, fills few with the romance of "Asian success." So people start right out by looking at Thailand with a critical eye.

The writers, of course, make up only a fraction of the expatriate community. It includes many businessmen who've come here to seek their fortunes. Many a Frenchman or Italian owns his own restaurant, which is why the French and Italian food here is better than almost anywhere else in Asia, where it tends to be cooked by local chefs. Others have built middle to large companies, such as American Tom van Blarcom who heads a PR firm. Writers also take advantage of the ease of doing business here. For example, Steve van Beek (whose book *Bangkok Then and Now* gives one of the best overviews of the growth of the city), publishes and distributes his books himself, without relying on a major publisher.

Until recently it has been easy to live here for years, even without a proper visa; and few hurdles stood in the way of founding a company. Thailand gives us time. Young people with no plan in mind come to Bangkok, bounce around for a bit, and then find something to do, often something they never could have imagined they had within them. Harold, avid collector of antique Thai ceramics, worked as an architect for years before he discovered an interest in historic culture. This is how the expats "recreate" themselves, à la Jennifer. It makes Bangkok a breeding place for successful foreigners, to the extent that today the city harbors the largest and most thriving expat population in this part of the world.

Not every foreigner here aspires to make a mark like the legendary Jim Thompson, who revived the silk industry in the 1950s, and left behind a foundation that continues to influence contemporary Bangkok. More reclusive types prefer to live quietly among their books and gardens, rather in the style of Taoist scholar John Blofeld. Typical of this group, my cousin Tom likes nothing more than to come home to the green oasis of the Ladphrao house after a hard day at the office and settle in with a CD of classical music and a good book. Bangkok is a good place to submerge and devote oneself to one's passions, hobbies, or vices. Life is inexpensive, and the neighbors do not much intrude.

Which brings me to the taxonomy of expats. Different species do not much mix. At one end of the spectrum are people here on "secondments," business people and diplomats posted by their home organizations. These usually leave after a stint of two or three years, and they live mostly among themselves.

Then there are the people who came on their own, without an international institution behind them. Many arrived for what they thought would be short visit, found a job or an interest, and ending up making a life in Bangkok. Jim Thompson, Philip Cornwel-Smith, Harold the pot collector, and Jennifer all belong to this group.

Far more numerous than the foreigners registered as residents are the tourists who come and go, in the process falling in love with a boyfriend or a girlfriend. And they are legion. When Khajorn and I lived in Indra Condominium in Pratunam, it seemed that every other apartment was leased to a Thai supported by a lover abroad. The foreign patrons travel to Thailand when they can for a few months, and spend the rest of the year back in their home countries where they have jobs and spouses. Many choose Thailand in the end, but the transition can take decades. The number of foreigners who live partly in Bangkok, partly somewhere else, must be many tens of thousands. I was one of them for ten years.

The "friends and lovers" group has its soft underbelly, the ageing philanderers who troll the depths of Bangkok's go-go bars. For them, Bangkok is an addiction, rather than a home. It's the sight

of a fat elderly Westerner walking hand-in-hand down the street with a comely young Thai woman that draws the disapproving stare of many a tourist. Disreputable though they may be, this group too adds to the spice of the city. It's expats like these that make Bangkok truly exotic.

For the philanderer the fun ends all too soon, when a Thai woman or man snares him. To support the obligations of spouse and family, he establishes a bar, restaurant, hotel, or export firm, and pretty soon he's running a business or forging a career like the rest of us. Patrick Gauvain, the American photographer known by the name of "Shrimp," exemplifies "The Rake's Progress." A highly regarded photographer who has lived in Bangkok for decades, Shrimp made a name for himself with his annual calendar of Asian female nudes. Now married and well established, he still describes himself, a bit wistfully perhaps, as "an old reprobate."

At the far end of the expat spectrum, a handful of foreigners have mastered Thai language and become Thai citizens. One of these is Douglas Latchford, a British friend of mine who has lived in Bangkok since the 50s. In 1965 he gained Thai citizenship, something that even at the time was unusual for a Westerner and has become very rare today. Douglas became a sort of "godfather" to me after my move in 1997, advising me in business and financial affairs.

By "expat society," I speak of Westerners. Thais are so diverse that other Asians such as Chinese and Japanese can easily blend in. Westerners, however, will always stand out. My cousin Tasi, when she worked as a volunteer at the Klong Toei slum, was bemused at the way the schoolchildren gathered around her, asking for her autograph, and giggling at her. What did they find so funny? Well, it's her blond hair, her pale white skin, and from a Thai perspective, her ample proportions.

We *farang* differ in physique distinctively, even drastically, from the populations within which we dwell in East Asia, something which would not be true, for example, about an American living in Paris or a Dane in Moscow. As George Kates pointed out from his experience in Beijing in the 1930s, we have knock-knees, big

noses, and blotchy complexions; we tend to be tall and fat; we bump into things. We're *un capello nella minestra*, a hair in the soup. It's something I grew up with in Japan, so I've come to take it for granted.

MR Chakrarot remarks, "In the *Traiphum* cosmology, there are Arabs to the west, and Chinese to the east. To the north are a race of crazy people so advanced that they don't need to work. They live to be 900 years old, and if they need something, they simply go to a magical tree and wish on it. I think it's an old lampoon on you Europeans."[26]

Given the strangeness of this tribe from the north, it's all the more remarkable that Thailand handles the *farang* with such aplomb. This is unquestionably the most welcoming country for a Westerner in Asia. The number of inter-marriages must be huge. I've seen TV specials about villages in Isarn that consist almost exclusively of Thai women married to foreigners, with the lanes full of mixed-blood children.

In Bangkok, the offspring of Thai-Western marriages, known as *luk-khrueng* ("half children"), or *luk-siew* ("crescent children") for those with only a quarter or less of foreign blood, have a privileged position which has been mostly denied to such people in China or Japan. Here they dazzle as stars of Thai soaps because of their unusual appearance, and because of their often superior education, and international background, serve as managers in large corporations. One *luk-siew*, Bird McIntyre, dominated pop music for decades as Thailand's biggest pop-star; Tata Young, daughter of an American-Thai union, reached the top of the charts across East Asia for the song *Sexy, Naughty, Bitchy*.

The mixture of races has been going on a long time, with Westerners playing a role ever since the early 1600s when the Dutch, British, and traders sailed up river to the old royal capital of Ayutthaya. The 19th century saw a fresh wave of Western adventurers, typified by Henry Alabaster, progenitor of the colorful Savetsila/Bird family, and from that time on they've kept coming. It's no wonder that Thailand by now would be used to mixed races, but from the perspective of other Asian nations, acceptance

of the *luk-khrueng*, *luk-siew*, and all the other combinations, is the greatest evidence of Thailand's open-mindedness.

The all-time most famous resident, even more than Jim Thompson, must be Anna Leonowens of *Anna and the King of Siam*, brought to Bangkok to tutor King Rama IV's children in English in the 1870s. She was hardly as close to him as her memoirs make out, but King Rama IV did have several close foreign friends and advisors who visited him regularly in the Palace, and to whom he wrote letters in English.

Anna was by no means the first foreigner to make a mark on Siam, whose capital flourished as polyglot crossroads long before the founding of Bangkok. Royal Ayutthaya of the 1630s and 1640s gained its wealth through trade, becoming international in a way that was unique in Far East Asia. The city hosted communities of Dutch, British, French, Portuguese, Chinese, Persians, Japanese, and Macassars from the island of Celebes. King Narai's favorite dinner was Persian, his desserts were Japanese. He sent embassies to Louis XIV in Versailles, and imported mirrored glass from France to decorate his palaces. His prime minister was a Greek adventurer named Constantine Phaulkon. A family of Persian extraction known as the Bunnags helped manage palace finances, surviving centuries of ups and downs to serve in high positions at court until the early 20th century. While no longer viceroys and prime ministers, Bunnags still hold a prominent place in Bangkok society today.

Phaulkon's rise and fall offers a useful lesson. Shipping out as a cabin boy from a stony island in the Adriatic, Phaulkon made his way to Thailand, where he took a job with the British East India Company. With fluent Thai and shrewd political instincts, he caught the eye of King Narai, who elevated him in the 1680s to the post of *Chaophraya Vichayen*, one of the highest ministers of the land. His heyday didn't last long. Disturbed at Phaulkon's and the French's undue influence, in 1688 the courtier Phra Petracha carried out a palace revolution that overthrew all of the King's relatives and palace guard. He had Phaulkon killed, and after the death of King Narai, Phra Petracha threw the French out of Thailand, and had their Bibles and crucifixes gathered up and burned.

While the doors were not shut as tightly as Japan's, Thailand remained largely closed to Westerners thereafter until the early 19th century. Phra Petracha's revolution has appeared to be a set-back, the end of a golden age in which King Narai welcomed people from all over the globe to a cosmopolitan capital. But it could be that Phra Petracha acted in the nick of time. These were the years when the Dutch and Spanish were gobbling up Indonesia and the Philippines; the Portuguese had already taken Goa and Macao, and the British and the French were soon to vie over India. Western colonization – often done in the name of bringing Christian salvation to the natives – was about to sweep over Asia, and Phaulcon was the opening gambit. One could argue that in throwing out the foreigners Phra Petracha saved Siam.

The moral of the story is that outside influence is only to be welcomed so long as it doesn't destabilize society. There was a backlash against the Chinese in the 1920s, and another anti-Chinese period lasting from the end of World War II until the 70s. In recent years, Thailand's government has started to wrestle with the problem of undesirable Westerners. The issue came to a head with John Mark Karr, a deranged English teacher who claimed to be the killer of child beauty queen JonBenét Ramsey, and was deported to America in August 2006 amidst a blaze of publicity. Although it turned out that Karr was innocent except in his dreams, the government announced new rules that would make it much harder for foreigners to live here without work permits.

This will force young foreigners to toe the line to their sponsoring agencies – a situation similar to what exists in Japan – with the result that there will be fewer who can take the time to simply hang around and discover themselves. The great era of Bangkok expats may have passed its zenith.

But we have left our mark on the city. There are hallowed halls within Bangkok that tourists rarely see, which cater mostly to foreigners, such as the FCCT (Foreign Correspondents Club of Thailand). The venerable Siam Society, housed in leafy grounds on Soi Asoke just a block from where I live on Soi 16, hosts talks and tours, and maintains a well-stocked research library.

One of the most active volunteer societies is the National Museum Volunteers (NMV), a society mainly of foreign women. These are basically docents, offering their services as guides at the National Museum, but they also sponsor talks, seminars, and study tours. With a history dating back decades, and membership of hundreds, the "NMV" is a force to be reckoned with.

All this involvement with expats was new to me. In Japan I had few foreign friends. The very word "expat" was unfamiliar. Expats were stockbrokers in Tokyo, not me. Everything changed when I moved to Bangkok, where I was an outsider, barely able to cope in Thai, and unfamiliar with Thai ways. I discovered a huge and vibrant foreign community, unlike anything I knew in Kyoto or Tokyo. My friends became the expats, and it took a long time before I acquired strong personal friendships with Thais. In this I think I'm typical of foreigners in Thailand. For all the surface smile and welcome, Thai society remains remarkably close-knit, keeping foreigners at a polite distance.

Thailand learned its smooth treatment of foreigners in the 19th century, when the nation faced its greatest danger of colonization. With the British moving in from the west and south, and the French from the east, Thailand urgently needed to prove to the Westerners that it was "civilized." As dramatized in *The King and I*, it involved women wearing bustles instead of Thai traditional dress, and members of the court sitting down to formal dinner tables and eating with spoon and fork. Dan Beach Bradley, an Englishman living in Bangkok in the 1830s through the 1870s, who founded Bangkok's first newspaper, the *Bangkok Recorder*, describes an occasion when King Rama IV summoned him to the Palace for breakfast. Except that only Beach was to eat. The King and his court sat watching him to see how he used the cutlery.

In Japan during this period, the court shifted from kimono to Western dress; after his coronation, Emperor Hirohito was never seen again in Japanese costume, and the other royals eschew kimono to this day. In the 1870s they built a dance hall in Tokyo known as *Rokumeikan* "Deer Cry Pavilion" where society leaders diligently practiced waltz and minuet.

Thailand's great modernizer King Rama V traveled to Europe, and returned with a taste for suits and cravats, cigars and liqueur. Shopkeepers still revere his image by offering on his altar a glass of tinted water in honor of the King's taste for brandy.

The rallying cry of the Western colonizers was that they were bringing civilization to the savage races of the East. Proud China and Burma would never bow to this pressure. The idea of taking pains to learn from the barbarian Westerners, as King Rama IV did with Dan Beach Bradley, was anathema. And so the Europeans over-ran them.

However, Japan and Thailand did what was necessary. The fact that women wore lacy dresses and carried parasols, the men knew how to use a teaspoon, and the King drank brandy, saved them. It proved that they were "civilized." It's a weird twist of history, but whether you got conquered or not had a lot to do with table manners and ballroom dancing skills.

Of course, much of the change was just on the surface. King Rama VI, who was educated at Sandhurst and Oxford, would seem to be the epitome of the English gentleman. He gave seated dinners at long tables spread with white linen, at which everyone wore bow ties and tails. But Professor Vithi recalls being told a story by MR Kukrit Pramoj, Prime Minister of Thailand in the mid 1970s. In his youth, Kukrit had been a royal page to King Rama VI. While the dignitaries ate a ten-course dinner with all the right spoons, knives, and forks, little Kukrit's job as a royal page was to crawl under the table and massage the King's weary legs. In short, quite different things were going on above and below the table.

Vithi points out, "To this day wealthy Thais tend to have homes that feature lots of red-velvet-and-gilt Louis XIV furniture, with six-meter long dining tables seating twenty. But they never use them. At lunch time they go into the pantry, sit on the floor, and eat sticky rice."

Both Japan and Thailand made the "above the table" changes needed to keep the foreigners at bay, while keeping their old internal systems intact "below the table." The outside modernized, but the inside kept to its old ways.

As far as external forms are concerned, the idea that "being Western is more civilized" made a huge imprint and its hold is still strong. The Thai film *Hom Rong* (The Overture) deals with the 1930s and 40s era when the military repressed traditional music in favor of piano and jazz. Likewise, in Japan, Western classical music had a resounding victory; a hundred years passed before schools began teaching Japanese music again in the early 2000s.

In Thailand, the deeply indurated idea that "Western is more civilized" explains why you rarely see people wearing traditional dress or living in an old-style house. For those of us Westerners who regret the way that East Asians seem so willing to cast aside their traditional culture in favor of things modern and Western, we should not forget that it was our own ancestors who set this train of events in motion. The Europeans arrived in their gunboats and delivered a shock that still reverberates, centuries later.

The way Thailand and Japan handled the foreigners was similar in the 19th century, but diverged thereafter. Japan's answer, once the nation stood well on its feet economically and militarily, was more or less to get rid of them. Even now, only a tiny percentage of expats ever manage to set up their own businesses; and the government mandates that foreign teachers in national universities be discharged after a three-year term. Any longer than that and they might know too much. Even at leading hotels in Tokyo you have to search hard to find an English language newspaper. Most Japanese see few foreigners in their lives. Despite much talk of "internationalization," Japan's answer, as it was in the 1620s, has basically been to stay closed.

Thailand, even during the fascist years before World War II, didn't have the option of restricting foreigners. Situated between British India and French Indo-china, modern Thailand took the same approach that mercantile Ayutthaya had taken: welcome in the foreigners, and profit from them.

After World War II, a steady influx of foreigners arrived, including enterpreneurs who established businesses like Douglas Latchford, and Peace Corps volunteers who stayed on to make careers as academics. In the 1960s and 70s floods of American

military swept in, leaving the legacy of red light districts at Patpong in Bangkok, spilling over into Pattaya, a weekend resort on the eastern seaboard. Today Pattaya forms the nexus of a huge expat retirement community, a Bangkok-on-the-sea with its own infrastructure of apartments, restaurants, newspapers, and hospitals – all catering to the foreign residents. The latest arrivals: a large and growing Russian community.

From the 1980s, Thailand established itself as one of the world's premier tourist destinations. The backpackers swarmed to Bangkok, building Khaosan Road into the youth mecca that it is today.

Meanwhile, Japanese companies invested heavily in Thailand, bringing in thousands of employees, followed by tens of thousands more as support for their community, working in restaurants, bars, printers, even *tatami*-makers. In the 1990s, high-end package tourists from Europe and America spurred the growth of luxury resorts and spas. Today the streets of Bangkok swarm with tourists. At my local Foodland supermarket I can buy newspapers not only in English but in French, German, Russian, Chinese, Japanese, Italian, Danish, and Swedish.

The juggling act goes on. In the 1970s and 80s, Thailand built especially cozy relations with America; in the 1990s we heard much about "Japan-Thailand friendship." At the beginning of the 21st century, it was China's turn. Thailand's history with China has been dusted off; ministers and diplomats attend Chinese festivals with great fanfare. As it has done for centuries, Thailand is balancing the ambitions of foreign powers while maintaining its freedom – and making money in the process.

Naturally there's another side to the welcome we Westerners receive in this country. After a charming, even warm encounter, the Thai goes home to his Thai universe and the foreigner returns to a tourist or expat enclave. Mont Redmond, in his book *Wondering into Thai Culture*, writes: "Be as affable and animated as you can; you will fail. The relationship begins to cool just as you were expecting it to gain in warmth. Suddenly you are dropped and forgotten. Were you too proud? too eager to please? too clever? too stupid? what? None of these. Just too *farang*."[27]

You could call it "*farang* fatigue." I've seen this happen many times in Japan and Thailand. The young Japanese or Thai finds Westerners utterly exciting. He or she can't spend enough time with their Western friends, who seem to carry about them the breath of freedom and enlightenment, and from whom they sop up many a fascinating idea about the world. Then one day, the young Asian suddenly loses interest. He reverts to his native society, and his days of consorting with foreigners are largely over.

Years ago, in Japan, to answer this mystery, I turned to my spiritual advisor William Gilkey, who had lived in India in the 1940s, China in the 1950s, and Japan ever since. With Gilkey's long knowledge of East Asia, I thought he might shed some light. "How does it happen?" I once asked Gilkey. "Why do they lose interest in us, and so fast?!"

"It's like when you go out for a drive on a nice sunny day," Gilkey replied. "Your car is whizzing into the hills, the sun is shining, the birds chirping, and all is delightful. Then it starts getting dark. You realize you're far off in the mountains, it's cold, and you don't know where you are. From that moment onwards, you have only one thought in your mind: *how to get home.*"

"Home" is the traditional culture, the attitudes of reserve and nuance, the willingness to let vague things be, that form the basis of old East Asian societies. Our Western-style free and aggressive thinking will always act as a pressure on the Thais, and as a foreign resident here it's only prudent to keep in mind the effect that one might be having. "*Buea farang* (I'm sick of *farang*)" says my trusty assistant Saa. This from a woman who speaks fluent English, whose best friends have been Americans, and who travels constantly to Europe. While I feel for the moment that this doesn't include me, it's a sign to be careful. It's time to guard against one's normal exuberance and practice a bit of reserve. But then, it was always time to do that.

Of course the fatigue goes both ways. The American poet Ezra Pound, long an expat in Italy, wrote, "I am homesick after mine own kind/ Oh I know that there are folk about me, friendly faces / But I am homesick after mine old kind." That's our plaintive chant,

the song of the expats, who, wherever we are in the world, tend naturally to seek "our own kind."

Keeping the foreigners quietly in their place – this is how Thailand protects itself. For all their expert table manners that so impressed ambassadors of the 19th century powers, King Rama IV's and King Rama V's courts remained more or less medieval autocracies. Thailand has mastered the art of accepting the external world and yet remaining resolutely itself. This is why despite the hordes of tourists and expats in their midst, and the onslaught of the internet and mass media, Thailand remains so "very Thai." In this respect Thailand resembles Italy, another smiling "*la dolce vita*" land, which has long been flooded with foreign visitors and even conquerors. Italy charms outsiders but keeps them at arm's length.

One can see the paradoxes of Thailand's internationalism at work in one of its more quirky and elite institutions: the annual Oxford Cambridge Dinner. Open only to graduates of those two universities and their guests, its very requirement for attendance, lies elsewhere, on the other side of the world. Here one can see the end result of the "civilizing" process that began with King Rama IV's English letters and King Rama V's canes and cravats. Since Prince Svasti, Ping's ancestor, first went to study at Oxford in the 19th century, the sons and daughters of the upper class and the nobility have been going for generations to Oxford and Cambridge, and today they include bank presidents, politicians, prime ministers, college professors. If you gave the same party in Tokyo, few would hold any position of importance. Most would be unworldly second-tier academics. Here, they're active society leaders helping to run the country.

At the Oxbridge Dinner, suave and worldly Thais give speeches sparkling with British wit that an American such as myself can hardly keep up with. Thailand, at least at this rarefied level, has truly mastered the Westerners' idiom. Although we're welcome here, the Thais have already got it all themselves. They just don't need us.

No Asian nation ever did. Seen from that point of view, the Thais are awfully nice about it. There is no question but that in Bangkok,

for a foreigner, the ease of living and cordiality extended by the locals is head and shoulders above any other Asian capital. Whether Thais are enjoying the encounter, or whether inside they are thinking, *"Buea farang,"* it makes little difference to the smiling welcome we receive. As hackneyed as it is, we do live here because of the Thai Smile.

It occurs to me, nowadays, maybe Asian cities do need foreigners after all. Huge populations of expats make Paris and New York "buzz" in a way that Rome, as lovely as it is, never quite does. Expats are the yeast that makes the bread rise. Tokyo tries so hard to be international, but the role of foreigners, and foreign-educated Japanese in society, is just too small to make a difference.

Even in internationalized Hong Kong and Singapore, the expats don't have quite the impact that they do in Bangkok. I think it might be because a large proportion of foreigners in those places have seconded from the home offices of big international firms. In Bangkok we get far more independents, and they're the ones who infiltrate into all sorts of unexpected corners.

Actually nobody has any idea how many foreigners actually reside here because the expat population tends to be so transient. Many live here for years as semi-tourists, as I did in the 1990s. They might own a condo and spend half the year here with their lover, and even be doing some business on the side – but they don't apply for resident visas and don't register with their home embassies, so they go uncounted. It's the many transients and independents with no clear abode or occupation who bring color and surprise to Bangkok expat life.

That's why, after a trip back to Japan, or an excursion to China, returning to Bangkok feels like returning to the big wide world. It's like that feeling you get when you come over the Hudson River and see the towers of Manhattan looming beyond the bridge. Bangkok is where the action is.

It's nice to see our expat band as a kind of yeast. That, of course, doesn't change our fundamental irrelevance to Thai society. I'm grateful for good expat friends such as Philip Cornwel-Smith and Douglas Latchford who have been guides and companions in

exploring this complex and colorful country, as well as the redoubtable Jennifer Gampell, who is always welcome at my parties. And grateful for the Thai friends I've slowly made over the years. Bangkok may sometimes have razor teeth, but the Smile is always there, and so is *jai*, the Heart. Yet, after all this time, the difficulty of penetrating Thai society gives me continually the strange sensation that I'm seeing the whole thing go by as I speed behind a glass car window. Although a long term resident, I'm still just a tourist here.

THE IRON FAN

It's not something I talk much about, but I have a secret career. It began when I was working for Oomoto, a Shinto foundation outside of Kyoto. Oomoto was unusual in that, unlike most religious groups, it didn't require of the staff that we convert and become followers. This meant that the Oomoto staff were considered religiously neutral, so in the 1980s, when Japan's religions started getting involved in interfaith conferences, they turned to Oomoto, who lent me to them as their translator and arranger. Thus I became, without ever planning to be, translator for Japan's Buddhist and Shinto religions.

The work involved travel to religious centers around the world, and sometimes called for some quick thinking. Such as when we visited the Grand Mufti of Turkey in Ankara to invite him to attend a conference in Tokyo. The Grand Mufti warmly greeted the delegation of Shinto priests and Buddhist abbots, had them served sweet Turkish coffee in crystal glasses, and delivered an eloquent lecture about how flattered he was to be invited and what an honor it was to meet such great spiritual leaders. Everyone was delighted, but as we were being escorted down the hallway, someone in a fez pulled me aside and beckoned me back into the Mufti's audience room. "Sit down," ordered the Mufti. I did. There was no coffee this time. "Now tell me, who were those people?!"

When I left Oomoto and moved my base to Bangkok in 1997, I assumed that my religious translation days were over. But one day in summer of 1999 I received a phone call from a PR firm in New

York who represented one of the religions I had worked with in Japan. "The United Nations is planning a worldwide gathering of religious leaders in New York next year," they told me. "It's to be called the Millennium World Peace Summit of Religious and Spiritual Leaders. This will be the biggest and most prestigious gathering of religions ever: cardinals from the Vatican, Protestant and Greek Orthodox bishops, sheiks and muftis from the Islamic world, Shinto priests from Japan, Buddhist monks from Sri Lanka, Vietnam, and China, Hindu holy men, and Native American chiefs. Also leading scientists and naturalists, like Jane Goodall, primatologist famed for her study of chimpanzees – they're all attending. Can you find some Thai Buddhist leaders to join the summit?"

Impressed at the idea that I might be able to go to New York with the Buddhists and maybe meet Jane Goodall, I agreed. The problem was, I didn't know any Buddhist leaders. Until that day I had hardly ever met a Thai monk. When Khajorn and I celebrated the completion of the Chiangkham house, nine monks came to consecrate it in a morning ceremony. Later, when Khajorn and I went into business with Ying, she introduced us to a high monk to whose temple outside of Bangkok, Khajorn, my colleague from Japan, Bodhi Fishman, and I, went to have our fortunes read. We arrived at about midnight and sat on the floor with hands reverently clasped before him, in a vast aluminum-roofed hall, filled with shiny new Buddha images.

The abbot addressed us one by one. He told Bodhi that he would always be a support to me – which turned out to be true, as over a decade later Bodhi and I still work together. He advised Khajorn that he would be healthy if he got enough sleep. True enough. He informed Ying that she should give up one of the Buddhist sins: lying, drinking, stealing, sexual misconduct, or taking life. She said, "Well, I like meat too much to give up taking life. I enjoy sex, so can't give that up. I'm an antique dealer, so I could never stop lying. I'll give up drink." The abbot warned me that I should only do business by myself and should never go into partnership, as tying up with the wrong person could lead to disaster. This

came true within weeks when trouble started in our benjarong partnership with Ying herself.

Having seen some of the abbot's prophecies come true in short order, I had a healthy respect for the clairvoyant abilities of Thai monks, but no idea of where to find Buddhist leaders in Bangkok. I asked around and a Thai writer friend suggested that I meet Phra Rajavaramuni, rector of Thailand's largest Buddhist university, Mahachulalongkorn Rajvidhayalaya University (MCU). He was also a leading Buddhist intellectual, having written a thesis comparing Buddhist teachings with the existentialist philosophy of Jean-Paul Sartre.

Saa and I traveled across town to Wat Mahathat, a large temple complex housing the university, just west of Sanam Luang (parade grounds) by the Grand Palace. Once arrived, there was no sitting on the floor in attitudes of respect and no fortune telling. It was all quite businesslike. We were shown into an office where we sat on chairs facing Phra Rajavaramuni at a desk piled with papers. Round faced and cheerful looking, he appeared to be about thirty, although he must have been well into his forties to have achieved such a prestigious position. He quickly grasped the importance of the Millennium Summit. "I'll take care of it," he said, and called in his assistant Phra Maha Sawai, who appeared with a computer and took down our email addresses.

A few weeks later Phra Rajavaramuni summoned us again to MCU, this time to watch Phra Maha Sawai deliver a PowerPoint presentation to a room full of orange-robed monks who headed powerful monasteries across the country. Among them there was a figure in white, Mae Chee Sansanee Sthirasuta, one of Thailand's most charismatic Buddhist nuns, famed for preaching to teenagers and bringing them to meditate at her center. Mae Chee Sansanee has her own website. What with Phra Maha Sawai's PowerPoint and Mae Chee Sansanee's website, it was dawning on me that Thai Buddhism has been quick to embrace modern technology.

New York wanted Thailand's Supreme Patriarch to attend the conference, but this was out of the question, due to the Patriarch's precarious health. After several months of discussion, they finally

chose the venerable 93-year old Councillor Somdej Phra Putthakhosachan, number three in the hierarchy, to head the delegation. Sixteen other abbots from temples in every region of Thailand would attend him. Thai Buddhism, bound up tightly with royal prestige, must be one of the world's best organized religious bureaucracies. King Rama IV, who spent twenty-seven years as a monk before acceding to the throne, reformed the clergy, leaving behind the strictly controlled system we see today. There are two old sects, the Maha Nikaya and the Dhammayuttika Nikaya, but these divide largely along administrative lines, and the average person would be challenged to tell the difference.

This system is starting to change in recent years as people who feel unsatisfied with mainstream Buddhism turn to new alternatives, such as *phra thu dong* "forest monks," who have existed for centuries, keeping their distance from the Buddhist hierarchy while practicing meditation at hermitages far from the cities. Modern forest monks sometimes gain large followings among the public as well as support from the elites in the cities.

New groups who are closer to being actual sects, have established themselves in recent years, notably Dhammakaya, with its wealthy endowment and huge modern temple in Pathum Thani Province north of Bangkok. Santi Asoke, a "fundamentalist" sect whose leader clashed with the authorities and was arrested in the late 1980s, continues to influence Thai politics through its hold on politicians such as former Bangkok Mayor Chamlong Srimuang, who is vegetarian, celibate, and claims to have no worldly possessions. Nevertheless, unlike China or Japan, where Buddhism long ago fragmented into dozens of sub-sects (which are still fragmenting and creating "new religions"), Thai Buddhism is still largely a unity.

Historically, Buddhism, with its emphasis on renouncing the world, always posed a problem for royal courts. In 8th and 9th century China, when tax-free monastic institutions began depleting the imperial treasury, the emperor took drastic steps, ordering the temples burned, the icons smashed, and the monks defrocked.

Buddhism revived after this, but never flourished as before. In Japan, the imperial court simply sidestepped the temples. The emperor moved his capital from Nara to Kyoto, leaving the vast religious establishments of Nara to quietly molder away, far from the center of power.

Thailand took an inclusive approach. The King brought Buddhism inside the court. In the heart of the old royal palace of Ayutthaya stood the royal temple, which is duplicated today in Wat Phra Kaew, the Temple of the Emerald Buddha, inside the Grand Palace. Kept closely aligned with the King and his court, Buddhism did not fragment into conflicting sects. One could say that it's the great stabilizing force, the quiet center around which the chaos of Bangkok revolves. Enter one of Bangkok's temples, whether a grand royal one such as Wat Suthat, or a small neighborhood wat, and the calm of the Buddha envelops you. The complications and uncertainties, the noise and dust, even the *sanuk*, fade away in a transcendental moment. Wat Phra Kaew, even on its busiest days crowded with tourists, seems somehow to partake of this supernal quiet.

However, from previous experience I knew that interfaith meetings are anything but quiet. Amidst the babble of competing dogmas, the monks would need to communicate, and translating for them would be far beyond my Thai language skills. So I called upon Num (my landlord, who happens to be an excellent translator) to help. And so in August 2000, Saa, Num, and I flew to New York with the Councilor, Phra Rajavaramuni, Phra Maha Sawai, the sixteen monks, and Mae Chee Sansanee. We gathered in the lobby of Don Muang Airport, and knelt before the Councilor who blessed us all.

In New York, for the opening of the Summit, the monks (and nun) held a ceremony of blessing on the stage of the United Nations Assembly Hall. It was possibly the most prominent appearance of Thai monks on the world stage ever. They had brought with them a bottle of holy waters from nine temples, which they were going to sprinkle into the audience, using bundles of fibers made from long-stemmed *Yaa Kaa* grass.

Ten minutes before the ritual began, we realized that the bundles of *Yaa Kaa* had been left in the hotel. While those around him panicked, Phra Rajavaramuni reacted with Buddhist unflappability. "Any leaves will do," he said. Num rushed outside and frantically searched until he found a tree in the UN's Japanese garden and snapped off a branch. ("I apologized to the tree," he explained. "I said, 'Sorry, but this is for World Peace.'"). At the high podium they sprinkled the nine holy waters with leaves from the UN garden, and all went well. On the way down from the stage, Num noticed Jane Goodall seated in the front row. Suddenly she spoke to him. "I collect religious objects," she said. "Could I please have those leaves?" So the Thais' sacred water sprinkler ended up in Tanzania with the chimpanzees.

While at the UN, Phra Rajavaramuni gave a speech entitled "A Buddhist View on Conflict Resolution." But however well reasoned, presentations such as this were not really what the conference was about. The point was networking, for Rabbis to meet Bishops, and Muftis to shake hands with Patriarchs. The rest was an experience rather like the "Ecclesiastical Fashion Show" in Fellini's movie *Roma*. We spent our time immersed in the crowds that mark such interfaith events, colorful with lots of flowing robes, brocades, tall hats, and jewelry.

Back in the 1920s, Onisaburo, the founder of Oomoto, spoke of what he called "the garden of religions." The spiritual roots of all faiths are the same, he said, but depending on where the sprouts arise – in a hot or cold place, and with different historical and ethnic backgrounds – they take different shapes like a thousand multi-formed flowers. Onisaburo suggested that it would be a bore if every flower in the garden looked alike, and that we should be thankful for the glorious variety of religions.

The delegation of Thai monks felt quite at home in the religious mixture at the UN because Thailand itself is a "garden of religions." This might not seem so obvious in a country that is usually seen as a Buddhist nation (despite its roughly 4% Muslim minority). But it was not always primarily Buddhist. The ancient Mons and later the Thais who settled here were animists; and the Khmer Empire that

dominated Thailand for hundreds of years was for much of its history Hindu. Thailand retains all of these strains.

While it's a broad generalization, one could say that North and Northeast Thailand, influenced by the peoples of the Mekong, are more animist; the royal tradition of Central Thailand is more Hindu. Prof Vithi quips, "Bangkok people think of themselves as Thai Buddhists. But actually they're Chinese Hindus!" He's referring to the fact that a large percentage of Bangkokians are all or part Chinese in parentage; and that they pray as often to Brahma and Vishnu as they do to Buddha.

Four-headed Brahma, who grants all wishes, is ubiquitous in Bangkok. His most famous shrine stands at the Erawan Hotel corner, thronged by petitioners all day and night. When I made my first trip to Bangkok after the "Voice in the Bullet Train" in 1989, one of the first places I visited was the Erawan Shrine. To this day it's a special place for me, and I visit at least twice a year, even though the wish I made back then, and have been repeating ever since, has not yet been granted. I don't give up hope, and I always try to remember to *wai* when I walk by the Brahma shrine outside my apartment building.

Statue of Brahma
Four-headed Brahma, facing the four cardinal directions.

In addition to Brahma, you see Garuda (Vishnu's winged mount) in front of banks and government buildings, the trident of Indra, King of the Gods, on top of temples and palaces. Ganesha, the elephant-headed god, patron of the arts (and symbol of the Fine Arts Department), features prominently in museums and theaters. As you enter the Grand Palace, the first thing you encounter is a statue of Rusii (the Hermit), the Indian master who teaches us all wisdom. Every year in spring and fall, Bangkok universities perform

ceremonies of *wai khru* ("homage to teachers"), at which masks of Ganesha and Rusii preside over the high altar.

In Bangkok you also come across some very unusual Hindu gods, such as Trimurti, the five-faced combination of three deities: Brahma, Vishnu, and Shiva. There's a popular Trimurti statue in front of Central World Plaza shopping center, and for no clear reason, this one has got the reputation of being a god of love, and so is much patronized by teenage girls. Rahu, god of eclipses, has his own mysterious cult. Some years ago the newspapers speculated darkly about why the wife of a powerful politician was seen performing rites to Rahu.

Garuda
The royal insignia of Thailand.

Neither Brahma nor Trimurti, nor even Rahu or the Guru, have many shrines in India. In fact there's even an old tale that Brahma was cursed that he would not have shrines in India to be worshipped at. The "Hindu" cult in Bangkok has little to do with Hinduism as we see it today in India; it has taken on a Thai character.

One of my favorite places in Bangkok is Devasthan (literally "Place of the Gods"), the Brahmin Shrine, across the street from Wat Suthat and Saochingcha (the Giant Swing). It's a small place,

Mask of Ganesh
Remover of obstacles, and patron god of the arts.

easily overlooked, but it lies at the heart of the royal Hindu cult. Brahmin priests from this shrine perform ceremonies in the palace,

and they're much in demand for rituals across the nation. I did once manage to visit this temple at dawn for the *Phithi Kon Juk* "Cutting of the Topknot Ceremony," which takes place annually in early January.

As we enter the 21st century, the cult of Hindu gods flourishes more than ever in Bangkok. It's part of the growing gap between Bangkok urbanites, fond of Hindu deities, and the rural poor, still largely devoted to Buddhism and animism. Many young people in the city are bored with mainstream Buddhism, so they turn either to puritanical Buddhism ("Buddhist fundamentalism"), or to the Hindu gods. While Buddhism mostly offers teachings about facing the facts and living with them, the Hindu gods provide hope of *changing* those facts of your life. It's a bit like buying a lottery ticket.

Chinese gods have also made a home in Bangkok. Enter a Chinese shophouse, and it usually displays a little red shrine in the back somewhere with writing in Chinese characters, and a Chinese protective god inside. Even Thais with no Chinese background often keep Chinese divinities around them. Khajorn was told by a fortune-teller that we needed to acquire the Three Gods of Good Fortune: *Hok, Lok,* and *Siu* (Longevity, Wealth, Happiness). So we made a trip to Chinatown and purchased three ceramic statues of these bearded Taoist patriarchs. Perched high above my bedroom, just by the air conditioner, *Hok, Lok,* and *Siu* look after me to this day.

Chinese temples abound, especially in Chinatown, of course. Some are Buddhist, others Taoist (dedicated to the Jade Emperor, or the Southern Pole Star), but all are distinguished by dense eye-stinging clouds of incense, and the sound of people shaking boxes of sticks to tell their fortunes. Of the Chinese deities, the Goddess of Compassion, *Guanyin* (called *Guan-Im* by the Thais) has an appeal that extends far beyond the Chinese community. Her gaudily decorated temple at Chokchai 4 in Ladphrao is crowded every day with people petitioning for divine mercy.

One type of shrine in Bangkok, for sheer numbers sweeps away all the Hindu, Buddhist, and Chinese divinities together. These are the "spirit houses," *Saanphraphum* (shrine to the earth), and

Saanjaothii (shrine to the spirit of a place), that stand beside homes and buildings. A spirit house usually takes the form of a small temple standing on a raised pedestal. Inside are miniature figures of "the grandfather and the grandmother," with dancers, symbolizing the local spirits of the place who need to be placated and appeased by the people living on their land. The smallest huts and the highest skyscrapers, all may have *Saanphraphum* or *Saanjaothii* shrines.

These shrines represent the deeper level of animism that flows below Thai daily life. Not only do people propitiate the place spirits in various ways, but most Thais believe in *phii*, or ghosts, who populate every corner of Bangkok. From the point of view of

Saanphraphum shrine
Spirit house topped with Mt Meru tower, draped with garlands.

modern real estate, the fear of *phii* helps explain why Bangkokians have been so quick to tear down romantic old wooden buildings and replace them with the new. It's because these houses are haunted, the abodes of vengeful *phii*. Not that *phii* limit their activities to old houses. In August 2009, a television photographer created a sensation when he seemed to have captured the image of *phii* even in a Bangkok jail.

One *phii*, Mae Nak, has a cult of her own. According to legend, Nak married a young man named Mak, who was later drafted to military service, and while he was off at war, she died in childbirth. On his return to their home along the Phrakhanong canal, Mak finds his wife seemingly in good health. For a while, he lives happily with her, only to learn that she's a ghost. The story has been told and

re-told in books, songs, movies, musicals, and even an opera. Mae Nak's shrine can be found at Wat Mahabut on On Nut road, not far from the old Phrakhanong canal. Her ghost objects to young men being drafted and sent off to war, so this is the natural place for those facing Thailand's peacetime draft (chosen by lottery) to come and pray to be exempted from military service. Worshipers adorn Mae Nak's altar with gifts of dresses, cosmetics, toys for the baby, and even a TV to keep her company.

Animism expresses itself in the phallic cult, nowadays less evident in Bangkok, but still to be seen in the phallus-shaped amulets, *Palad Khik*, that you find on sale at Chatuchak Weekend Market, and on display at the notorious Chao Mae Tubtim shrine, piled high with phalluses large and small, behind the Swissôtel Nai Lert Park. Actually, the word "animism" is not quite right, as it doesn't cover the multitude of deities you see in Bangkok that one might call "gods of daily life," who don't fit into any particular religious category. Most popular is *Nang Kwak*, the "beckoning lady," who, kneeling with outstretched hand curving downwards, beckons luck into thousands of shops across the city.

Animism is much about magic – fortune telling, protecting against or exorcising *phii*, love potions, curses and counter-curses. The most powerful magic, it is believed, comes from the

Nang Kwak
With gold leaf applied
to the palm of her "money hand,"
she beckons customers and profits.

Khmers. Khmer witch-doctors are much feared, and occult Khmer writing features prominently in tattoos and other ritual inscriptions. Mon-Khmer are the substratum of modern Thailand, the indigenous people, whose chthonian wisdom underlies and precedes the arrival of the Thai. So the Khmer are believed to hold the keys to mystery.

I once witnessed up close Khmer magic at work in Bangkok. Kevin, a Canadian friend of mine was dating a young woman named Bok from Buriram who was born from a Khmer father and Suay mother. The Suay are one of Thailand's ancient tribes, with a language all their own, and the ability, it is thought, to commune with elephants, which is why they make excellent elephant mahouts. Bok and Kevin became good friends, but not much more, and Bok decided to do something about this.

One night, as a group of friends were gathered drinking wine at my apartment, Bok pulled out a small brown bottle about two centimeters high. This, she declared, contained a few precious drops of the legendary *namman phrai* oil used by sorcerers as a love potion. She had received it from her father, who had inherited it from Khmer wizards before him. *Namman phrai* is made, according to old belief, from the melted-down chin fat of the violently dead. Touch one drop of this ointment, and you will surely fall in love. "Don't touch it!" everyone yelled. But Bok smiled and said, "Nothing to worry, can't you see? It's sealed tight." Kevin picked up the little bottle out of curiosity. And then he noticed: the entire surface, even the lid and the bottom, were covered with a film of oil that was coating his fingers. Bok had tricked him!

Well, what did it matter? Another Thai superstition. After that night Kevin and I and the other guests forgot all about it. Until, of course, it happened. In short order Kevin fell heavily in love with Bok – and as J.K. Rowling could have told us, love artificially induced by magical potions never has a happy ending. Within a year Bok and Kevin had parted in miserable circumstances, and I'm not sure that he ever entirely recovered. Since then I take Khmer magic seriously.

So do Thai politicians. The battle between the pro and anti Thaksin factions from 2006-2009 was accompanied by a parallel war of magic. Reporter Wassana Nanuam published a best-selling book chronicling the skirmishes and counter-assaults of voodoo, as the leaders of the two sides enlisted soothsayers and masters of the dark arts to help them, performing ceremonies to boost their own good luck and cast curses on the opposing camps. Says Wassana,

"Thai politics today is not only about political one-upmanship through money, power, and guns. It's also about the battle of black magic."[28]

Lines between religions blur, as when Brahma shrines serve as spirit houses. Buddhism of two varieties (local Theravada and Chinese Mahayana), Taoism, Hinduism, and animism mix and mingle freely on Bangkok's streets. I don't know where I have ever been that I felt so surrounded by spirits. Even Japan, where most people are both Shinto and Buddhist, has, after all, just two major religions. Here we have at least five.

To these you also need to add Christianity and Islam. Early royal courts relied heavily on Muslim traders and administrators, so much so that Ayutthaya had districts devoted to Macassars and Malays. Bangkok has many well-established Muslim neighborhoods, such as the one near Soi Rongnamkaeng where I used to live, as well as the area around the Jim Thompson house.

As for Christianity, few Thais are Christian, far fewer than Muslim. But the outward forms of Christianity blend in as another ingredient, a foreign spice, into the Bangkok melting pot. When Christmas comes, Central World Plaza raises a huge Christmas tree, dazzling with fairy lights. More fairy lights and Christmas trees decorate the sidewalk in front of the Four Seasons Hotel on Rajdamri Road where thousands of people go to promenade and take photos. Shops overflow with little Santas, and malls reverberate with "I'm dreaming of a white Christmas."

Amidst this great "party of the spirits" going on in Bangkok, mainstream Buddhism is a surprisingly sober affair. Thai Buddhism as we see it today derives from Sri Lankan Theravada Buddhism, and the Sri Lankans are the most serious, the Calvinists of the Buddhist world. Thai temples, especially the more prestigious ones, strictly enforce the *vinaya* (monastic rules), and this created all sorts of situations for me and Num to sort out during the Millennium World Peace Summit in New York. The rules decreed that monks could not sleep on thick mattresses, so they removed the sheets and blankets from their beds and slept on the floor of their hotel suite. They are not allowed to eat anything after noon – which was a

problem when the afternoon debate sessions dragged on into the evening. Num spent hours standing at the airline reservations counter ensuring that the monks were seated only next to men, as they cannot sit next to a woman. The lady at the desk kept asking "Why?" "I don't know why!" answered Num, "But they just can't!"

Monks don't even have names of their own, as we learned after returning to Bangkok. The names we were familiar with turned out to be nothing but titles, and as our monk acquaintances have risen in the hierarchy, their names keep changing with them. Phra Rajavaramuni changed to Phra Thep Sophon, later rising to the higher title of Phra Dharmakosajarn, while the once simply-named Phra Maha Sawai has become the tongue-twisting Phra Krupalad Suwaddhana Vajirakhun.

Since 2000, Num, Saa, and I continued helping out with MCU conferences. The MCU group was inspired by their New York experiences to hold similar events in Bangkok. As had happened to me in Japan, without ever planning to be, Num now finds himself the unofficial translator for Thai Buddhism at these international gatherings. I lend a hand sometimes. I feel I could use the merit.

Once, at an interfaith gathering years ago at Mt Sinai, Hagami Shocho of Japan (another monk-philosopher) commented: "We tend to think of the West as 'rational', and the East as 'irrational' and emotional. But let's look at religion. Buddhism is supremely rational. Ruthless logic takes you, step by step, to ultimate emptiness – which is beyond all gods."

On the street we notice the colorful and superstitious aspects of Buddhism, the freeing of birds, turtles, and fish at festivals, the pasting of gold leaf on to idols. But at a deeper level, Buddhism really is about emptiness, and the Thais, who take their Buddhism seriously, have absorbed that. They've been taught since childhood that everything in the material world is illusion, that desires are the root of all evil, that life is fated by karma. Even the best karma is not as good as no karma.

In the real world, I don't get the impression that these teachings have succeeded in dampening desires very much. At least not judging by my young Thai friends who dream of building a home

in the country for their parents, or the big-haired ladies in the department stores who hanker after Gucci and Prada. But it does give people stamina and a kind of strength to bear the difficulties of life. When I'm sad or depressed, Saa or another good Thai friend will simply say, "Well, it's your karma." Not very encouraging that. But at another level, it's a great psychological release. Seeing all one's loves and dreams as nothing but emptiness – it teaches patience and even a sort of wisdom.

It's all summed up in the Thai expression *mai pen rai*, one of the first words that a visitor to Thailand learns: "never mind," "it doesn't matter." *Mai pen rai* encapsulates what one could call the Thais' "light touch." When I first started coming to Bangkok I used to contrast it with the equivalent expression in Japan: *shikata ga nai* "it can't be helped," "nothing to be done about it." The Japanese approach seemed more hopeless and fatalistic; the Thai more devil-may-care. Over time, I've come to feel, however, that the Thais and the Japanese are basically saying the same thing. The difference is that the Thais say it with a smile.

Pimsai Amranand writes in her memoirs about Victor Sassoon, legendary British expat who arrived in Bangkok in 1953: "Once he was backing his brand new car out of the drive and he thought the gardener had opened the gate for him. There was a scrunch and he got out of his car to see the damage. All the servants came running out of the house when they heard his wail and they all came and looked and laughed. They roared with laughter and said, "*Mai pen rai*," which means 'never mind'. He couldn't understand it. He said that servants in India where he had lived for many years would have been very sorry for him. They wouldn't have laughed."[29]

Before coming to live in Bangkok, I had studied Tibetan Buddhism in some depth, but had given less thought to Japanese Buddhism. In Japan, Zen preaches *Mu* ("nothingness"), but the *Mu* of Zen felt to me more like a witty aesthetic concept, a clever idea for designing gardens, but not very close to the heart. It didn't relate much to daily life. In modern Japan, people rarely refer to Buddhist ideas in daily conversation.

In Bangkok, people speak and think about Buddhism all the time. Of course, it could be that nowadays I'm more receptive to the Buddhist message. Maybe the Japanese have been speaking of Buddhism all along but I just wasn't listening. It took moving to Bangkok, where life is so fun, so *sanuk*, the surface so pleasurable, but at the same time full of surprise, disappointment, and uncertainty. Bangkok may be suffused with Hindu gods, *phii*, and other divinities, but for me, at least, Buddhism trumps them all. It's where people go in the end to seek quiet, solace, the emptiness beyond the kaleidoscopic swirl of forms and desires in the city.

At an interfaith summit in Kyoto back in the 1980s, representatives of all the world's religions decided that they would produce a communiqué announcing something that they could all agree on. After much argument, everyone finally signed off on the idea that "We all believe in a supreme divine power." "Wait a minute," said the Sri Lankans. "Not so. At the highest level, we Buddhists don't believe in *anything*. At the end of time and the universe, there is only emptiness." They had to tear up the communiqué and start all over again. Finishing it would require meeting again the following year – for another interfaith summit.

All this detachment and emptiness comes balanced with the sheer joy in existence that the Thais call *sanuk*. One can certainly have a lot of fun in China or Japan, and Japan is famous for its whimsical fashions and "floating world" nightlife. Nevertheless, "fun" is not something you hear about very much in those countries. *Gaman* ("patience"), *ganbare* ("persevere!") – these expressions, which you run across every day in Japan, drive people to work so hard and be so creative. The Chinese say "eating bitterness," referring to the years of struggle to create their fortunes in adopted lands. But the Thais look to see if a thing is *sanuk* before they decide if it's worth the effort. *Sanuk* is such a stereotype of Thailand that the most popular internet portal to things Thai is called *sanook.com*. One can imagine *sanuk* as the logical result of Buddhist nihilism. If life is short and in the end nothing truly matters, then one might as well enjoy oneself.

According to Professor Vithi, *sanuk* is related to the concept of the Himmaphan forest, where spirits dwell. He says, "It's a safe space in Thai culture. For example, in *fon pii* [shamanistic dance in the north] people get to do things you're not supposed to do. Women smoke and drink; there's phallic stuff. Himmaphan vents, allows for wicked behavior. It's not you, it's the *phii*."

Vithi continues, somehow managing to put *phii*, *sanuk*, *mai pen rai*, naughty Himmaphan, and pure Buddhism all in one picture:

> Especially in Bangkok culture, the emphasis is so much on *riaproy* (propriety), people dressed up and standing to attention in hot jackets. So you want to be disorderly, because the fact is, though, that all this propriety is not happiness enough. *Sanuk* equates to happiness, beyond the hardships of life. It's celestial beings not wearing hot jackets. *Nangfaa* (celestial maidens) and *thevada* (divinities) chasing each other, enjoying wickedness. In paintings, in a corner, somebody is doing something odd. In music, they slip in a sensual pornographic comment.
>
> Himmaphan reflects the pre-Buddhist, pre-Hindu world, when we worshipped jungle spirits. All these spirits have not gone away. The *pii* of the jungle are still with us, many of them serving the good, serving Buddhism.
>
> The symbolism of Himmaphan is that you have to swim through the stress of the jungle, the unruly, to the disciplined mind, for the peace of nirvana. It's the barrier between human existence and divine existence.
>
> This makes Thai culture very human. While our ultimate aim is Buddhist enlightenment, we understand human weaknesses for naughty things. Our eyes are looking towards *nirvana*, but our hands are groping along the way. Growing up in this culture, you can become a good human. You can forgive and say *mai pen rai*.[30]

In my Japanese art collection there is a fan with iron ribs covered with yellow paper. Noble families used such fans to train children

in Noh dance; the fan was so unwieldy that the child developed excellent control. Upon coming of age, the dancer acquired a real bamboo fan, and the lightness and freedom of use made dancing henceforth the easiest thing in the world.

For me, the iron fan symbolized Japan. The hierarchy and indirectness that so bedevils foreigners arriving in Thailand exists in far more elaborate forms in Japan – a dimension of difficulty above the bland Thai smile. When I made my official move to Bangkok in 1997, it seemed to me that after a lifetime in Japan, Thailand should come easy.

Yet those decades of experience in Japan proved to be nearly worthless. For Thailand is truly a thing unto its own, and the Thai smile conceals sensitivity and shades of nuance that can make the stiff Japanese bow appear almost primitive. For the next ten years I struggled to "find" Bangkok and to create a life here.

Nothing was what I had imagined it would be. A simple thing like the City Pillar, supposedly the center of Bangkok, turned out to be two pillars. And it's not even the true center of the city as far as road distances are concerned. I tried to learn Thai – and can still only manage simple conversation. I investigated many a real estate venture – but found that owning land comes in several shades, from "registered deed," to "squatters right," to "don't know." I imagined that I would become an art collector – but what had seemed so innocent and even spiritually uplifting in Japan, took on darker overtones down here. So I held back, and although I met some extraordinary connoisseurs, I never built a collection. I set out to establish a program of traditional arts – and instead I found myself back in school again. What I did do was to run a shop selling benjarong, something that was far from my basic interests, and which closed after six years, losing all the money that my investors had entrusted me with. In short, nothing was as it seemed to be, all was evanescent, everything slipped through my fingers.

It's not just a matter of uncertainty in my personal affairs. The political landscape of Thailand also lies on shifting ground. In Japan, just as you can be sure that the trains will run on time, so

you can depend on society around you to behave according to the rules. It's a comfort to know that, even as political parties come and go, few great changes will take place in our lifetimes.

Not so in Thailand, where the society rests on a seismic fault zone. The struggles between the Red and Yellow Shirts in 2007-2009 exposed deep fissures, and everyone knows that further upheavals are in store. As a result, you can't assume that the same people will be in power when you wake up in the morning. Nobody can guess where Bangkok is really heading.

Meanwhile, like my Thai entrepreneur friends who close one business at the Night Bazaar only to start another in Chatuchak, or my employees who dream every week that they're going to win the lottery, I go on with my life in Bangkok looking forward to the next turn of the karmic wheel.

Once I thought I knew something about antiques, performing arts, business, East Asian culture and history, language learning, houses, expats, Buddhism, and the role that we foreigners play in Asia. Now, things appear rather different. Elusive Bangkok seems like the iron fan compared to organized Japan.

Part of the experience has been a hard one, of difficulty and disillusionment, coming to grips with the emptiness under the charming surface of things. That's Bangkok's biggest lesson, perhaps, but it also happens to be classic Buddhist teaching.

In any case, one had best be in the place that teaches one patience and some detachment – plus, of course, plenty of *sanuk*. As for the rest, *mai pen rai*. I came to Bangkok seeking much, but found just one thing for sure: home.

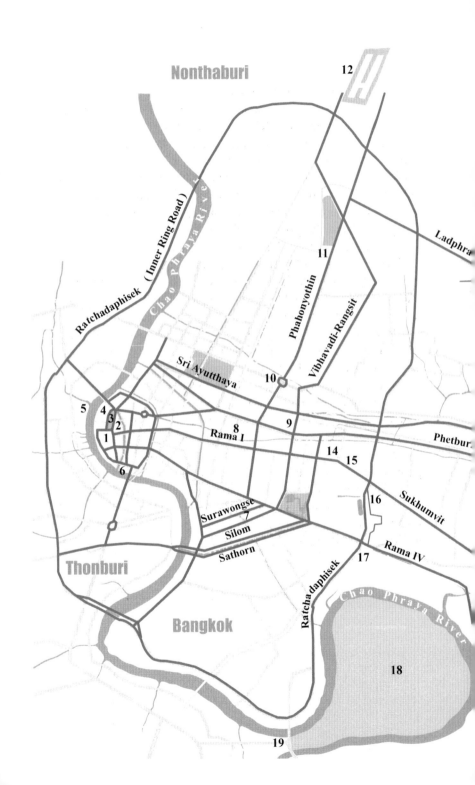

Nonthaburi

12

Ratchadaphisek (Inner Ring Road)

Chao Phraya River

Ladphra

Phahonyothin

Vibhavadi-Rangsit

11

Sri Ayutthaya

10

5 4
3 2
1

8
Rama I

9

Phetbur.

14
15

6

16

Sukhumvit

Surawongse
7
Silom
Sathorn

Ratchadaphisek

17

Rama IV

Thonburi

Bangkok

Chao Phraya River

18

19

B a n g k o k

1 Grand Palace
2 City Pillar
3 Sanam Luang
4 National Museum (Phutthaisawan Chapel)
5 Patravadi Theatre
6 Flower Market
7 Patpong
8 Jim Thompson House
9 Pratunam
10 Victory Monument
11 Chatuchak Weekend Market
12 Don Muang Airport
13 Ladphrao House
14 Soi Nana
15 Nai Lert Building
16 Soi 16
17 Klong Toei
18 Bang Kachao
19 Bhumibol Bridges
20 Suvarnabhumi Airport

20

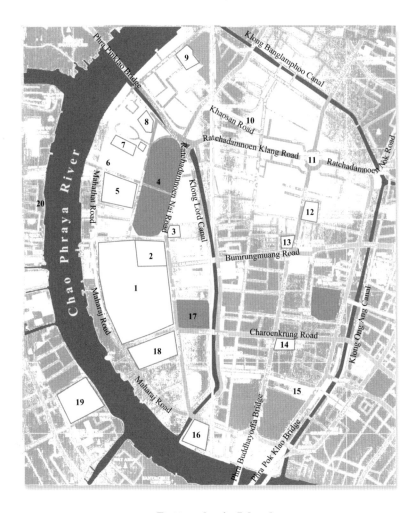

Rattanakosin Island

1 Grand Palace
2 Emerald Buddha Temple (Wat Phra Kaew)
3 City Pillar (Sao Lak Muang)
4 Royal Ground (Sanam Luang)
5 Mahachulalongkorn University/Wat Mahathat
6 Thammasat University
7 National Museum (Phutthaisawan Chapel)
8 National Theatre
9 Baan Phra Arthit
10 Khaosan Road

11 Democracy Monument
12 City Hall
13 Brahmin Temple (Devastan)
14 Sala Chalermkrung Royal Theatre
15 Pahurat Market
16 Flower Market (Pak Klong Talad)
17 Saranrom Park
18 Wat Pho
19 Temple of the Dawn (Wat Arun)
20 Patravadi Theatre

ENDNOTES

1 Philip Cornwel-Smith, *Very Thai* (Bangkok: River Books, 2005) p. 36

2 Steve van Beek, *Bangkok, Then and Now* (Bangkok: AB Publications, 1999) p. 15

3 Andrew Marshall, "Jailhouse Shock," *TIME* (12 January 2009) p. 42

4 Daniel Ziv and Guy Sharett, *Bangkok Inside Out* (Jakarta: Equinox Publishing, 2005) p. 20

5 Pimsai Amranand, *My Family, My Friends, and I* (Bangkok: December 1977) p. 27

6 David K. Wyatt, *Thailand a Short History* (Hong Kong: Silkworm Books, 1984) p. 73

7 Supawadee Inthawong, "Sombat Khong Phudee', A century-old tale on manners is animated for television screens," *Bangkok Post* (25 September 2008)

8 Supawadee Inthawong, "Sombat Khong Phudee'

9 Conversation with Mr Chakrarot Chitrabongs at Oxford and Cambridge Annual Dinner, October 7, 2009

10 Conversation with Vithi Phanichphant, October 15, 2009

11 Joshua Harris, "Where Next for contemporary Thai Art?" *Bangkok Post* (27 December 2007) Outlook p. 02

12 Peter Jackson, "Performative Genders, Perverse Desires: A Bio-History of Thailand's Same Sex and Transgender Cultures," *Intersections: Gender, History and Culture in the Asian Context* (August 9 2003) Issue 9, p. 9

13 Pimsai Amranand, *My Family, My Friends, and I*, p. 39

14 Mont Redmond, *Wondering into Thai Culture* (Bangkok: Redmondian Insight Enterprises Co Ltd, 1998) p 139

15 Pimsai Amranand, *My Family, My Friends, and I*, p. 33

16 Mont Redmond, *Wondering into Thai Culture*, p 223

17 Interview with Suthichai Yoon of The Nation, quoted in *The China Post* (July 23 2009)

18 Lawrence Durrell, *Mountolive*, (USA: E.P. Dutton & Co, 1961) p. 129,

19 Pimsai Amranand and William Warren, *Gardening in Bangkok* (Bangkok: The Siam Society, 1996) p 15,

20 Pimsai Amranand and William Warren, *Gardening in Bangkok*, p. 16

21 Philip Cornwel-Smith, *Very Thai*, p. 86

22 Peter Jackson, "Performative Genders, Perverse Desires: A Bio-History of Thailand's Same Sex and Transgender Cultures," *Intersections: Gender, History and Culture in the Asian Context* (August 9 2003) Issue 9, p. 13

23 Peter Jackson, "Performative Genders," p. 14

24 Peter Jackson, "Performative Genders," p. 13

25 Joshua Harris, Outlook p. 02, *Bangkok Post*, "Where Next for contemporary Thai Art?", Dec 27, 2007

26 Conversation with MR Chakrarot Chitrabongs, October 7, 2009

27 Mont Redmond, *Wondering into Thai Culture*, p 152,

28 Sanitsuda Ekachai, "Black Magic Politics," *Bangkok Post* (16 March 2009) Outlook, p. 01

29 Pimsai Amranand, *My Family, My Friends, and I*, p. 62

30 Conversation with Vithi Phanichphant, April 10, 2009

APPENDIX

Kings of the Chakri Dynasty

		Reigned
Rama I	King Buddha Yodfa Chulalok	1782 - 1809
Rama II	King Buddha Loetla Nabhalai	1809 - 1824
Rama III	King Nangklao	1824 - 1851
Rama IV	King Mongkut (Chomklao)	1851 - 1868
Rama V	King Chulalongkorn (Chulachomklao)	1868 - 1910
Rama VI	King Vajiravudh (Mongkutklao)	1910 - 1925
Rama VII	King Prajadhipok (Pokklao)	1925 - 1935
Rama VIII	King Ananda Mahidol	1935 - 1946
Rama IX	King Bhumibol Adulyadej	1946 - Present

THAI LEXICON

Transliteration of Thai words and proper names

Ananta Samakhom Throne Hall พระที่นั่งอนันตสมาคม
Anucha "Tom" Thirakanont อนุชา ทีรคานนท์ (ทอม)
Apinan Poshyananda ดร. อภินันท์ โปษยานนท์
apsara อัปสรา
Arporn Ngam คณะละครอาภรณ์งาม
Baan Mankhong บ้านมั่นคง
bai jak ใบจาก
bai sema ใบเสมา
bai toei ใบเตย
baisri บายศรี
Baiyoke 1 อาคารใบหยก 1
Baiyoke 2 อาคารใบหยก 2
Ban Chiang บ้านเชียง
Bunditpatanasilpa Institute สถาบันบัณฑิตพัฒนศิลป์
Bang Kachao บางกะเจ้า
Bang Pa-in บางปะอิน
Bangkok Noi Canal คลองบางกอกน้อย
Banglampoo บางลำภู
bao-bao เบาๆ
Benjarong เบญจรงค์
Bhumibol I and Bhumibol II Bridges
 สะพานภูมิพล 1 และสะพานภูมิพล 2 หรือ
 สะพานวงแหวนอุตสาหกรรมเดิม
Big บิ๊ก, see Peeramon "Big Chomdhavat
Bird McIntyre (Thongchai) เบิร์ด ธงไชย แมคอินไตย์
bok phrong dooy sutjarit บกพร่องโดยสุจริต
boon บุญ
Brahma พระพรหม
Buddhist Sangha พระสงฆ์
buea farang เบื่อฝรั่ง
Bunnag family ตระกูลบุนนาค
chadaa ชฎา
Chakrabongse House บ้านจักรพงษ์ หรือ
 วังจักรพงษ์เดิม
Chakrarot Chitrabongs, MR ม.ร.ว.จักรรถ จิตรพงศ์
Chakri Dynasty ราชวงศ์จักรี
Chalermchai Kositpipat เฉลิมชัย โฆษิตพิพัฒน์
Chalermsri Savetasila เฉลิมศรี เศวตศิลา
Chamlong Srimuang พลตรีจำลอง ศรีเมือง
chanode โฉนด
Chao Dara Ratsami เจ้าดารารัศมี
Chao Phraya Phrasadet Surentrarthipbodi
 (MR Pia Malakul) เจ้าพระยาพระเสด็จสุเรนทราธิบดี
 (ม.ร.ว.เปีย มาลากุล)
Charoen Krung ถนนเจริญกรุง
chedi เจดีย์

Chiangkham เชียงคำ
Chiiori Benjarong ชีโอริ เบญจรงค์
Chinatown ย่านเยาวราช
chofa ช่อฟ้า
Chokchaisii Market ตลาดโชคชัย 4
chommanat ต้นชมนาด
Chong Nonsi ช่องนนทรี
City Pillar, see Shrine of the City Pillar
Constantine Phaulkon คอนสแตนติน ฟอลคอน หรือ
 เจ้าพระยาวิชาเยนทร์
Cultural Surveillance Center ศูนย์เฝ้าระวังทางวัฒนธรรม
dok kratum ดอกกระทุ่ม
deva (thevada) เทวา เทวดา เทพ
Devakul family ราชสกุลเทวกุล
Devavesm Palace วังเทเวศม์
Dhammakaya (Wat Phra Dhammakaya) วัดพระธรรมกาย
Dhammayuttika Nikaya ธรรมยุติกนิกาย
dok mai wai ดอกไม้ไหว
Don Muang airport สนามบินดอนเมือง
Duang Prateep Foundation มูลนิธิดวงประทีป
Emerald Buddha พระแก้วมรกต หรือ พระพุทธมหามณี-
 รัตนปฏิมากร
Erawan Shrine ศาลท้าวมหาพรหม โรงแรมเอราวัณ
Exchange Tower อาคารเอ็กซ์เชนจ์ ทาวเวอร์
farang ฝรั่ง
Fine Arts Department กรมศิลปากร
fon leb ฟ้อนเล็บ
fon pii ฟ้อนผี
forest monks (phra thu dong) พระธุดงค์
Front Palace, see Wang Na
Garuda ครุฑ
Gaysorn Plaza เกษรพลาซ่า
gig กิ๊ก
gin khao rue yang กินข้าวหรือยัง
Ginny Bird เวอร์จิเนีย เฉลิมศรี เบิร์ด
Goethe Institute สถาบันเกอเธ่
 (สถาบันวัฒนธรรมไทย-เยอรมัน)
Government House ทำเนียบรัฐบาล
kraab กราบ
krengjai เกรงใจ
Guanyin (Guan-Im) เจ้าแม่กวนอิม
Hanuman หนุมาน
hatsadiling, see nok hatsadiling
Himmaphan หิมพานต์
Hilton Hotel, see Swissôtel Nai Lert Park
Hindu ฮินดู

Hok, Lok, and Siu ฮก ลก ชิ่ว
Hom Rong โหมโรง
hua chai Poh หัวใจโป๋ว
hun lakhon lek หุ่นละครเล็ก
Indie อินดี้
Indra พระอินทร์
Indra Condominium อินทรา คอนโดมิเนียม
Indra Hotel (Indra Regent Hotel) โรงแรมอินทรารีเจนท์
Ing Kanjanavanit สมาน รัชฎ์ กาญจนะวณิชย์ (อิ๋ง)
Inter อินเตอร์
Isarn (Isaan) อีสาน
jaeo แจ่ว
jai ใจ
jai rawn ใจร้อน
jai yenyen (jai yen) ใจเย็นๆ (ใจเย็น)
jampa ดอกจำปา
jampi ดอกจำปี
Java ชวา
jiib จีบ
jim nam จิ้มน้ำ
Jim Thompson's House บ้านจิม ทอมป์สัน
Jirasak Thongyuak จิระศักดิ์ ทองหยวก
Joe Louis, see Traditional Thai Puppet Theater
Jomphol Por, see Phibunsongkhram
jongkrabane โจงกระเบน
kaeng แกง
kaeng jeud แกงจืด
kaeng lueang แกงเหลือง
kaeng som แกงส้ม
kaeng tai plaa แกงไตปลา
Kai, see Surat "Kai" Jongda
kangkeng กางเกง
kangkeng talay กางเกงทะเล
kap hey rua chom kruang khao wan
 กาพย์เห่เรือชมเครื่องคาวหวาน
kapi กะปิ
kapyani กาพย์ยานี
katoey กะเทย
Kelantan รัฐกะลันตัน
Kengtung เชียงตุง
Khaek แขก
Khajorn Khamkong ขจร คำคง
kham คำ
Khanchai "Jom" Homjan ขรรค์ชัย หอมจันทร์ (จอม)
khanom jiin ขนมจีน
khantok ขันโตก
khao chae ข้าวแช่
khao niao ข้าวเหนียว
khao tom jiin ข้าวต้มจีน
khao yam ข้าวยำ

khaomok kai ข้าวหมกไก่
Khloem เคลิ้ม
Khmu ขมุ
Khon โขน
Khru ครู
Khru Kai, see Surat "Kai" Jongda
khrueang ratchasakkara เครื่องราชสักการะ
khunnang ขุนนาง
khunying คุณหญิง
King Lithai พระยาลิไท หรือ พระมหาธรรมราชาที่ 1
King Narai สมเด็จพระนารายณ์มหาราช
kit teung baan คิดถึงบ้าน
Klong Lord Canal คลองหลอด
Klong Om Canal คลองอ้อม
Klong Phaisingto คลองไผ่สิงห์โต
Klong Saen Saeb (Saen Saep) คลองแสนแสบ
Klong Toei slum ชุมชนคลองเตย
koi kung ก้อยกุ้ง
kra กระ
krajiab กระเจี๊ยบ
kranok ลายกนก (ลายกระหนก)
krathong กระทง
kua gling คั่วกลิ้ง
Kukrit Pramoj, MR ม.ร.ว.คึกฤทธิ์ ปราโมช
lai kranok, see kranok
Lai Thai ลายไทย
lakhon nai ละครใน
lakhon nohk ละครนอก
Langkasuka อาณาจักรลังกาสุกะ
Lanna ลานนา, ล้านนา
Last life in the Universe เรื่องรัก น้อยนิด มหาศาล
lay เล, see talay
likay ลิเก
luk-khrueng ลูกครึ่ง
Lumpini Park สวนลุมพินี
Luwa (Wa) ลัวะ หรือ ว้า
ma fueng มะเฟือง
ma gawk มะกอก
ma muang มะม่วง
ma yom มะยม
Maarayaat (Etiquette) มารยาท
madmii มัดหมี่
Mae Chee Sansanee Sthirasuta แม่ชีศันสนีย์ เสถียรสุต
Mae Nak แม่นาค
Mae Tubtim shrine ศาลเจ้าแม่ทับทิม
maengda แมงดา
Maha Nikaya มหานิกาย
Mahachulalongkornrajavidyalaya University
 มหาวิทยาลัยมหาจุฬาลงกรณราชวิทยาลัย
Mahajanaka พระมหาชนก

Phra Kaew Morakot, see Emerald Buddha
Phra Maha Sawai พระมหาไสว (Phrakrupalad
 Suwaddhanavajirakhun พระครูปลัด สุวัฒนวชิรคุณ)
Phra Petraja สมเด็จพระเพทราชา
Phra Rajavaramuni พระราชวรมุนี
Phra Ruang พระร่วง
Phra Tamnak Daeng พระตำหนักแดง (ตำหนักแดง)
Phra Thepsophon พระเทพโสภณ
Phrakhanong Canal คลองพระโขนง
phrik พริก
phrik thai พริกไทย
phuangmalai พวงมาลัย
phudii ผู้ดี
Phutthaisawan Chapel พระที่นั่งพุทไธสวรรย์
phuu mii itthiphon ผู้มีอิทธิพล
Pichet Klunchun พิเชษฐ์ กลั่นชื่น
Pimsai Amranand, MR ม.ร.ว.ปิ้มสาย อัมระนันทน์
Ping Amranand ปิงคสวัสดิ์ อัมระนันทน์ (ปิ้ง)
Pinklao, Prince of the Front Palace พระบาทสมเด็จ
 พระปิ่นเกล้าเจ้าอยู่หัว กรมพระราชวังบวรสถานมงคล
piphaat วงปี่พาทย์
Piyasvasti "Pok" Amranand ปิยสวัสดิ์ อัมระนันทน์ (ป๊อก)
plaa krai ปลากราย
plaa raa ปลาร้า
plaa thuu ปลาทู
Pok Amranand, see Piyasvasti "Pok" Amranand
por bor tor 5 ภ.บ.ท. 5
por bor tor 6 ภ.บ.ท. 6
pra ประ
prajam yam ประจำยาม
prang ปรางค์ (พระปรางค์)
Prasart Collection (Prasart Museum) พิพิธภัณฑ์ปราสาท
pret, see phii pret
Prince Chumbhot พระเจ้าวรวงศ์เธอ พระองค์เจ้า
 จุมภฏพงษ์บริพัตร กรมหมื่นนครสวรรค์ศักดิพินิต
Prince Damrong สมเด็จพระเจ้าบรมวงศ์เธอ
 กรมพระยาดำรงราชานุภาพ
Prince Issarasena พระเจ้าราชวรวงศ์เธอ
 พระองค์เจ้าพงศ์อิศรเรศ กรมหมื่นกษัตริย์ศรีศักดิเดช
Prince Mahidol สมเด็จพระมหิตลาธิเบศร อดุลยเดชวิกรม
 พระบรมราชชนก
Prince Naris, see Prince Narisra Nuvadtiwongs
Prince Narisra Nuvadtiwongs สมเด็จพระเจ้าบรมวงศ์เธอ
 เจ้าฟ้าจิตรเจริญ กรมพระยานริศรานุวัดติวงศ์
Prince Svasti สมเด็จพระเจ้าบรมวงศ์เธอ
 พระองค์เจ้าสวัสดิโสภณ กรมพระสวัสดิวัฒนวิศิษฎ์
Princess Galyani สมเด็จพระเจ้าพี่นางเธอ
 เจ้าฟ้ากัลยาณิวัฒนา กรมหลวงนราธิวาสราชนครินทร์
Rachen "Num" Suvichadasakhun ราเชนทร์ สุวิชาดาสกุล
 (หนุ่ม)

rai ไร่
raja pataen ราชปะแตน
Rajdamri Road ถนนราชดำริ
Rama พระราม
Ramakien รามเกียรติ์
Ramathibodi รามาธิบดี
Ramayana รามายณะ, see Ramakien
ramruay phit pakkati ร่ำรวยผิดปกติ
ramwong รำวง
Ratchada ย่านรัชดาฯ
Ravana, see Totsakan
RCA (Royal City Avenue) อาร์ซีเอ (รอยัล ซิตี้ เอเวนิว)
Red Shirts เสื้อแดง หรือ แนวร่วมประชาธิปไตยต่อต้าน
 เผด็จการแห่งชาติ
riaproy เรียบร้อย
rishi ฤๅษี
Rusii, see rishi
River City ศูนย์การค้าริเวอร์ซิตี้
Ronnarong "Ong" Khampha รณรงค์ คำผา (อ๋อง)
Royal Bangkok Sports Club ราชกรีฑาสโมสร
Ruen Urai restaurant ร้านอาหารเรือนอุไร
Saa, see Tanachanan "Saa" Petchsombat
Saanjaothii ศาลเจ้าที่
Saanphraphum ศาลพระภูมิ
saeb แซ่บ
sai sin สายสิญจน์
sakdina ศักดินา
Sakul Intakul สกุล อินทกุล
sala ศาลา
Sala Chalermkrung Royal Theatre ศาลาเฉลิมกรุง
Samet เกาะเสม็ด
Sanam Luang สนามหลวง
Sanskrit สันสกฤต
Santi Asoke สันติอโศก
Santi Svetavimala สันติ เศวตวิมล
sanuk สนุก
Sao Intrakin เสาอินทขิล
Saochingcha (Giant Swing) เสาชิงช้า
Sarasin Road ถนนสารสิน
Savetsila family ตระกูลเศวตศิลา
sawasdii สวัสดี
Second King, see Pinklao
Shrine of the City Pillar ศาลหลักเมือง
Siam สยาม
Siam Niramit สยามนิรมิต
Siam Society สยามสมาคมในพระบรมราชูปถัมภ์
Siddhi Savetsila (Savetasila) องคมนตรี
 พลอากาศเอกสิทธิ เศวตศิลา
Soe โซ่, see Vitsanu "Soe" Riewseng
Soi Asoke ซอยอโศก